ANSEL ADAMS

4OO PHOTOGRAPHS

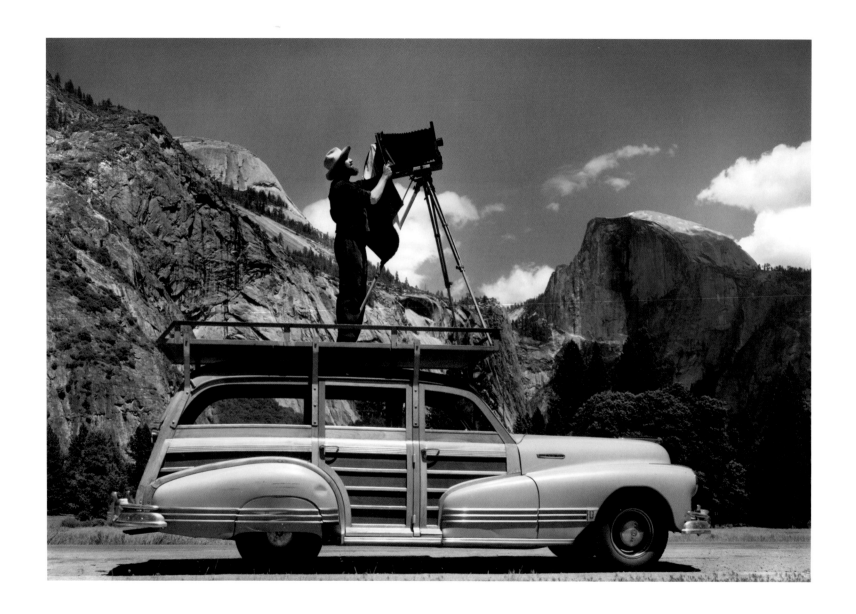

ANSEL ADAMS PHOTOGRAPHING IN YOSEMITE, 1942, BY CEDRIC WRIGHT

ANSEL ADAMS

400 PHOTOGRAPHS

EDITED BY ANDREA G. STILLMAN

LITTLE, BROWN AND COMPANY NEW YORK · BOSTON · LONDON

For John Szarkowski

He inspires us all…

CONTENTS

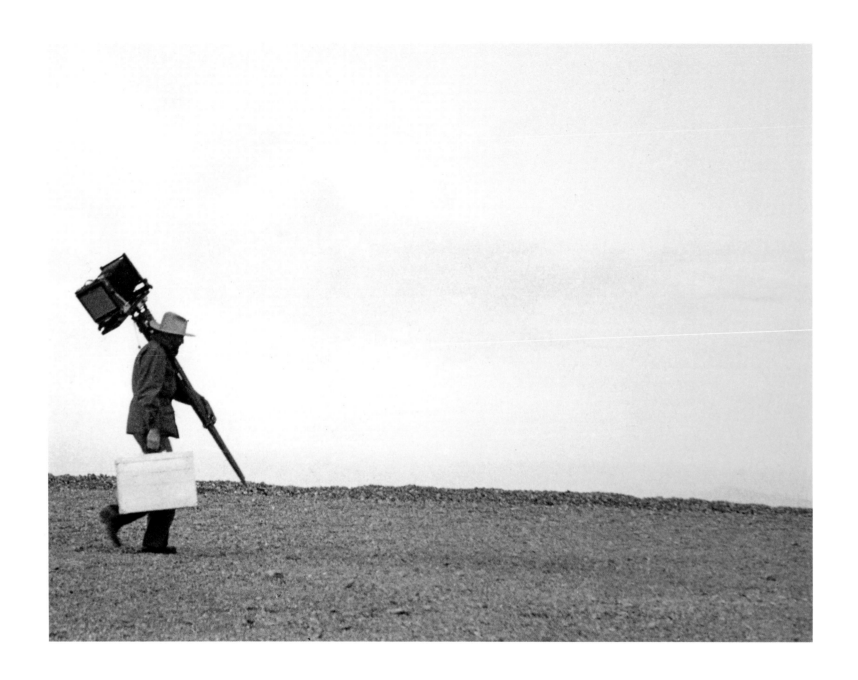

ANSEL ADAMS IN THE SOUTHWEST, 1947, BY BEAUMONT NEWHALL

INTRODUCTION

THE LONG VIEW

ANSEL ADAMS was always in motion, always ready to laugh, always gentlemanly. He was a big, bearded man dressed in work pants and a colorful shirt, with his signature Stetson. After a morning in the darkroom, he would emerge beaming, holding up a dripping wet print, and announce, "I think I got it!" Occasionally the piano would call, and he would sit down at his beloved Mason & Hamlin to commune with Bach or Scriabin. But it was photography in the great American wilderness that set his mind and body racing.

Adams edited twenty-eight books of his photographs and wrote another ten on photographic technique. Since his death in 1984, The Ansel Adams Trust has, in collaboration with Little, Brown and Company, published an additional sixteen books. This book, however, is the only one that traces Adams' artistic development from the first photographs made in 1916 to the last great photographs made in the 1960s. From the thousands of photographs in his archive and in museums and private collections, four hundred of the most significant have been selected and arranged in roughly chronological order by decade. You will find in these pages the iconic images most associated with Adams' name, but there are also unknown and rarely seen images. Many of the photographs are annotated, often in his own words, in the notes on pages 413–428.

More than one third of the four hundred photographs in this book were made in the mountains of the Sierra Nevada, Adams' true spiritual home. The Sierra is as constant a presence in this book as it was in his life. Indeed, it is possible to trace Adams' artistic evolution through the twenty-two portraits of Half Dome included herein.

Adams had a rare gift: he was able to transform geographic reality into transcendent emotional experience. How did he accomplish this? Through hard work and experience, he developed a technical mastery that allowed him to photograph with facility and confidence. He could

1920S

1930S

make a photograph in the rain or even in a snowstorm, and he could photograph a mountain thirty miles distant or a stump white with frost at his feet. In a pinch, he could even photograph a moonrise without a light meter, knowing only the candles per square foot of the moon. Moreover, his skills in the darkroom were unsurpassed, and he could make a gorgeous print from any negative, even a negative with problems.

Edward Weston said that "composition is the strongest way of seeing." Adams had an intuitive sense of the strongest composition, whether the subject was a landscape or a still life in the studio. This was a gift, not something that could be learned, and he possessed it even in his teens.

Adams' biography by his friend Nancy Newhall is sub-titled *The Eloquent Light*. Dawn light, noon light, the light of early evening — light transforms Adams' subjects into dramatic statements about a specific moment in time. Whether it is a snow-covered mountain, a frozen lake, white crosses in a graveyard, or ferns by the side of the road, it is light that defines an Ansel Adams photograph.

Adams had a message: the earth has been given to us to live on and enjoy, and we have an obligation to preserve it for future generations. This passion for the preservation of the natural world informed his photographs.

If Henry David Thoreau was the philosopher of the wilderness movement and John Muir its popularizer, Ansel Adams was its artist. Although deeply involved as a director of the Sierra Club for thirty-eight years, Adams very rarely

1940s

1950s

1960s

made a particular photograph for a specific environmentalist purpose. With important exceptions such as the use of his photographs — and his legendary 1938 book (reissued in 2006), *Sierra Nevada: The John Muir Trail* — to lobby for a Kings Canyon National Park, his impact has been at a broad level of consciousness-raising rather than as campaign illustration. Literally millions of Americans have seen exhibitions of Adams' photographs and have immersed themselves in his books. It can be said that what Muir was to his epoch, Adams has been to ours . . . a kind of visual Muir, a symbol of conscience, of reverence, of caring for the land.

In 1980 President Jimmy Carter conferred the Presidential Medal of Freedom — America's highest civilian award — on Ansel Adams. The citation reads:

At one with the power of the American landscape, and renowned for the patient skill and timeless beauty of his work, photographer Ansel Adams has been visionary in his efforts to preserve the country's wild and scenic areas, both on film and on Earth. Drawn to the beauty of nature's monuments, he is regarded by environmentalists as a monument himself, and by photographers as a national institution. It is through his foresight and fortitude that so much of America has been saved for future Americans.

Adams took the long view of life. It seems fitting that his camera's usual position was a considerable distance from the subject, the long view.

Andrea G. Stillman
New York, New York
November 2006

1916–1930 YOSEMITE AND THE HIGH SIERRA

In the summer of 1916, when he was fourteen years old, Adams visited Yosemite National Park for the first time. With his first camera, he made what he called a "visual diary" — a record of where he had been. On his return to San Francisco, his father helped him paste the photographs in an album and title them in white ink on black paper (see pages 13–15).

Adams continued to spend part of every summer in the Sierra and to explore his natural aptitude for both the aesthetic and technical elements of photography. The photographs that he made from 1918 to 1927 alternated between mere records of scenery and more artistic expressions, sometimes with surprisingly abstract results. In 1927, while composing a photograph of Half Dome (page 35), for the first time he was able to imagine what he wanted the finished print to express before he clicked the shutter. He later called this process "visualization." As his technical and artistic ability continued to grow, he began to photograph with greater authority, and the images he made in Canada in 1928 achieved a new intensity and power (page 50–52). By 1930 Adams decided to abandon the career he had planned as a pianist and chose instead to pursue photography.

Half Dome.

PAGE FROM CHILDHOOD ALBUM: FIRST PHOTOGRAPH OF HALF DOME, 1916

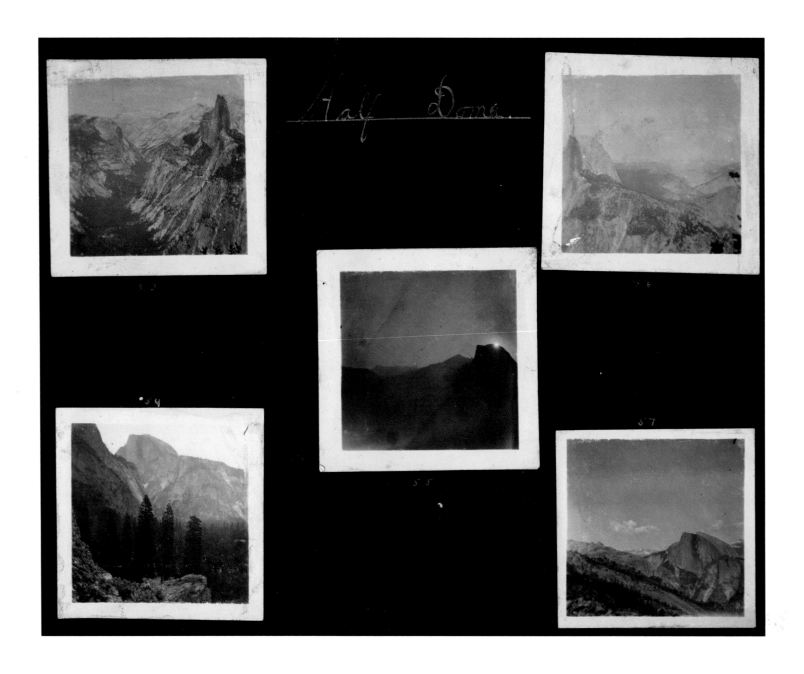

Half Dome

PAGE FROM CHILDHOOD ALBUM: VIEWS OF HALF DOME, 1916

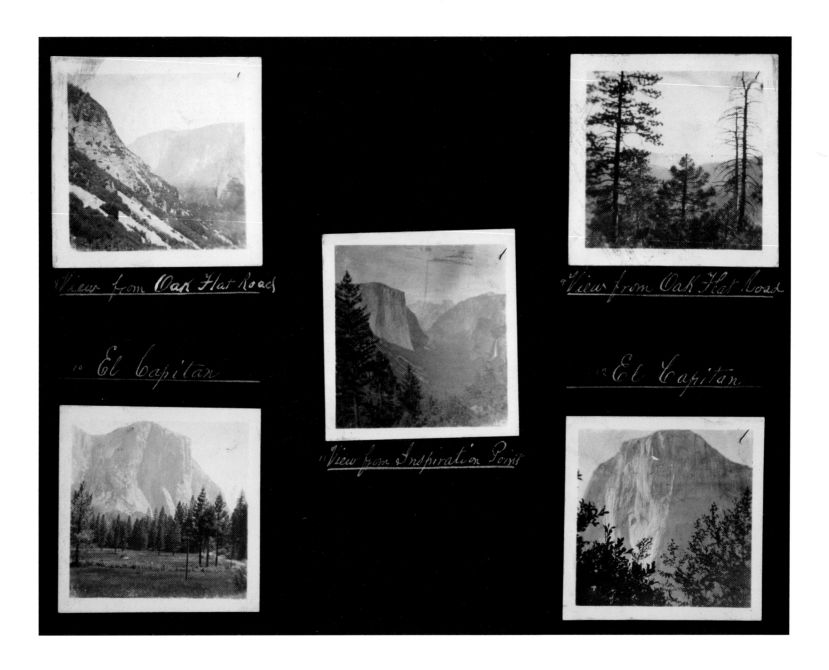

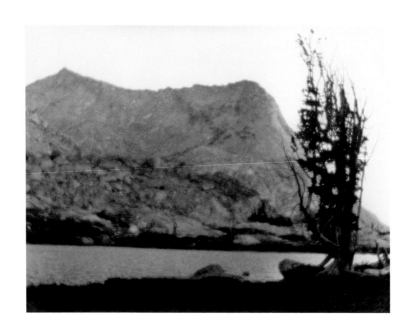

VOGELSANG PEAK, FLETCHER LAKE, TREE, YOSEMITE NATIONAL PARK, CALIFORNIA, C. 1919

MOUNT FLORENCE THROUGH TREES, YOSEMITE NATIONAL PARK, CALIFORNIA, C. 1923

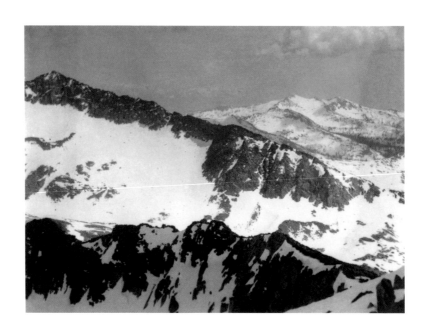

MERCED PEAK FROM RED PEAK, YOSEMITE NATIONAL PARK, CALIFORNIA, C. 1920

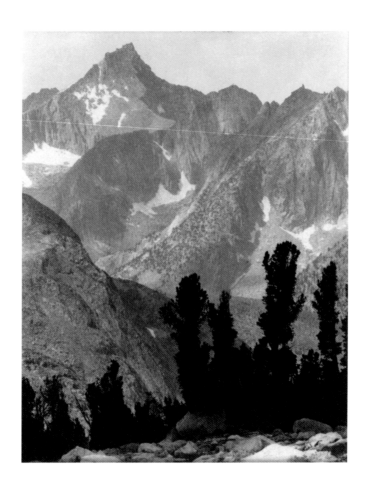

MOUNT CLARENCE KING, KINGS CANYON NATIONAL PARK, CALIFORNIA, C. 1923

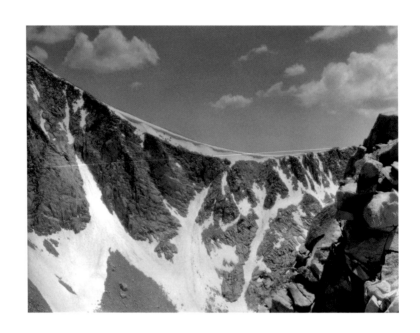

RIDGE, SIERRA NEVADA, CALIFORNIA, C. 1925

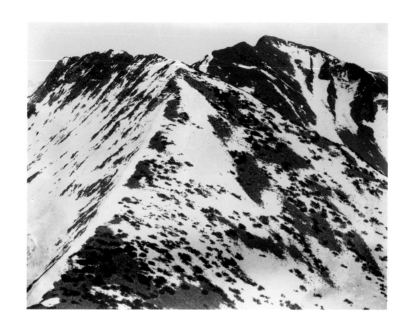

SUMMIT OF RED PEAK, SIERRA NEVADA, CALIFORNIA, 1920

FALL IN UPPER TENAYA CANYON, YOSEMITE NATIONAL PARK, CALIFORNIA, C. 1920

SIMMONS PEAK, IN THE MACLURE FORK CANYON, YOSEMITE NATIONAL PARK, CALIFORNIA, C. 1924

VERNAL FALL THROUGH TREE, YOSEMITE NATIONAL PARK, CALIFORNIA, 1920

BACK OF HALF DOME, YOSEMITE NATIONAL PARK, CALIFORNIA, C. 1920

LODGEPOLE PINES, LYELL FORK OF THE MERCED RIVER, YOSEMITE NATIONAL PARK, CALIFORNIA, 1921

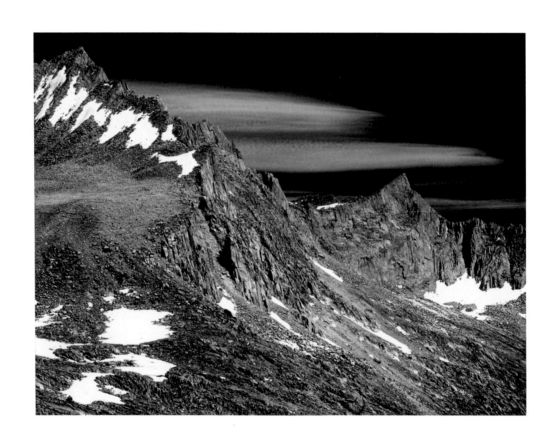

MOUNT ABBOTT, SIERRA NEVADA, CALIFORNIA, 1929

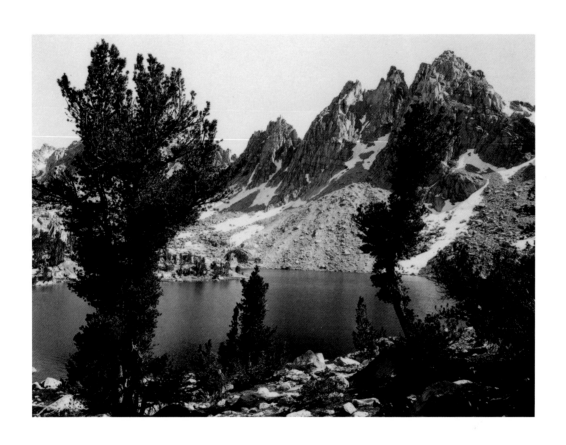

KEARSARGE PINNACLES, KINGS CANYON NATIONAL PARK, CALIFORNIA, C. 1925

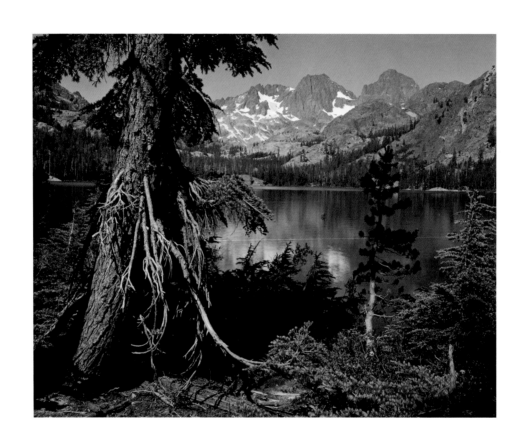

SHADOW LAKE, MOUNT RITTER AND BANNER PEAK, SIERRA NEVADA, CALIFORNIA, 1929

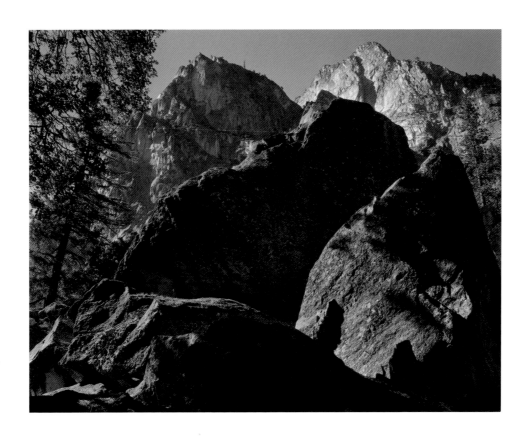

GRAND SENTINEL AND TALUS, KINGS CANYON NATIONAL PARK, CALIFORNIA, C. 1925

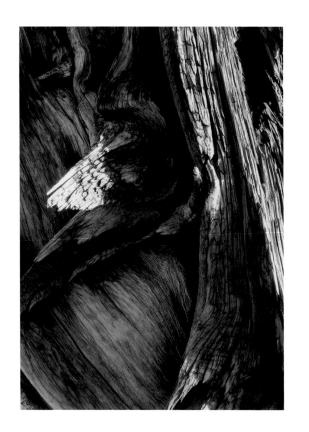 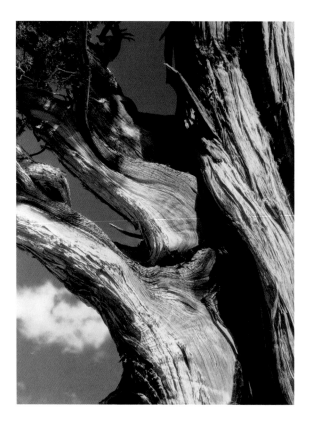

DETAIL, JUNIPER WOOD, SIERRA NEVADA, CALIFORNIA, C. 1927

THE HERMIT, SIERRA NEVADA, CALIFORNIA, C. 1930

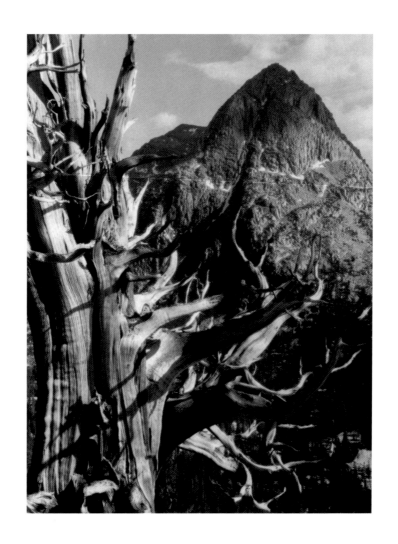

JUNIPER, SIERRA NEVADA, CALIFORNIA, C. 1930

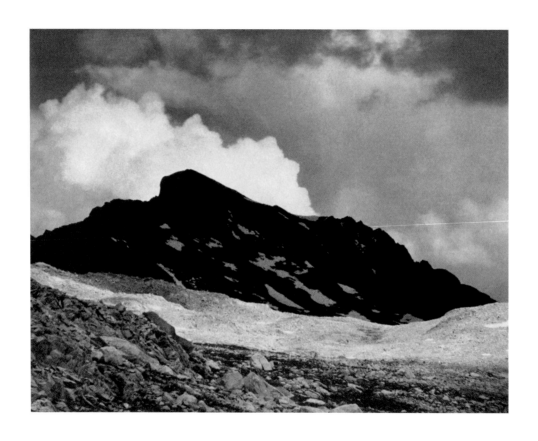

THE BLACK GIANT, MUIR PASS, SIERRA NEVADA, CALIFORNIA, 1930

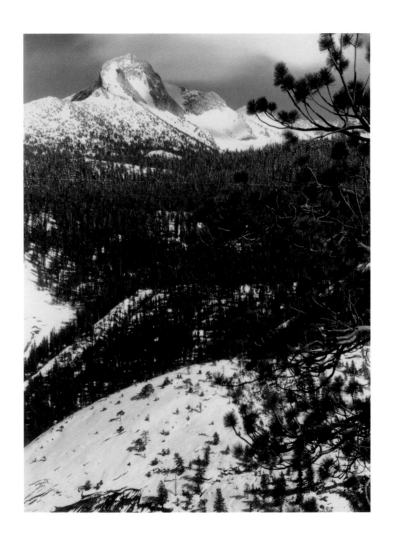

MOUNT GALEN CLARK, YOSEMITE NATIONAL PARK, CALIFORNIA, 1927

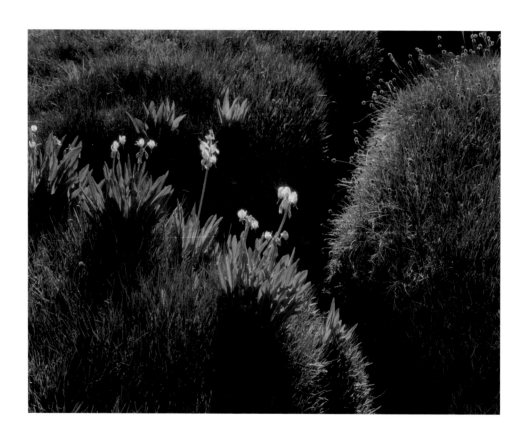

MEADOW DETAIL, SEQUOIA NATIONAL PARK, CALIFORNIA, 1930

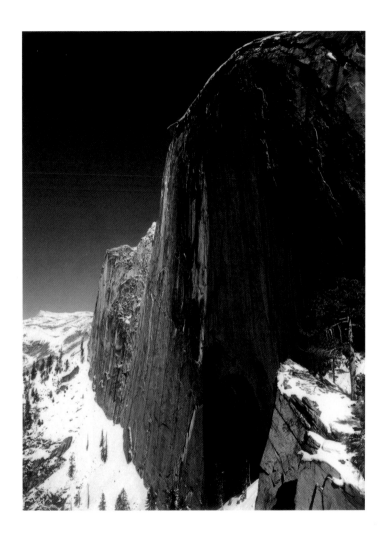

MONOLITH, THE FACE OF HALF DOME, YOSEMITE NATIONAL PARK, CALIFORNIA, 1927

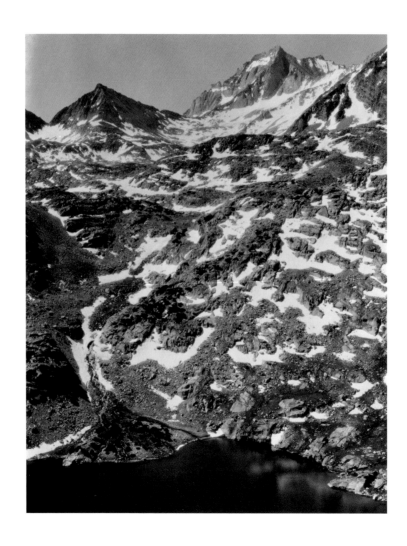

VIEW SOUTH FROM TRAIL, EAST OF MONO PASS, SIERRA NEVADA, CALIFORNIA, C. 1930

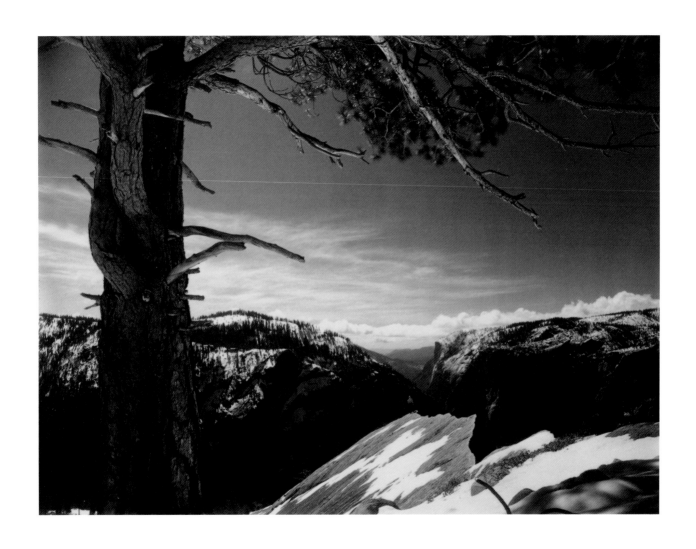

ON THE HEIGHTS, YOSEMITE NATIONAL PARK, CALIFORNIA, 1927

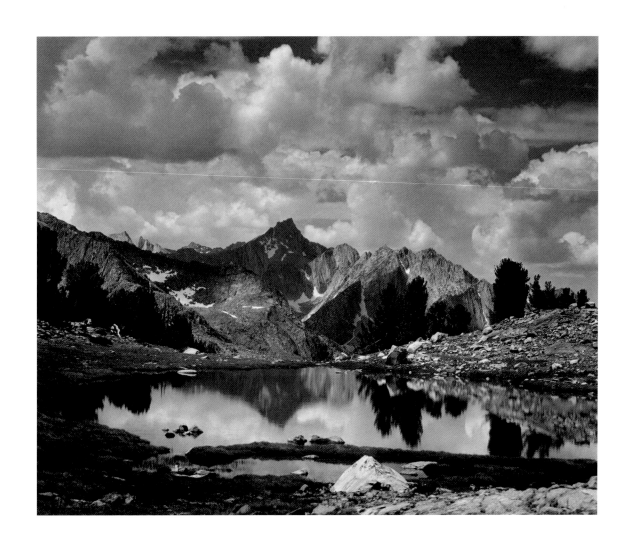

MOUNT CLARENCE KING, POOL, KINGS CANYON NATIONAL PARK, CALIFORNIA, C. 1925

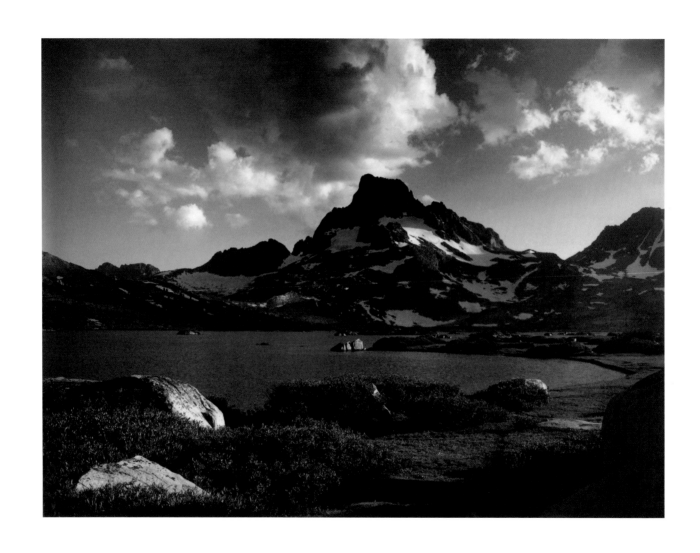

BANNER PEAK AND THOUSAND ISLAND LAKE, SIERRA NEVADA, CALIFORNIA, 1923

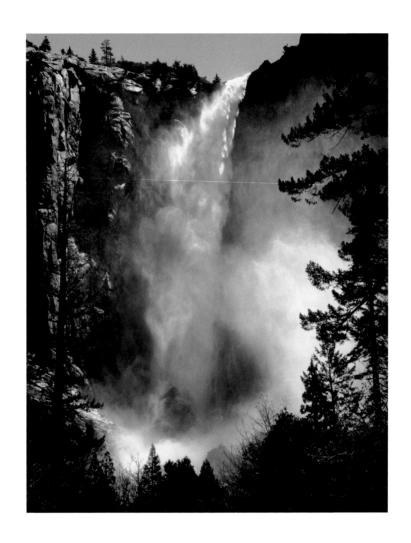

BRIDALVEIL FALL, YOSEMITE NATIONAL PARK, CALIFORNIA, 1927

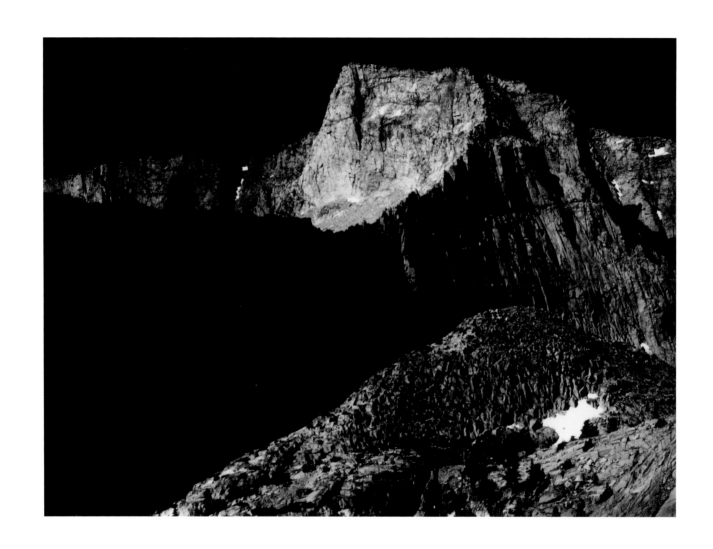

GLACIAL CIRQUE, MILESTONE RIDGE, SEQUOIA NATIONAL PARK, CALIFORNIA, C. 1927

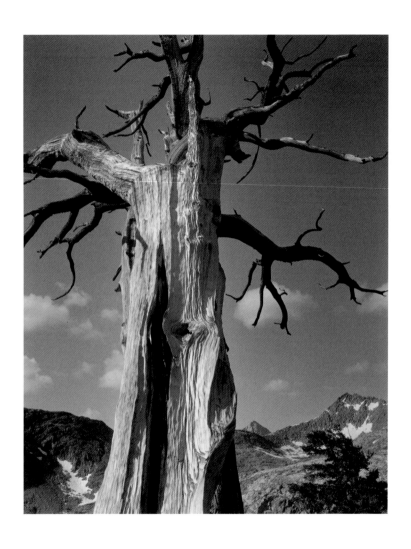

DEAD TREE, NEAR LITTLE FIVE LAKES, SEQUOIA NATIONAL PARK, CALIFORNIA, 1927

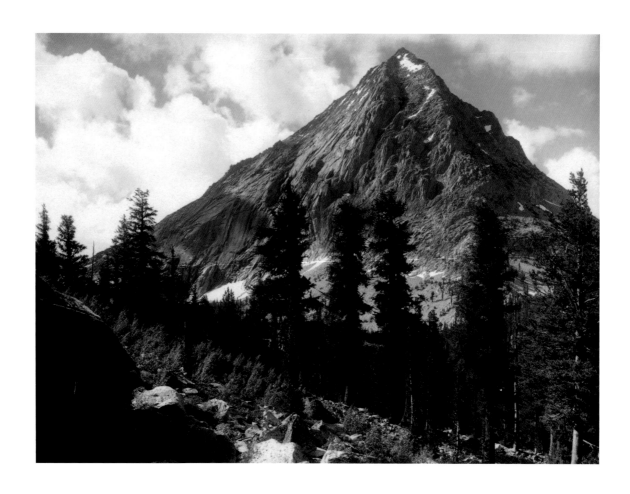

EAST VIDETTE, KINGS RIVER CANYON, CALIFORNIA, C. 1925

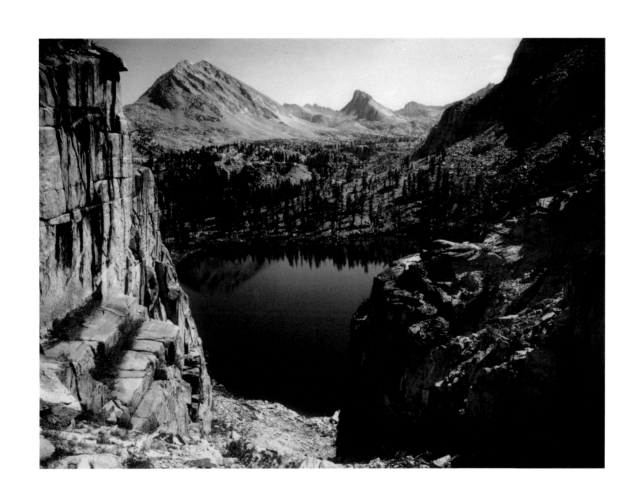

MARION LAKE, KINGS CANYON NATIONAL PARK, CALIFORNIA, C. 1925

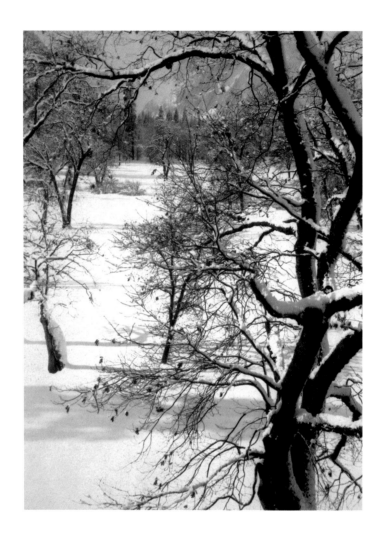

FROM THE AHWAHNEE HOTEL, WINTER, YOSEMITE NATIONAL PARK, CALIFORNIA, 1927

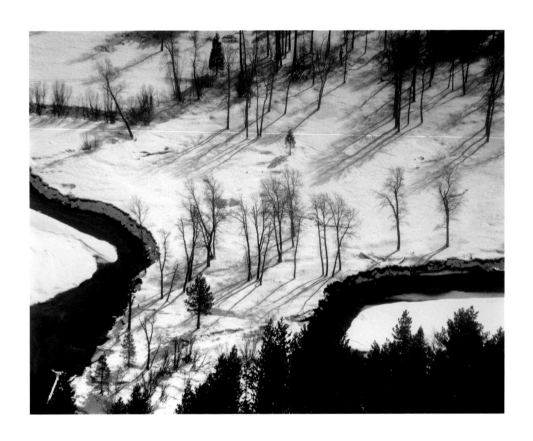

MERCED RIVER AND SNOW FROM COLUMBIA POINT, YOSEMITE NATIONAL PARK, CALIFORNIA, C. 1923 47

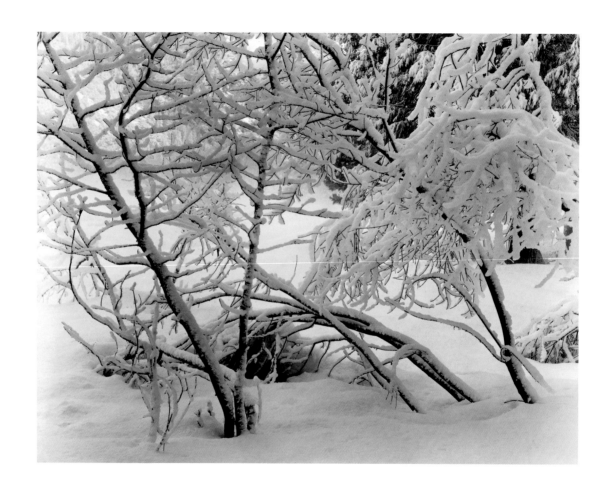

ALDERS IN SNOW, YOSEMITE NATIONAL PARK, CALIFORNIA, C. 1929

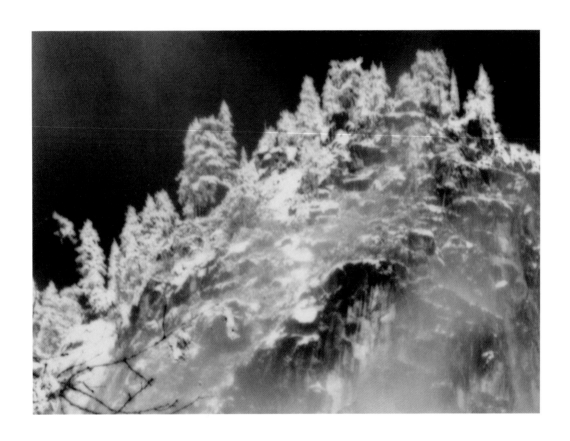

ROCK FACE AND TREES IN WINTER, YOSEMITE NATIONAL PARK, CALIFORNIA, 1928

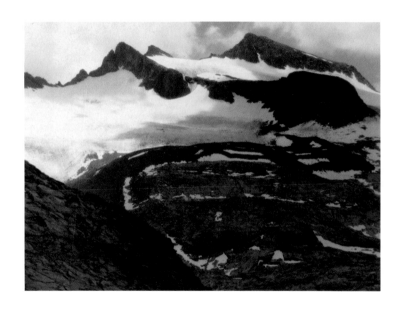

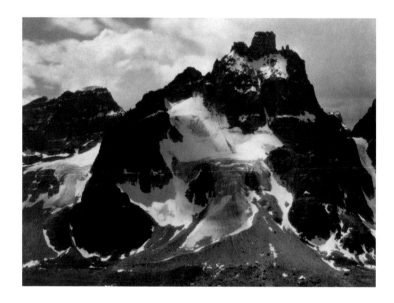

MOUNT LYELL AND MOUNT MACLURE, HEADWATERS OF THE TUOLUMNE RIVER, YOSEMITE NATIONAL PARK, CALIFORNIA, 1929

CAJIMONT-BAJRION, CANADIAN ROCKIES, 1928

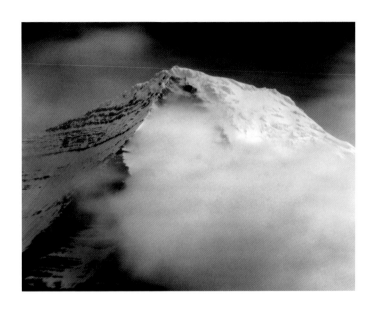 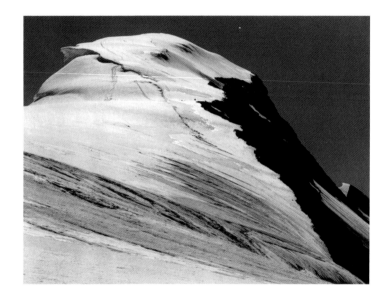

SUMMIT OF MOUNT ROBSON IN CLOUDS, JASPER NATIONAL PARK, CANADA, 1928
SUMMIT OF MOUNT RESPLENDENT, MOUNT ROBSON PROVINCIAL PARK, CANADA, 1928

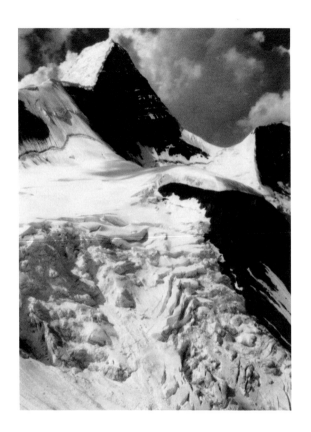 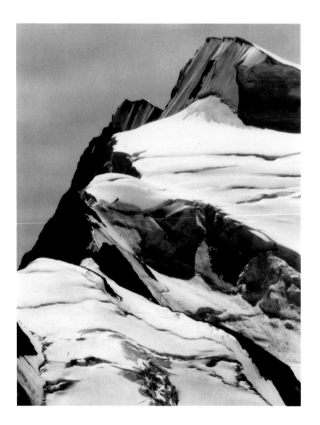

MOUNT ROBSON, JASPER NATIONAL PARK, CANADA, 1928
MOUNT RESPLENDENT, MOUNT ROBSON PROVINCIAL PARK, CANADA, 1928

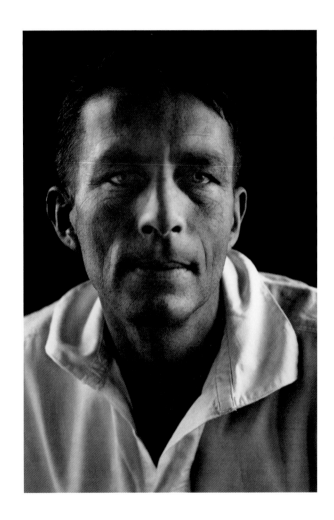 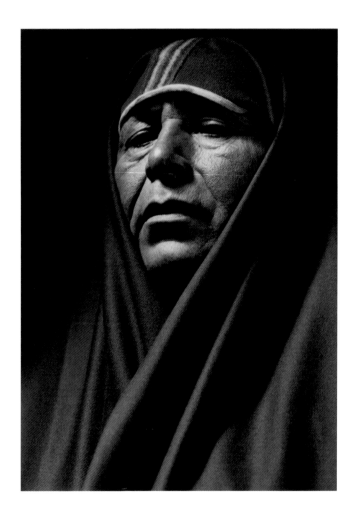

ROBINSON JEFFERS, CARMEL, CALIFORNIA, 1927

TONY LUJAN OF TAOS PUEBLO, NEW MEXICO, 1930 53

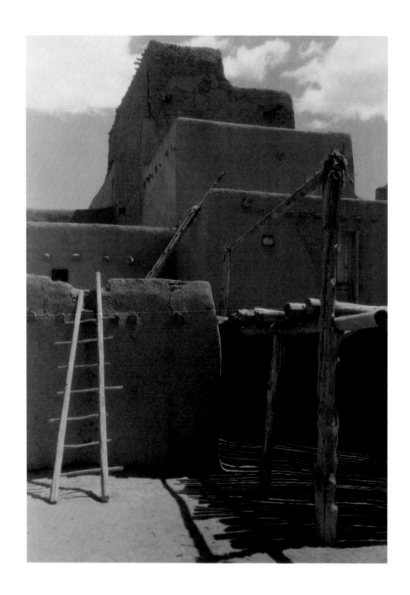

NORTH HOUSE, TAOS PUEBLO, NEW MEXICO, C. 1929

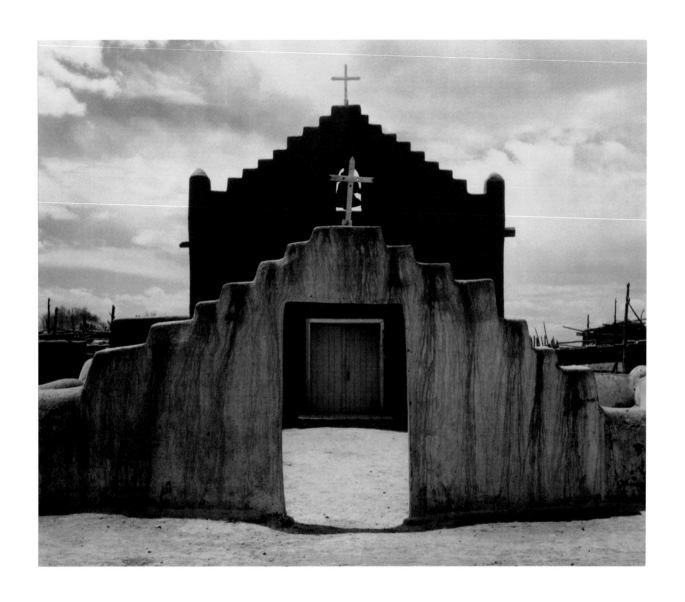

THE NEW CHURCH, TAOS PUEBLO, NEW MEXICO, C. 1928

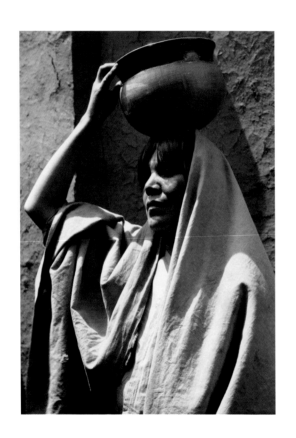
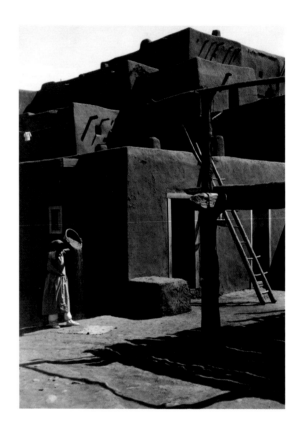

GIRL OF TAOS PUEBLO, NEW MEXICO, C. 1929
WINNOWING GRAIN, TAOS PUEBLO, NEW MEXICO, C. 1929

56

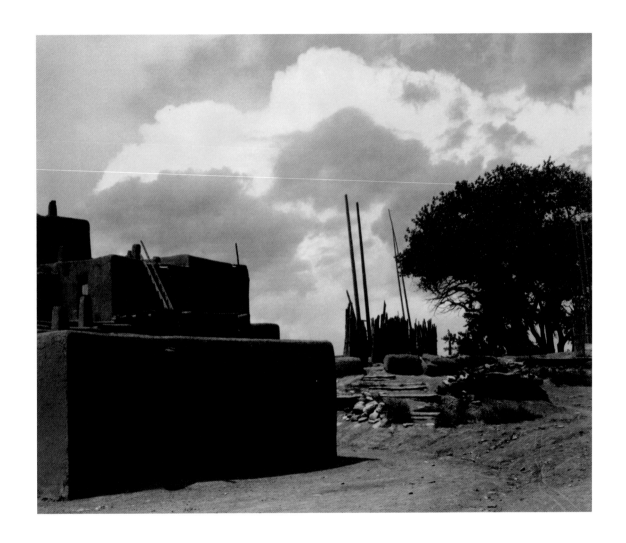

KIVA AND CLOUDS, TAOS PUEBLO, NEW MEXICO, C. 1929

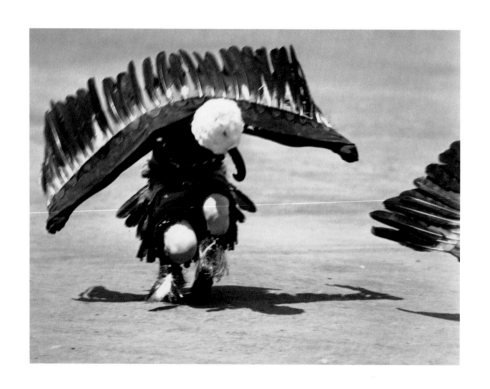

EAGLE DANCE, SAN ILDEFONSO PUEBLO, NEW MEXICO, C. 1928

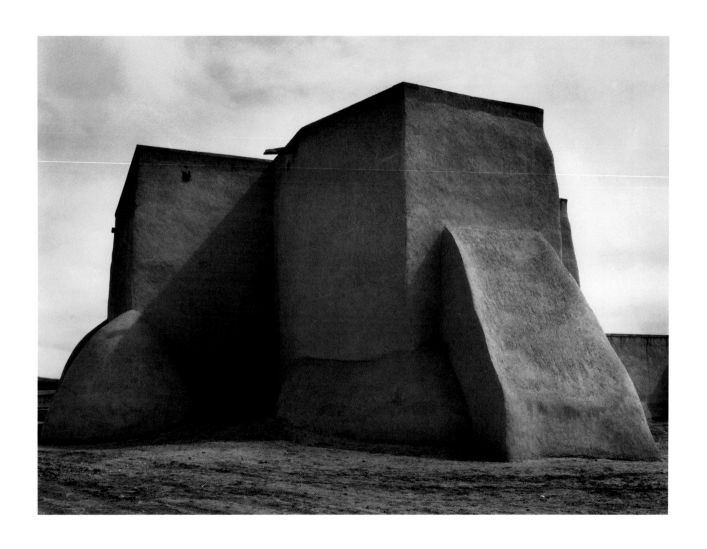

SAINT FRANCIS CHURCH, RANCHOS DE TAOS, NEW MEXICO, C. 1929

1931–1939 GROUP F/64 AND ALFRED STIEGLITZ

From 1931 to 1936 Adams was greatly influenced by his colleagues in Group f/64, a loose affiliation of West Coast photographers, including Edward Weston and Imogen Cunningham, that promoted "straight" photography. Adams began to photograph ordinary, everyday subjects such as a pinecone and eucalyptus leaves on the forest floor, or scissors and thread spread on a blanket. His photographs were characterized by what Adams called "the microscopic revelation of the lens." Compare *Lodgepole Pines* (page 25), made in 1921, with *Boards and Thistles* (page 63), made in 1932. The former was made with a soft-focus lens; Adams printed the image on cream-colored textured paper, and it could easily be mistaken for a charcoal drawing. *Boards and Thistles,* made with a sharp-focus lens and printed on glossy black-and-white paper, could not be mistaken for anything but a photograph.

The compositions of Adams' photographs began to change, as well. In the 1920s, they often suffered from what he later called "confused seeing," with the primary subject of the photograph not readily identifiable (page 37). In the 1930s he struggled to overcome that confusion, striving to present the subject in as straightforward a manner as possible, whether it was a still life, a building, or a landscape. Moreover, from time to time he began to lower the horizon to include cloud-filled skies (page 75), presaging his heroic landscapes of the 1940s.

The other decisive influence on Adams in the 1930s was his friendship with Alfred Stieglitz, the legendary photographer and director of America's foremost gallery of modern art, An American Place. In 1936 Stieglitz exhibited Adams' photographs, a watershed for Adams artistically and personally. After the show, he dedicated himself to "make the photography as clean, as decisive, and as honest as possible." The photograph of bare aspens on page 151 reflects the new direction in Adams' work.

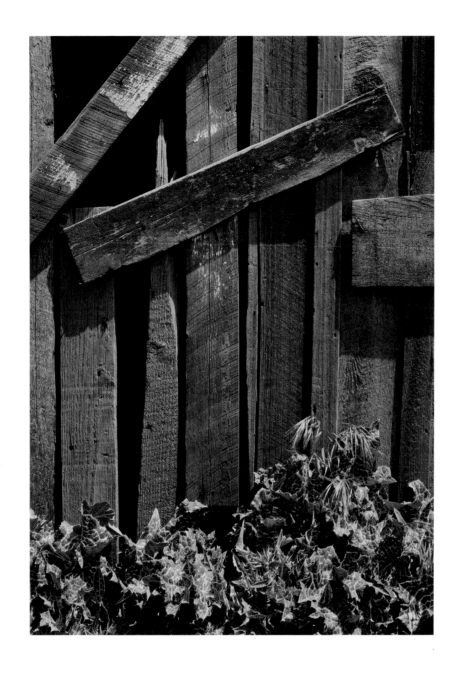

BOARDS AND THISTLES, SAN FRANCISCO, CALIFORNIA, 1932 63

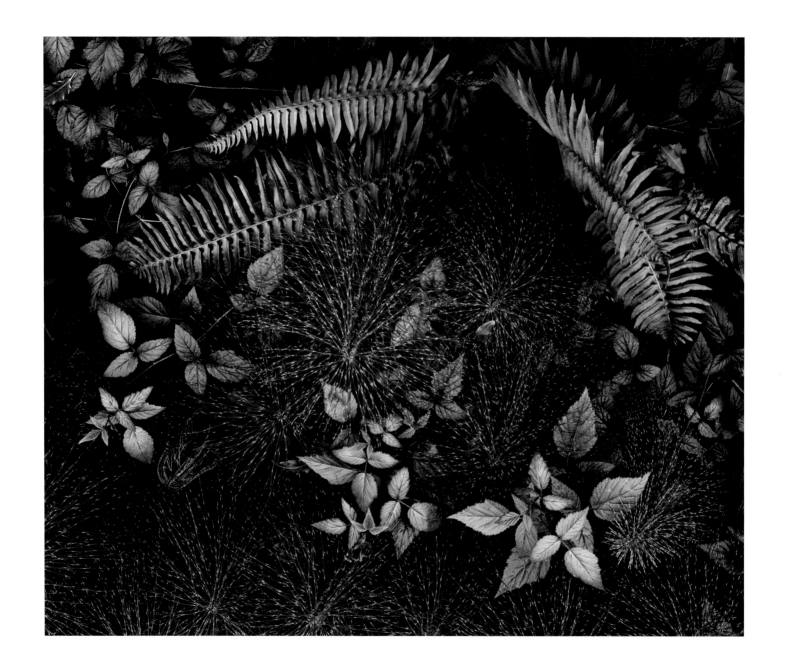

LEAVES, MILLS COLLEGE, CALIFORNIA, C. 1931

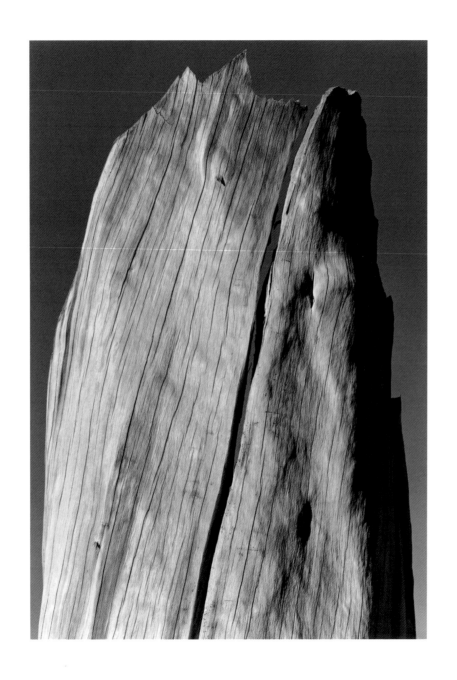

WHITE STUMP, SIERRA NEVADA, CALIFORNIA, 1936

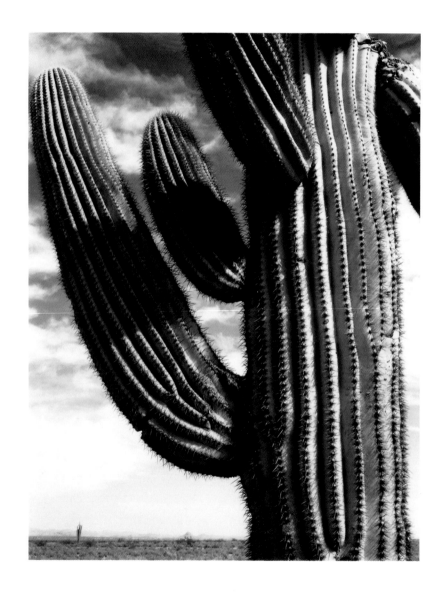

SAGUARO, NEAR PHOENIX, ARIZONA, C. 1932

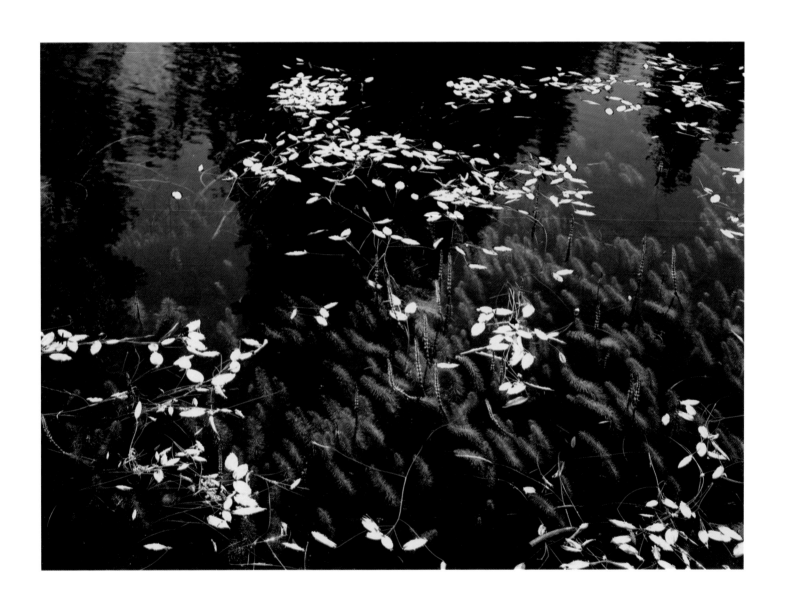

LEAVES ON POOL, CALIFORNIA, C. 1935

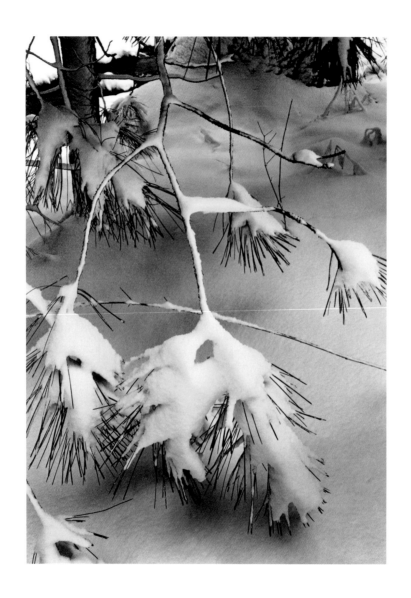

PINE BRANCH IN SNOW, YOSEMITE NATIONAL PARK, CALIFORNIA, C. 1932

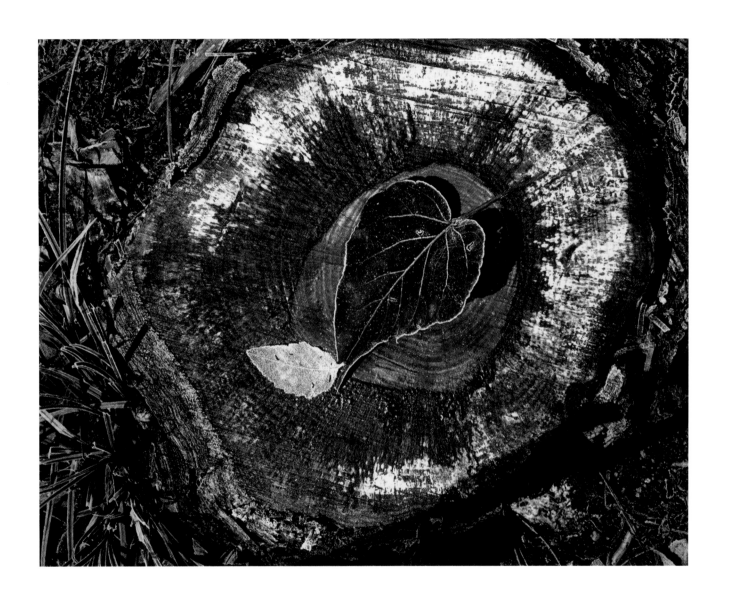

LEAVES, FROST, STUMP, OCTOBER MORNING, YOSEMITE NATIONAL PARK, CALIFORNIA, C. 1931

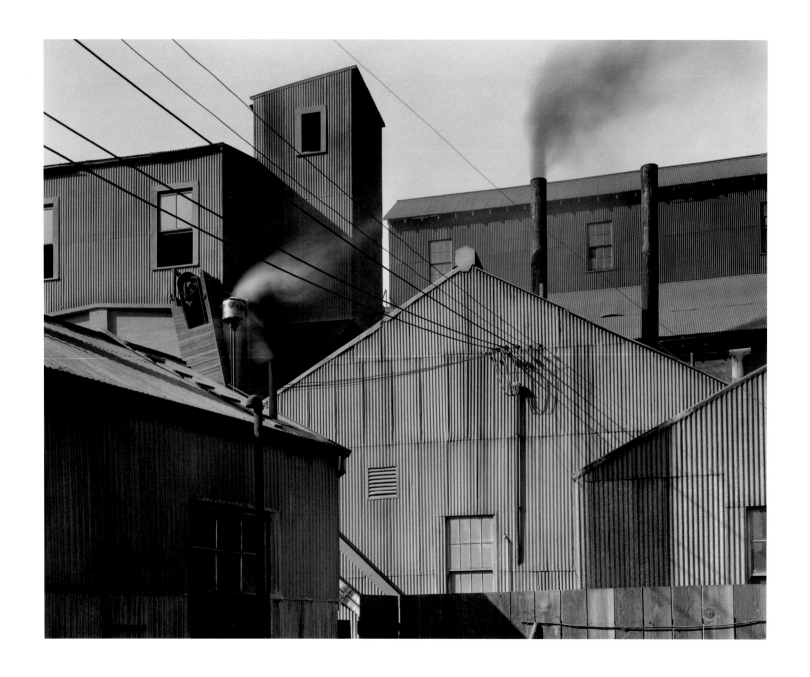

FACTORY BUILDING, SAN FRANCISCO, CALIFORNIA, 1932

GOTTARDO PIAZZONI IN HIS STUDIO, SAN FRANCISCO, CALIFORNIA, 1932

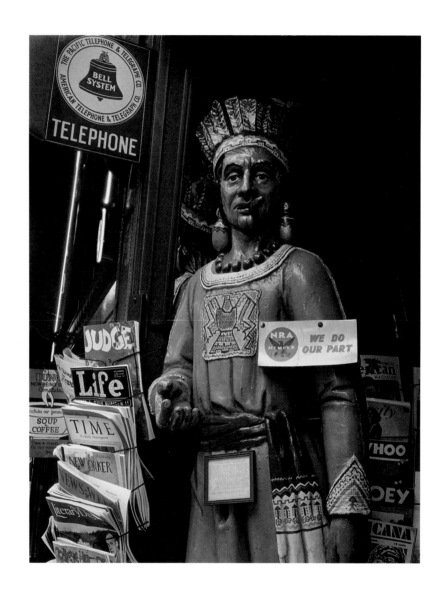

CIGAR STORE INDIAN, POWELL STREET, SAN FRANCISCO, CALIFORNIA, 1933

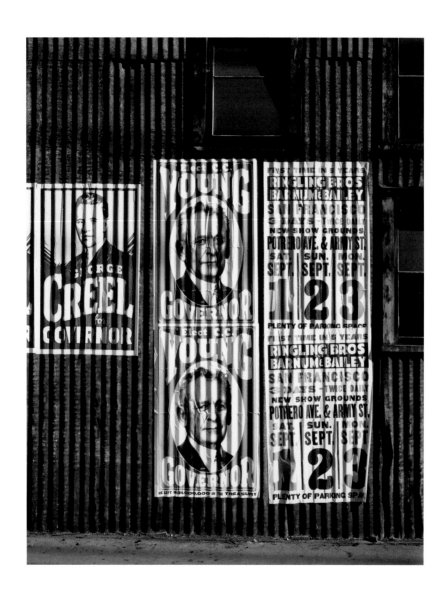

POLITICAL SIGN AND CIRCUS POSTERS, SAN FRANCISCO, CALIFORNIA, 1931

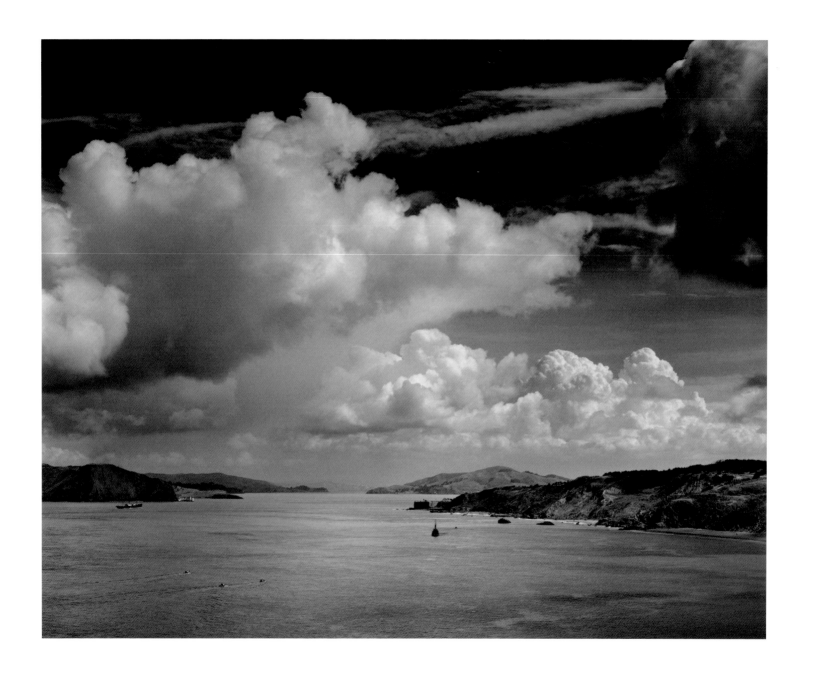

THE GOLDEN GATE BEFORE THE BRIDGE, SAN FRANCISCO, CALIFORNIA, 1932

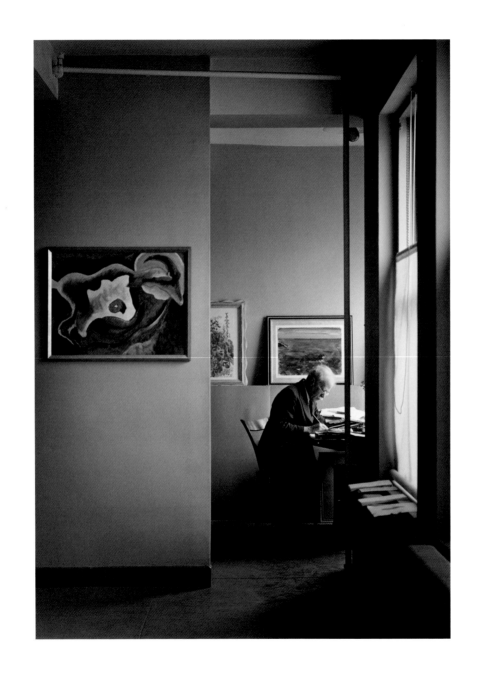

ALFRED STIEGLITZ AT AN AMERICAN PLACE, NEW YORK CITY, 1939

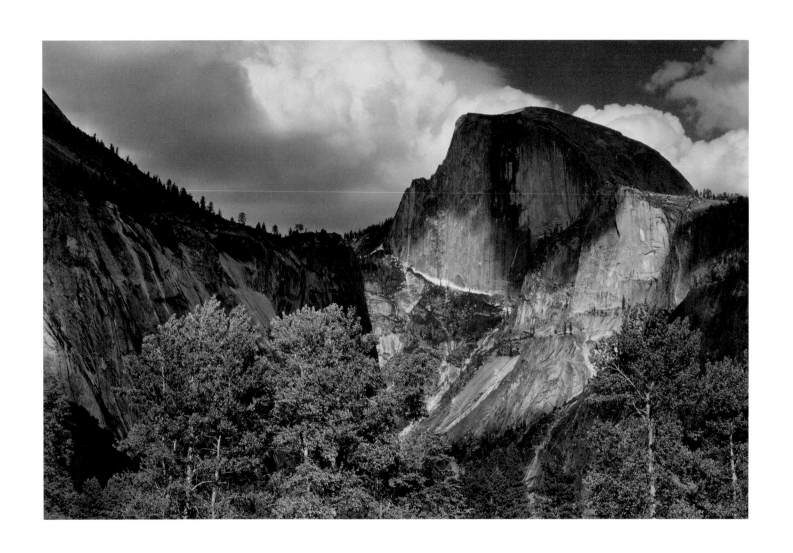

HALF DOME, COTTONWOOD TREES, YOSEMITE NATIONAL PARK, CALIFORNIA, C. 1932

ROCKS, BAKER BEACH, SAN FRANCISCO, CALIFORNIA, C. 1931

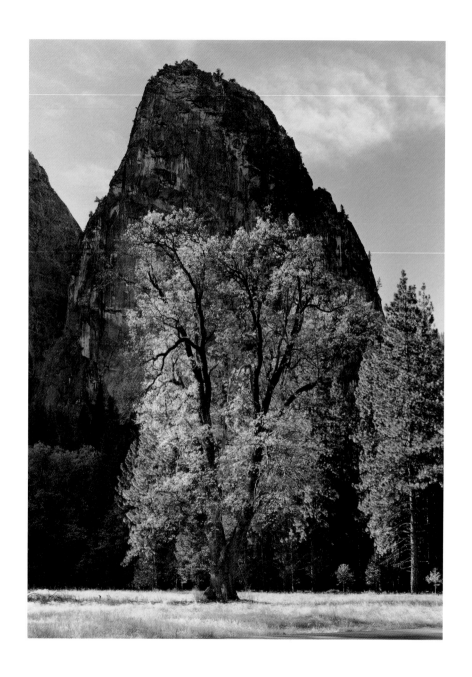

OAK TREE, AUTUMN, YOSEMITE NATIONAL PARK, CALIFORNIA, C. 1933

MADRONE BARK, SANTA CRUZ MOUNTAINS, CALIFORNIA, 1932
EUCALYPTUS STUMP, BARN, OLEMA, CALIFORNIA, C. 1932

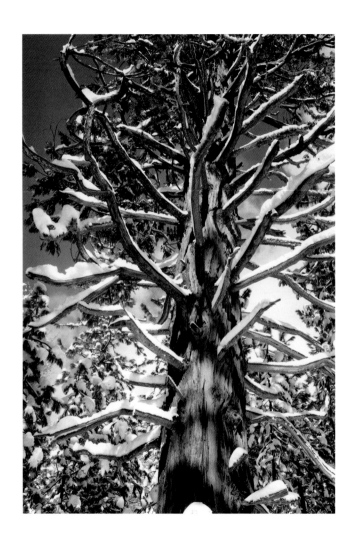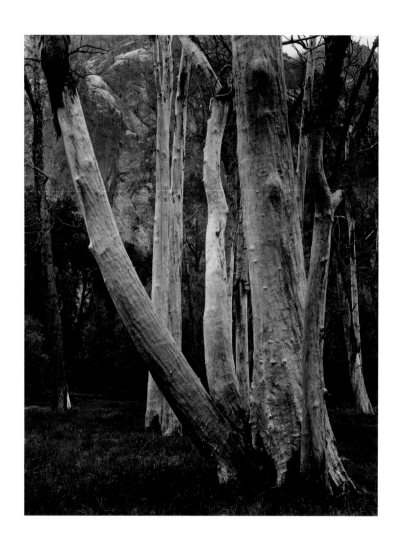

CEDAR TREE, WINTER, YOSEMITE NATIONAL PARK, CALIFORNIA, C. 1935
COTTONWOOD TRUNKS, YOSEMITE NATIONAL PARK, CALIFORNIA, 1932

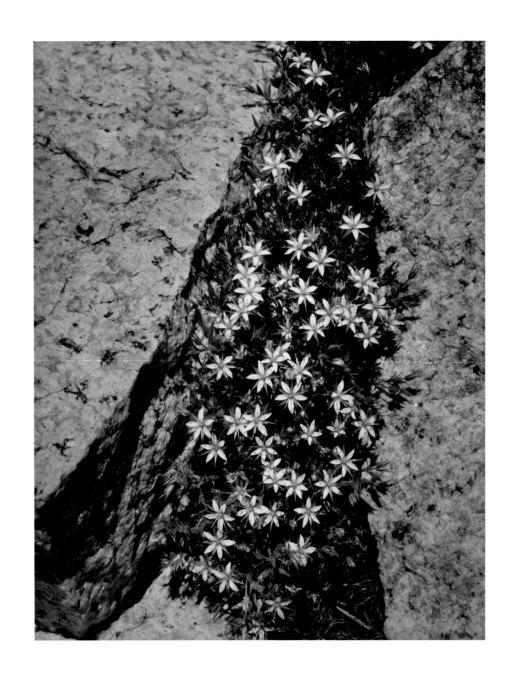

FLOWERS AND ROCK, SAN JOAQUIN SIERRA, CALIFORNIA, 1936

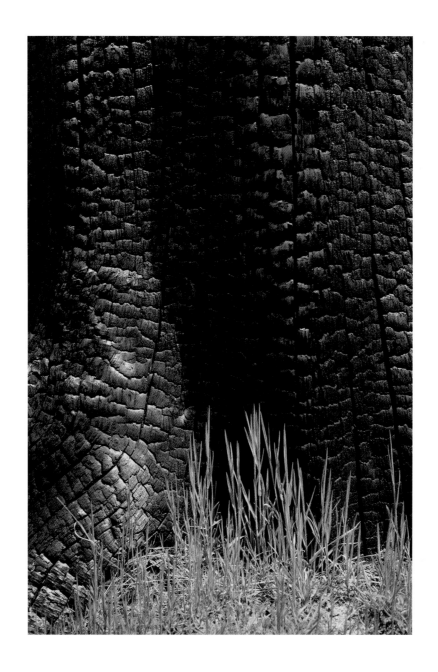

BURNT STUMP AND NEW GRASS, SIERRA NEVADA, CALIFORNIA, 1935

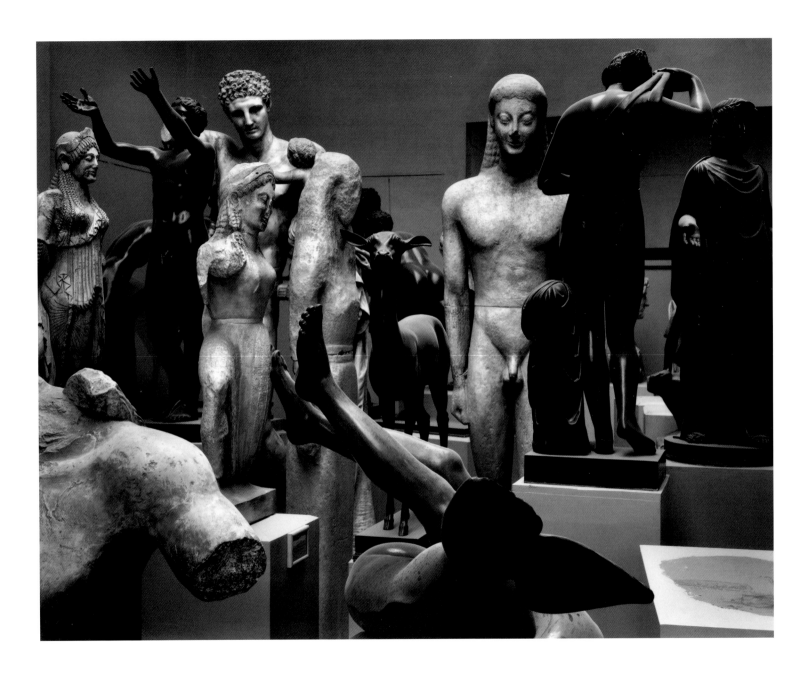

STOREROOM, M. H. DE YOUNG MEMORIAL MUSEUM, SAN FRANCISCO, CALIFORNIA, 1933

CAROLYN ANSPACHER, SAN FRANCISCO, CALIFORNIA, 1932

HEAD OF MINERVA, SUTRO GARDENS, SAN FRANCISCO, CALIFORNIA, 1934
WHITE GRAVESTONE, LAUREL HILL CEMETERY, SAN FRANCISCO, CALIFORNIA, C. 1936

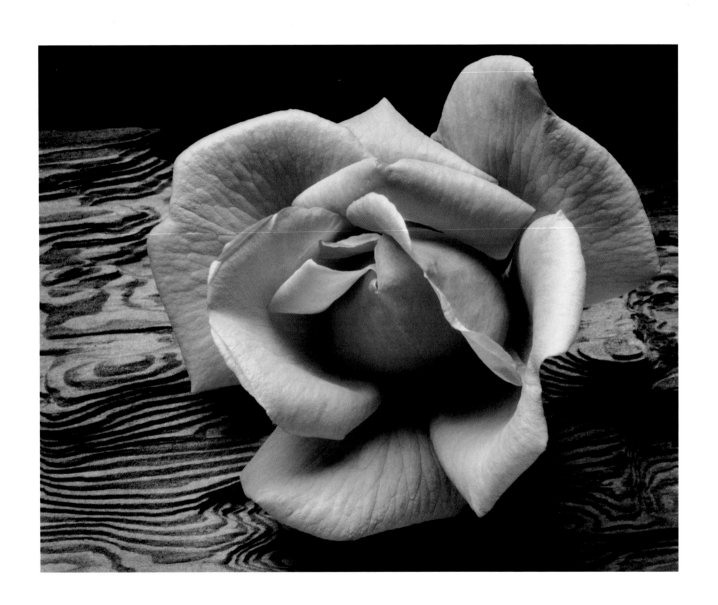

ROSE AND DRIFTWOOD, SAN FRANCISCO, CALIFORNIA, C. 1932

SCISSORS AND THREAD, SAN FRANCISCO, CALIFORNIA, 1931
STILL LIFE, SAN FRANCISCO, CALIFORNIA, C. 1932

PINE CONE AND EUCALYPTUS LEAVES, SAN FRANCISCO, CALIFORNIA, 1932

ARCHITECTURE, LAUREL HILL CEMETERY, SAN FRANCISCO, CALIFORNIA, C. 1936

JOSÉ CLEMENTE OROZCO, NEW YORK CITY, 1933  91

ERECTED 1854.

COURTHOUSE, MARIPOSA, CALIFORNIA, C. 1933

FROZEN LAKE AND CLIFFS, KAWEAH GAP, SIERRA NEVADA, CALIFORNIA, 1932

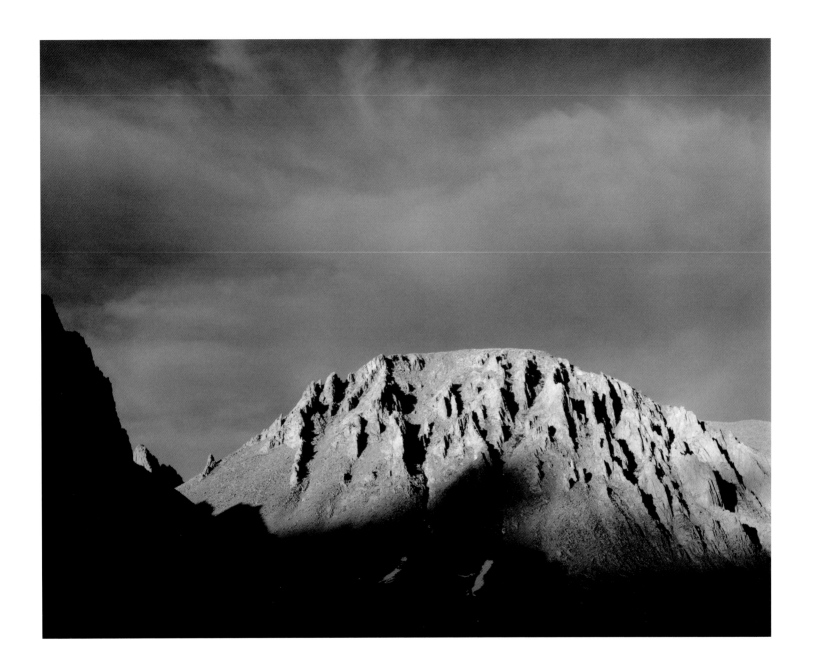

MOUNT WHITNEY FROM THE WEST, SIERRA NEVADA, CALIFORNIA, 1932

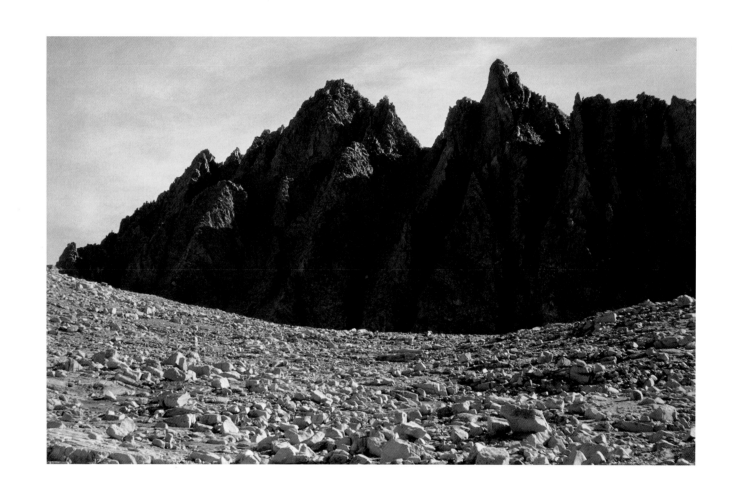

BISHOP PASS AND THE INCONSOLABLE RANGE, KINGS CANYON NATIONAL PARK, CALIFORNIA, 1936

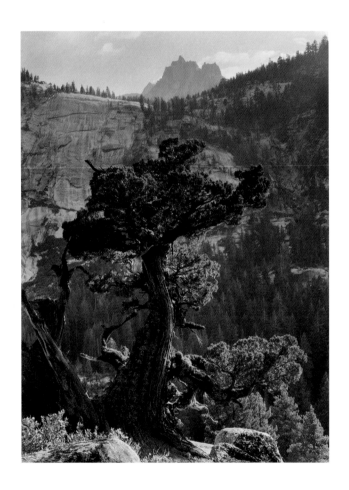 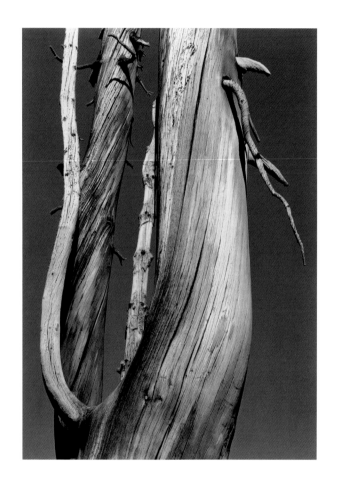

JUNIPER TREE, CRAGS UNDER MOUNT CLARK, YOSEMITE NATIONAL PARK, CALIFORNIA, C. 1936

DEAD TREE, DOG LAKE, YOSEMITE NATIONAL PARK, CALIFORNIA, 1933

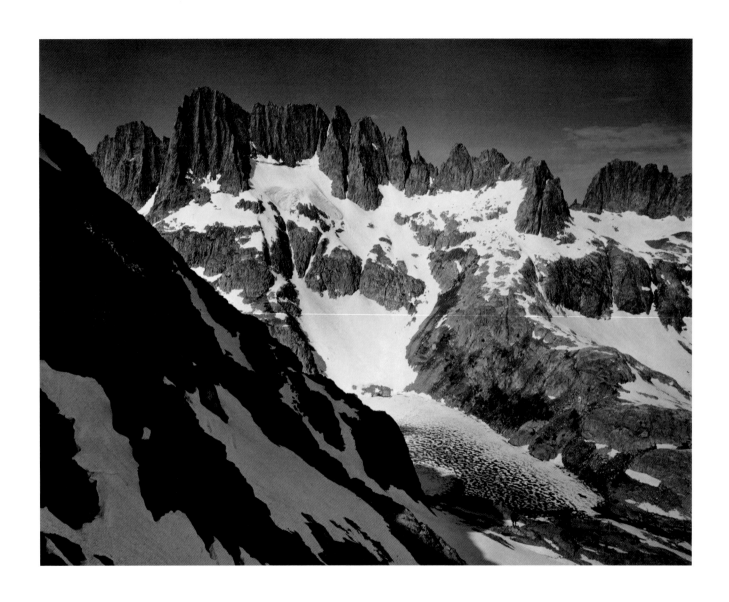

THE MINARETS AND ICEBERG LAKE FROM VOLCANIC RIDGE, SIERRA NEVADA, CALIFORNIA, C. 1935

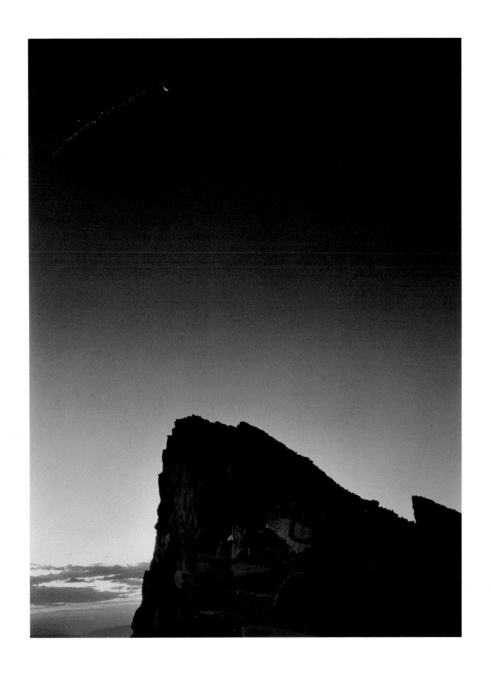

DAWN, MOUNT WHITNEY, SIERRA NEVADA, CALIFORNIA, 1932

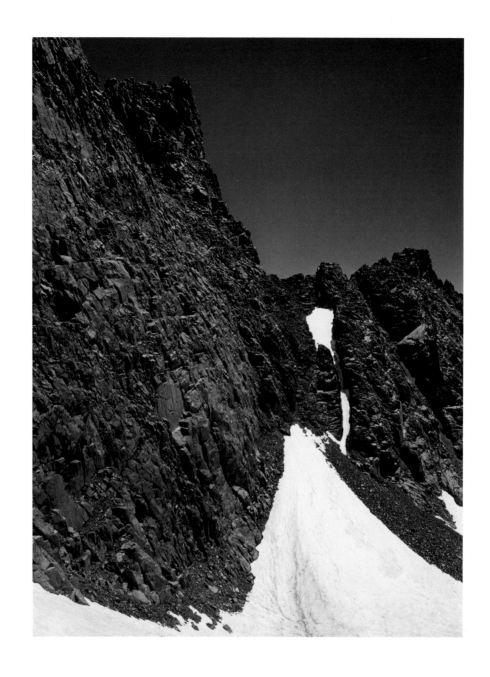

EAST CLIFF OF MICHAEL'S MINARET, SIERRA NEVADA, CALIFORNIA, C. 1935

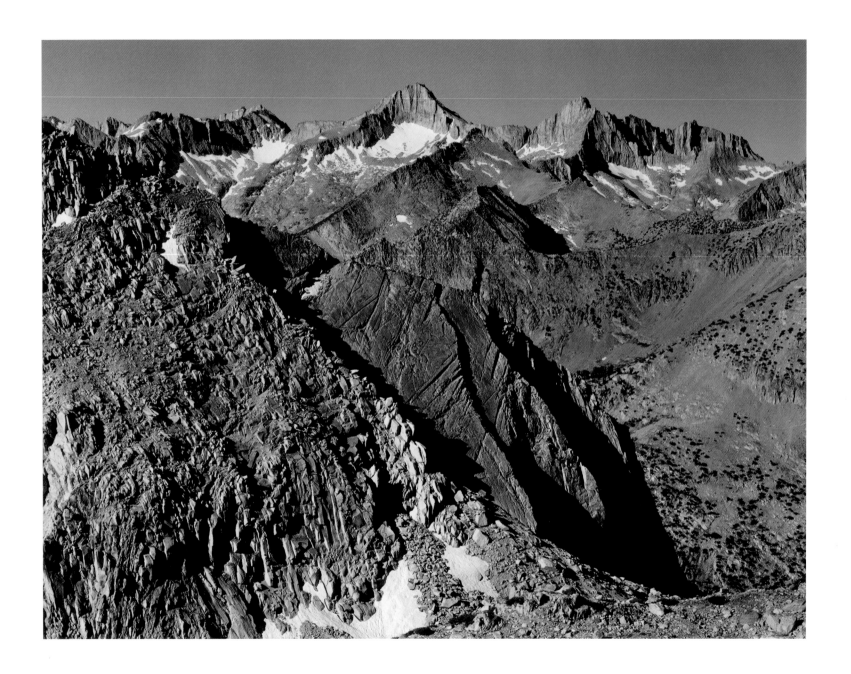

MOUNT BREWER GROUP FROM GLEN PASS, SIERRA NEVADA, CALIFORNIA, 1935

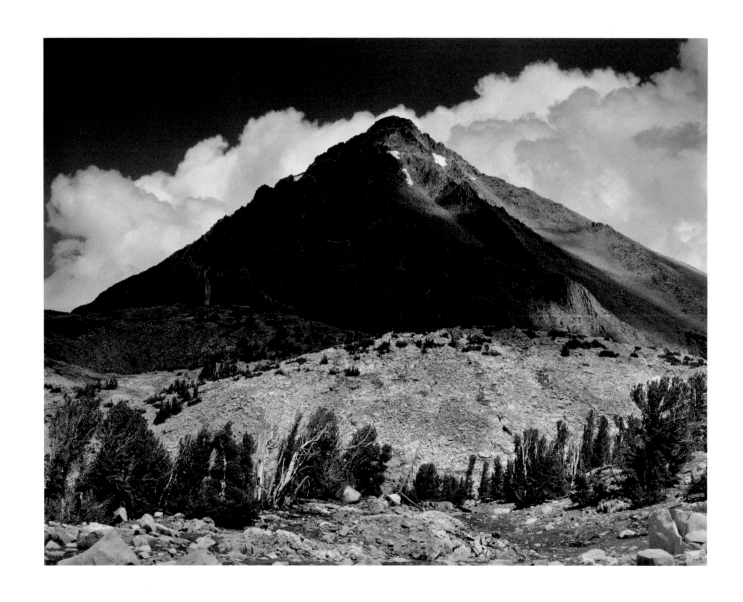

MOUNT WYNNE, KINGS CANYON NATIONAL PARK, CALIFORNIA, 1935

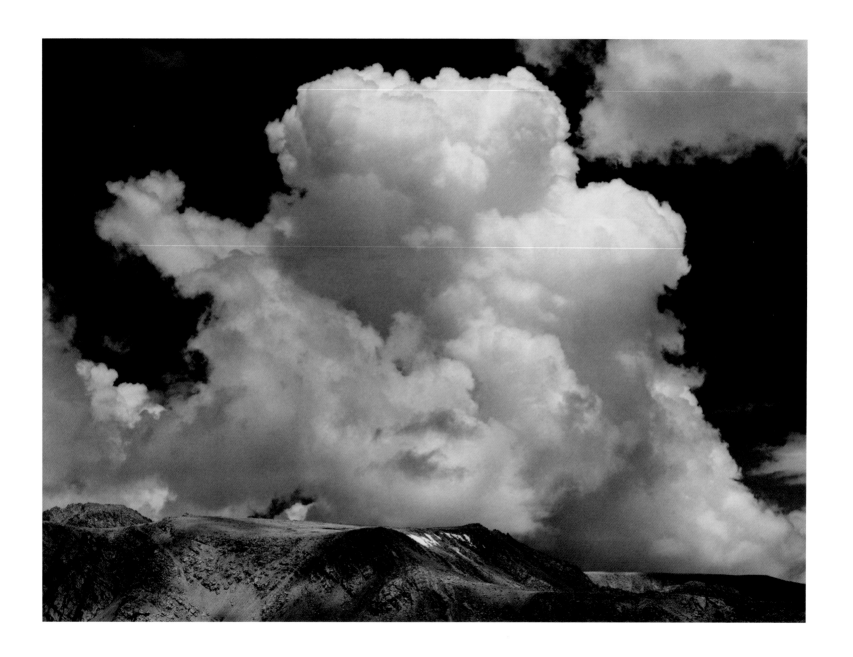

CLOUDS, SIERRA NEVADA, CALIFORNIA, C. 1936

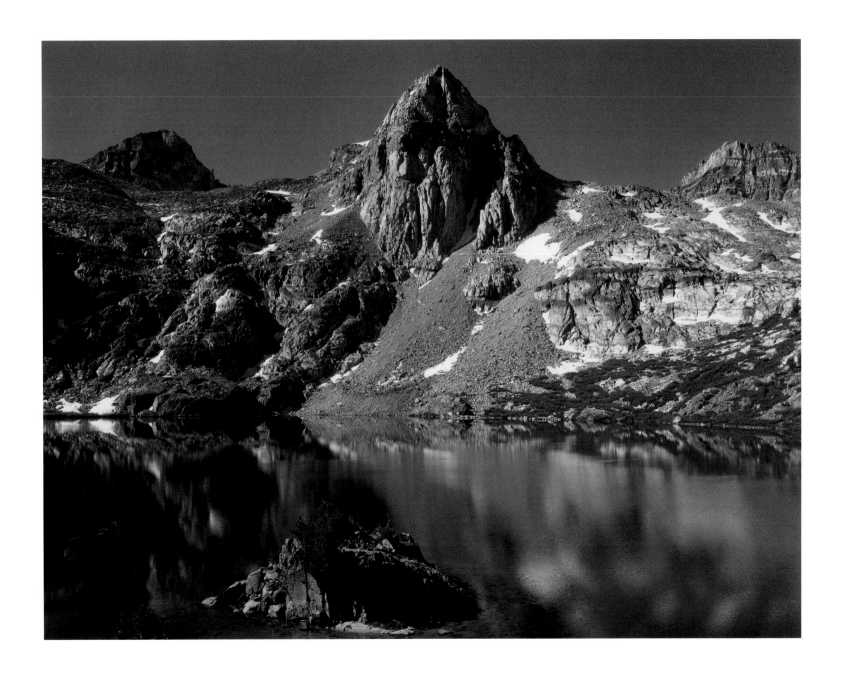

RAE LAKES, PAINTED LADY, KINGS CANYON NATIONAL PARK, CALIFORNIA, C. 1932

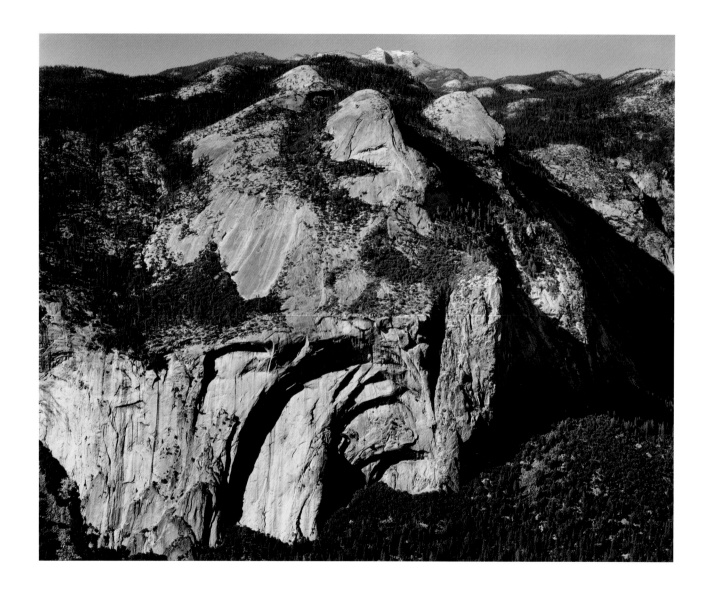

NORTH DOME FROM GLACIER POINT, YOSEMITE NATIONAL PARK, CALIFORNIA, C. 1937

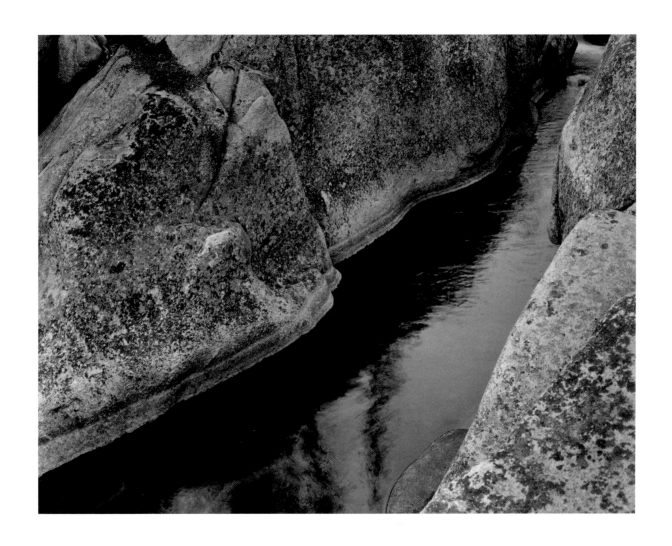

ROCK AND WATER, NEAR SPILLER CREEK, YOSEMITE NATIONAL PARK, CALIFORNIA, C. 1934

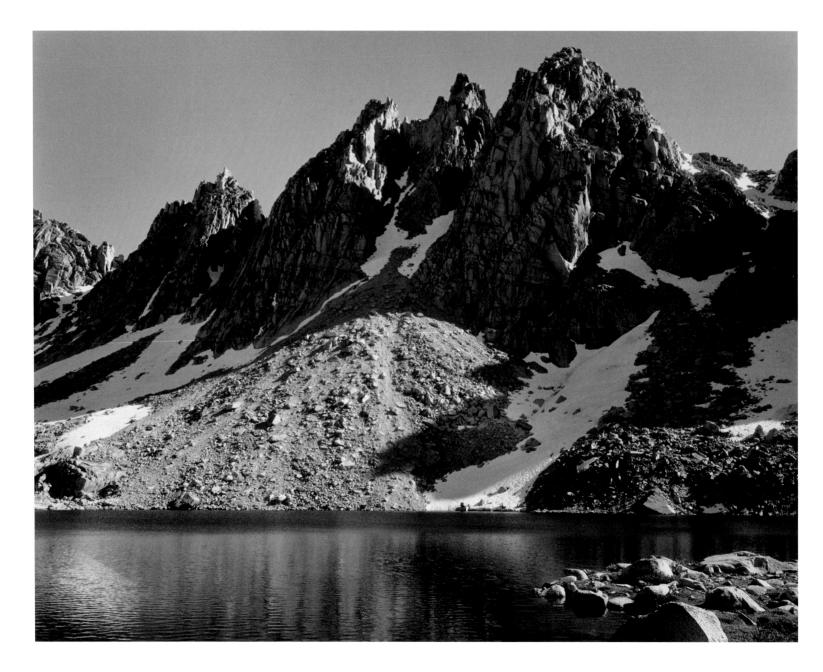

KEARSARGE PINNACLES, KINGS CANYON NATIONAL PARK, CALIFORNIA, C. 1934

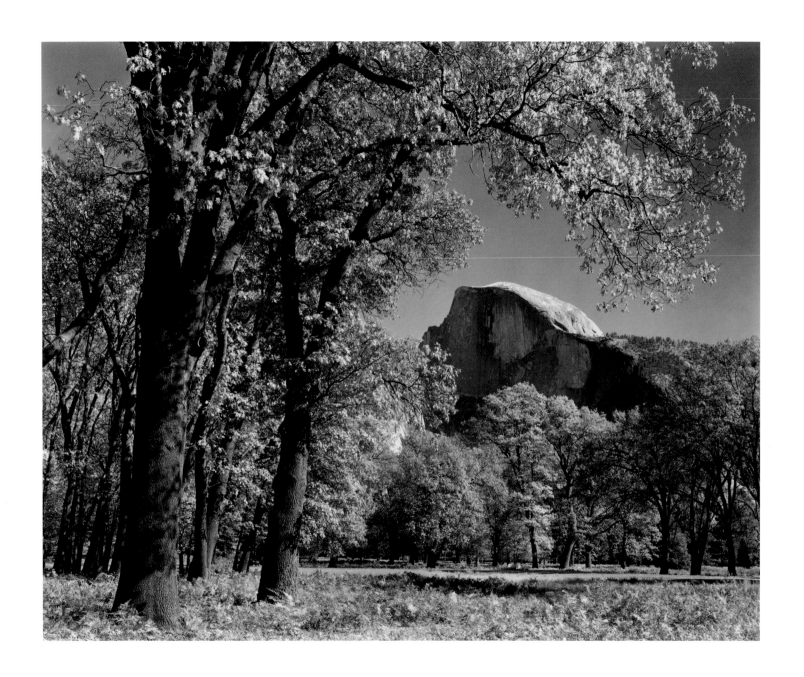

HALF DOME, OAK TREES, AUTUMN, YOSEMITE NATIONAL PARK, CALIFORNIA, 1938

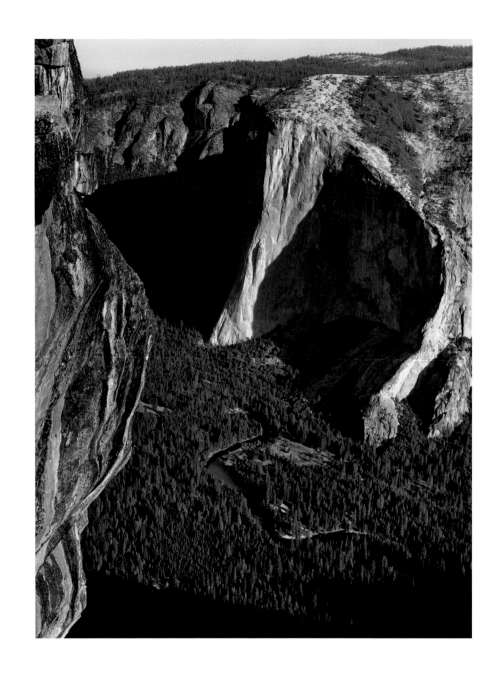

EL CAPITAN FROM TAFT POINT, YOSEMITE NATIONAL PARK, CALIFORNIA, C. 1936

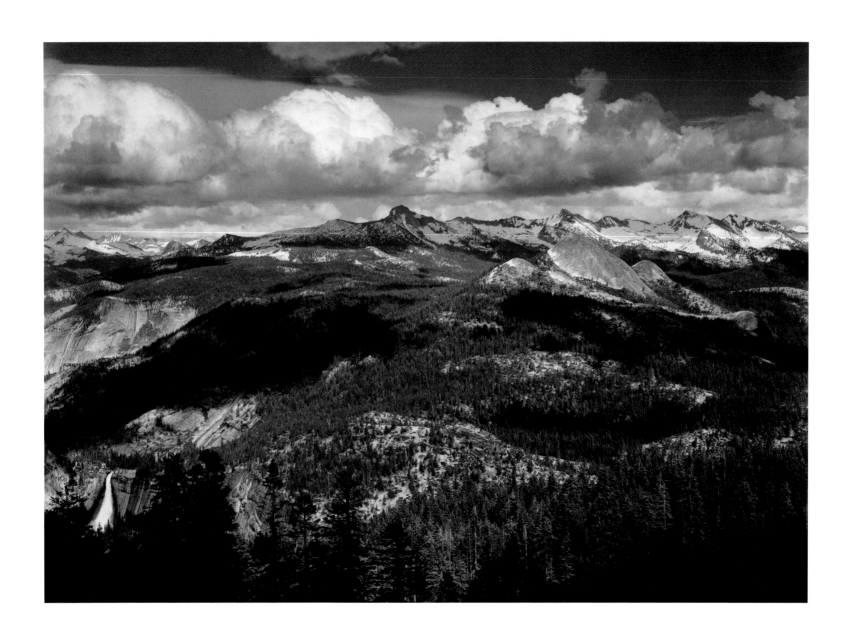

HIGH SIERRA FROM SENTINEL DOME, YOSEMITE NATIONAL PARK, CALIFORNIA, C. 1935

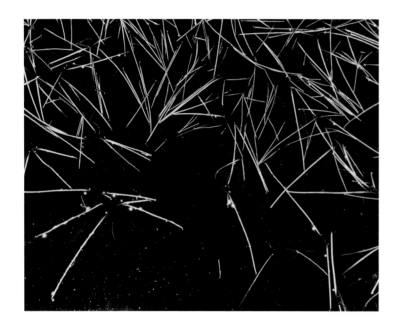

GRASS AND POOL, TUOLUMNE MEADOWS, YOSEMITE NATIONAL PARK, CALIFORNIA, C. 1935

112 GRASS AND WATER, TUOLUMNE MEADOWS, YOSEMITE NATIONAL PARK, CALIFORNIA, C. 1935

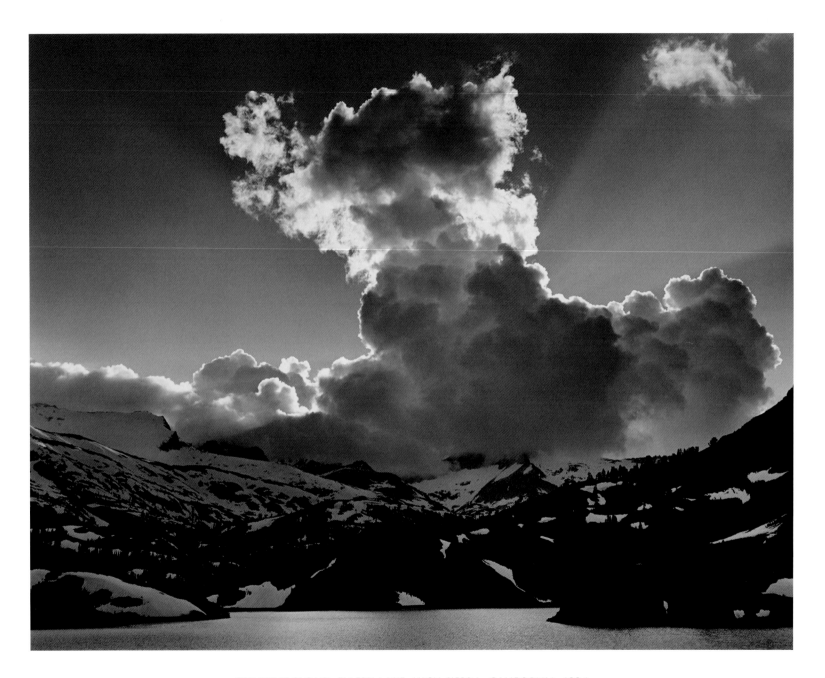

THUNDERCLOUD, ELLERY LAKE, HIGH SIERRA, CALIFORNIA, 1934

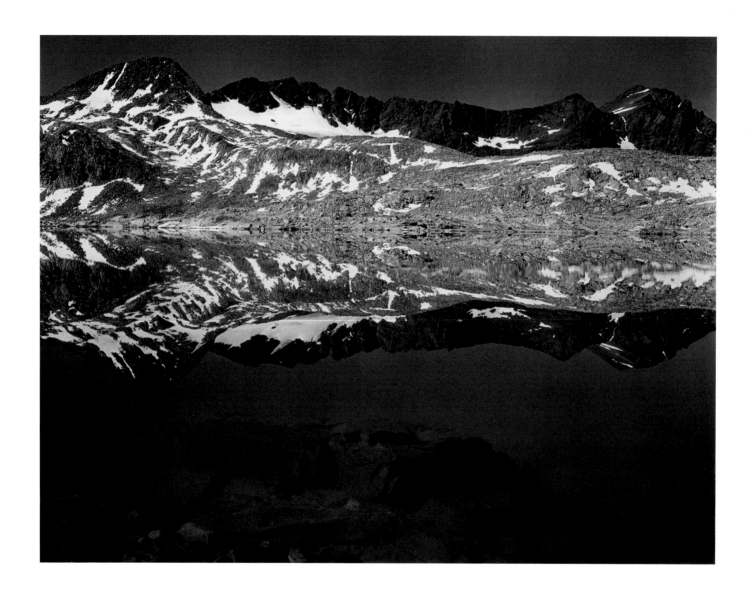

LAKE NEAR MUIR PASS, KINGS CANYON NATIONAL PARK, CALIFORNIA, C. 1934

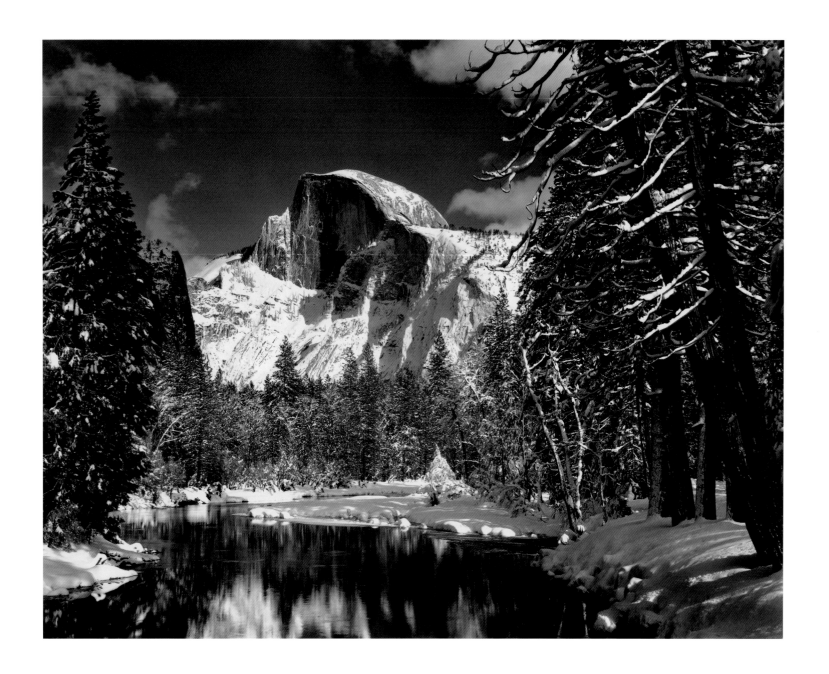

HALF DOME, MERCED RIVER, WINTER, YOSEMITE NATIONAL PARK, CALIFORNIA, 1938

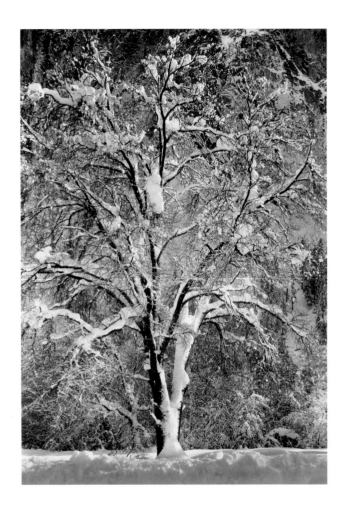
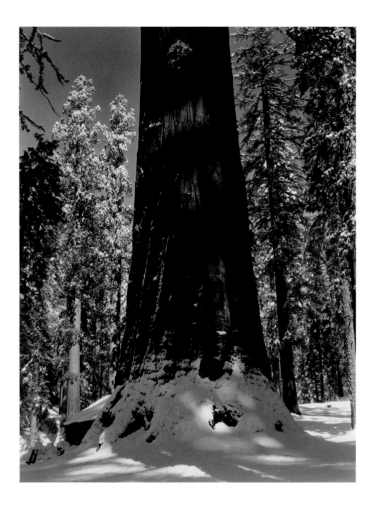

OAK TREE IN SNOW, YOSEMITE NATIONAL PARK, CALIFORNIA, C. 1933

REDWOOD TREE, MARIPOSA GROVE, WINTER, YOSEMITE NATIONAL PARK, CALIFORNIA, C. 1937

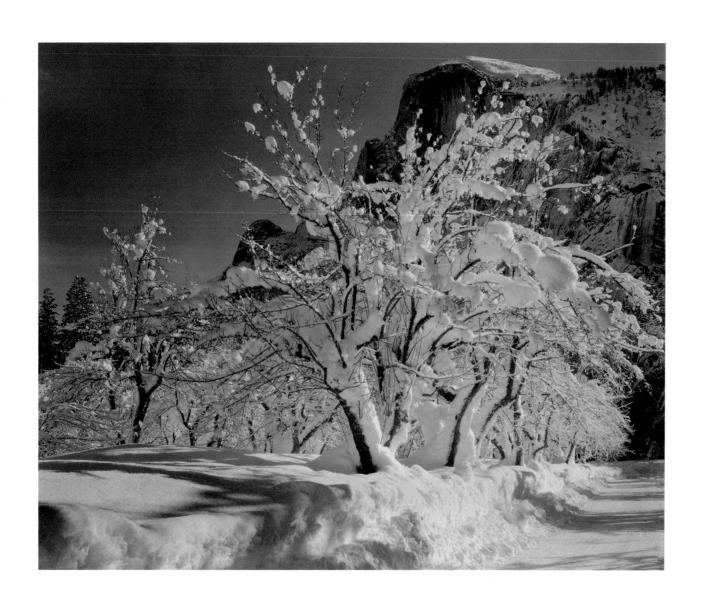

HALF DOME, APPLE ORCHARD, WINTER, YOSEMITE NATIONAL PARK, CALIFORNIA, C. 1932

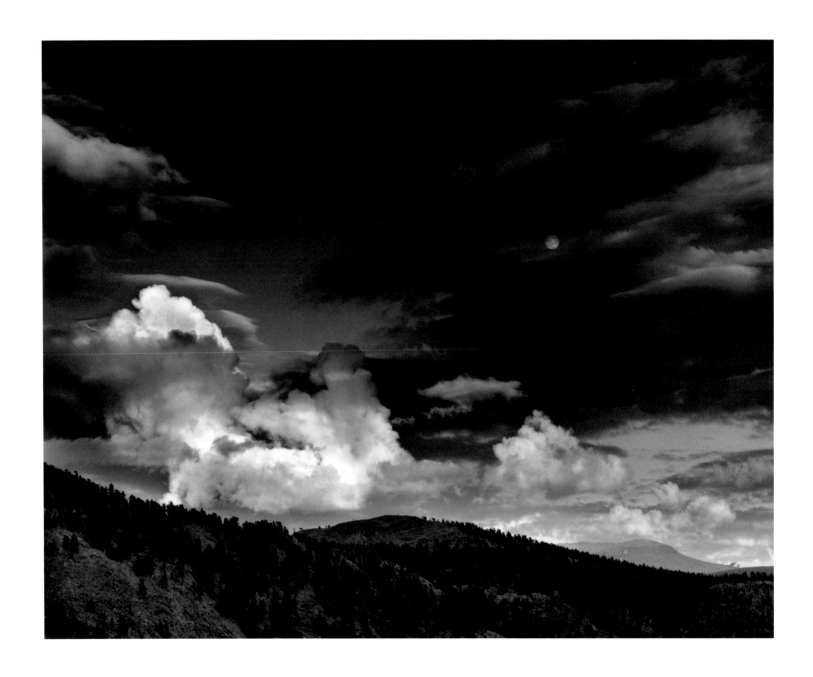

MOON AND CLOUDS, KERN RIVER BASIN, SIERRA NEVADA, CALIFORNIA, C. 1936

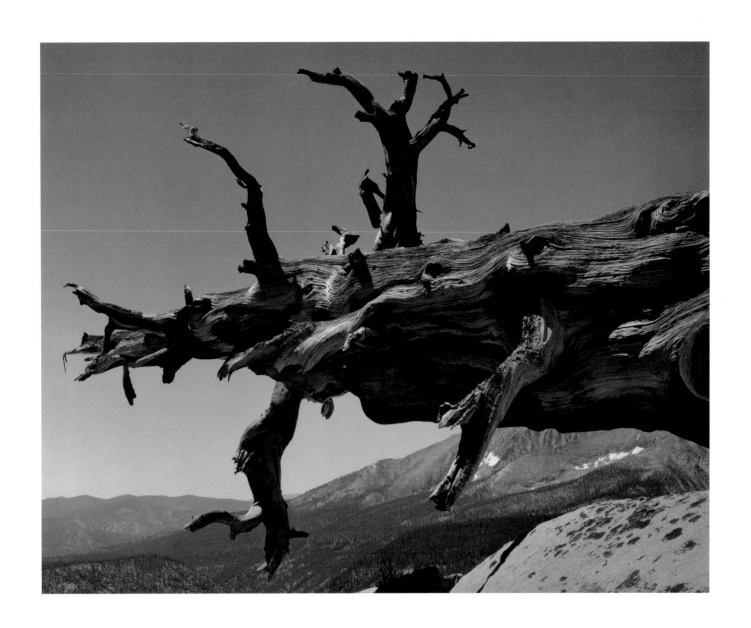

FALLEN TREE, KERN RIVER CANYON, SEQUOIA NATIONAL PARK, CALIFORNIA, C. 1935

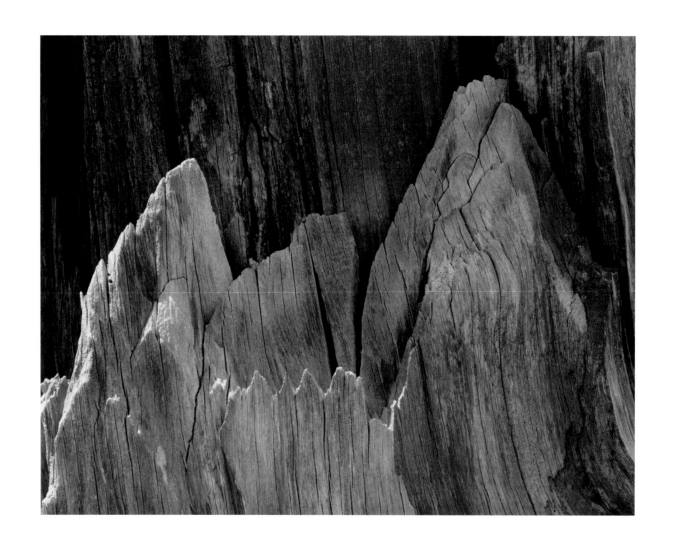

TREE DETAIL, SIERRA NEVADA, CALIFORNIA, 1936

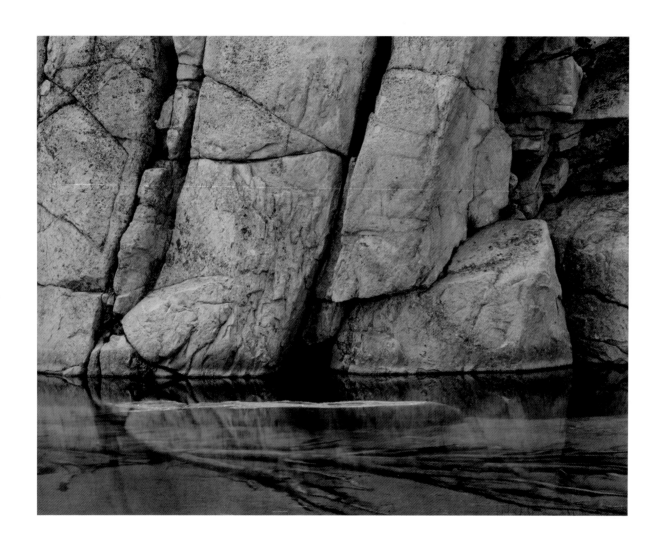

ROCK AND WATER, SIERRA NEVADA, CALIFORNIA, C. 1934

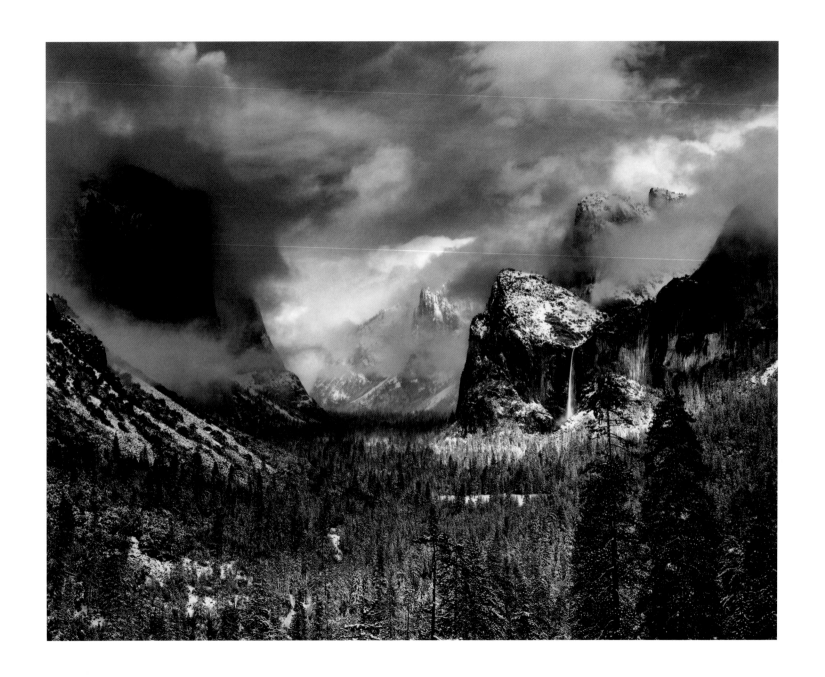

CLEARING WINTER STORM, YOSEMITE NATIONAL PARK, CALIFORNIA, C. 1937

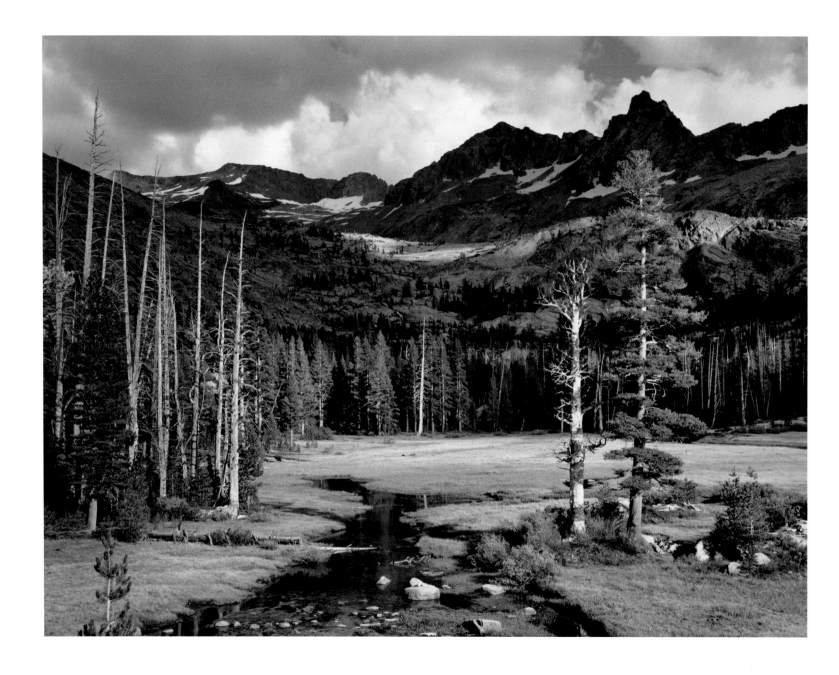

MOUNT ANSEL ADAMS, LYELL FORK OF THE MERCED RIVER, YOSEMITE NATIONAL PARK, CALIFORNIA, C. 1935

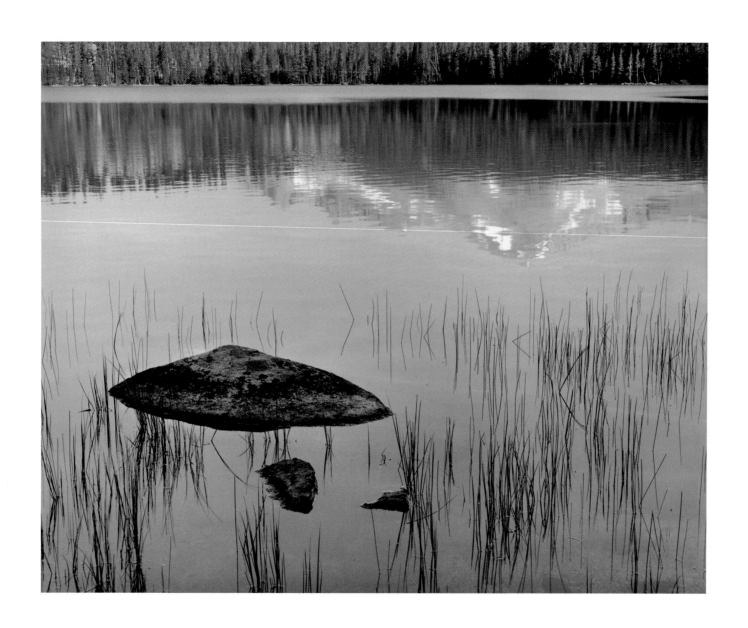

ROCK AND GRASS, MORAINE LAKE, SEQUOIA NATIONAL PARK, CALIFORNIA, 1936

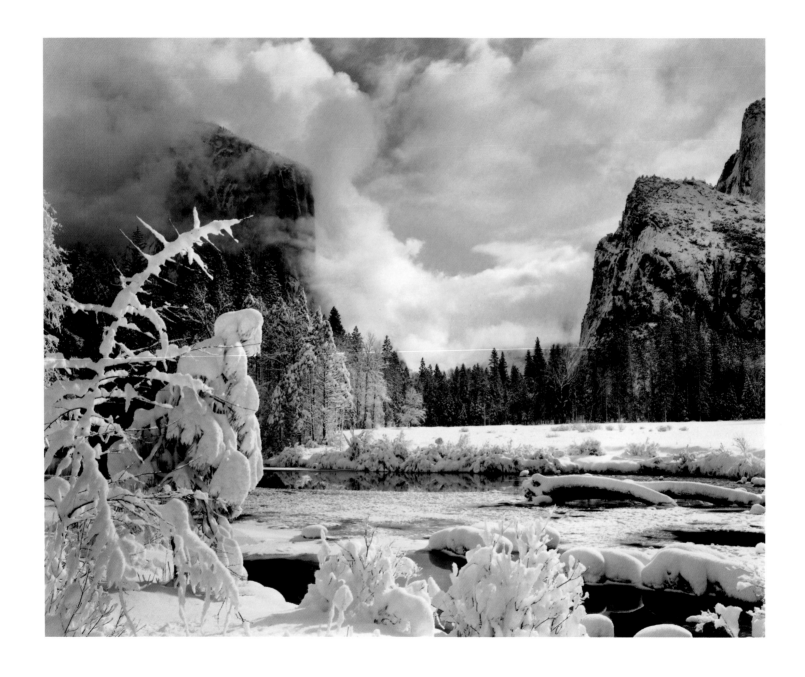

GATES OF THE VALLEY, WINTER, YOSEMITE NATIONAL PARK, CALIFORNIA, C. 1938

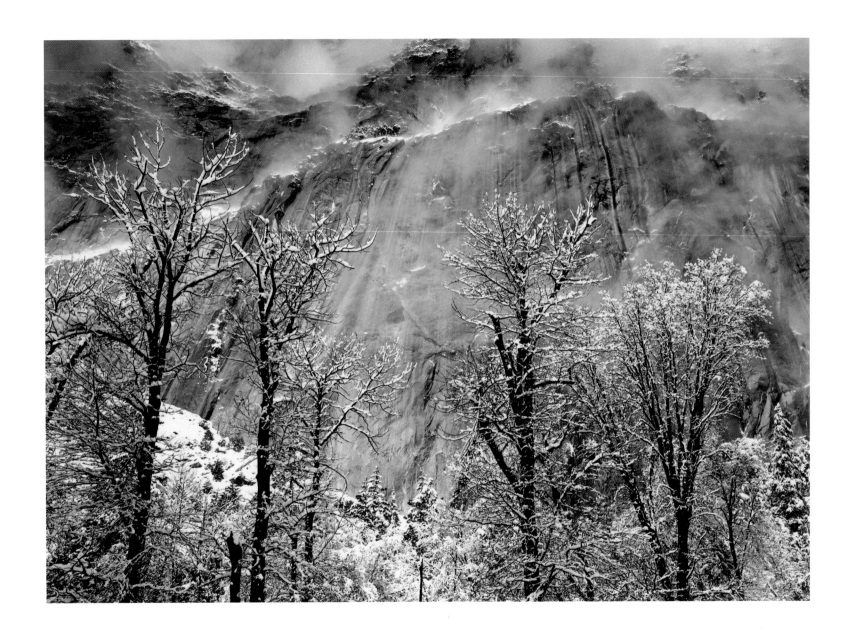

TREES AND CLIFFS OF EAGLE PEAK, WINTER, YOSEMITE NATIONAL PARK, CALIFORNIA, C. 1935

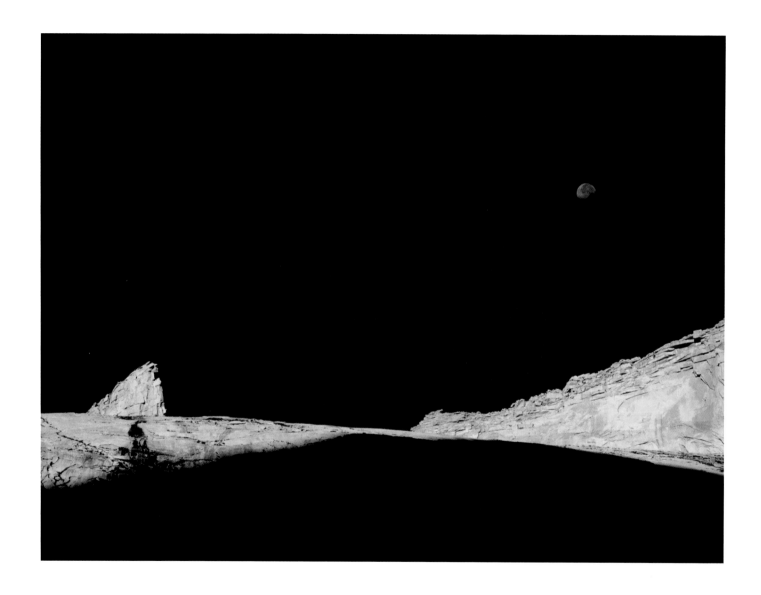

HIGH COUNTRY CRAGS AND MOON, SUNRISE, KINGS CANYON NATIONAL PARK, CALIFORNIA, C. 1935

DOGWOOD, YOSEMITE NATIONAL PARK, CALIFORNIA, C. 1938

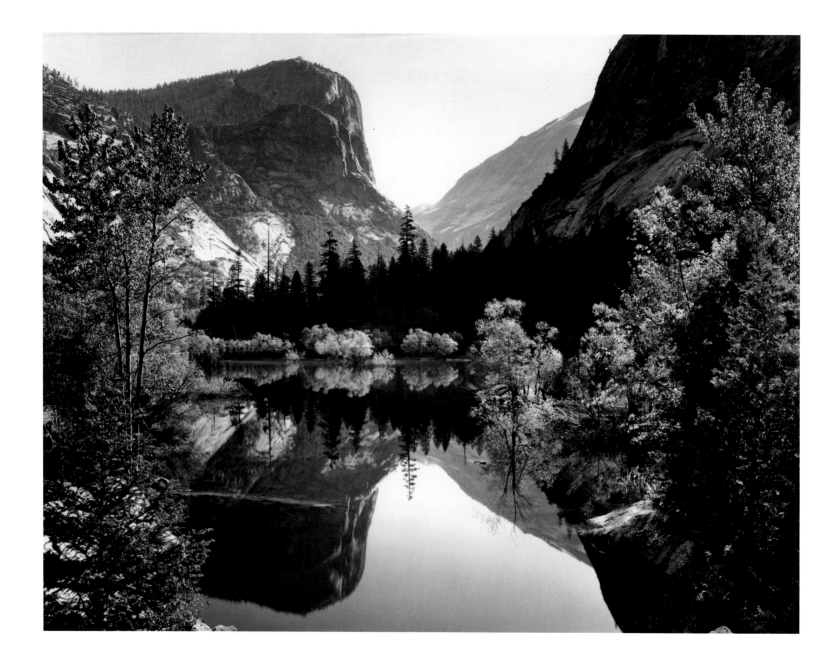

MIRROR LAKE, MOUNT WATKINS, SPRING, YOSEMITE NATIONAL PARK, CALIFORNIA, 1935

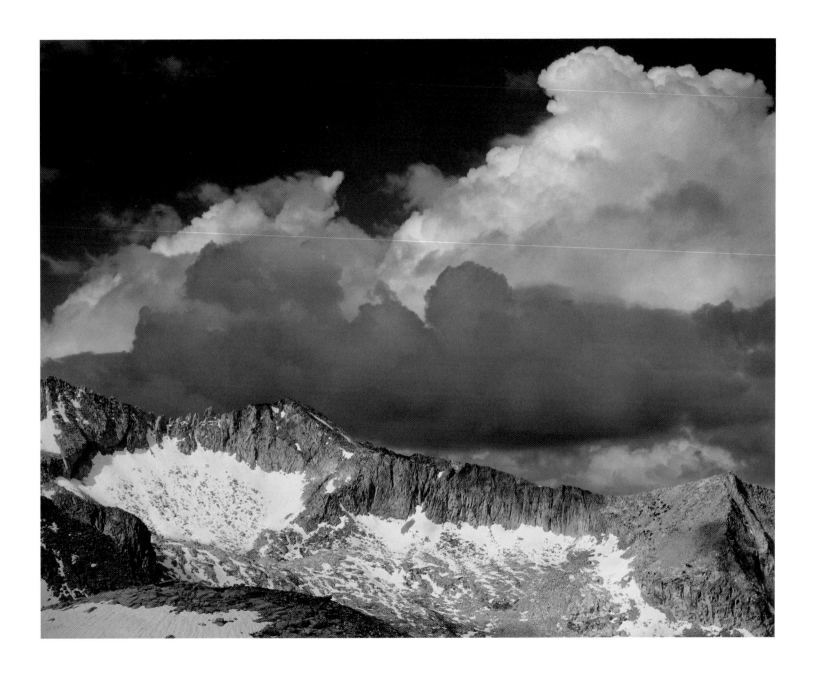

CLOUDS, KINGS RIVER DIVIDE, SIERRA NEVADA, CALIFORNIA, C. 1932

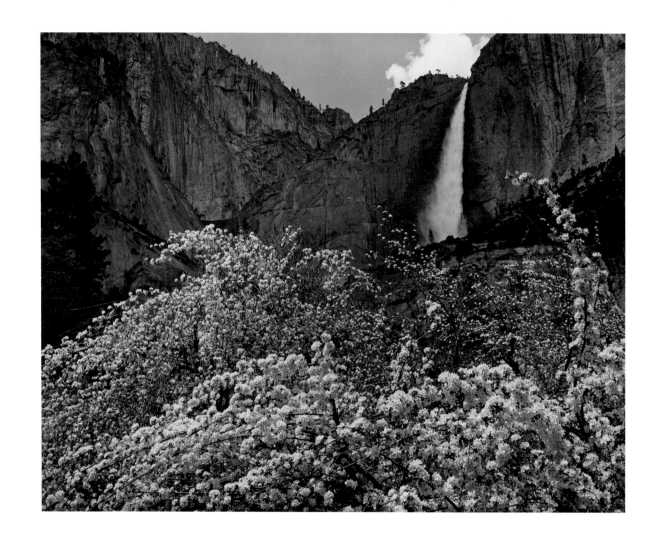

UPPER YOSEMITE FALL AND APPLE BLOSSOMS, YOSEMITE NATIONAL PARK, CALIFORNIA, C. 1936

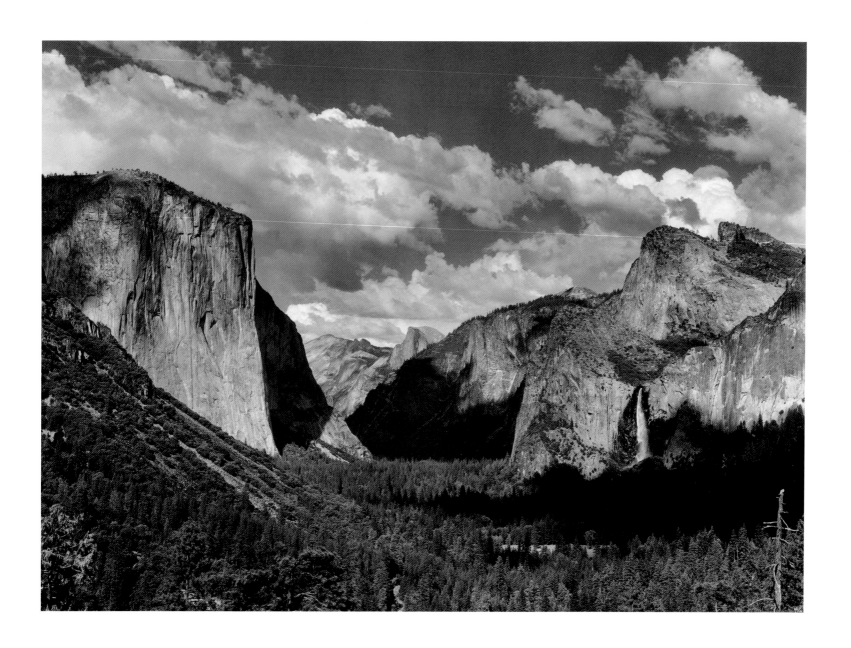

YOSEMITE VALLEY, SUMMER, CALIFORNIA, C. 1935

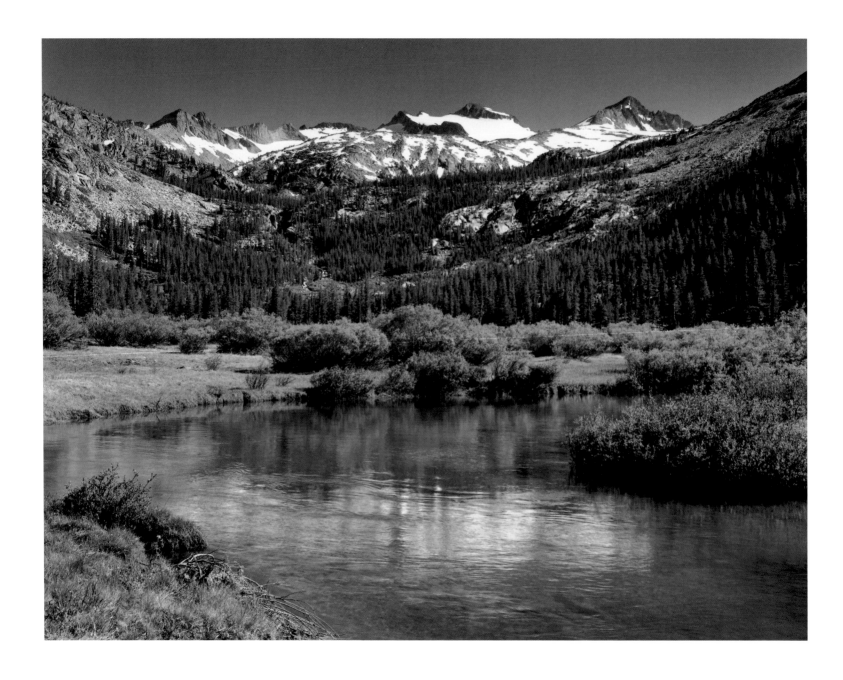

MOUNT LYELL AND MOUNT MACLURE, TUOLUMNE RIVER, YOSEMITE NATIONAL PARK, CALIFORNIA, C. 1936

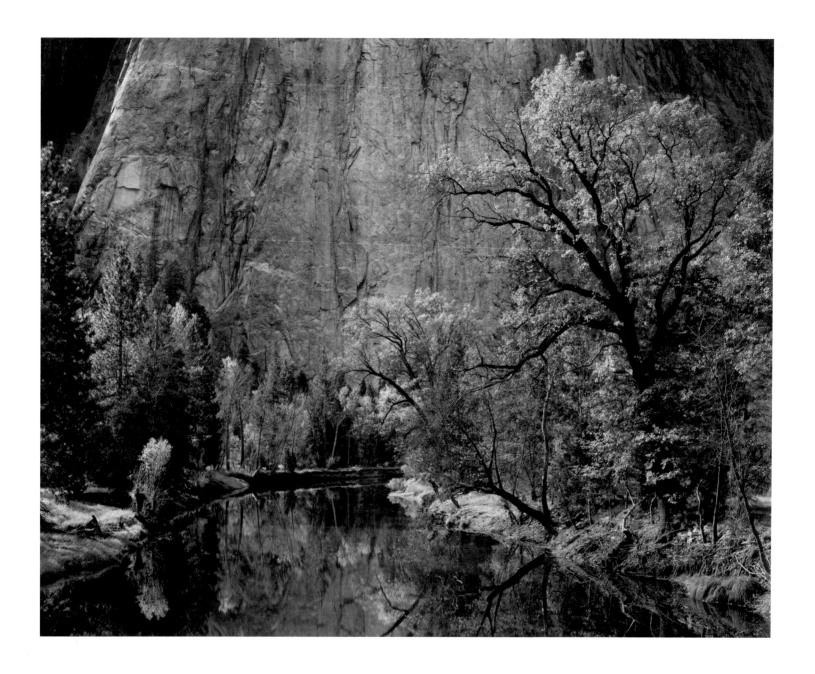

MERCED RIVER, CLIFFS OF CATHEDRAL ROCKS, AUTUMN, YOSEMITE NATIONAL PARK, CALIFORNIA, 1939

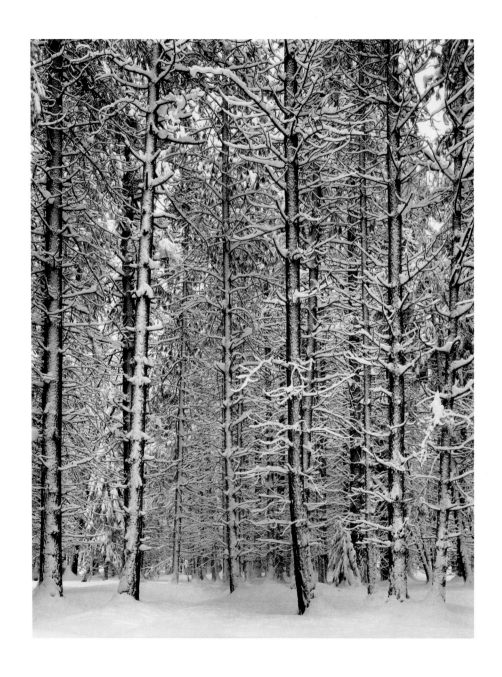

PINE FOREST IN SNOW, YOSEMITE NATIONAL PARK, CALIFORNIA, 1933

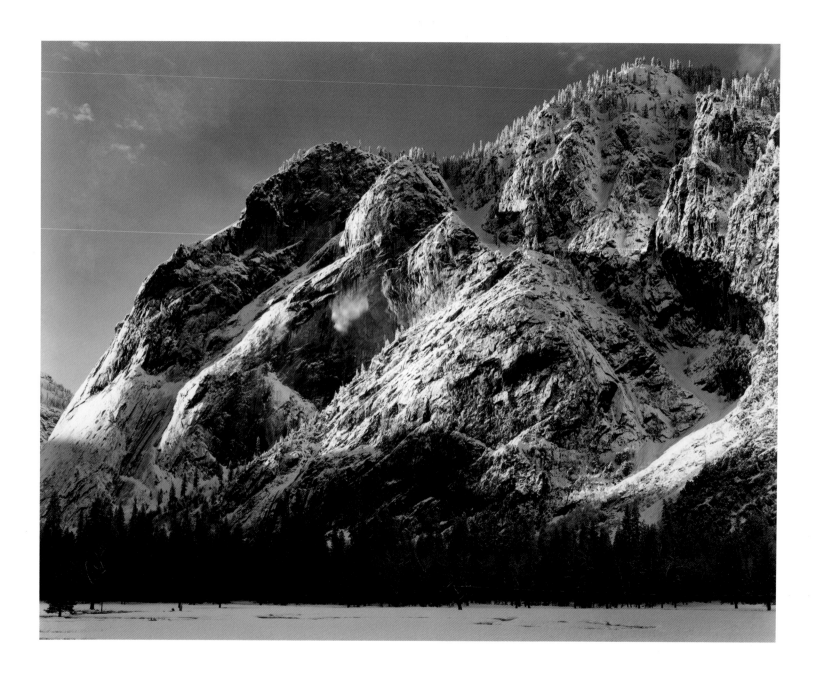

CLIFFS OF GLACIER POINT, AVALANCHE, YOSEMITE NATIONAL PARK, CALIFORNIA, C. 1935

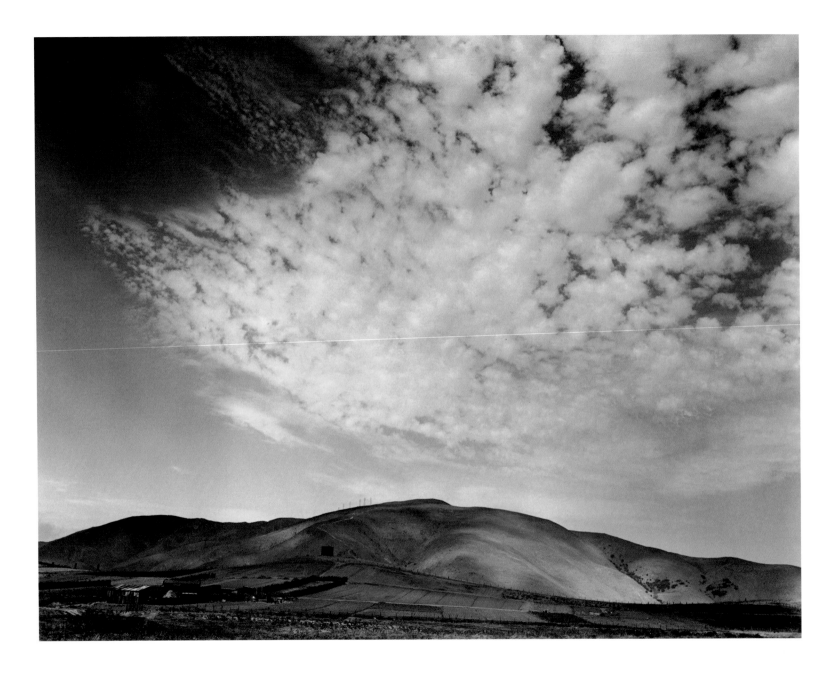

HILLS AND CLOUDS, SOUTH SAN FRANCISCO, CALIFORNIA, C. 1936

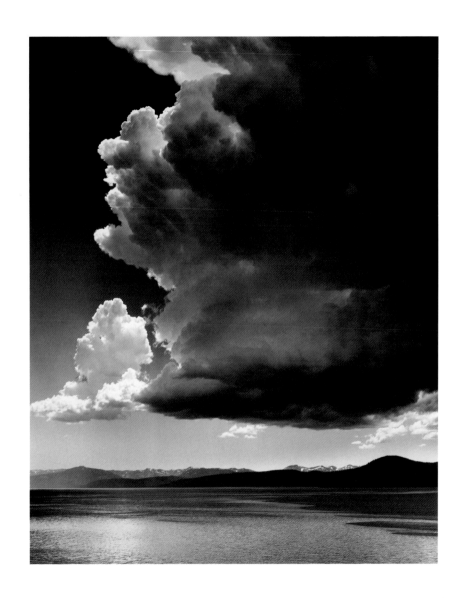

THUNDERCLOUD, LAKE TAHOE, CALIFORNIA, 1938

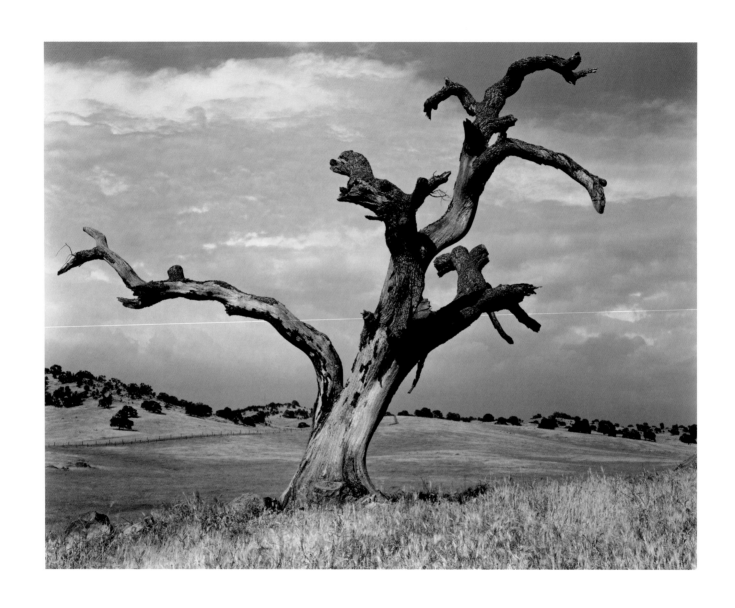

DEAD OAK TREE, SIERRA FOOTHILLS, ABOVE SNELLING, CALIFORNIA, 1938

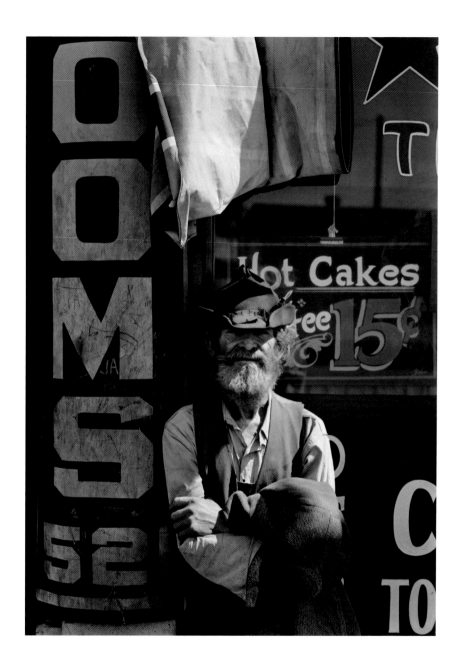

ITINERANT, MERCED, CALIFORNIA, 1936

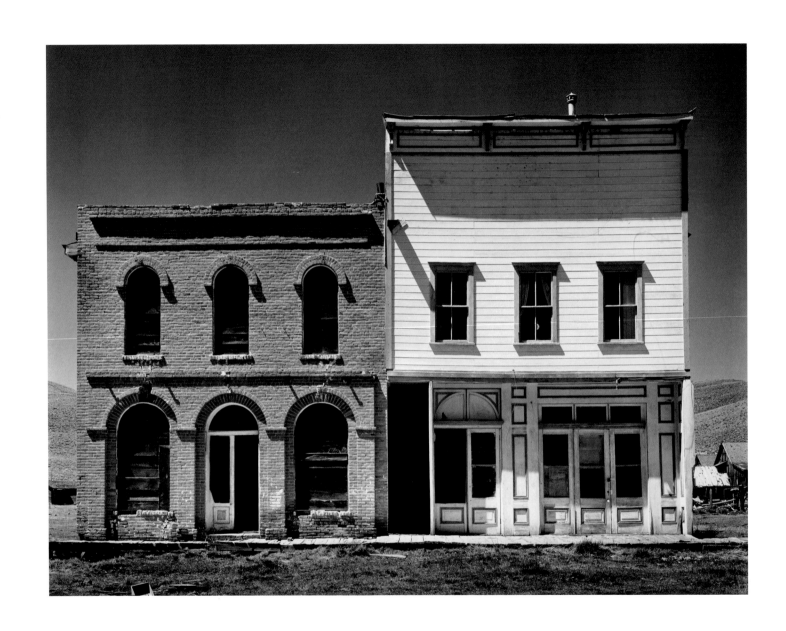

GHOST TOWN, BODIE, CALIFORNIA, 1938

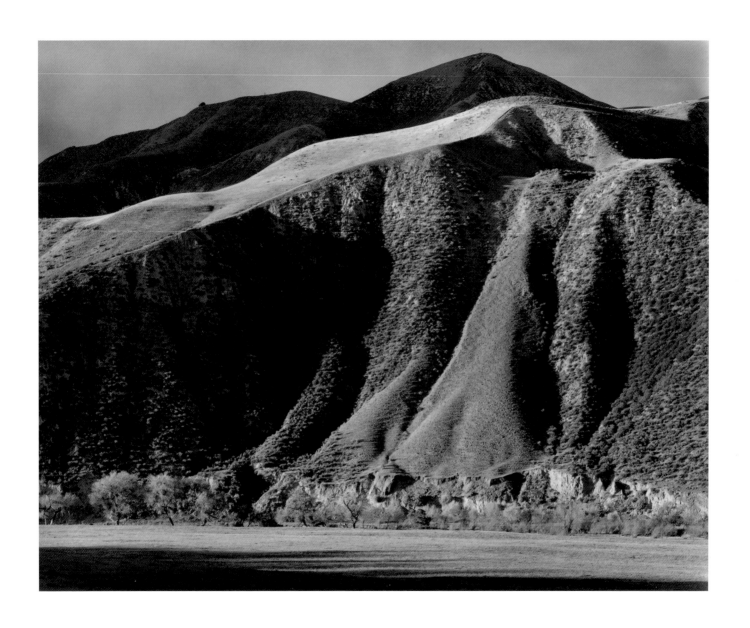

ERODED HILLS NEAR PACHECO PASS, DIABLO RANGE, CALIFORNIA, 1939

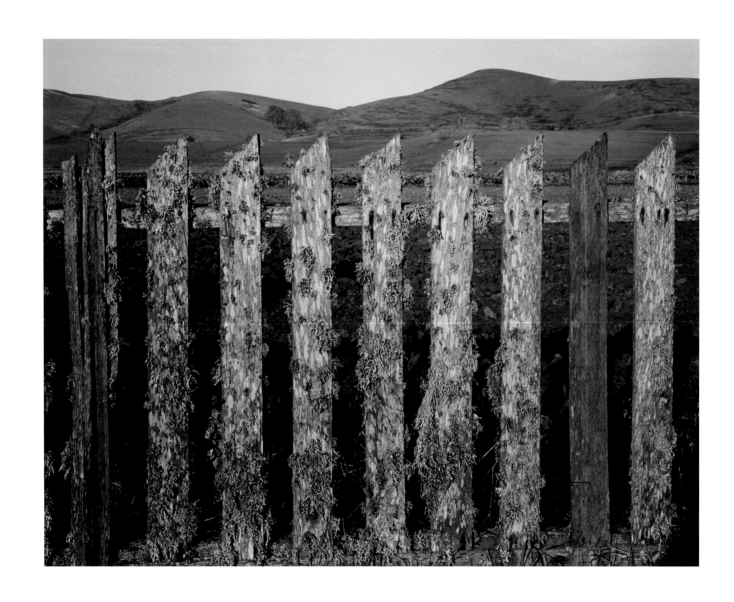

FENCE NEAR TOMALES BAY, CALIFORNIA, 1936

WINDMILL SPINNING, OWENS VALLEY, NEAR INDEPENDENCE, CALIFORNIA, 1935

YOUNG OAKS IN SNOW, YOSEMITE NATIONAL PARK, CALIFORNIA, C. 1938

ASPENS AND MOUNTAIN, AUTUMN, COLORADO, 1937

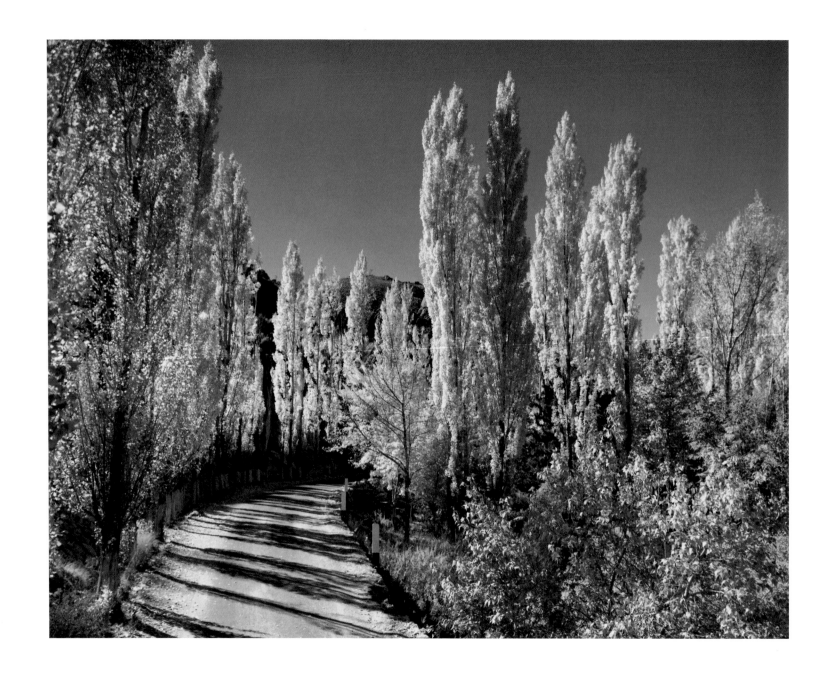

POPLARS, AUTUMN, OWENS VALLEY ROAD, CALIFORNIA, C. 1939

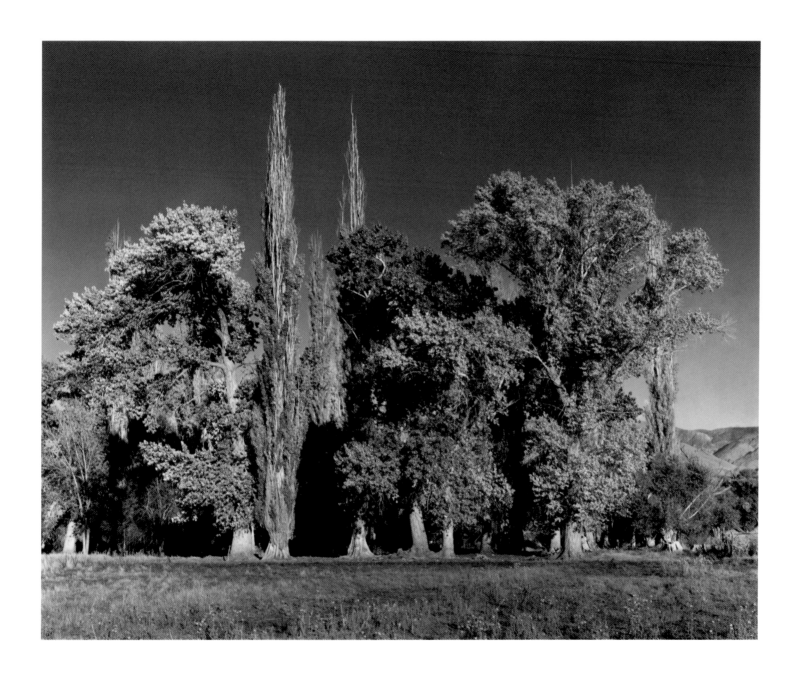

POPLARS AND COTTONWOOD TREES, OWENS VALLEY, CALIFORNIA, C. 1939

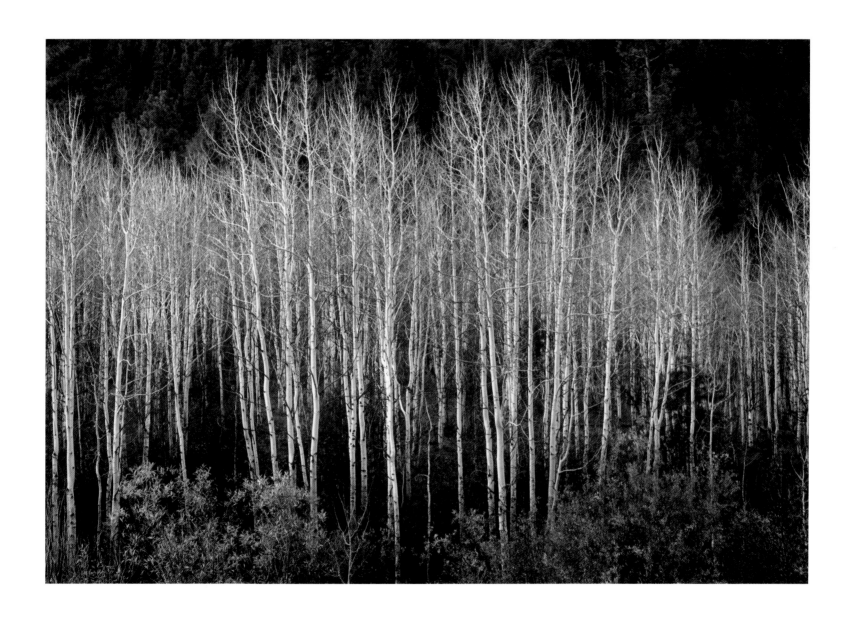

ASPENS, DAWN, AUTUMN, DOLORES RIVER CANYON, COLORADO, 1937

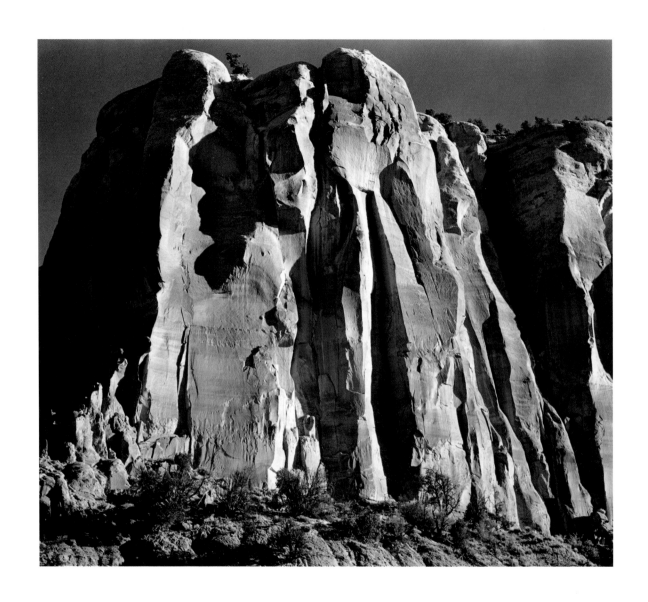

THE ENCHANTED MESA, NEAR ACOMA PUEBLO, NEW MEXICO, 1937

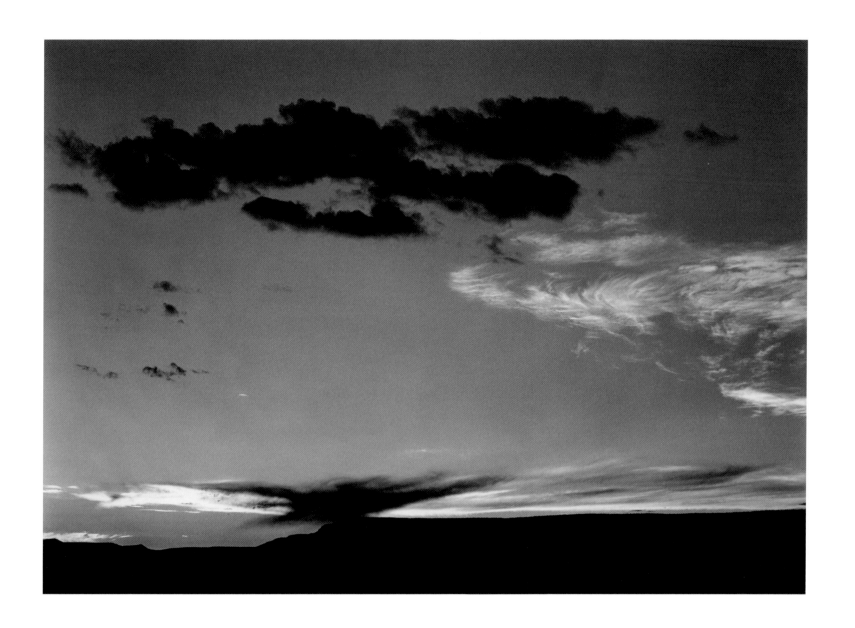

SUNSET, GHOST RANCH, NEW MEXICO, 1937

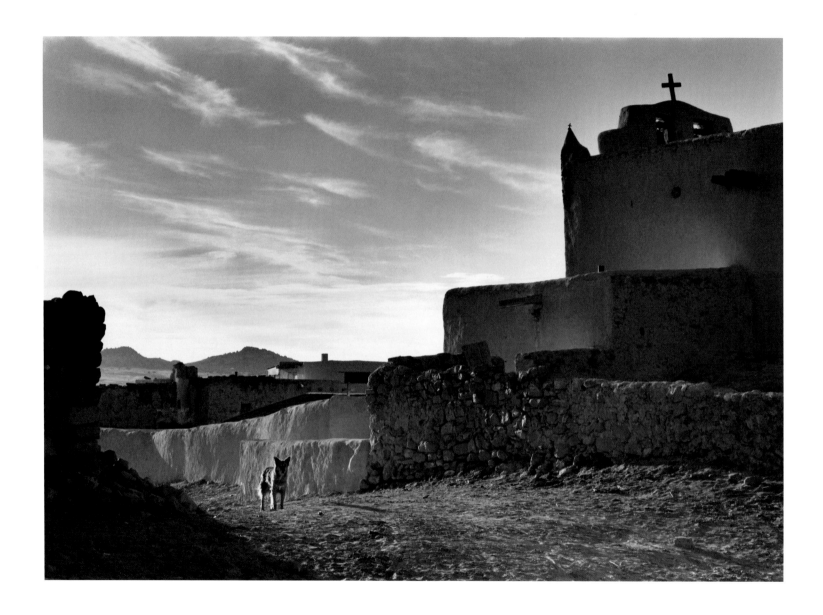

SUNRISE, LAGUNA PUEBLO, NEW MEXICO, 1937

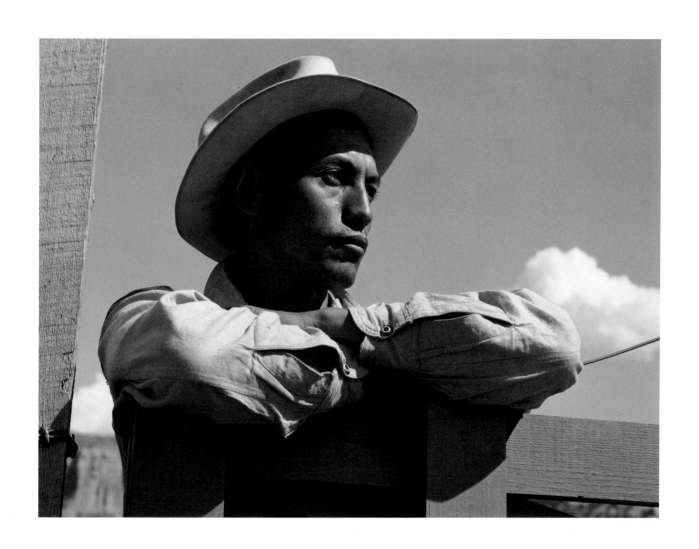

HISPANIC YOUTH, CHAMA VALLEY, NEW MEXICO, 1937

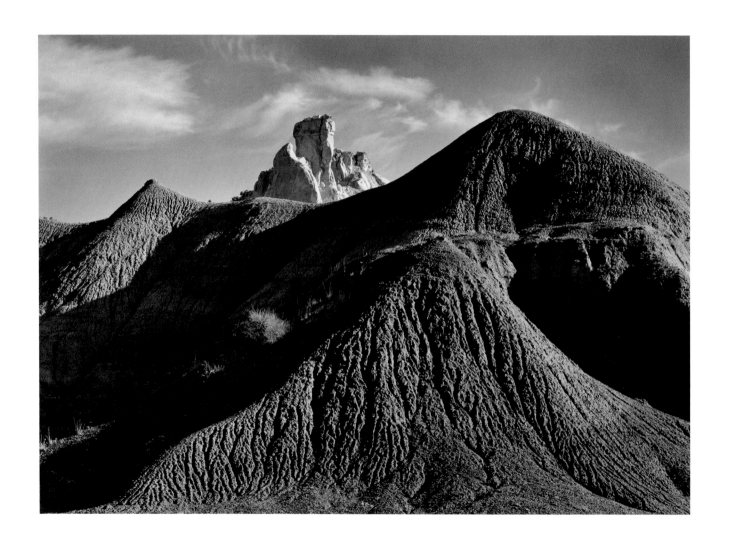

GHOST RANCH HILLS, CHAMA VALLEY, NEW MEXICO, 1937

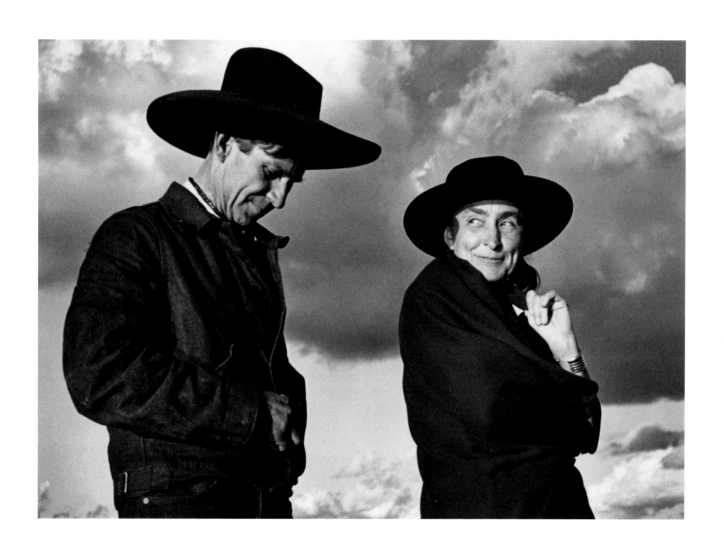

GEORGIA O'KEEFFE AND ORVILLE COX, CANYON DE CHELLY NATIONAL MONUMENT, ARIZONA, 1937

MONUMENT VALLEY, ARIZONA, 1937

DEAD TREE, SUNSET CRATER NATIONAL MONUMENT, ARIZONA, 1938

THUNDERSTORM, CHAMA VALLEY, NEW MEXICO, 1937

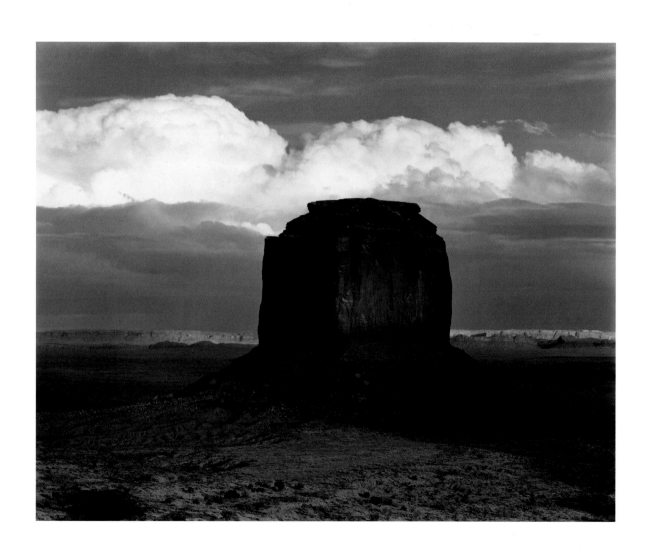

HOPI BUTTE, MONUMENT VALLEY, ARIZONA, C. 1937

In 1941 U.S. Secretary of the Interior Harold Ickes commissioned Adams to photograph the national parks and monuments for murals to be displayed in the Department of the Interior's new Washington, DC, headquarters. Adams visited many of the western national parks outside California and made hundreds of negatives. The project was a turning point in his career. He had a particular love and affection for California and the Southwest, and most of his photographs up until 1941 had been made there. The so-called mural project provided Adams with the opportunity to range well beyond these areas.

Unfortunately, Adams was able to complete only two photographic trips before the project was discontinued in 1942 as a result of America's entry into World War II. In 1947 and 1948 Adams was awarded Guggenheim Foundation fellowships to complete his exploration of the parks, which resulted in a book, *Our National Parks*. On his Guggenheim trips, Adams visited the eastern national parks and Alaska for the first time.

During the 1940s Adams more consistently lowered the horizon in his photographs in order to better record enormous skies and mountains.

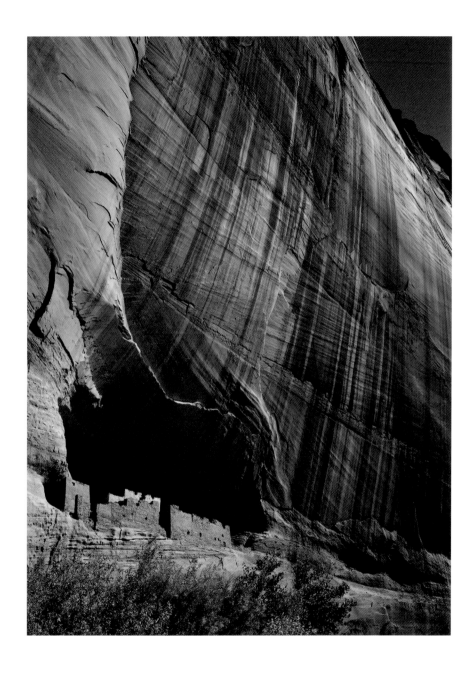

WHITE HOUSE RUIN, CANYON DE CHELLY NATIONAL MONUMENT, ARIZONA, 1942

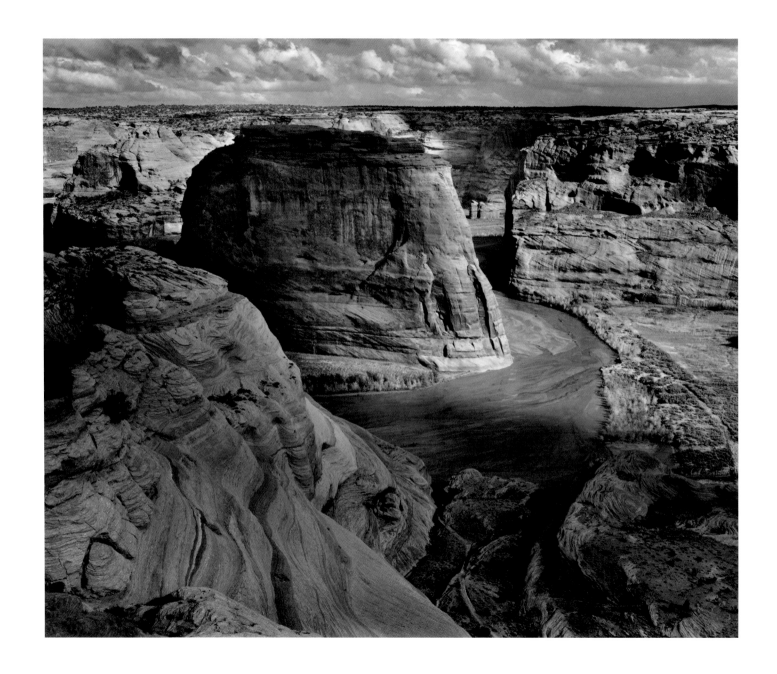

CANYON DE CHELLY NATIONAL MONUMENT, ARIZONA, 1942

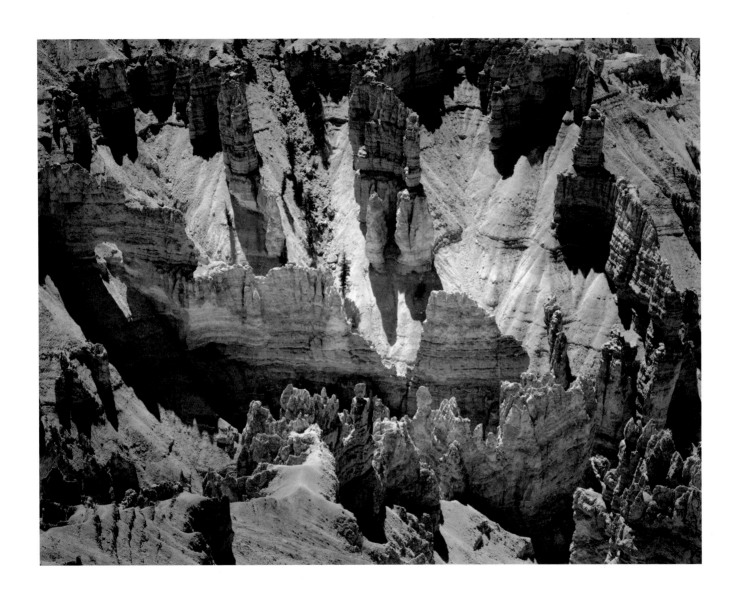

IN CEDAR BREAKS NATIONAL MONUMENT, UTAH, 1947

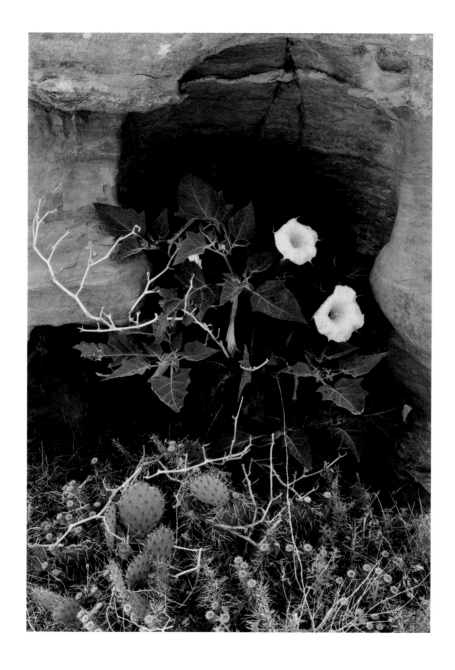

DATURA FLOWER, CANYON DE CHELLY NATIONAL MONUMENT, ARIZONA, 1947

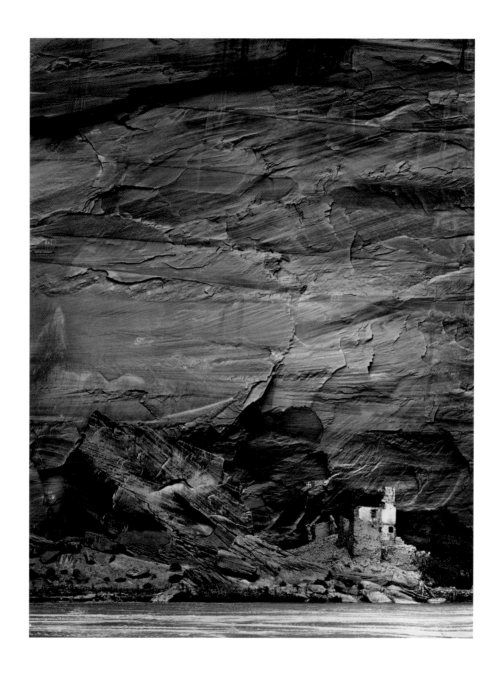

ANTELOPE HOUSE RUIN, CANYON DE CHELLY NATIONAL MONUMENT, ARIZONA, 1942

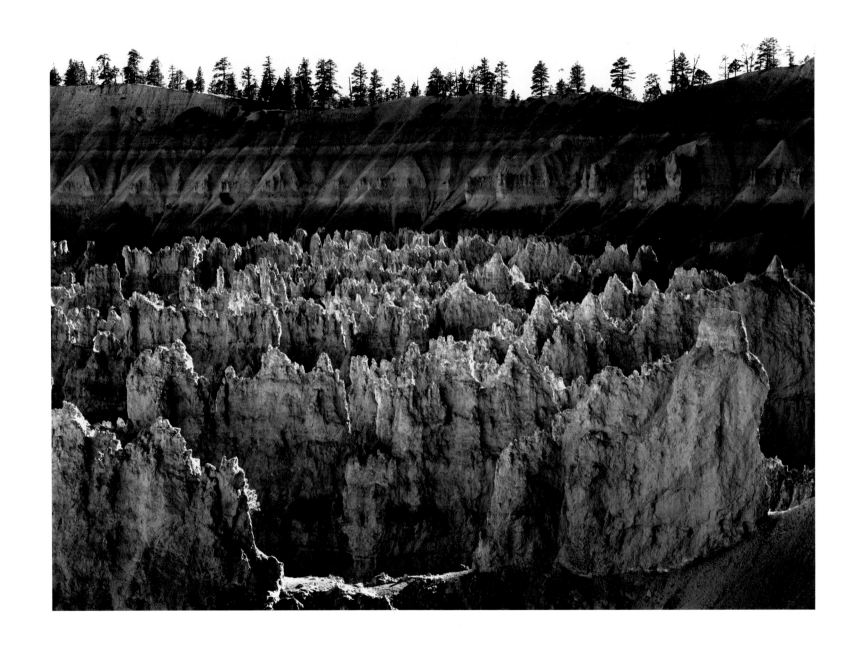

FORMATIONS, BRYCE CANYON NATIONAL PARK, UTAH, 1947

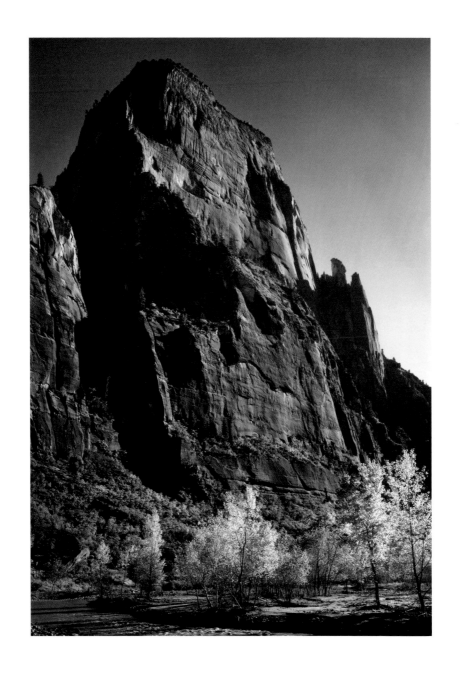

THE GREAT WHITE THRONE, ZION NATIONAL PARK, UTAH, 1942

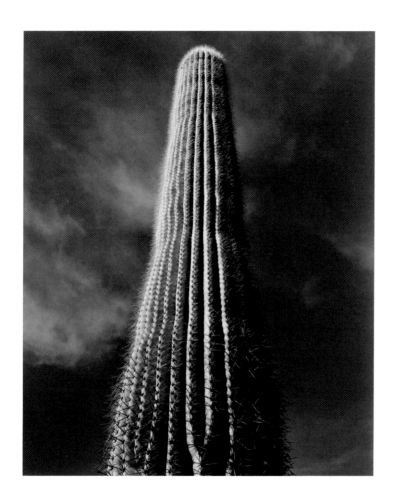 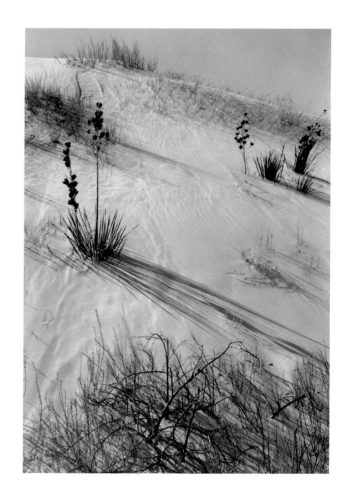

SAGUARO CACTUS, ARIZONA, 1942

DUNE, WHITE SANDS NATIONAL MONUMENT, NEW MEXICO, 1941

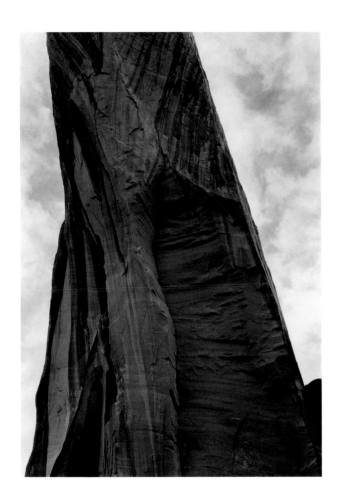

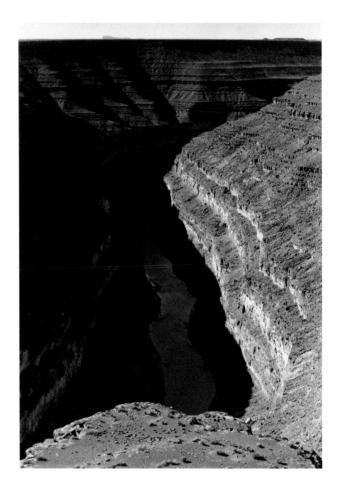

BASE OF WEST ARCH, RAINBOW BRIDGE NATIONAL MONUMENT, UTAH, 1942
GOOSENECKS OF THE SAN JUAN RIVER, NEAR MEXICAN HAT, UTAH, C. 1940

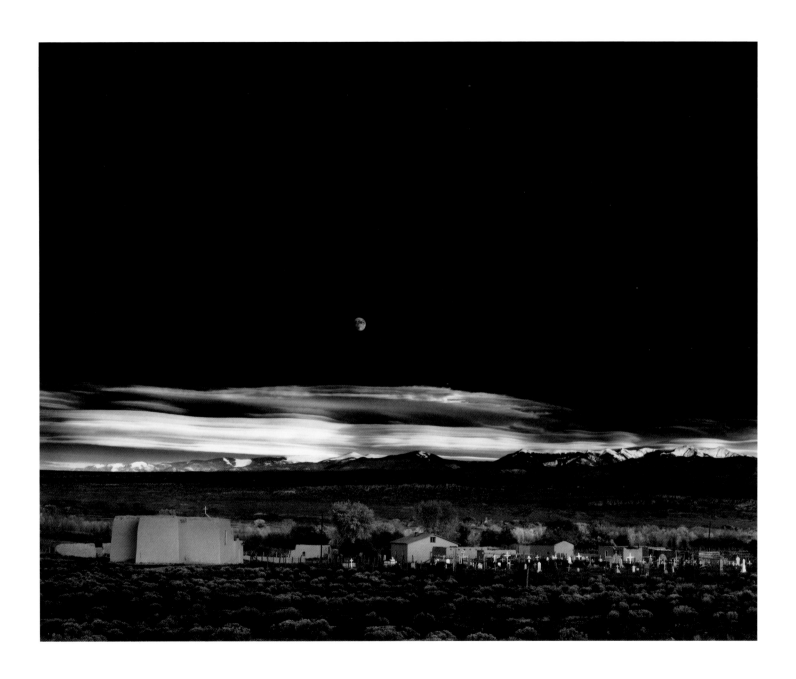

MOONRISE, HERNANDEZ, NEW MEXICO, 1941

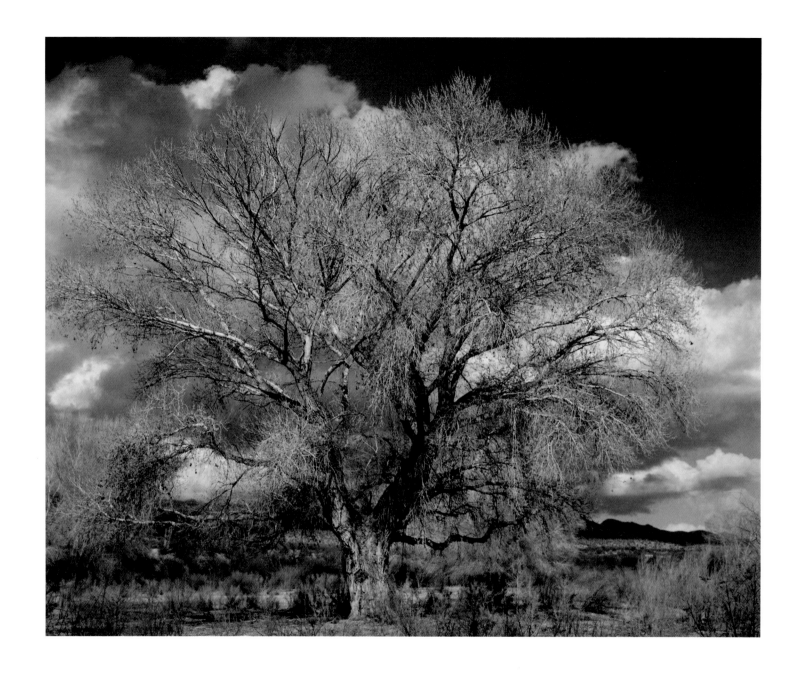

TREE AND CLOUDS, TUCSON, ARIZONA, C. 1944

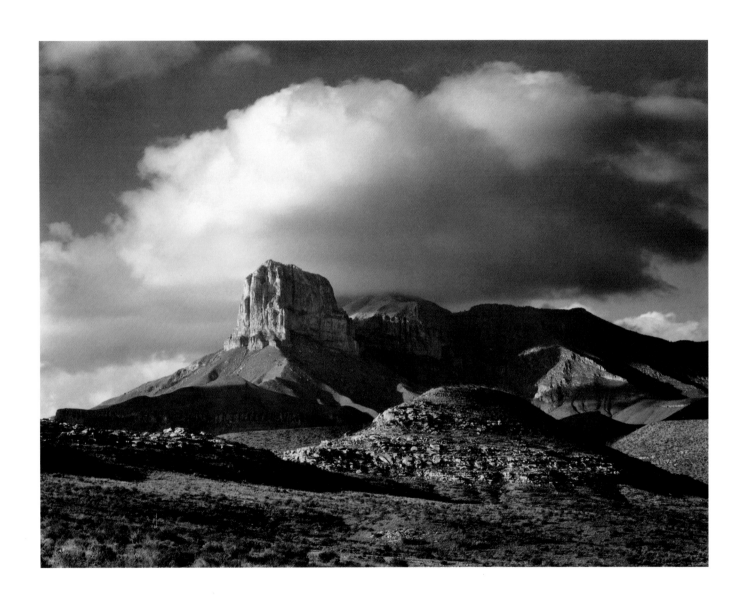

EL CAPITAN PEAK, GUADALUPE MOUNTAINS NATIONAL PARK, TEXAS, 1947

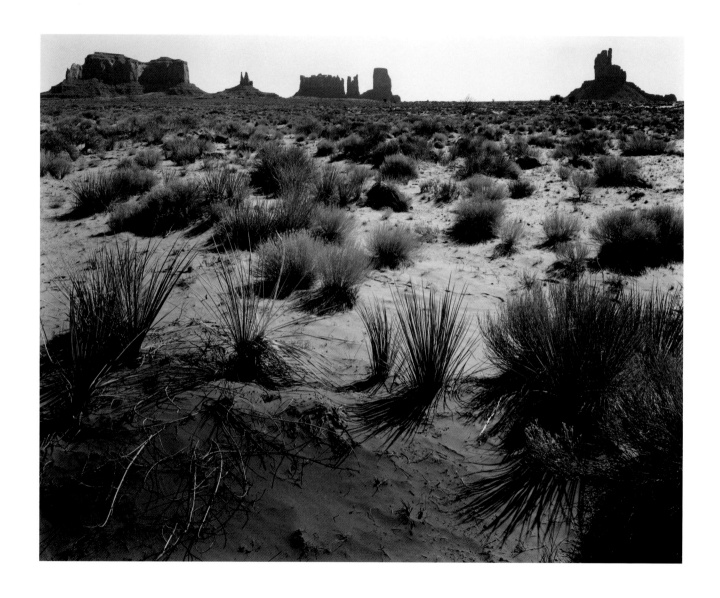

MONUMENT VALLEY, ARIZONA, C. 1947

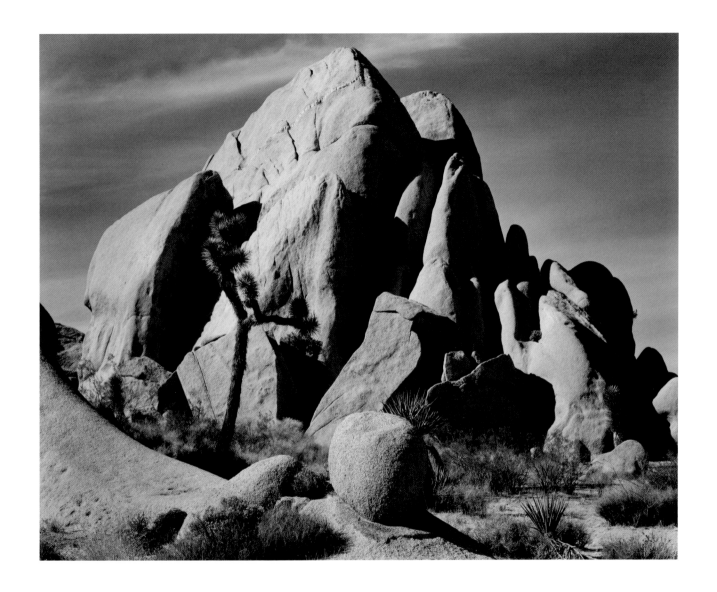

IN JOSHUA TREE NATIONAL PARK, CALIFORNIA, 1942

179

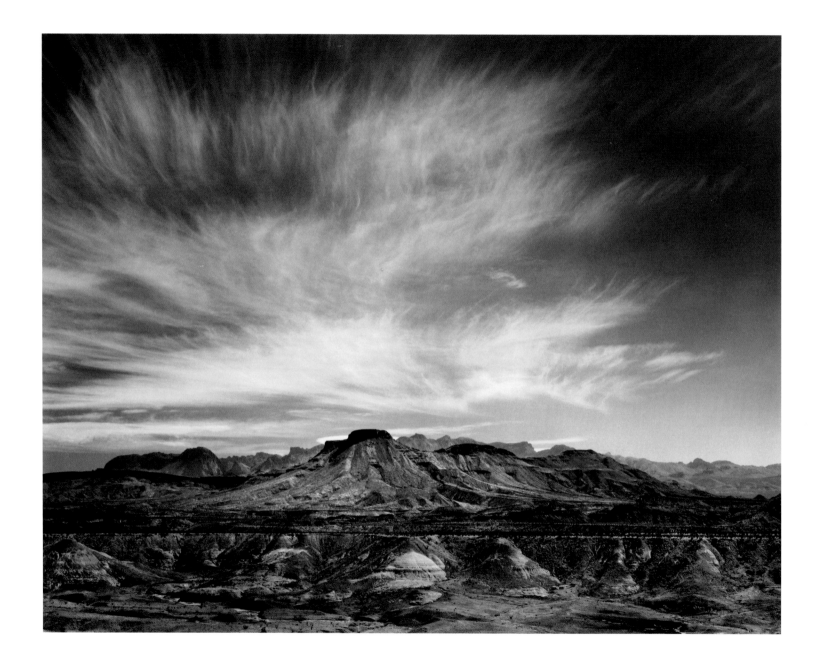

BURRO MESA AND THE CHISOS MOUNTAINS, BIG BEND NATIONAL PARK, TEXAS, 1947

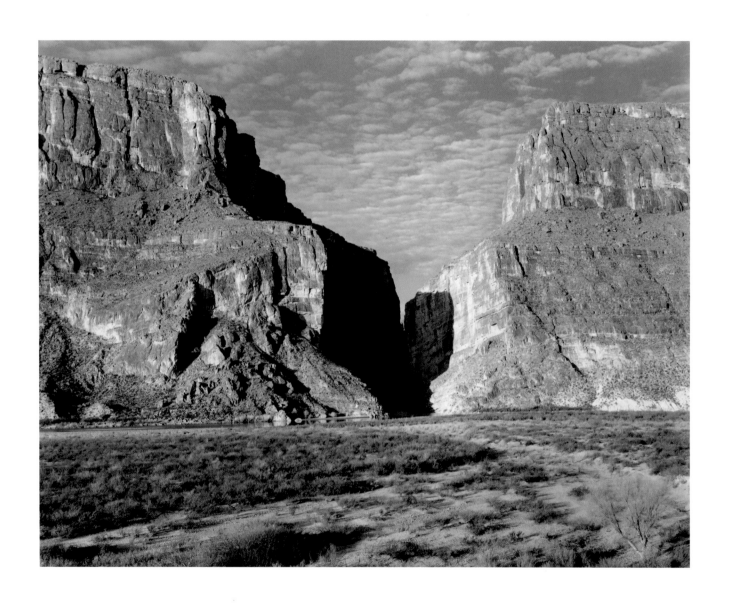

SANTA ELENA CANYON, BIG BEND NATIONAL PARK, TEXAS, 1947

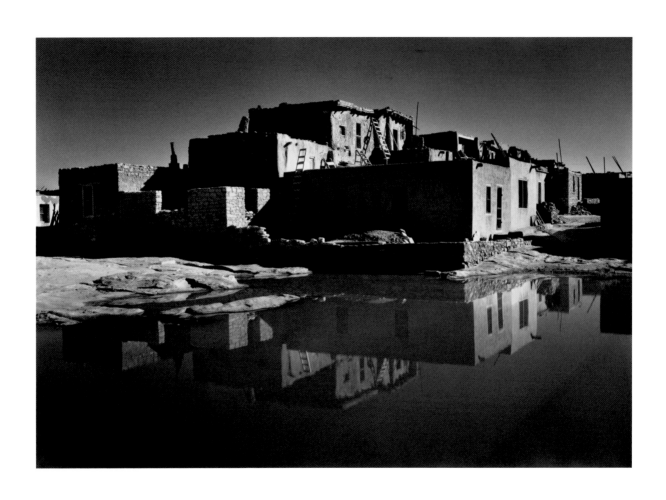

BUILDINGS AND POOL, ACOMA PUEBLO, NEW MEXICO, 1942

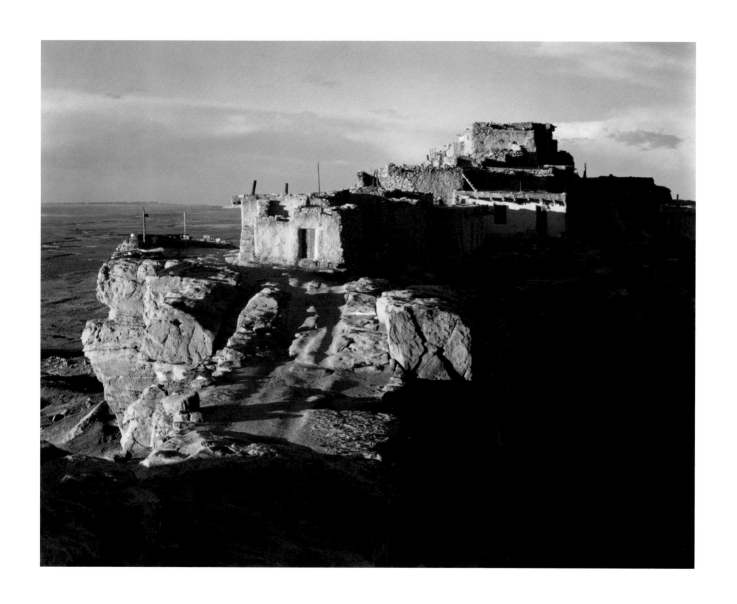

SUNRISE, OLD WALPI PUEBLO, ARIZONA, C. 1942

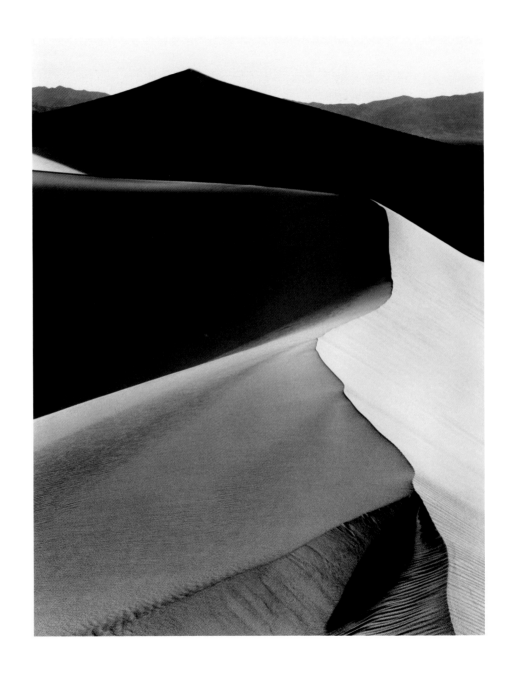

SAND DUNES, SUNRISE, DEATH VALLEY NATIONAL PARK, CALIFORNIA, C. 1948

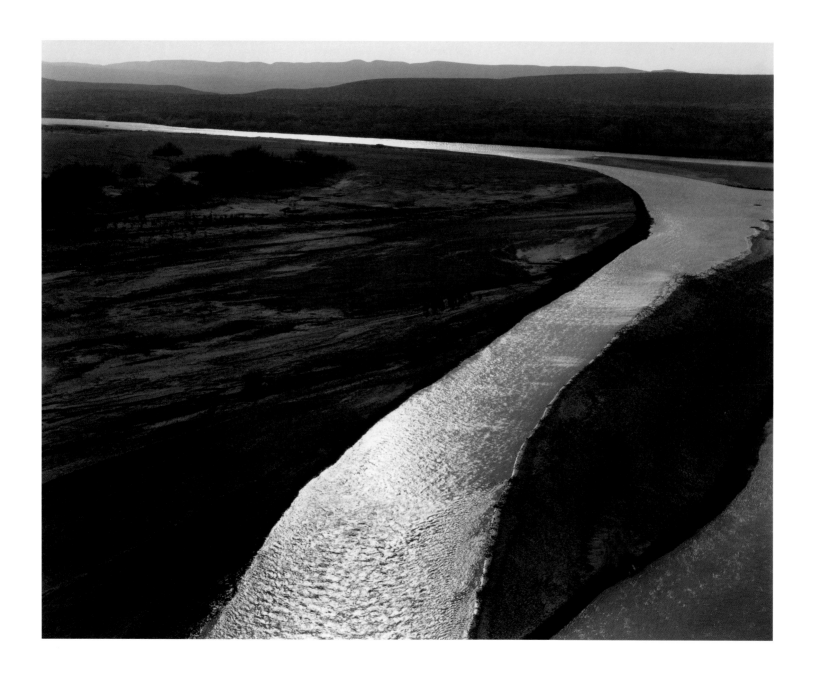

SAND BAR, RIO GRANDE, BIG BEND NATIONAL PARK, TEXAS, 1947

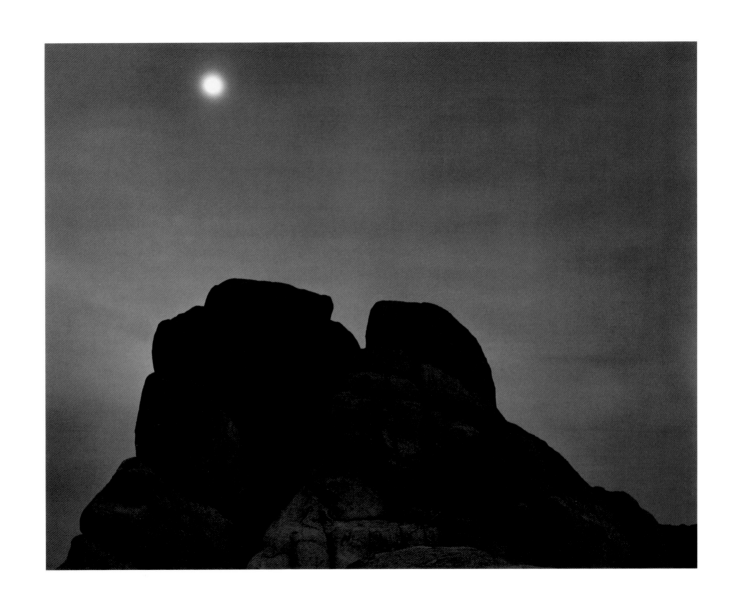

MOON AND ROCK, JOSHUA TREE NATIONAL PARK, CALIFORNIA, 1948

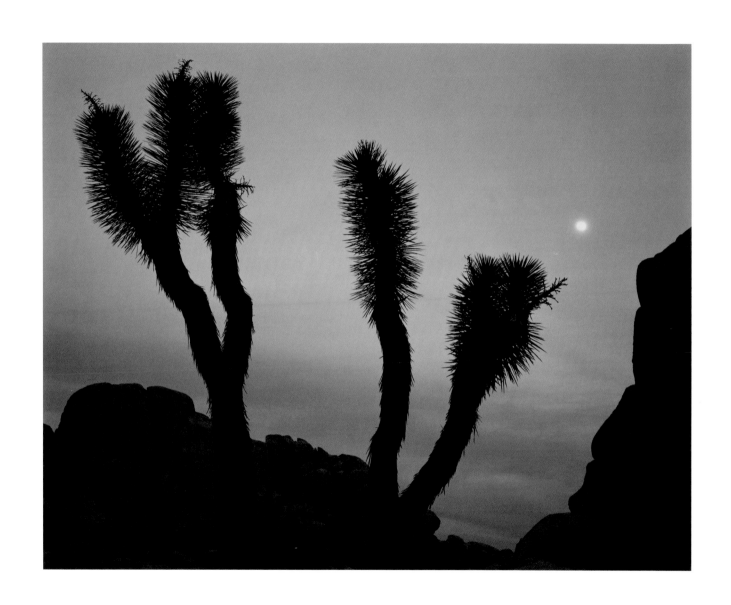

MOONRISE, JOSHUA TREE NATIONAL PARK, CALIFORNIA, 1948

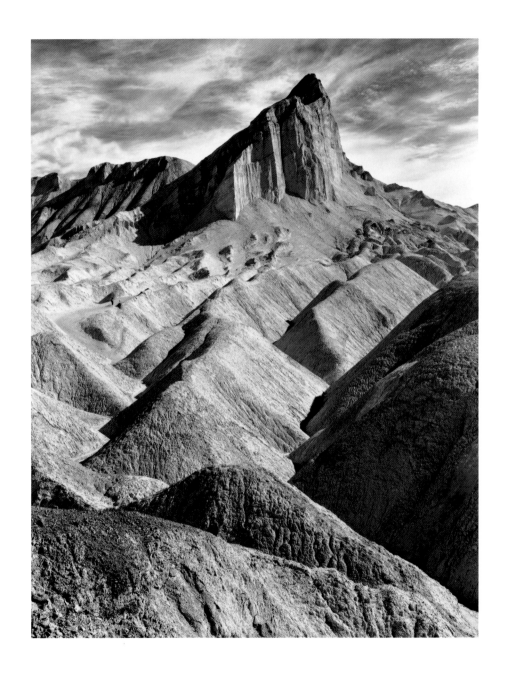

MANLY BEACON, DEATH VALLEY NATIONAL PARK, CALIFORNIA, C. 1948

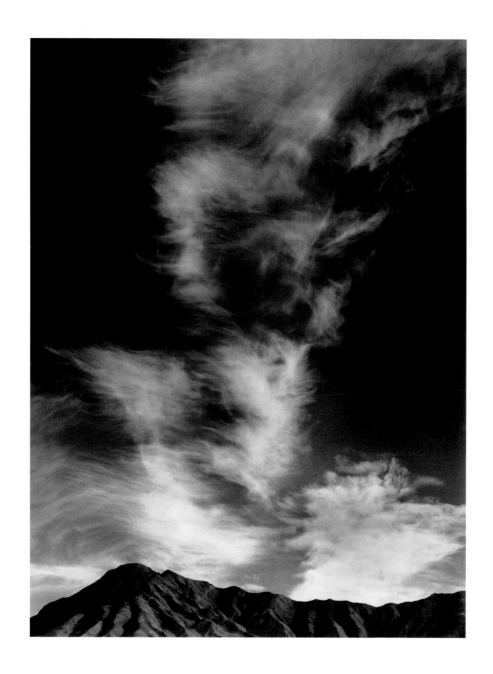

CLOUDS ABOVE GOLDEN CANYON, DEATH VALLEY NATIONAL PARK, CALIFORNIA, 1946

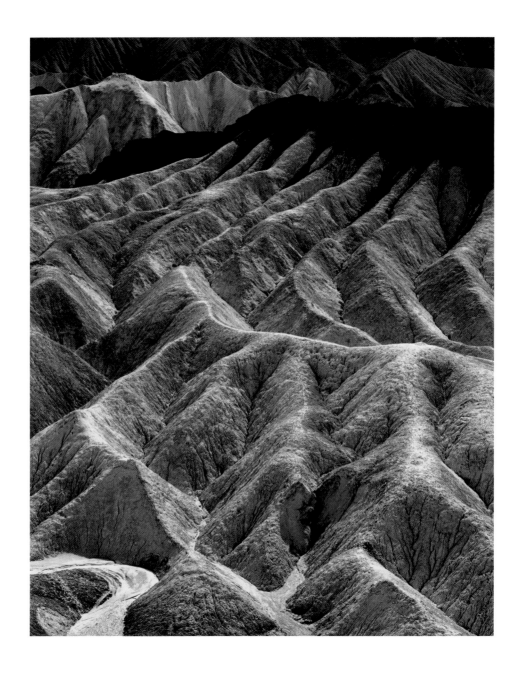

ZABRISKIE POINT, DEATH VALLEY NATIONAL PARK, CALIFORNIA, C. 1942

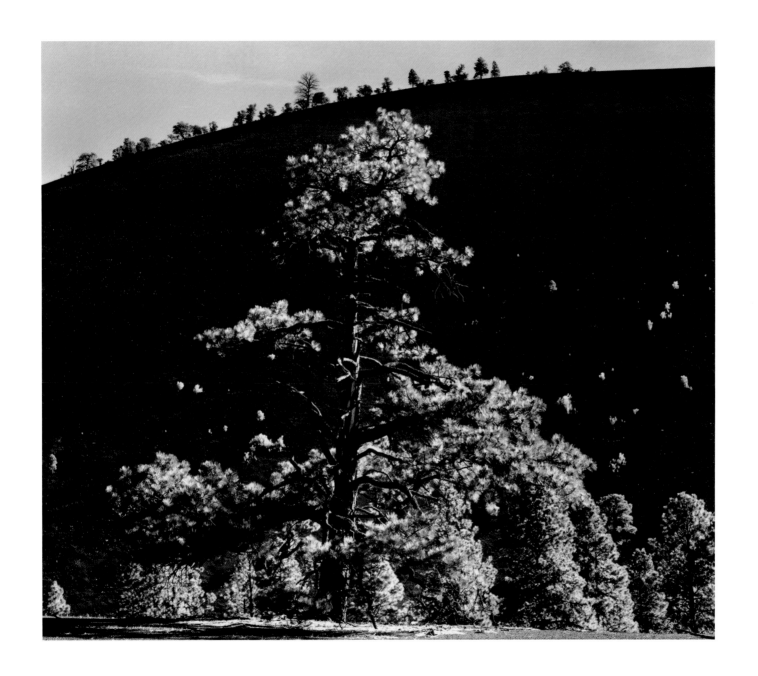

PUMICE SLOPE AND PINE TREES, SUNSET CRATER NATIONAL MONUMENT, ARIZONA, C. 1947

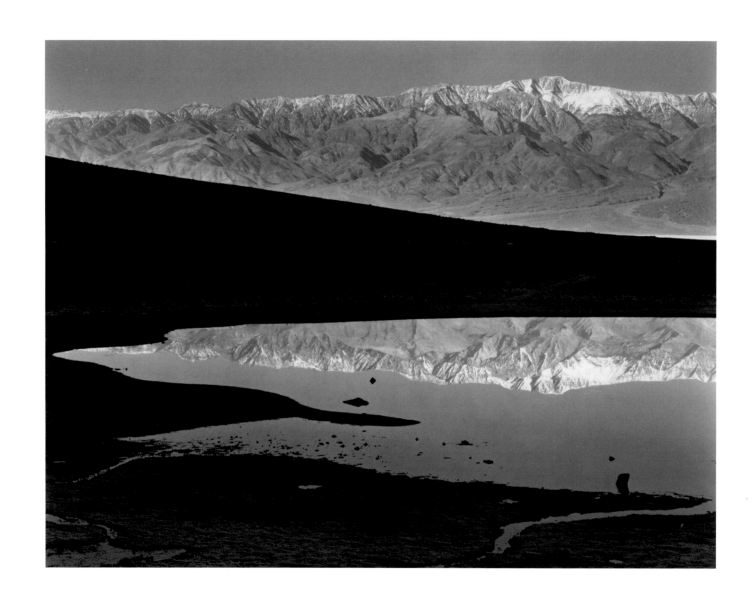

SUNRISE, BADWATER, DEATH VALLEY NATIONAL PARK, CALIFORNIA, 1948

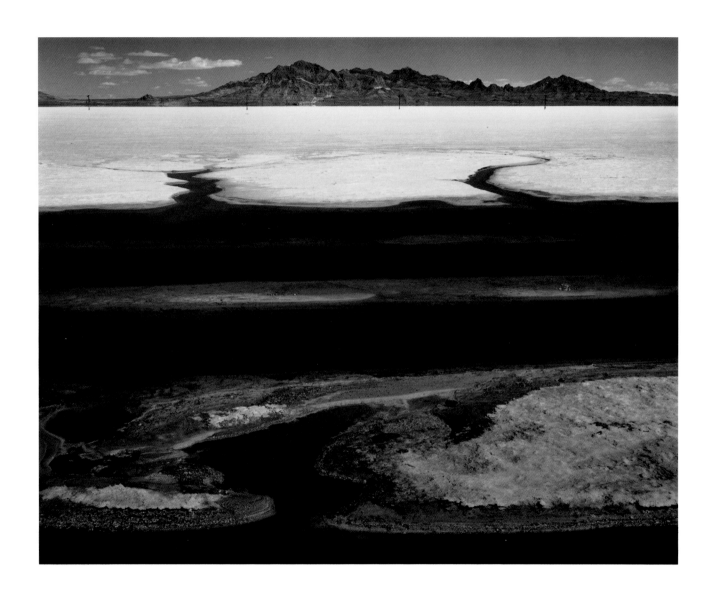

SALT FLATS, NEAR WENDOVER, UTAH, C. 1941

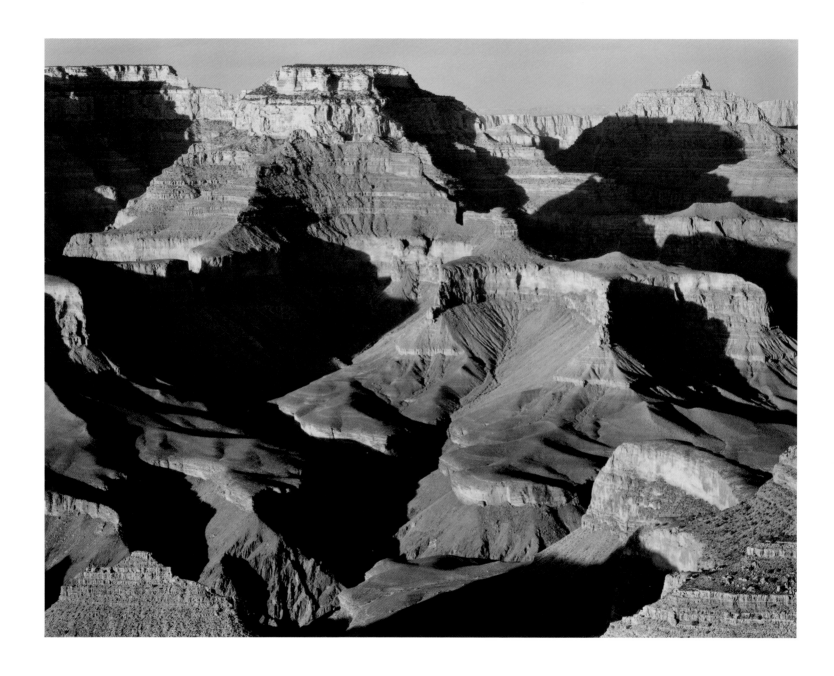

CAPE ROYAL FROM THE SOUTH RIM, GRAND CANYON NATIONAL PARK, ARIZONA, 1947

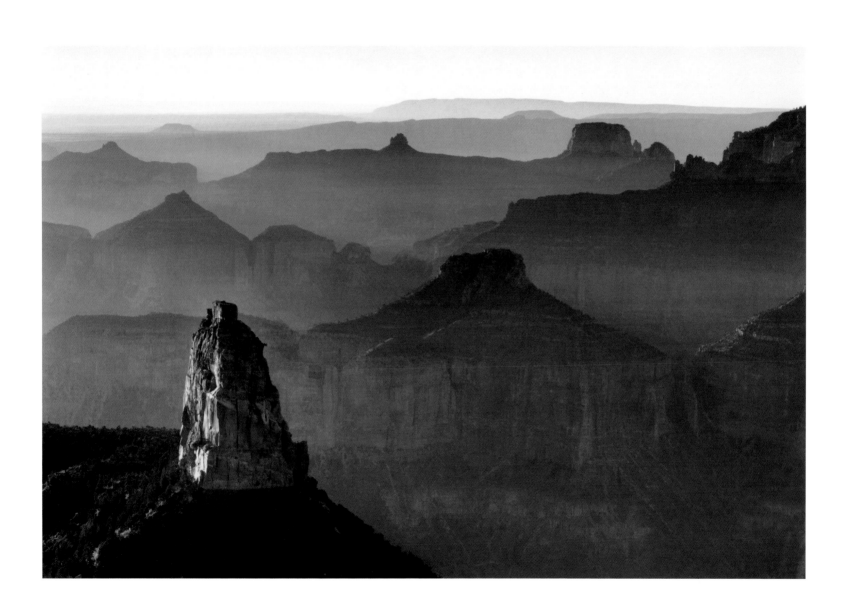

GRAND CANYON FROM POINT IMPERIAL, ARIZONA, C. 1942

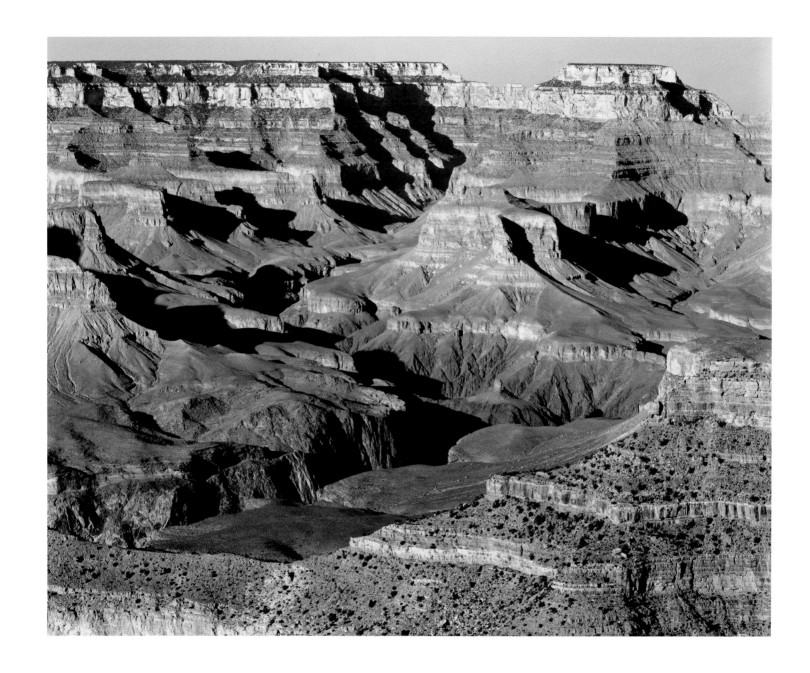

GRAND CANYON FROM YAVAPAI POINT, ARIZONA, 1942

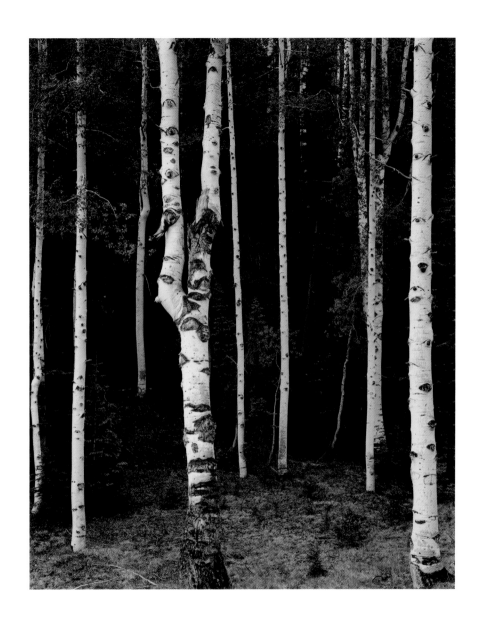

ASPEN GROVE, NORTH RIM, GRAND CANYON NATIONAL PARK, ARIZONA, C. 1947

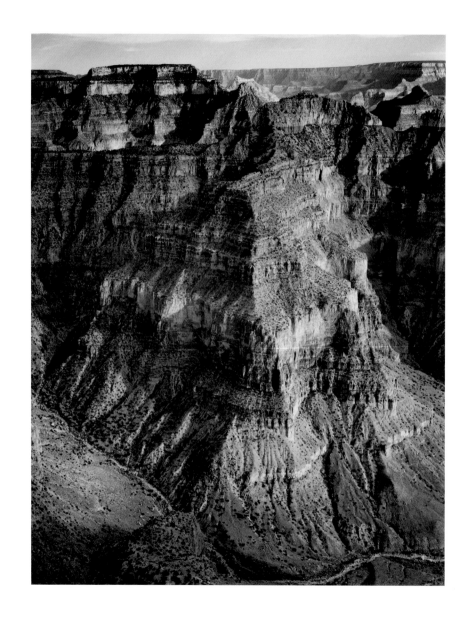

GRAND CANYON FROM POINT SUBLIME, ARIZONA, 1942

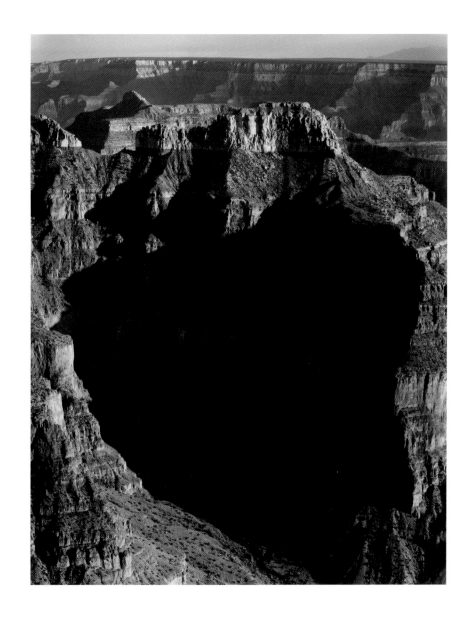

GRAND CANYON FROM POINT SUBLIME, ARIZONA, 1942

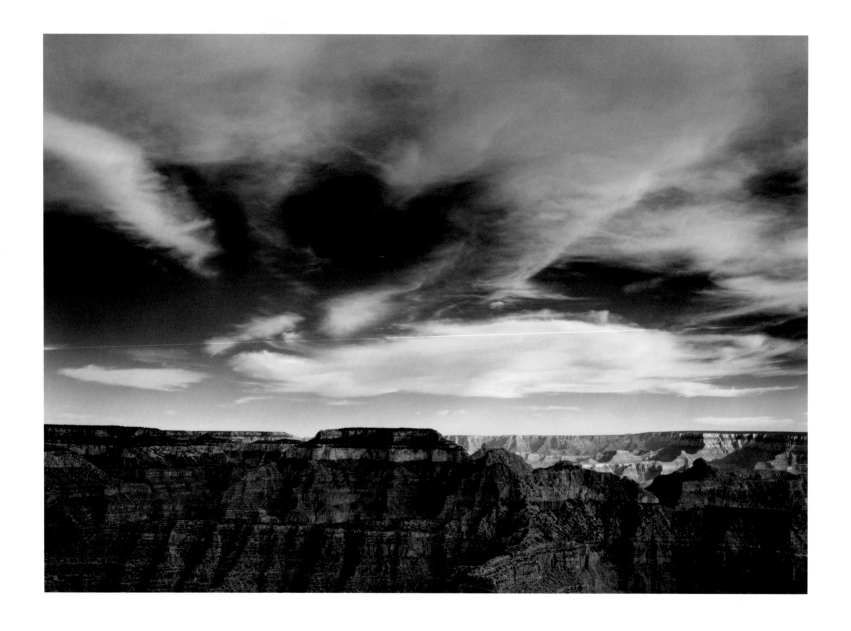

CLIFFS AND CLOUDS, GRAND CANYON NATIONAL PARK, ARIZONA, 1942

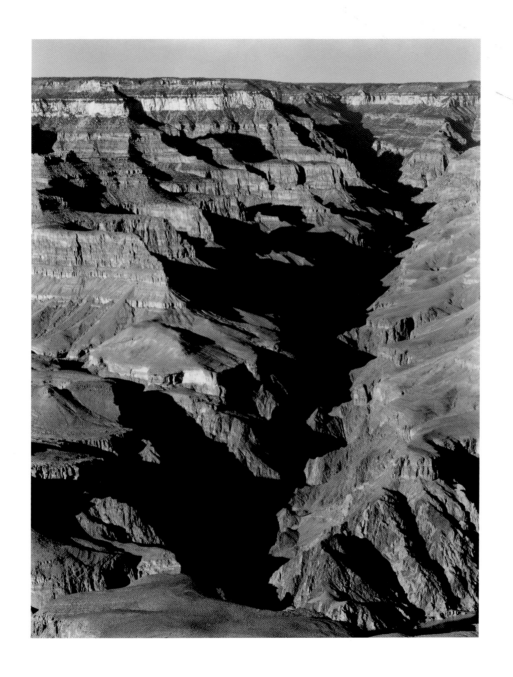

GRAND CANYON FROM YAVAPAI POINT, ARIZONA, 1942

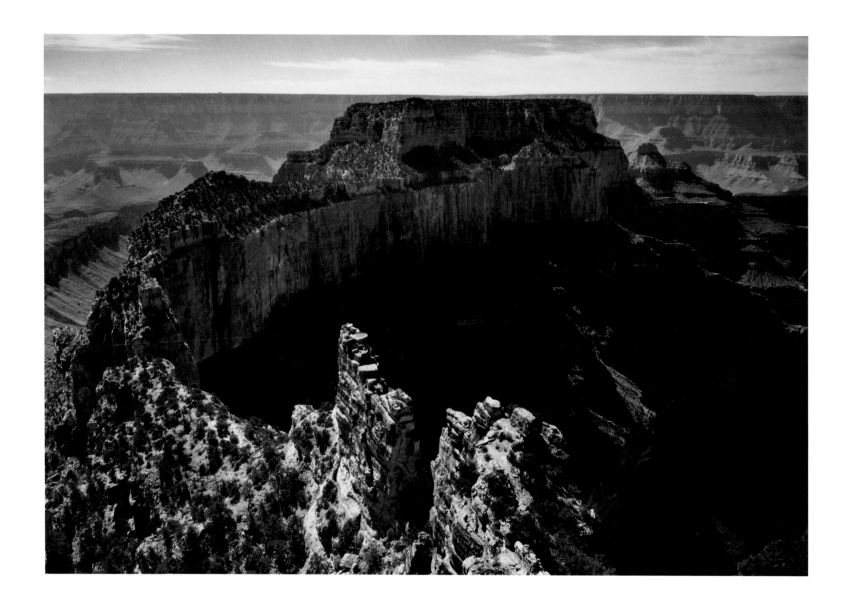

GRAND CANYON FROM CAPE ROYAL, ARIZONA, 1942

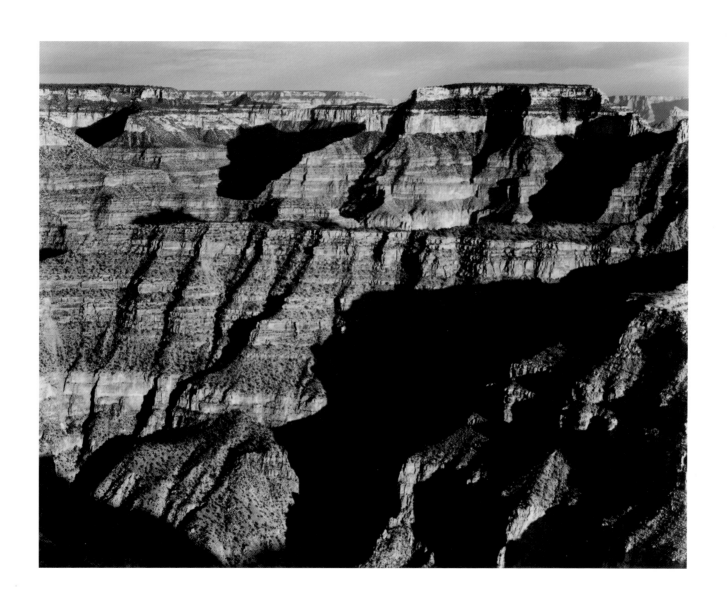

GRAND CANYON, ARIZONA, 1942

ASPEN GROVE, JACKSON LAKE, GRAND TETON NATIONAL PARK, WYOMING, C. 1948

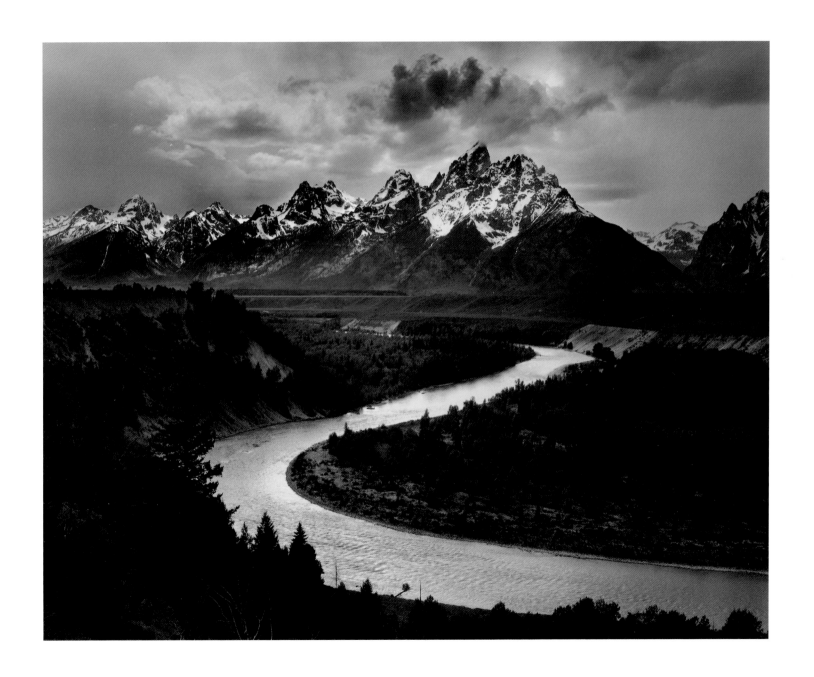

THE TETONS AND THE SNAKE RIVER, GRAND TETON NATIONAL PARK, WYOMING, 1942

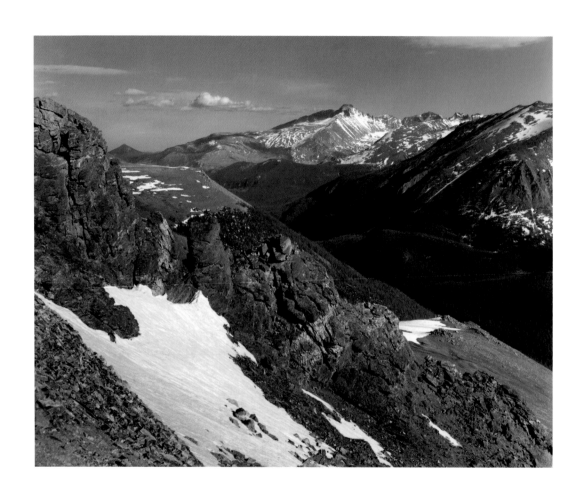

LONG'S PEAK, ROCKY MOUNTAIN NATIONAL PARK, COLORADO, 1942

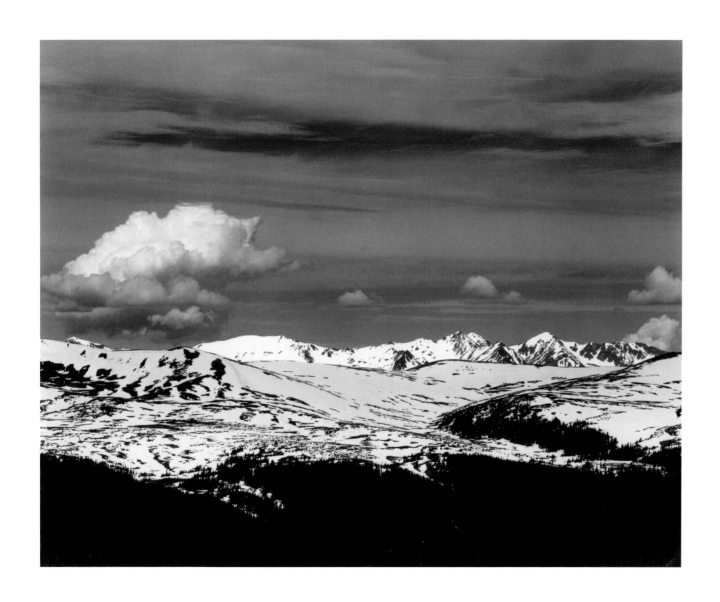

NEVER SUMMER RANGE, ROCKY MOUNTAIN NATIONAL PARK, COLORADO, 1942

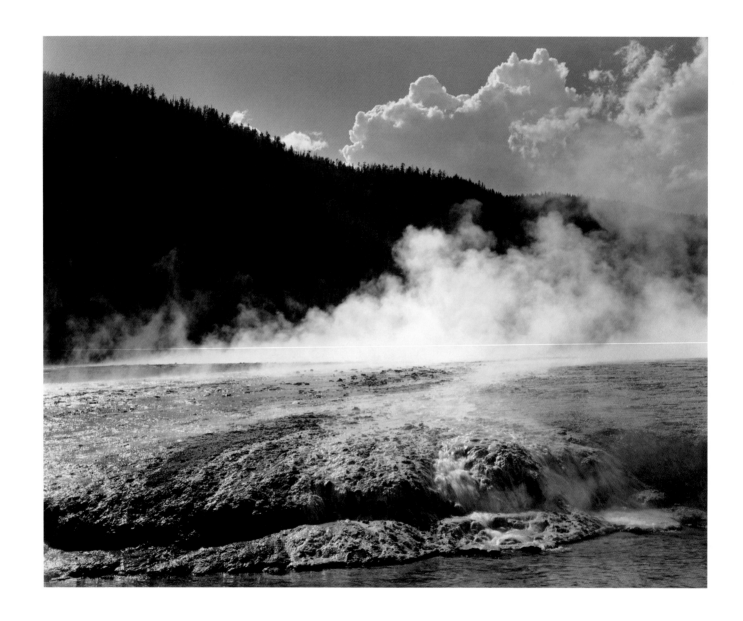

FIREHOLE RIVER, YELLOWSTONE NATIONAL PARK, WYOMING, 1942

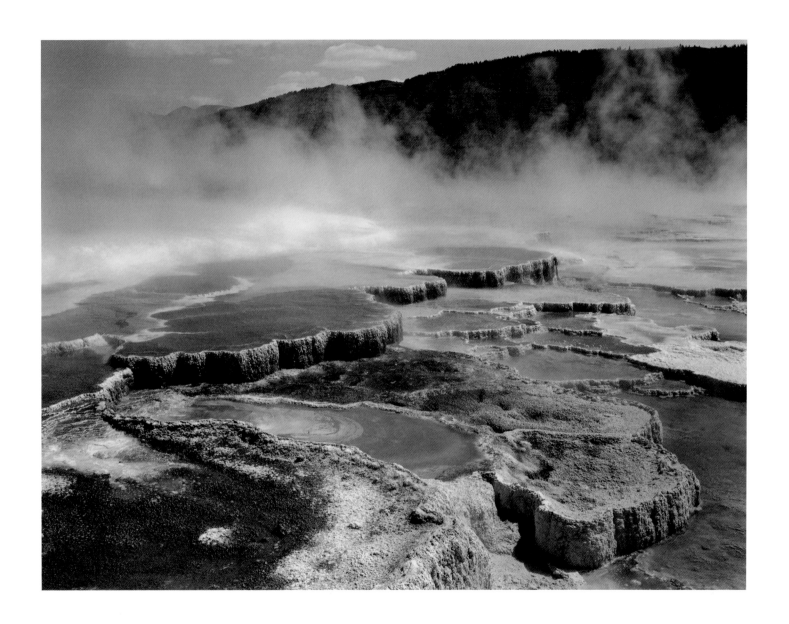

JUPITER TERRACE, MAMMOTH HOT SPRINGS, YELLOWSTONE NATIONAL PARK, WYOMING, 1942

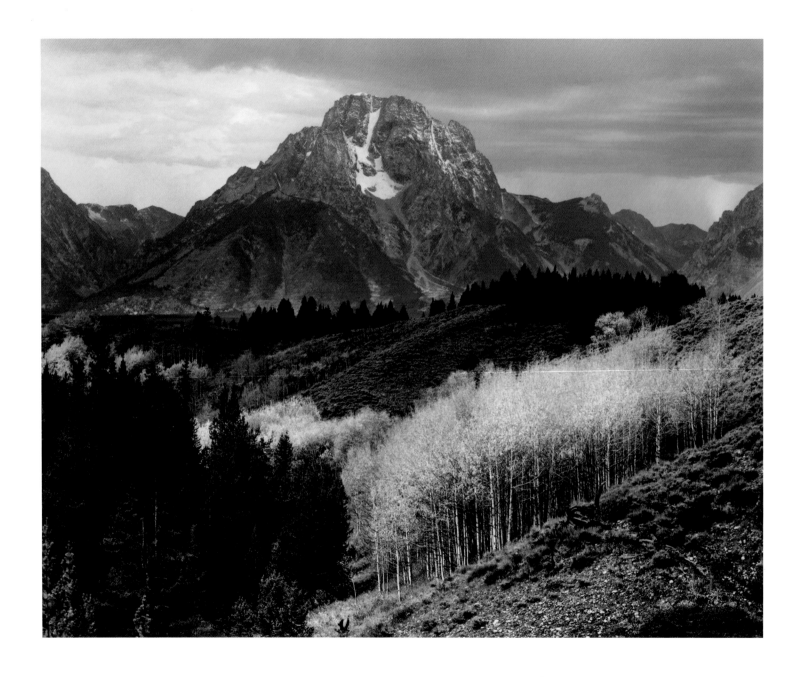

MOUNT MORAN, AUTUMN, GRAND TETON NATIONAL PARK, WYOMING, 1948

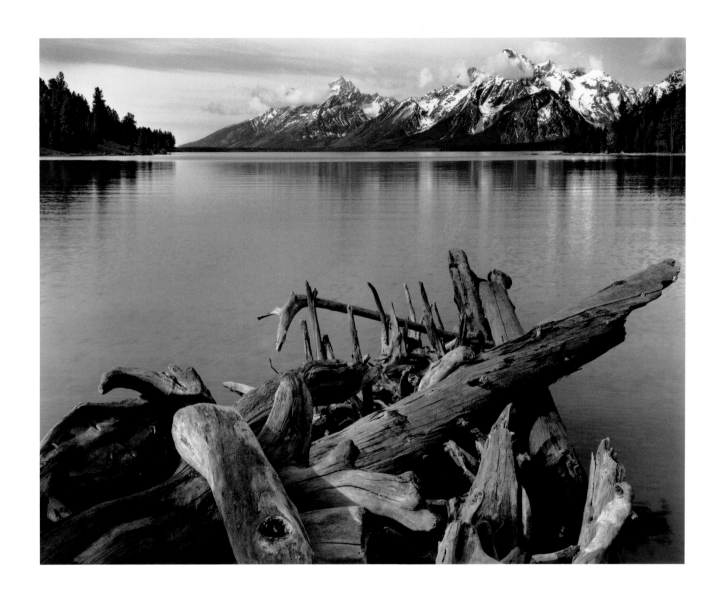

THE TETONS AND JACKSON LAKE, DRIFTWOOD, GRAND TETON NATIONAL PARK, WYOMING, 1942

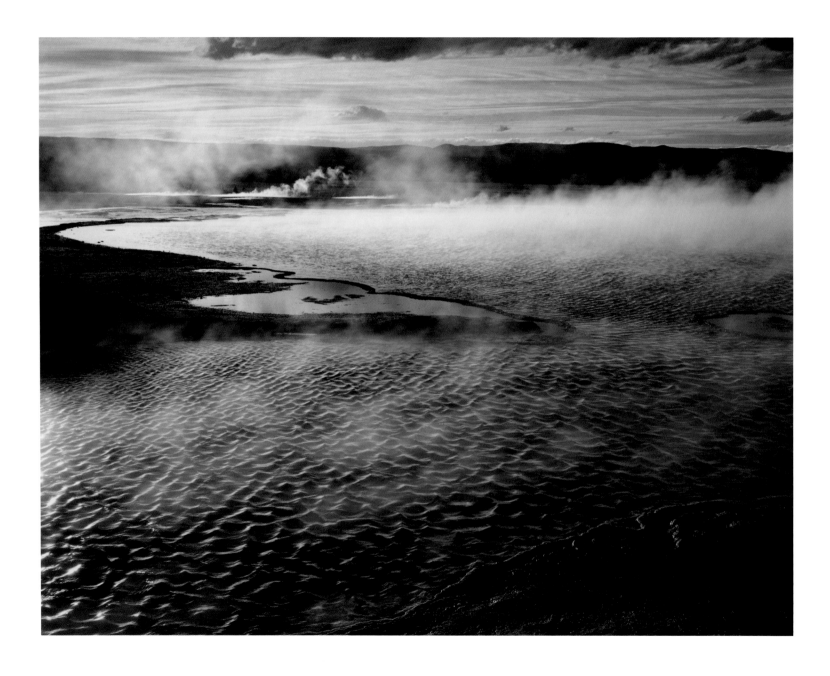

GRAND PRISMATIC SPRING, YELLOWSTONE NATIONAL PARK, WYOMING, 1942

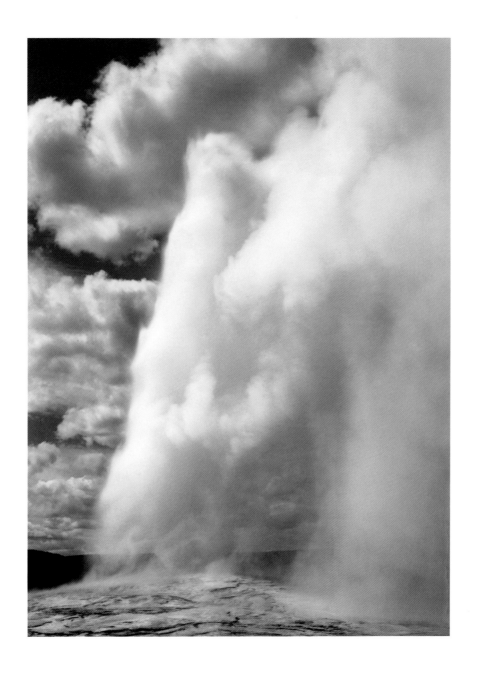

OLD FAITHFUL GEYSER, YELLOWSTONE NATIONAL PARK, WYOMING, 1941–1942

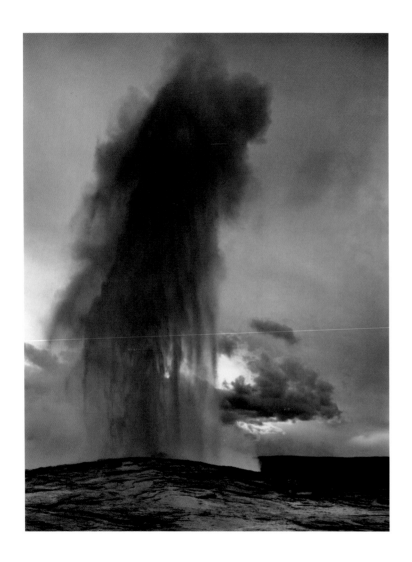
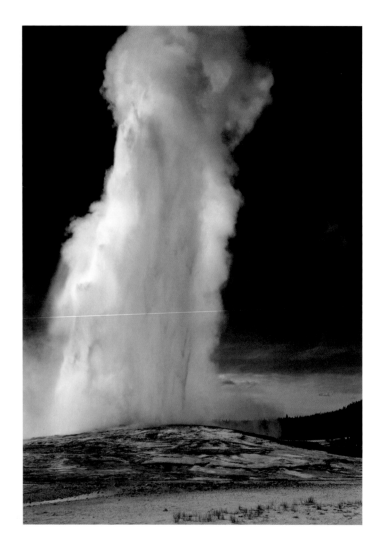

OLD FAITHFUL GEYSER, YELLOWSTONE NATIONAL PARK, WYOMING, 1941–1942

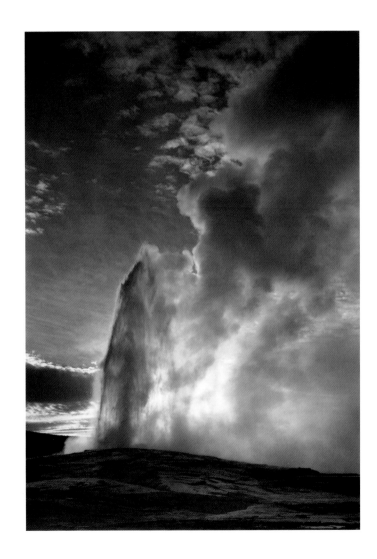
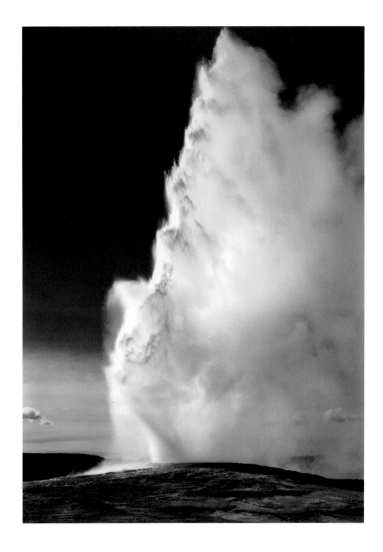

OLD FAITHFUL GEYSER, YELLOWSTONE NATIONAL PARK, WYOMING, 1941–1942

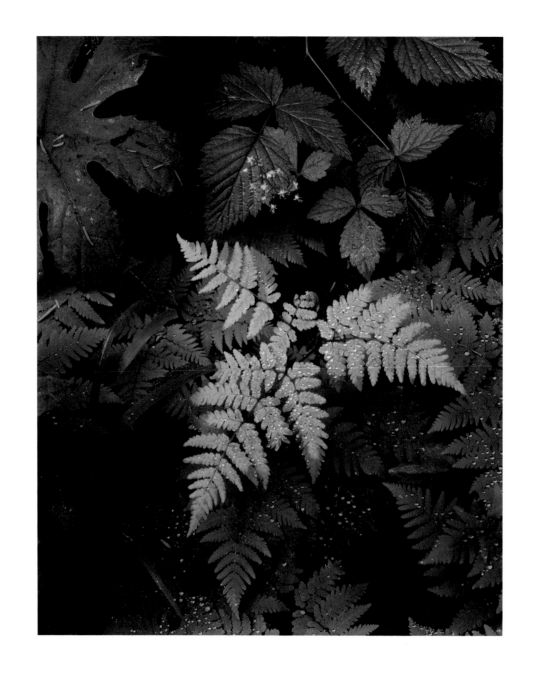

216 LEAVES, MOUNT RAINIER NATIONAL PARK, WASHINGTON, C. 1942

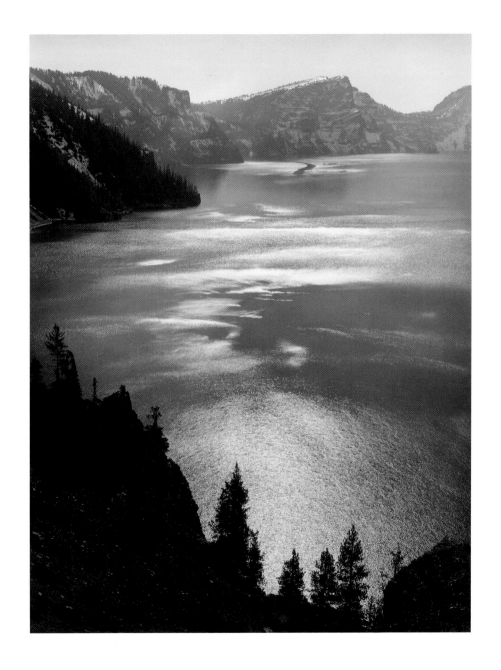

AFTERNOON SUN, CRATER LAKE NATIONAL PARK, OREGON, 1943

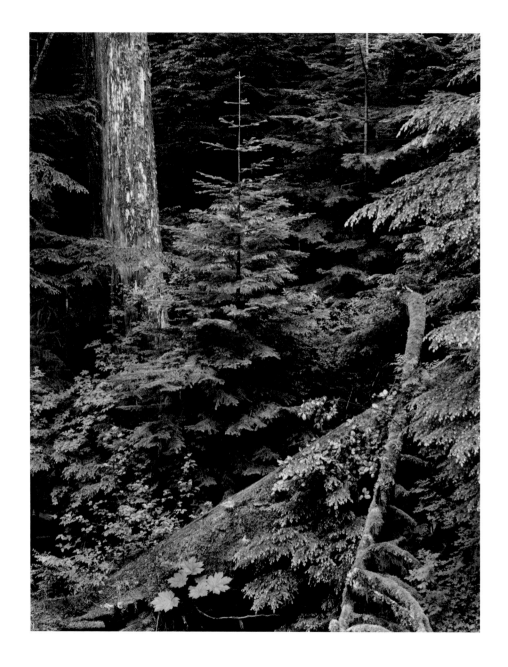

FOREST, EARLY MORNING, MOUNT RAINIER NATIONAL PARK, WASHINGTON, 1949

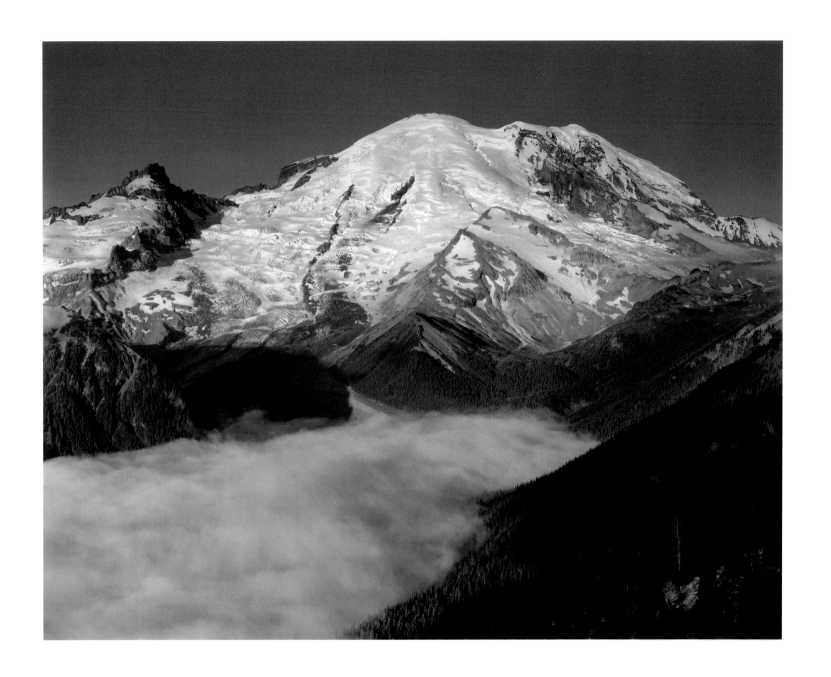

SUNRISE, MOUNT RAINIER NATIONAL PARK, WASHINGTON, 1948

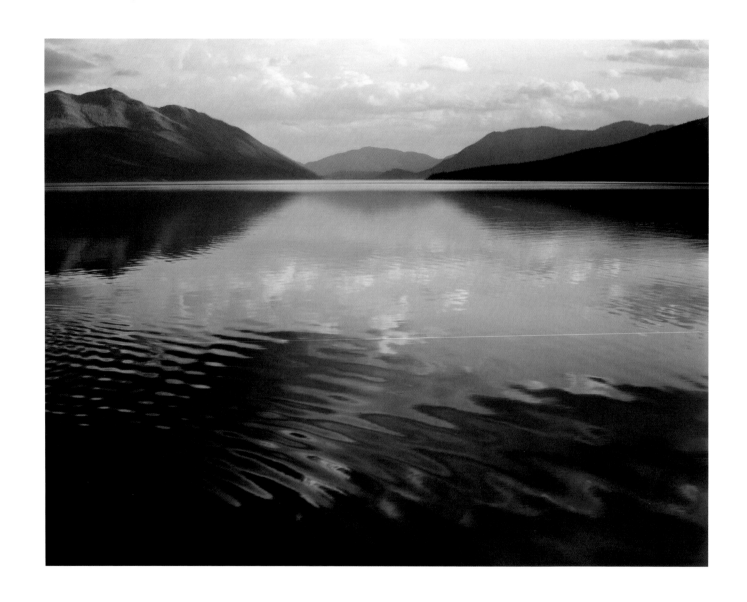

LAKE MCDONALD, EVENING, GLACIER NATIONAL PARK, MONTANA, 1942

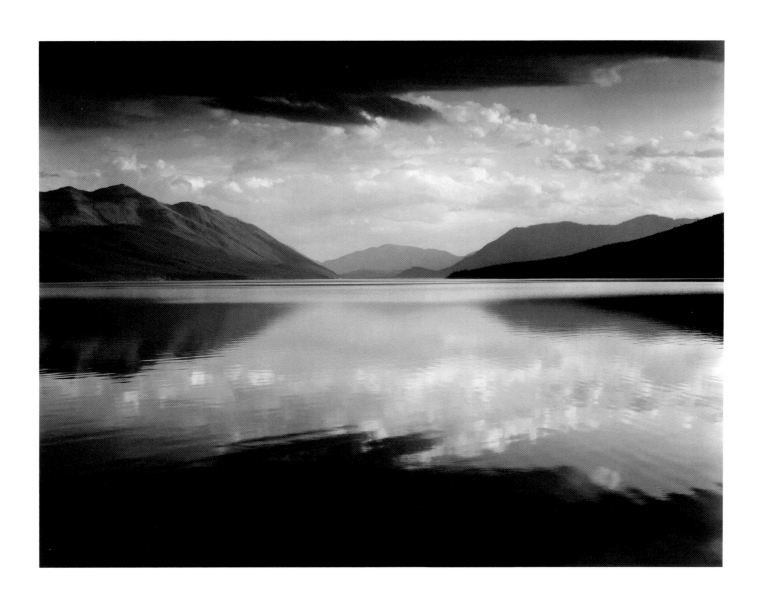

LAKE MCDONALD, EVENING, GLACIER NATIONAL PARK, MONTANA, 1942

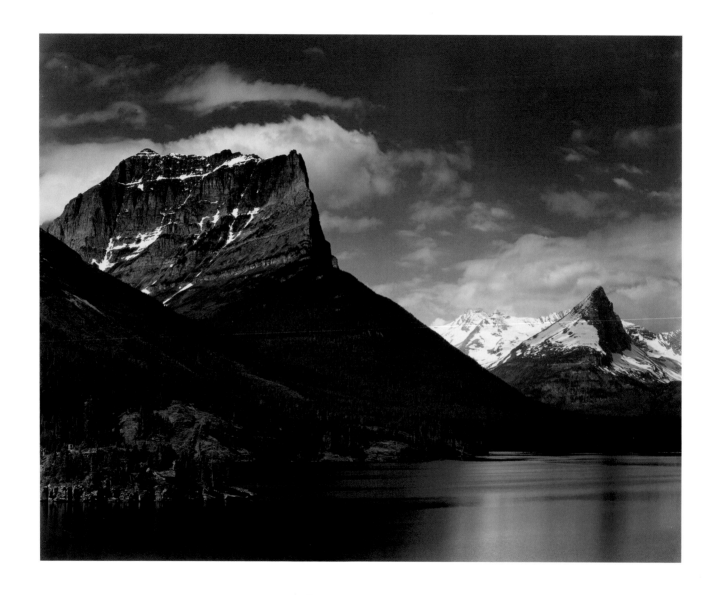

SAINT MARY'S LAKE, GLACIER NATIONAL PARK, MONTANA, 1942

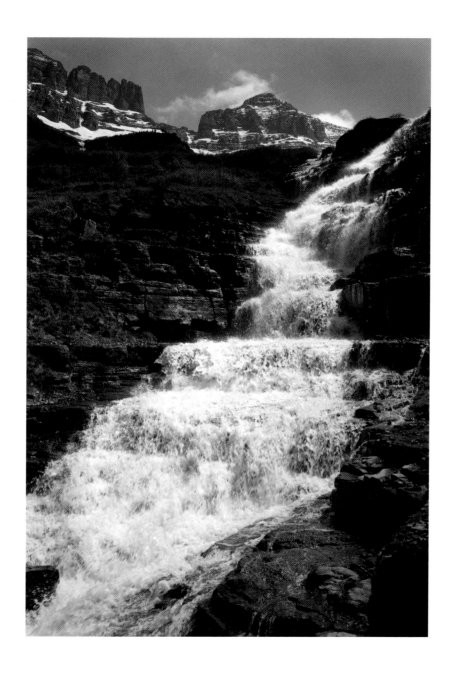

CASCADE, GLACIER NATIONAL PARK, MONTANA, 1942

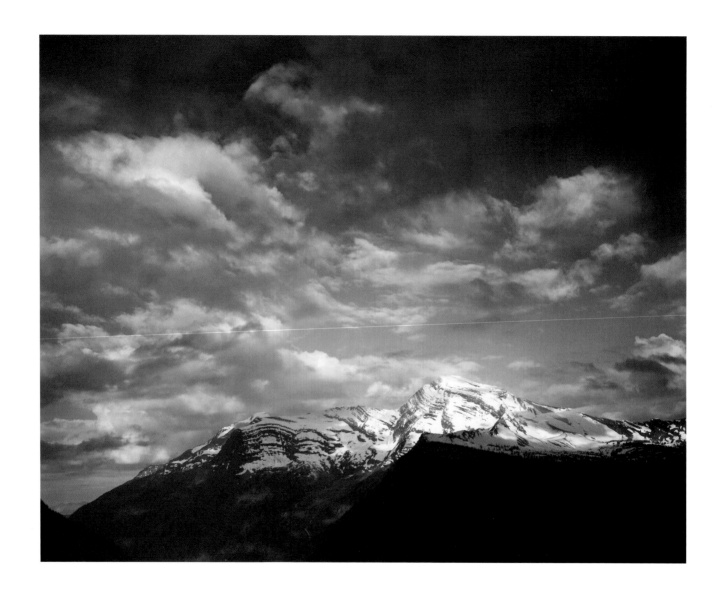

HEAVEN'S PEAK, GLACIER NATIONAL PARK, MONTANA, 1942

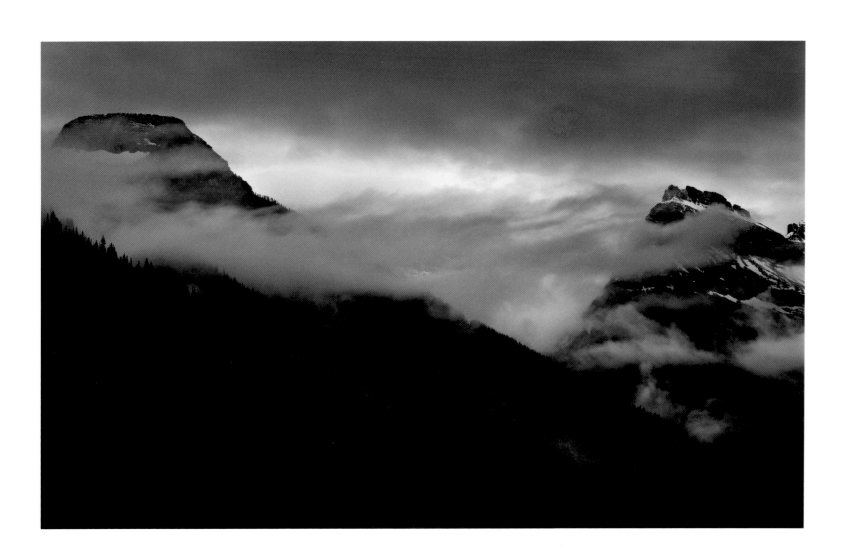

STORM CLOUDS, GLACIER NATIONAL PARK, MONTANA, 1942

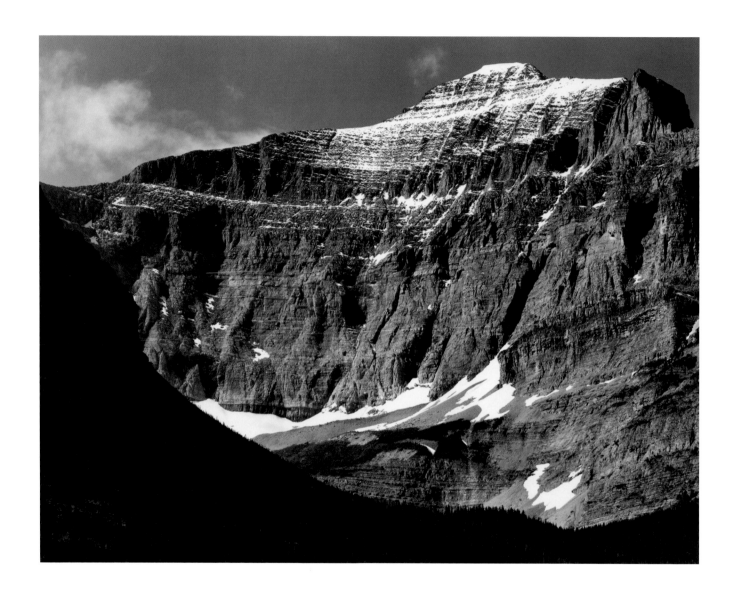

FROM GOING TO THE SUN MOUNTAIN, GLACIER NATIONAL PARK, MONTANA, 1942

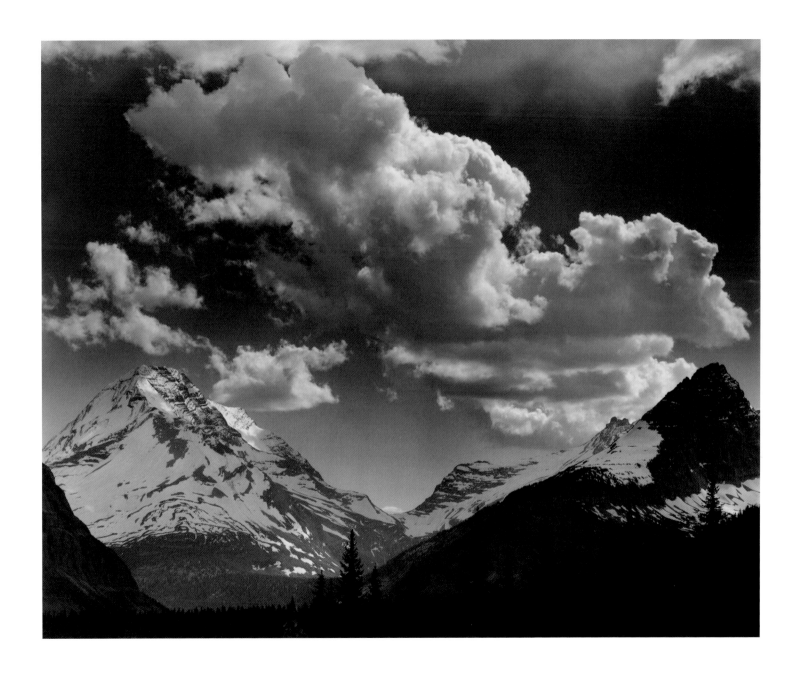

NOON CLOUDS, MOUNT JACKSON AND MOUNT FUSILADE, GLACIER NATIONAL PARK, MONTANA, 1942

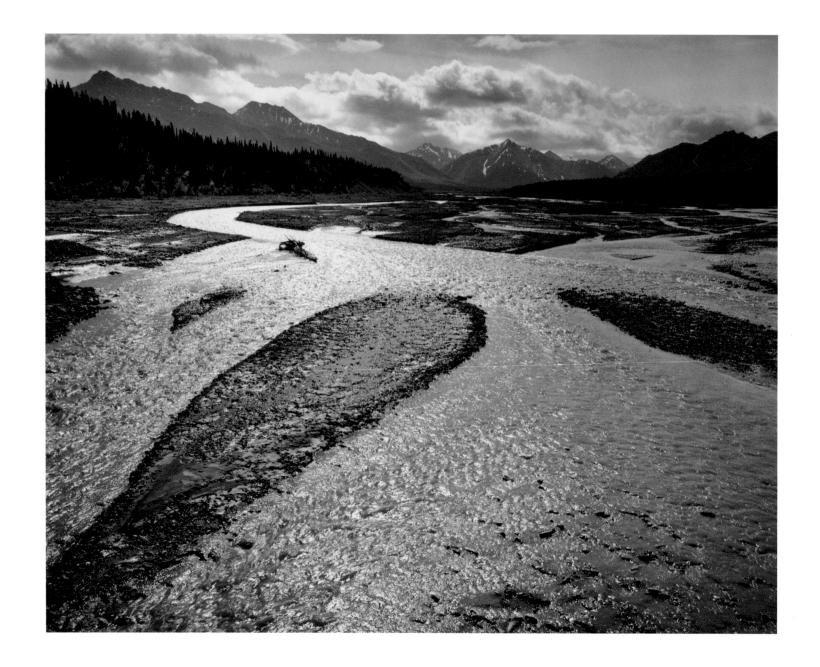

TEKLANIKA RIVER, DENALI NATIONAL PARK, ALASKA, 1947

TRAILSIDE, NEAR JUNEAU, ALASKA, 1947

LEAF, GLACIER BAY NATIONAL PARK, ALASKA, 1948

GRASS IN RAIN, GLACIER BAY NATIONAL PARK, ALASKA, 1948

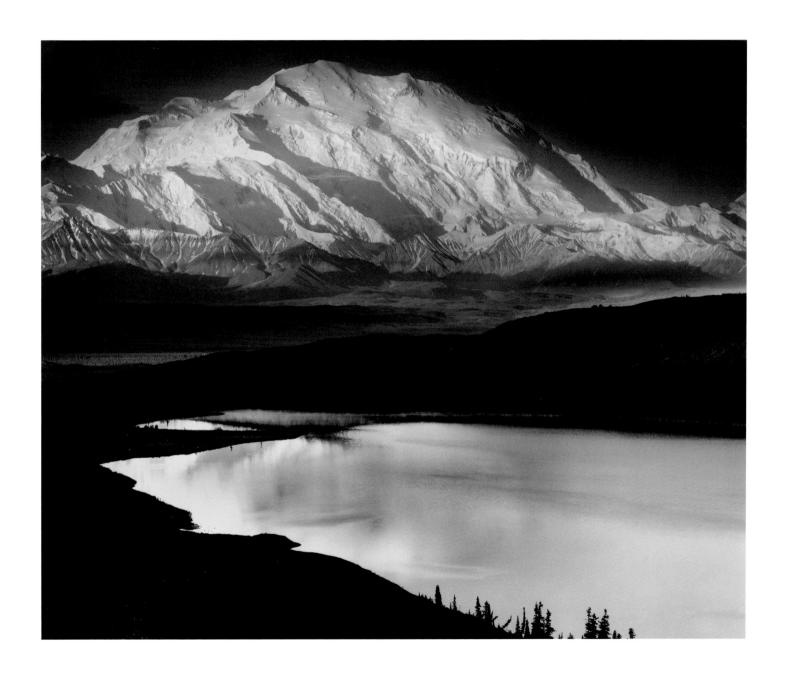

MOUNT MCKINLEY AND WONDER LAKE, DENALI NATIONAL PARK, ALASKA, 1947

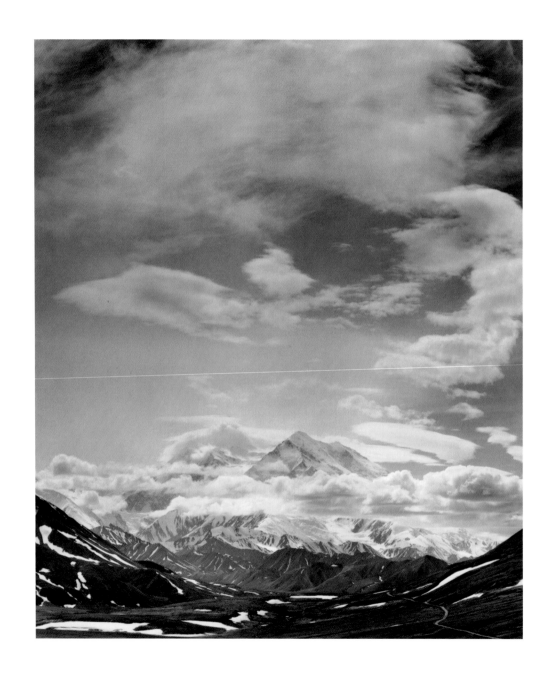

MOUNT MCKINLEY FROM STONEY PASS, DENALI NATIONAL PARK, ALASKA, 1948

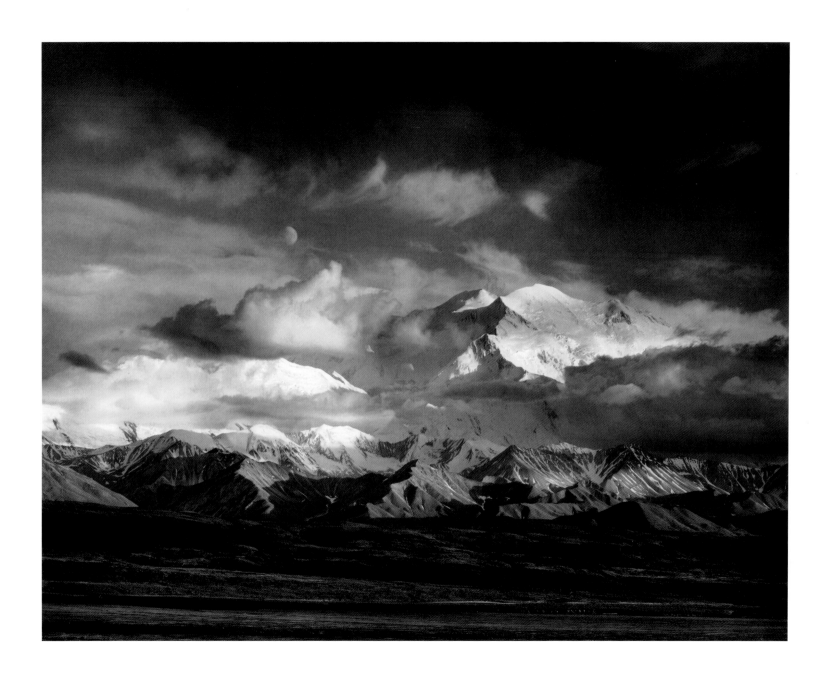

MOON AND MOUNT MCKINLEY, DENALI NATIONAL PARK, ALASKA, 1947

MOTH AND STUMP, INTERGLACIAL FOREST, GLACIER BAY NATIONAL PARK, ALASKA, 1948

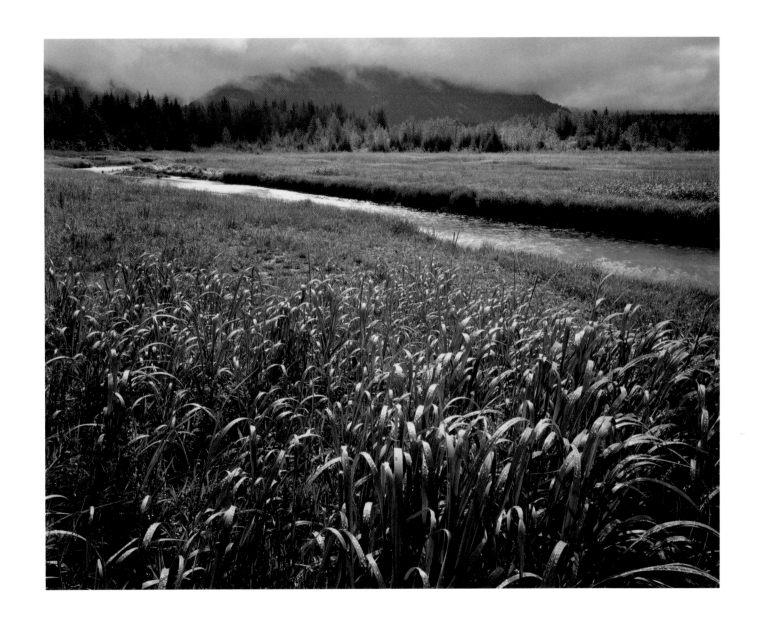

RAIN, BEARTRACK COVE, GLACIER BAY NATIONAL PARK, ALASKA, 1949

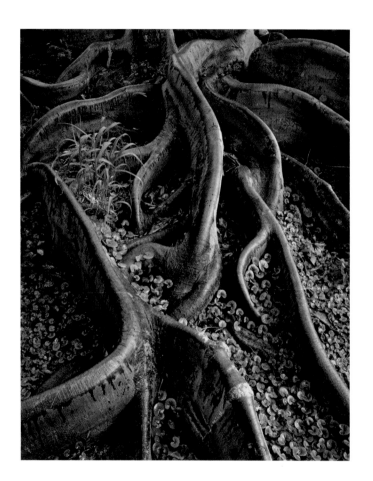

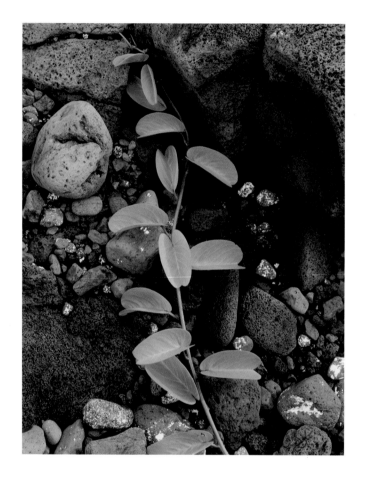

BANYAN ROOTS, FOSTER GARDENS, HONOLULU, HAWAII, C. 1948
VINE AND ROCKS, HAWAII, 1948

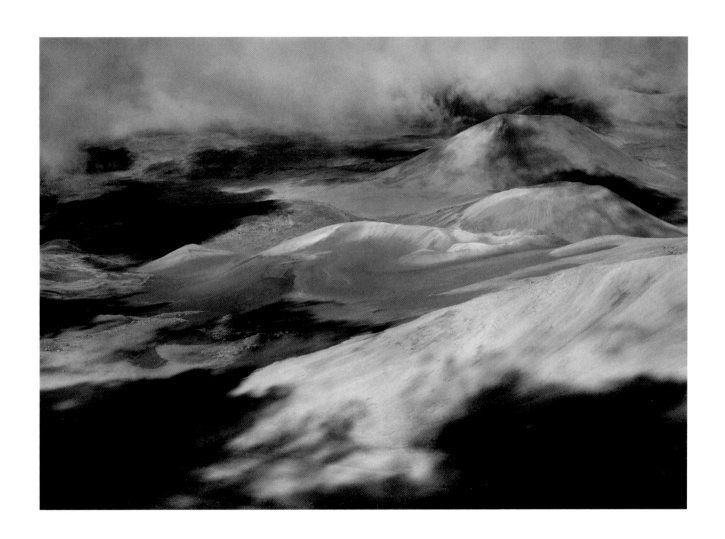

IN THE CRATER OF HALEAKALA, CLOUDS, HALEAKALA NATIONAL PARK, HAWAII, 1948

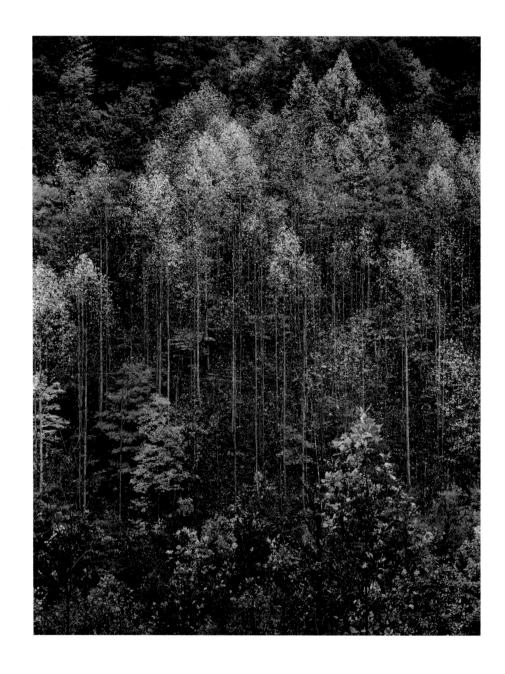

DAWN, AUTUMN, GREAT SMOKY MOUNTAINS NATIONAL PARK, TENNESSEE, 1948

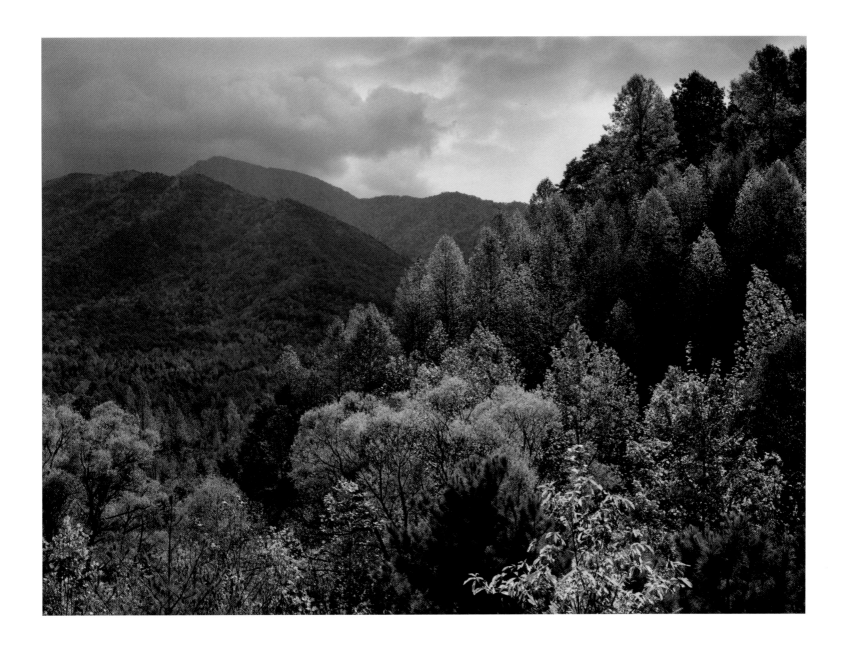

MOUNT LECONTE, AUTUMN, GREAT SMOKY MOUNTAINS NATIONAL PARK, TENNESSEE, 1948

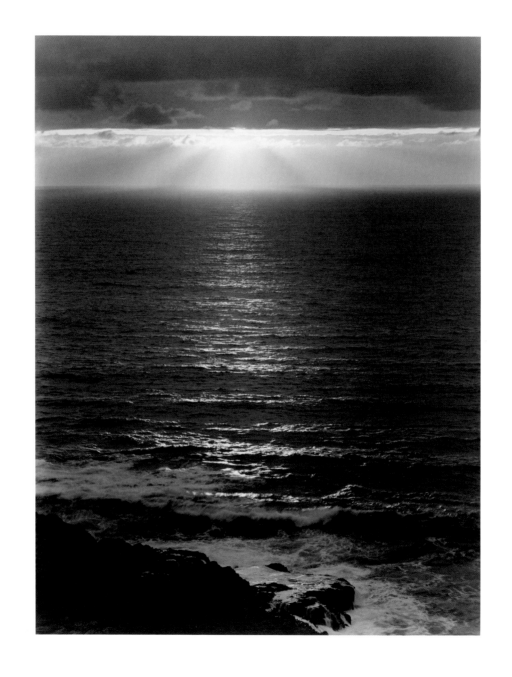

SUNDOWN, THE PACIFIC, NEAR CARMEL, CALIFORNIA, 1946

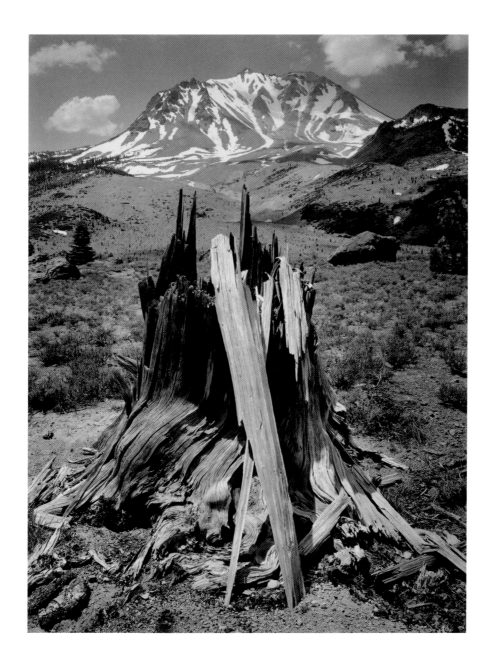

MOUNT LASSEN FROM DEVASTATED AREA, LASSEN VOLCANIC NATIONAL PARK, CALIFORNIA, 1949

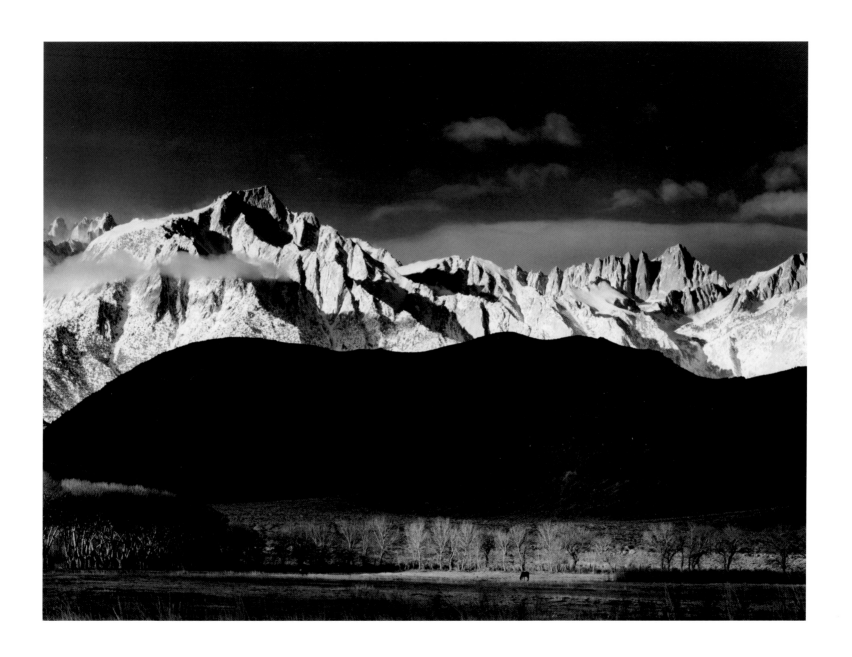

WINTER SUNRISE, SIERRA NEVADA, FROM LONE PINE, CALIFORNIA, 1944

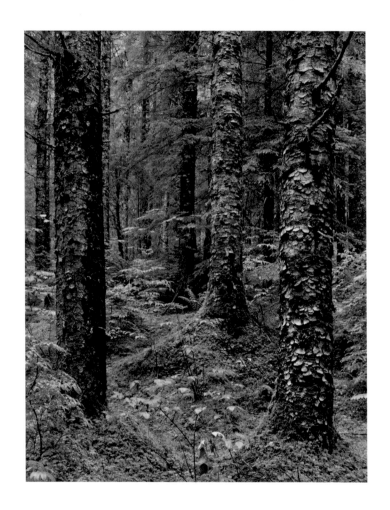
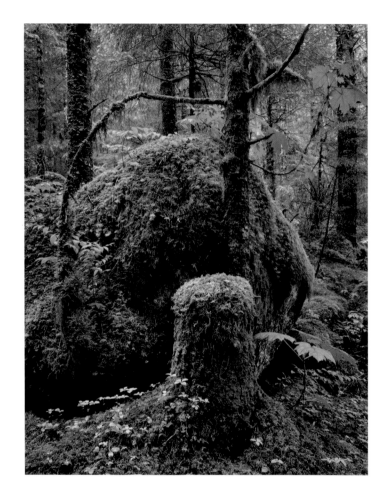

246 FOREST, BEARTRACK COVE, GLACIER BAY NATIONAL PARK, ALASKA, 1948

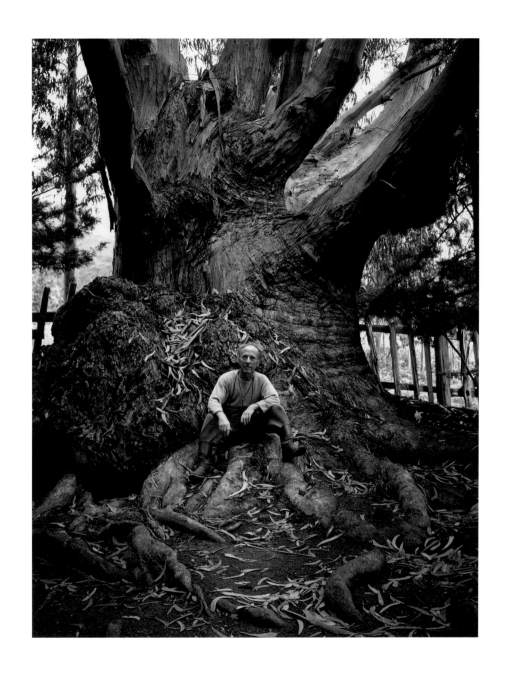

EDWARD WESTON, CARMEL HIGHLANDS, CALIFORNIA, 1945

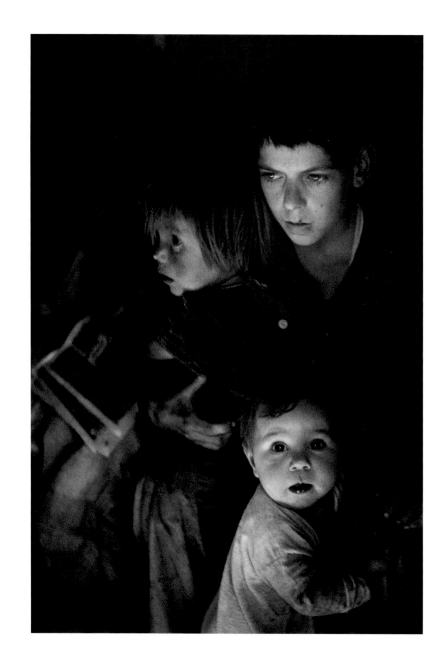

TRAILER CAMP CHILDREN, RICHMOND, CALIFORNIA, 1944

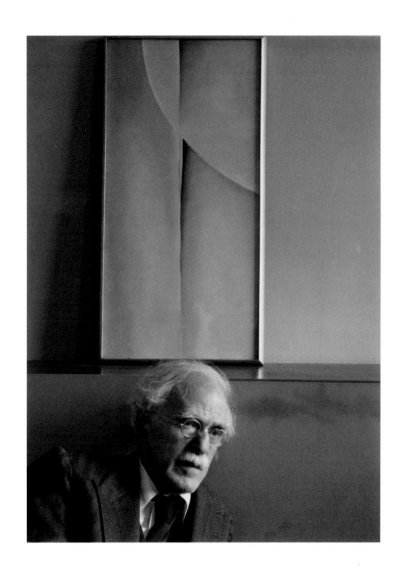

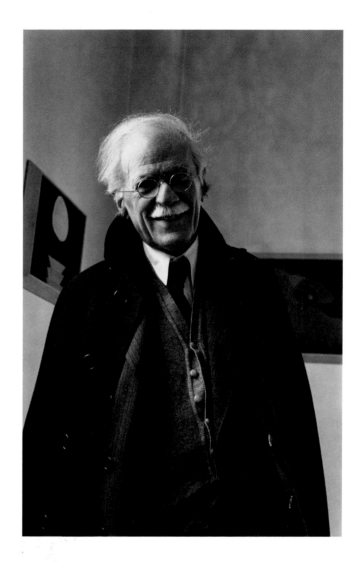

ALFRED STIEGLITZ AND PAINTING BY GEORGIA O'KEEFFE, AN AMERICAN PLACE, NEW YORK CITY, 1944
ALFRED STIEGLITZ, AN AMERICAN PLACE, NEW YORK CITY, 1945

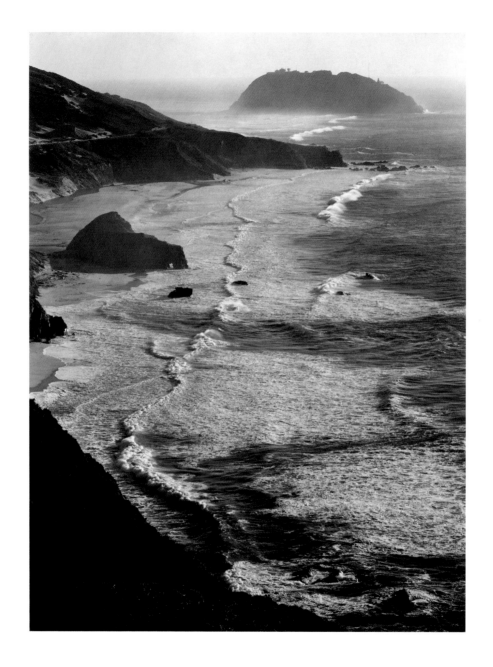

POINT SUR, STORM, BIG SUR, CALIFORNIA, 1946

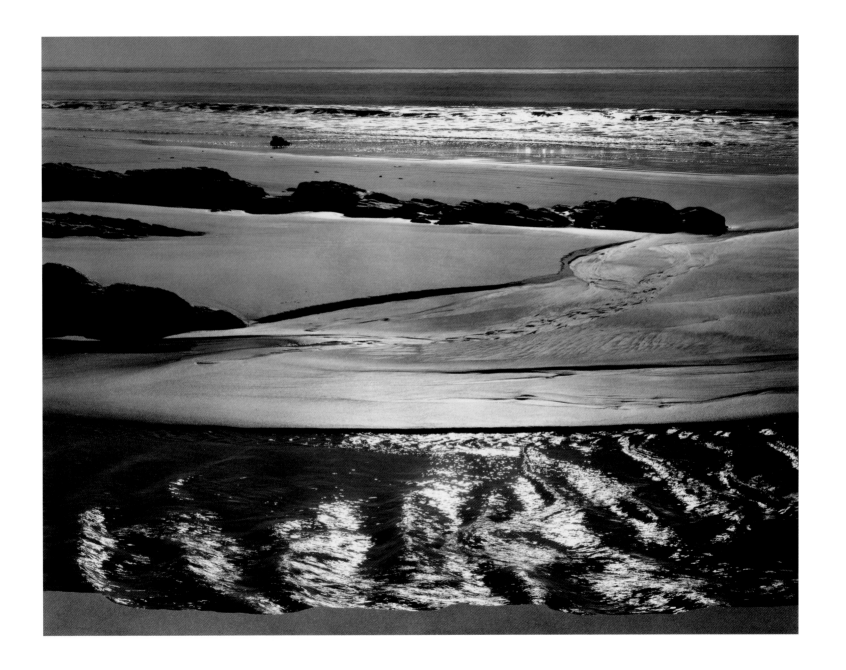

REFUGIO BEACH, CALIFORNIA, 1946

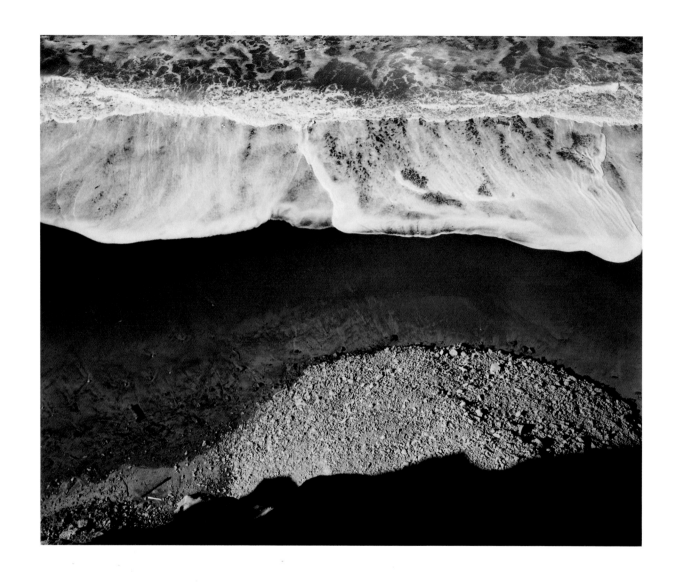

SURF SEQUENCE, SAN MATEO COUNTY COAST, CALIFORNIA, 1940

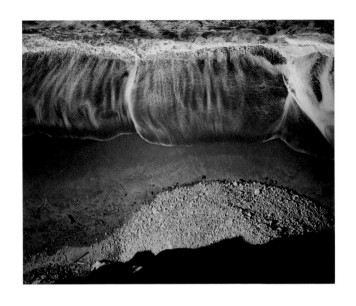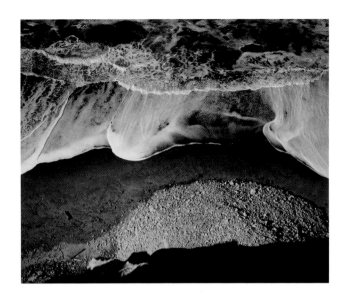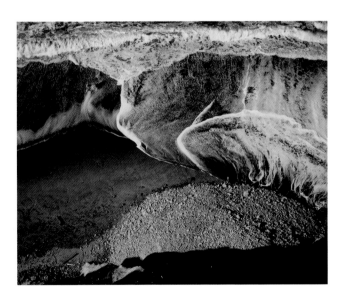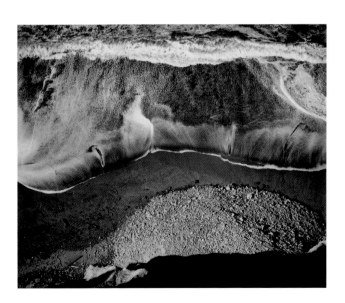

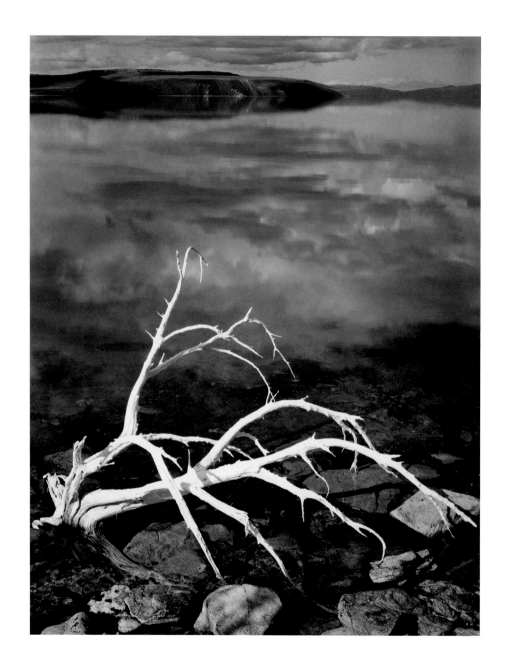

WHITE BRANCHES, MONO LAKE, CALIFORNIA, 1947

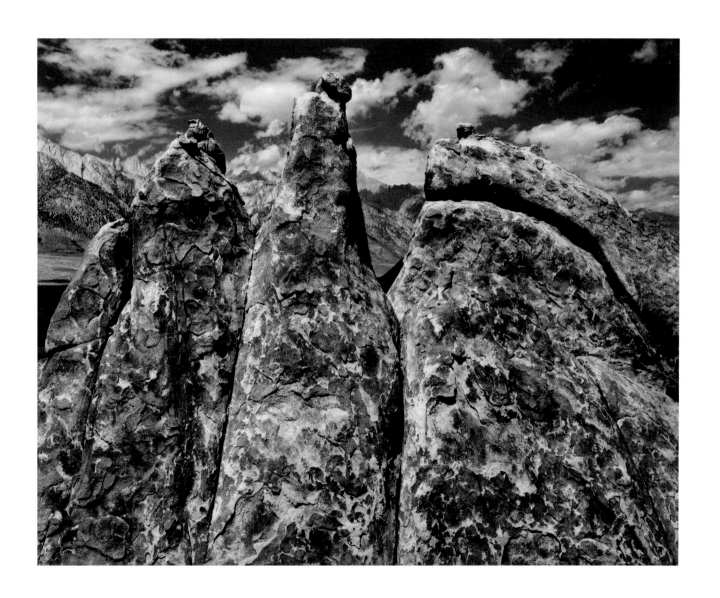

PINNACLES, ALABAMA HILLS, OWENS VALLEY, CALIFORNIA, 1945

METAMORPHIC ROCK AND SUMMER GRASS, FOOTHILLS, SIERRA NEVADA, CALIFORNIA, 1945

MONO LAKE, CALIFORNIA, 1947

THE ATLANTIC FROM SCHOODIC POINT, ACADIA NATIONAL PARK, MAINE, 1949

MUDHILLS, ARIZONA, 1947

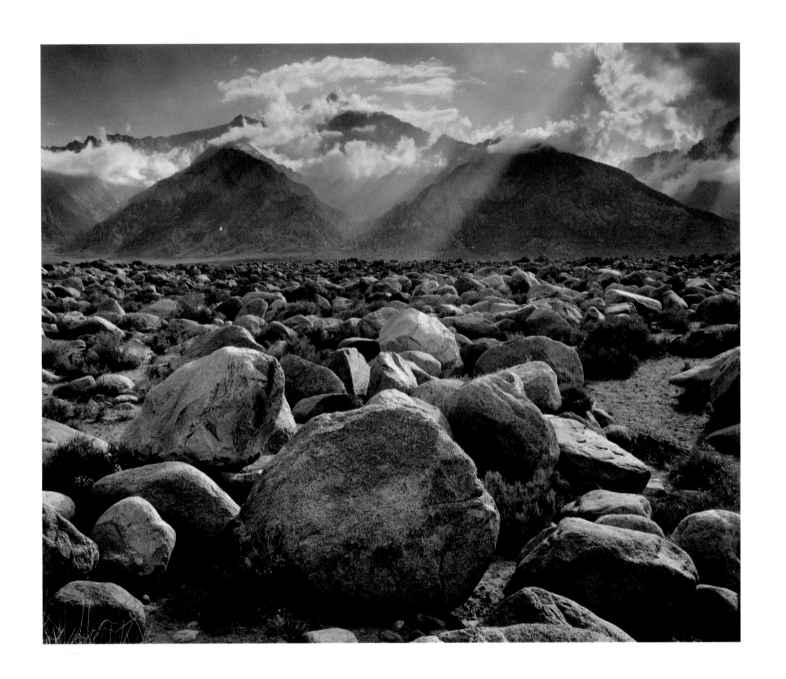

MOUNT WILLIAMSON, SIERRA NEVADA, FROM MANZANAR, CALIFORNIA, C. 1944

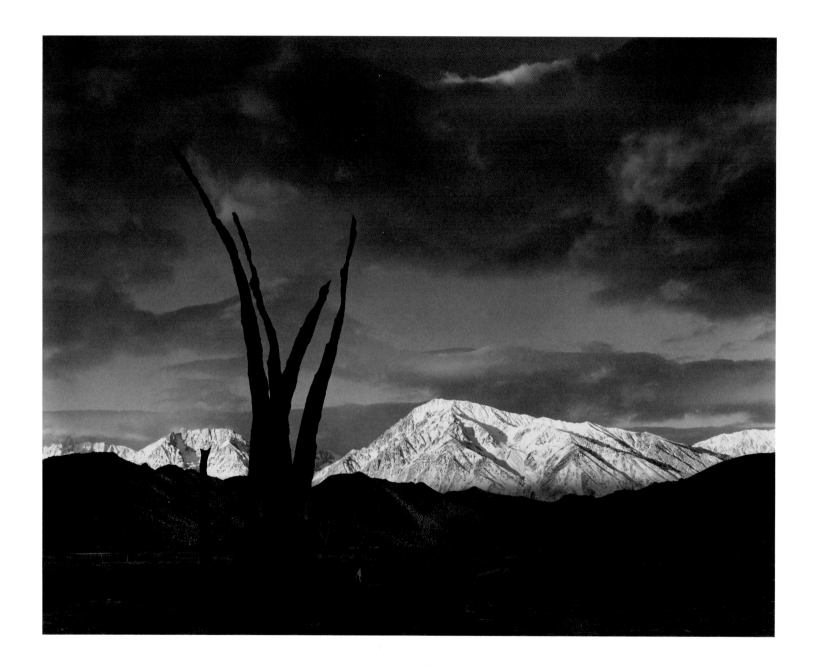

262 SUNRISE, MOUNT TOM, SIERRA NEVADA, CALIFORNIA, 1948

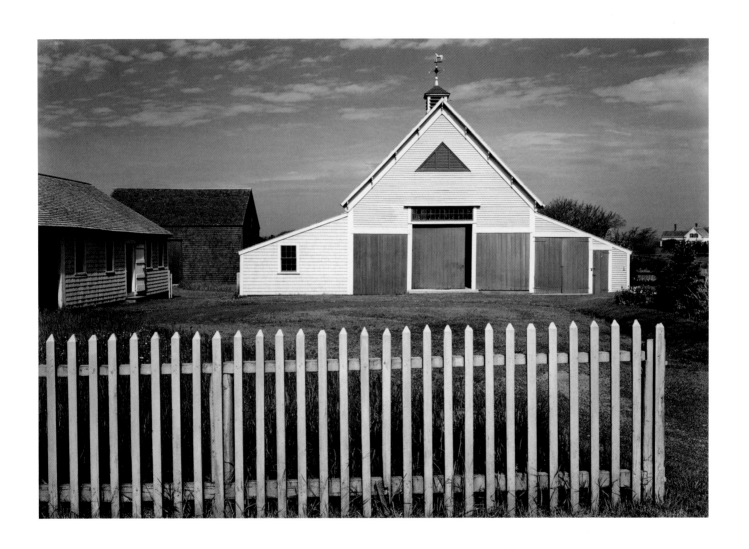

BARN, CAPE COD, MASSACHUSETTS, 1942

264 WHITE CHURCH, HORNITOS, CALIFORNIA, 1946

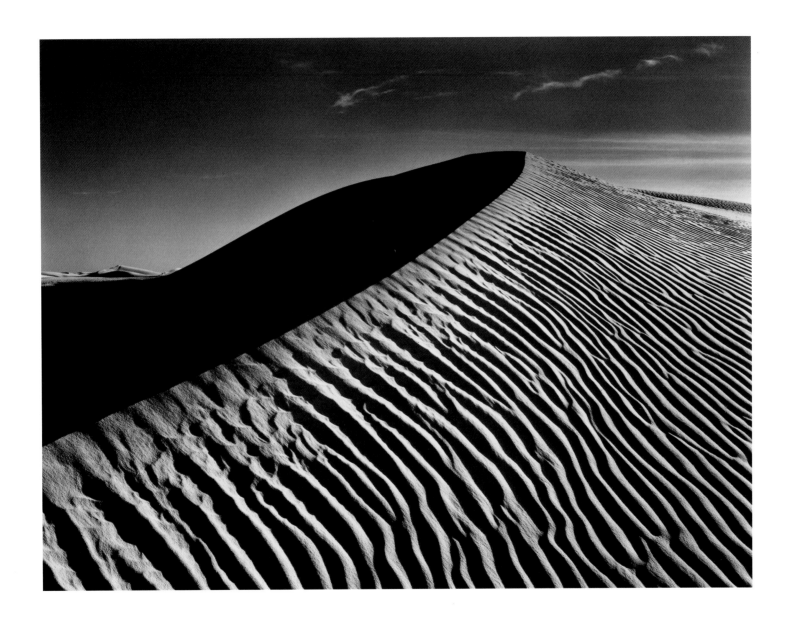

SAND DUNES, WHITE SANDS NATIONAL MONUMENT, NEW MEXICO, C. 1942

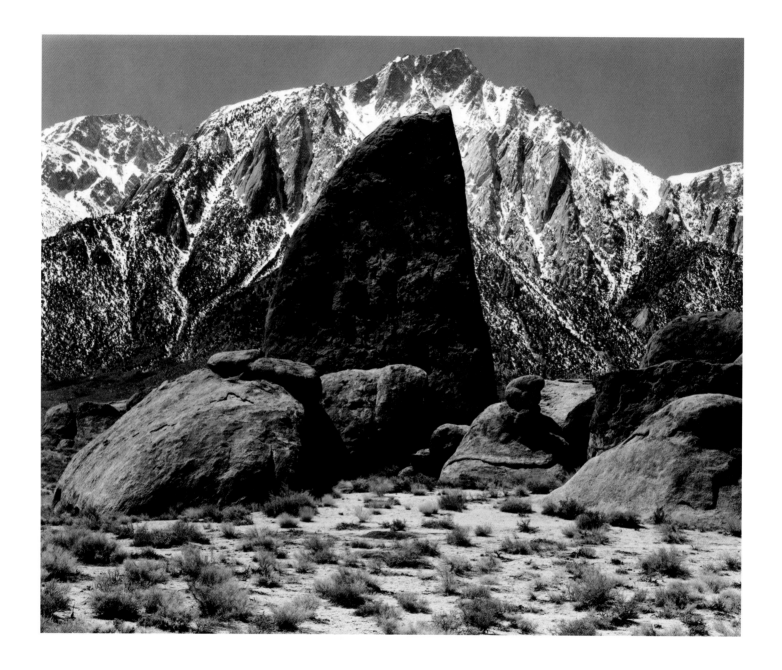

LONE PINE PEAK AND ROCKS, ALABAMA HILLS, OWENS VALLEY, CALIFORNIA, 1949

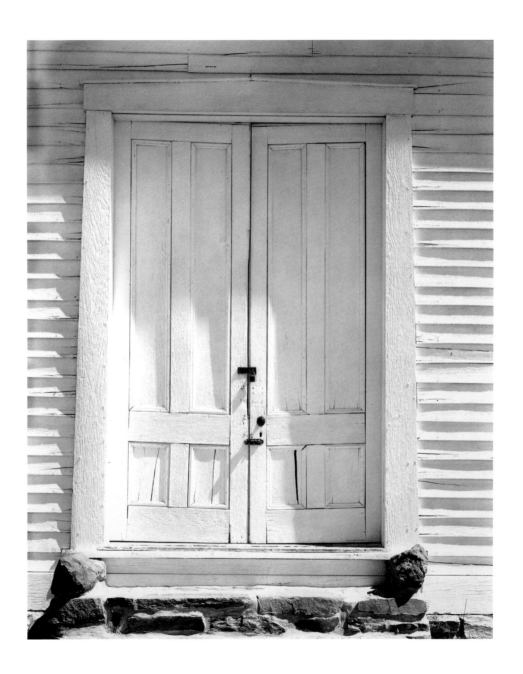

CHURCH DOOR, HORNITOS, CALIFORNIA, C. 1945

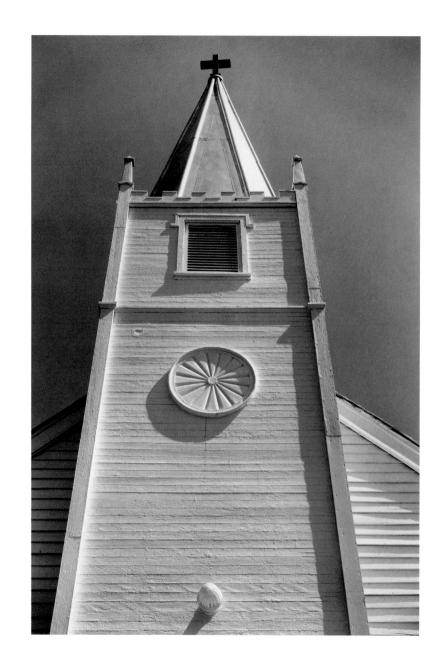

STEEPLE, ST. JOSEPH'S CHURCH, MARIPOSA, CALIFORNIA, 1948

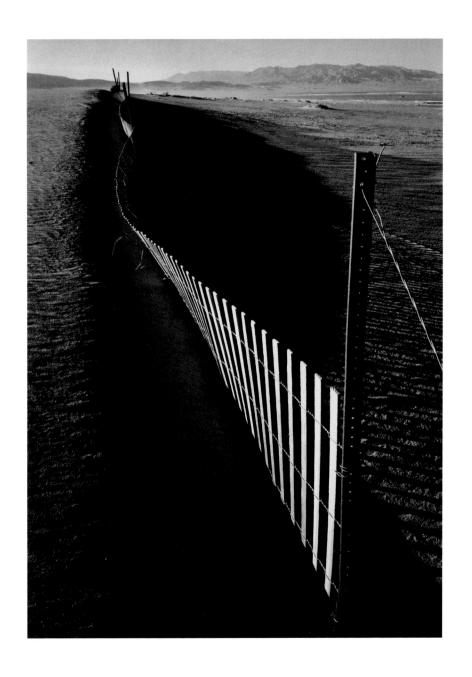

SAND FENCE, NEAR KEELER, CALIFORNIA, 1948

METAMORPHIC ROCKS, SIERRA FOOTHILLS, CALIFORNIA, C. 1945

MORMON TEMPLE, MANTI, UTAH, 1948

PASTURELAND, FENCE, HILLS, NEAR ALTAMONT, CALIFORNIA, 1946

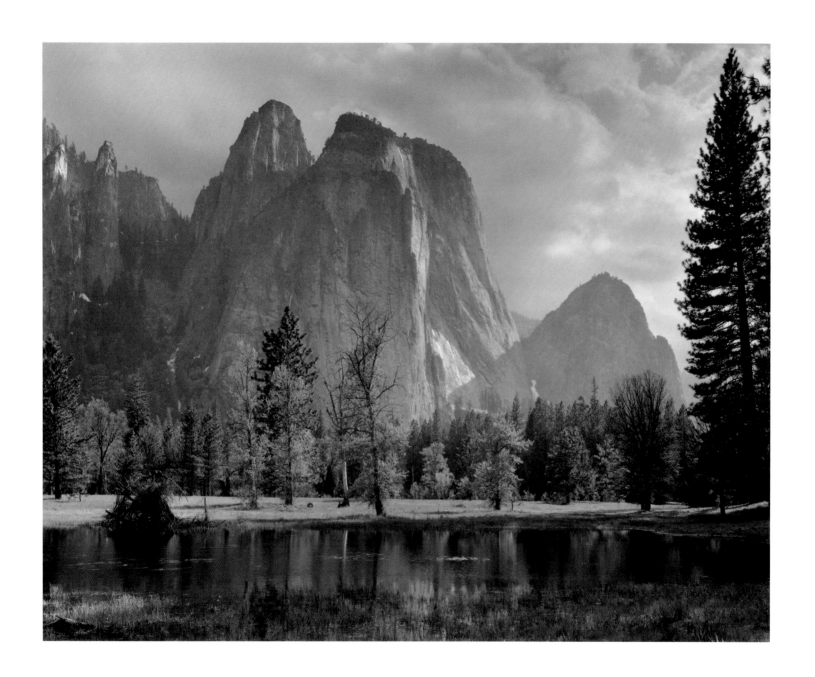

CATHEDRAL ROCKS, YOSEMITE NATIONAL PARK, CALIFORNIA, C. 1949

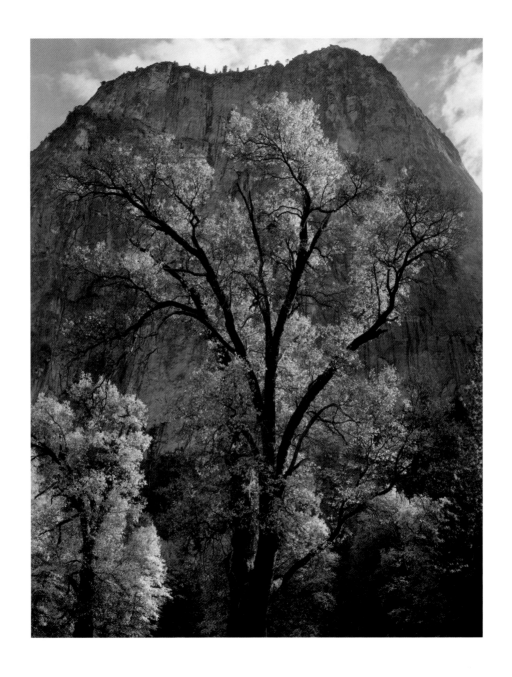

AUTUMN TREE AGAINST CATHEDRAL ROCKS, YOSEMITE NATIONAL PARK, CALIFORNIA, C. 1944

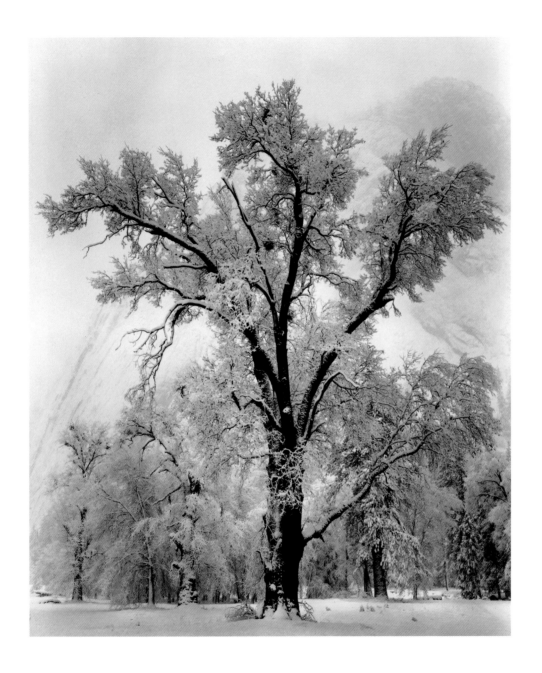

OAK TREE, SNOWSTORM, YOSEMITE NATIONAL PARK, CALIFORNIA, 1948

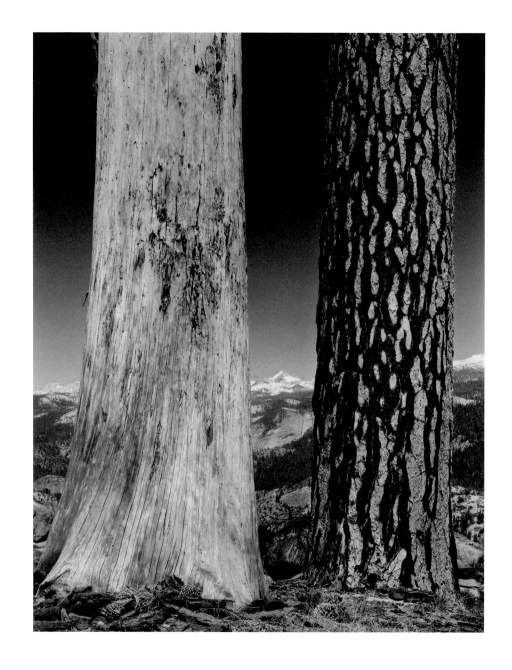

TREES, ILLILOUETTE RIDGE, YOSEMITE NATIONAL PARK, CALIFORNIA, 1945

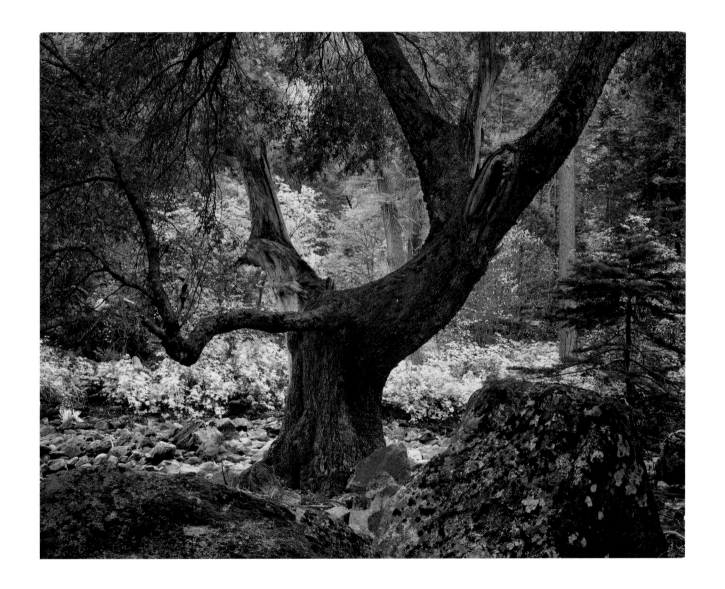

LATE AUTUMN EVENING, MERCED RIVER CANYON, YOSEMITE NATIONAL PARK, CALIFORNIA, 1944

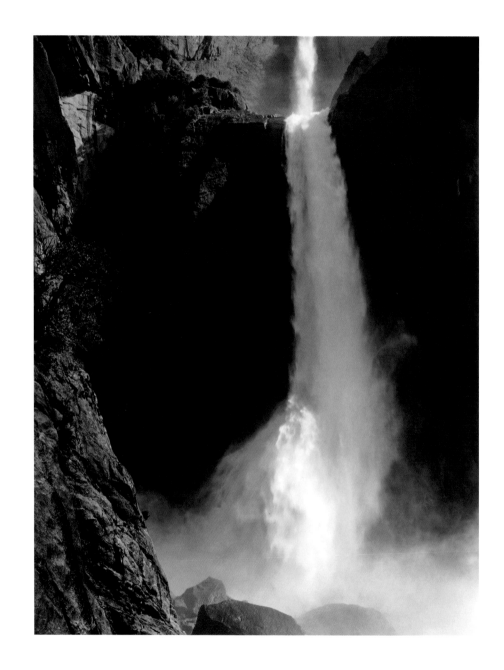

LOWER YOSEMITE FALL, YOSEMITE NATIONAL PARK, CALIFORNIA, C. 1946

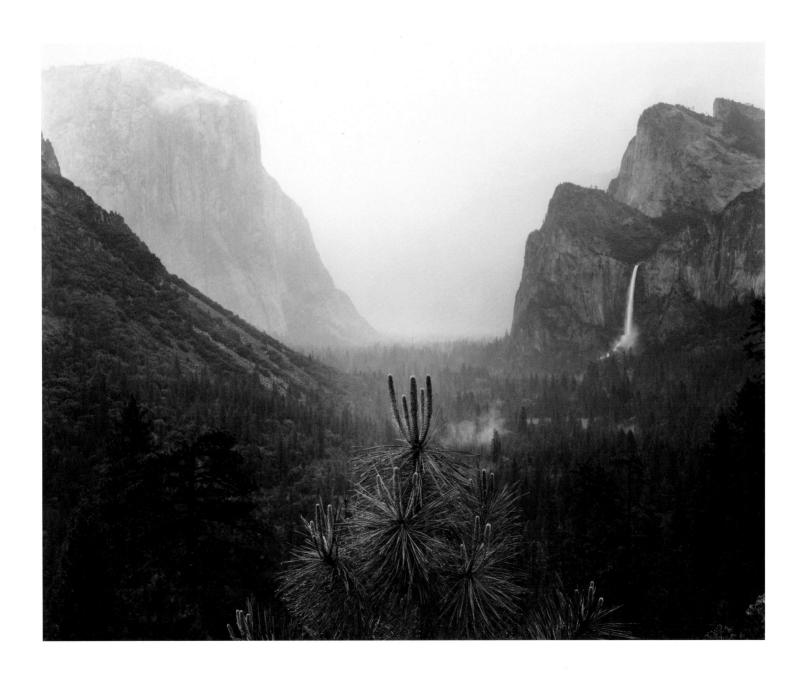

YOSEMITE VALLEY, RAIN, CALIFORNIA, C. 1945

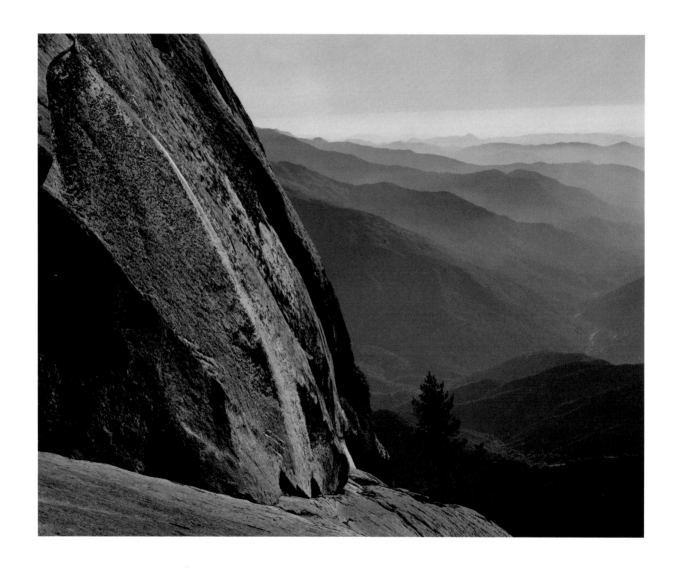

MORO ROCK, SEQUOIA NATIONAL PARK, CALIFORNIA, 1945

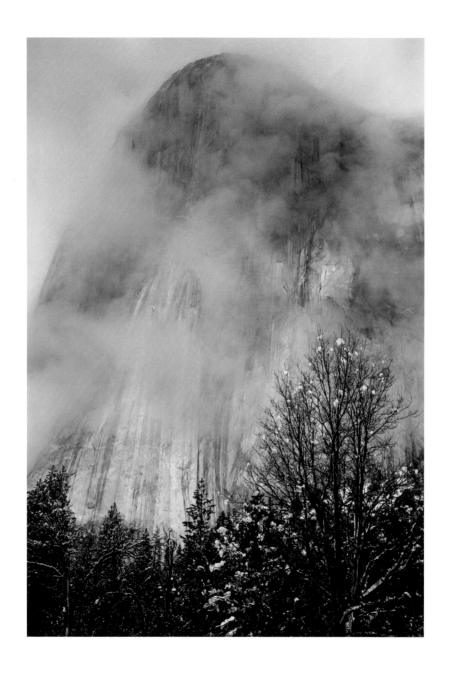

EL CAPITAN, CLIFFS AND TREE, WINTER, YOSEMITE NATIONAL PARK, CALIFORNIA, C. 1940

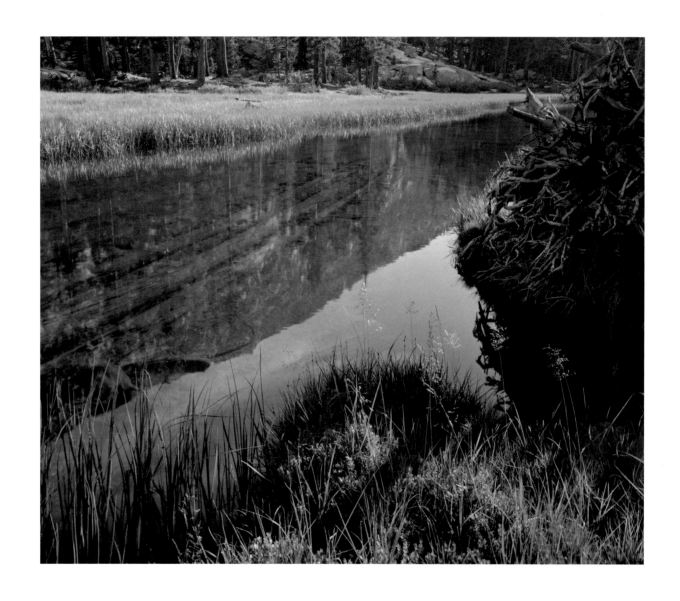

MEADOW AND STREAM, LYELL FORK OF THE MERCED RIVER, YOSEMITE NATIONAL PARK, CALIFORNIA, C. 1943

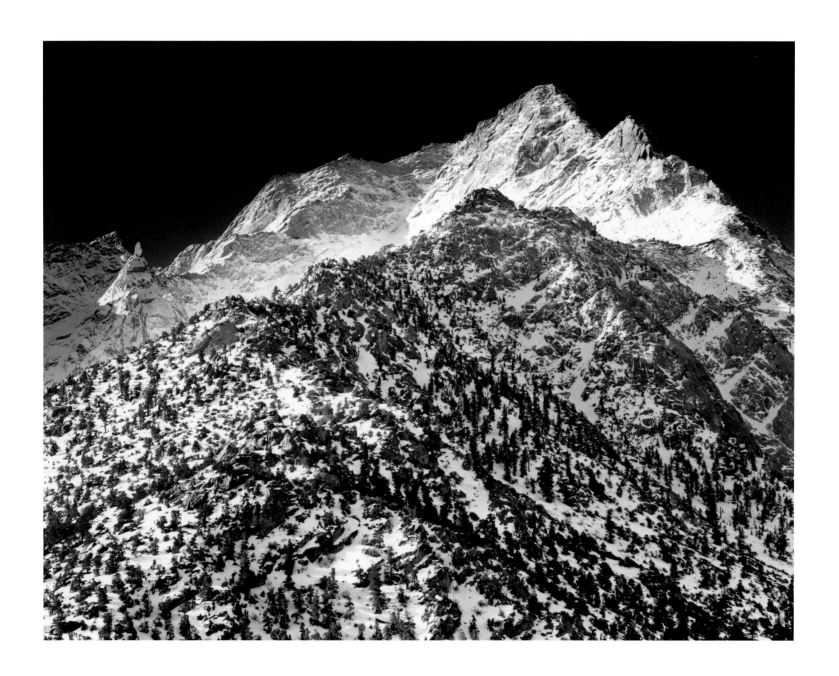

LONE PINE PEAK, WINTER SUNRISE, SIERRA NEVADA, CALIFORNIA, 1948

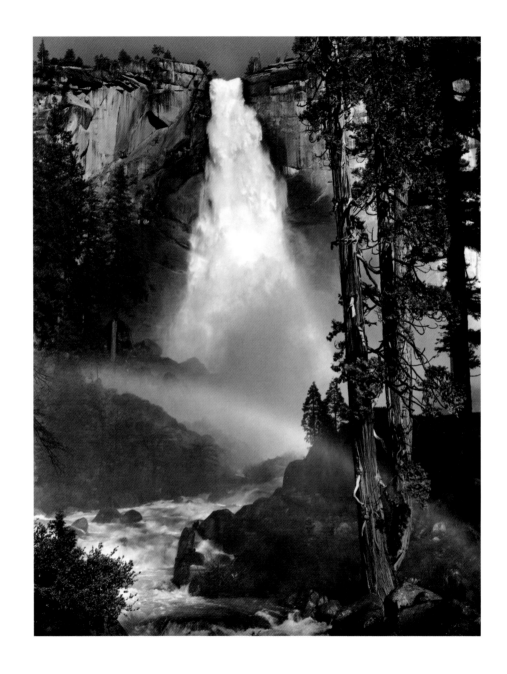

NEVADA FALL, RAINBOW, YOSEMITE NATIONAL PARK, CALIFORNIA, C. 1947

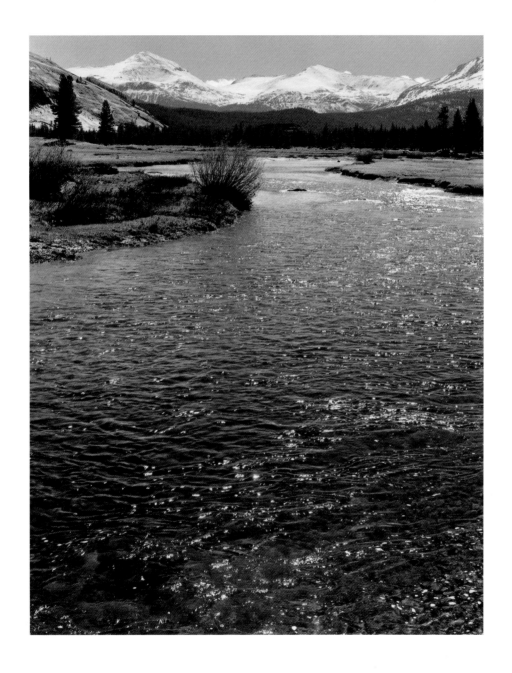

MOUNT DANA AND MOUNT GIBBS, TUOLUMNE RIVER, YOSEMITE NATIONAL PARK, CALIFORNIA, 1944

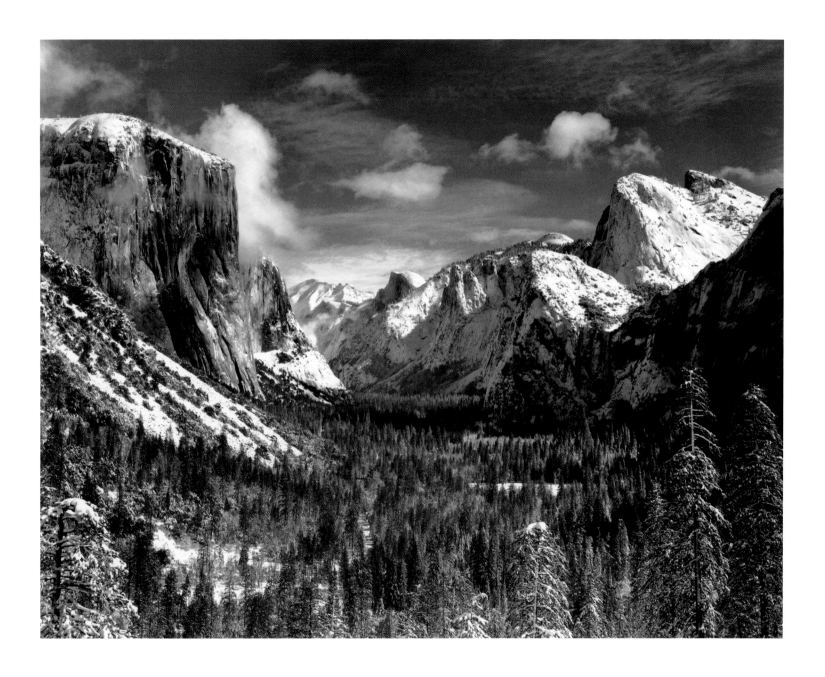

YOSEMITE VALLEY, WINTER, CALIFORNIA, C. 1940

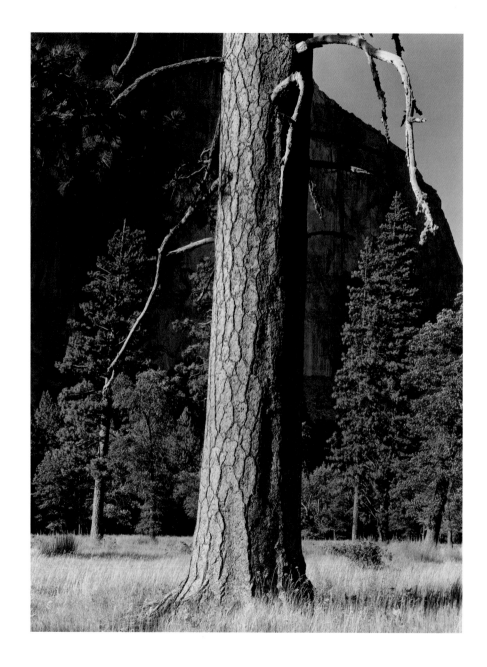

YELLOW PINE TREE, EL CAPITAN MEADOW, YOSEMITE NATIONAL PARK, CALIFORNIA, 1940

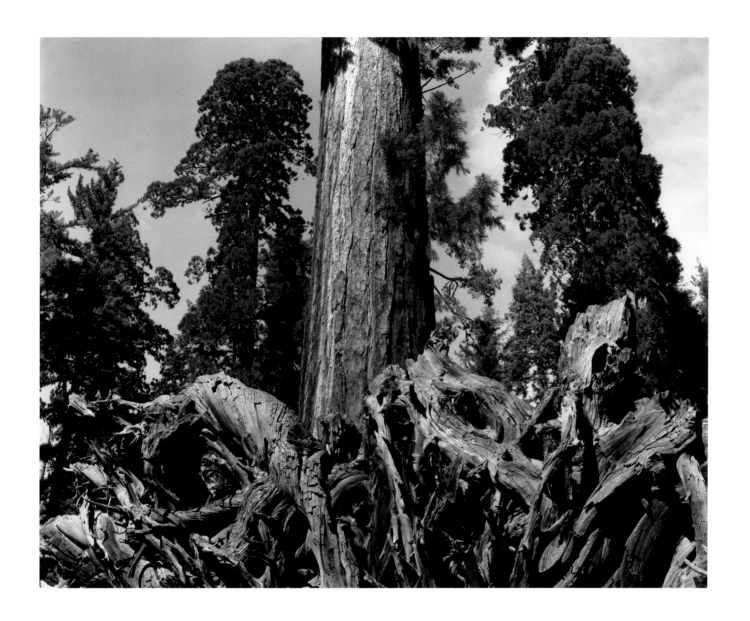

REDWOOD ROOTS AND TREE, MARIPOSA GROVE, YOSEMITE NATIONAL PARK, CALIFORNIA, 1944

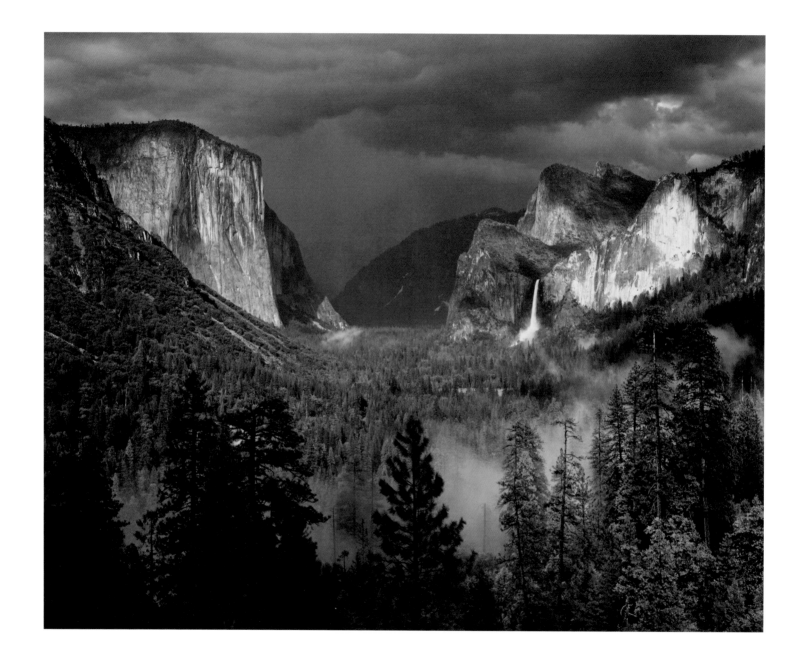

YOSEMITE VALLEY, THUNDERSTORM, CALIFORNIA, 1949

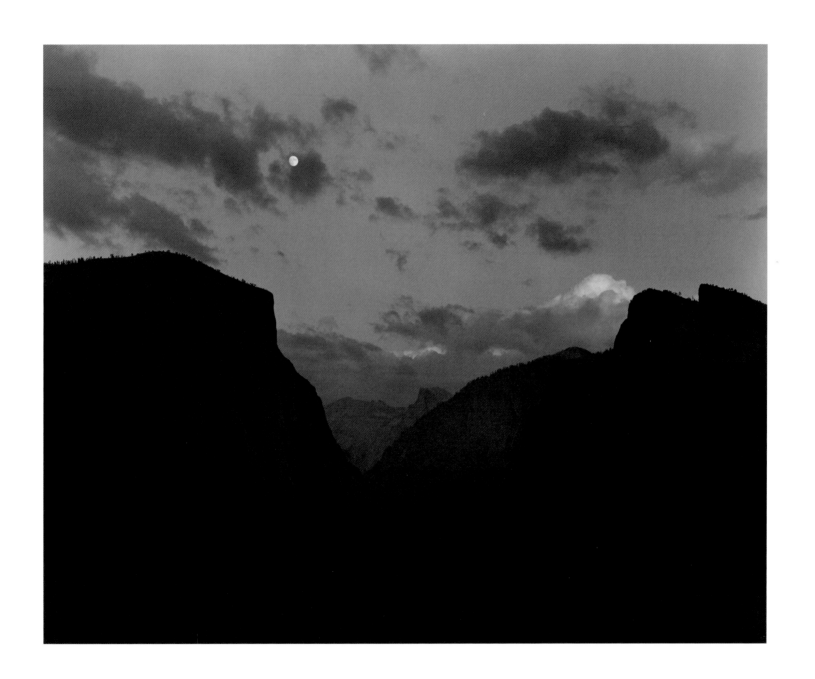

YOSEMITE VALLEY, MOONRISE, CALIFORNIA, 1944

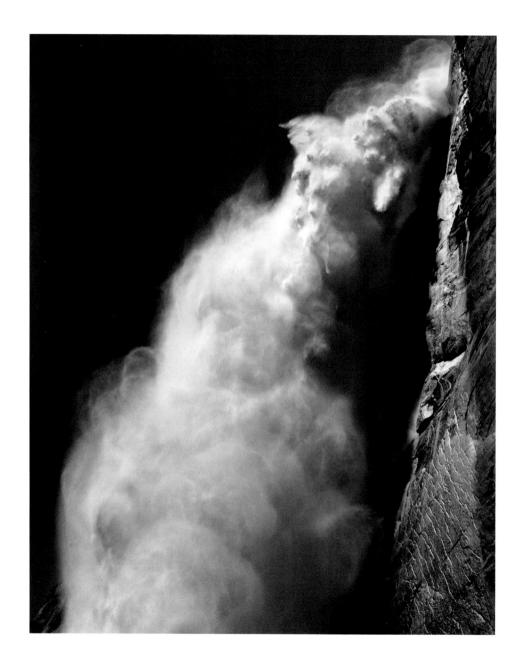

UPPER YOSEMITE FALL FROM FERN LEDGE, YOSEMITE NATIONAL PARK, CALIFORNIA, 1946

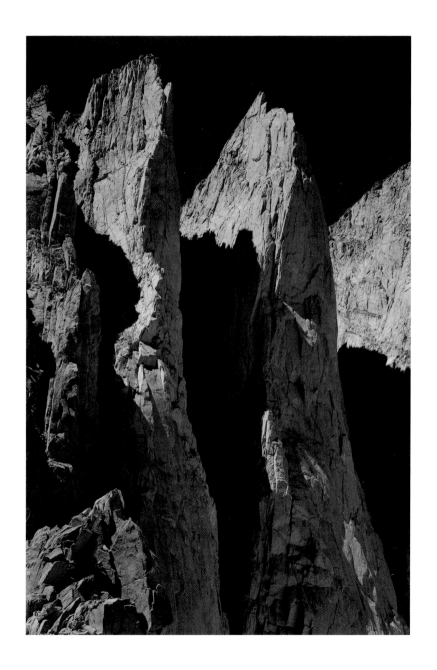

PINNACLES, MOUNT WHITNEY, SIERRA NEVADA, CALIFORNIA, C. 1940

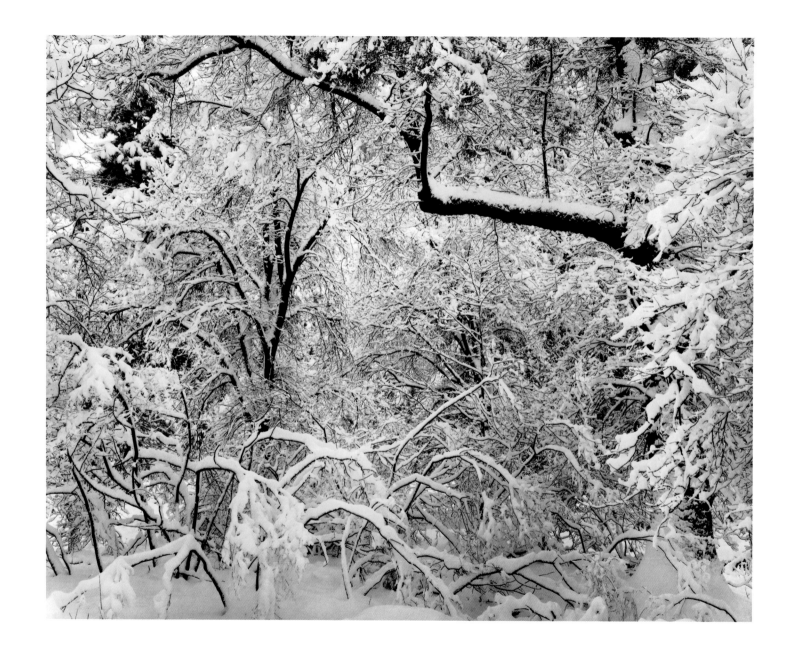

FRESH SNOW, YOSEMITE NATIONAL PARK, CALIFORNIA, C. 1947

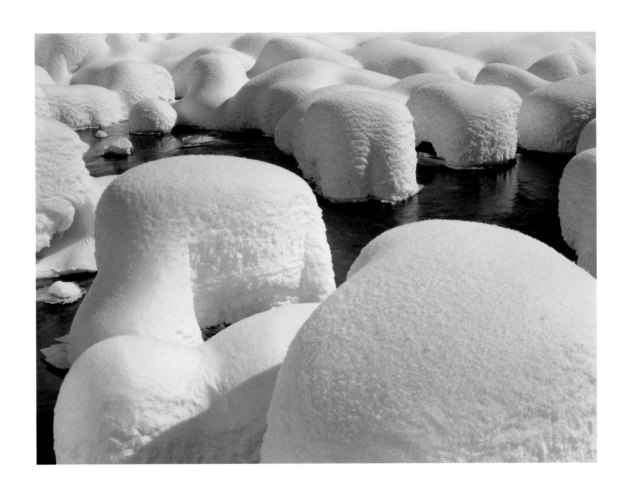

SNOW HUMMOCKS AT VALLEY VIEW, YOSEMITE NATIONAL PARK, CALIFORNIA, 1949

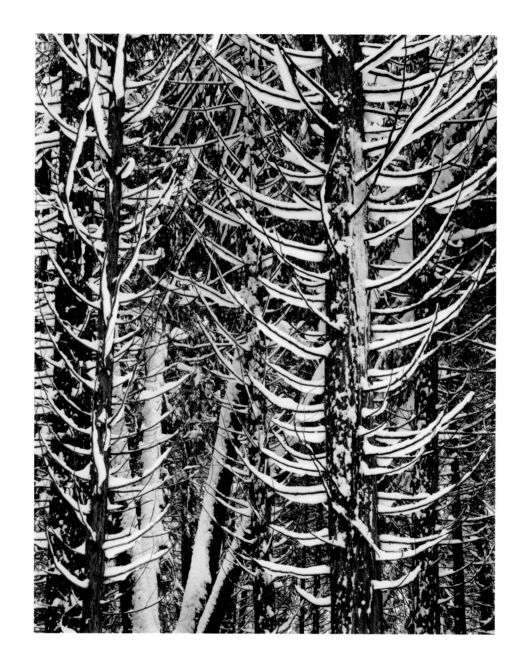

CEDAR TREES, WINTER, YOSEMITE NATIONAL PARK, CALIFORNIA, C. 1949

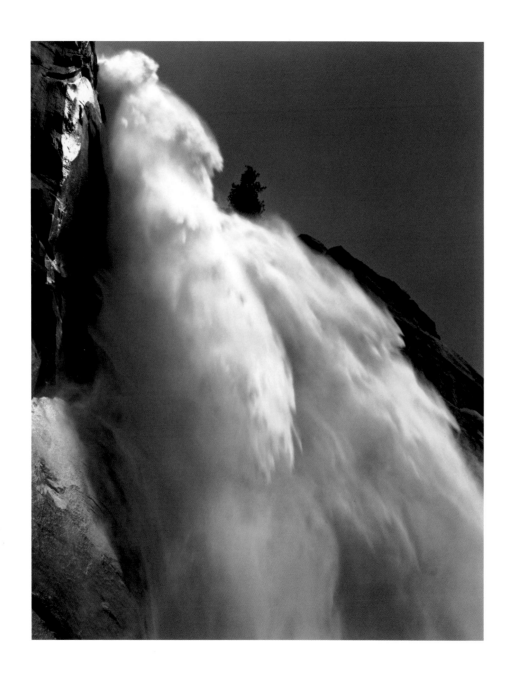

NEVADA FALL, YOSEMITE NATIONAL PARK, CALIFORNIA, 1946

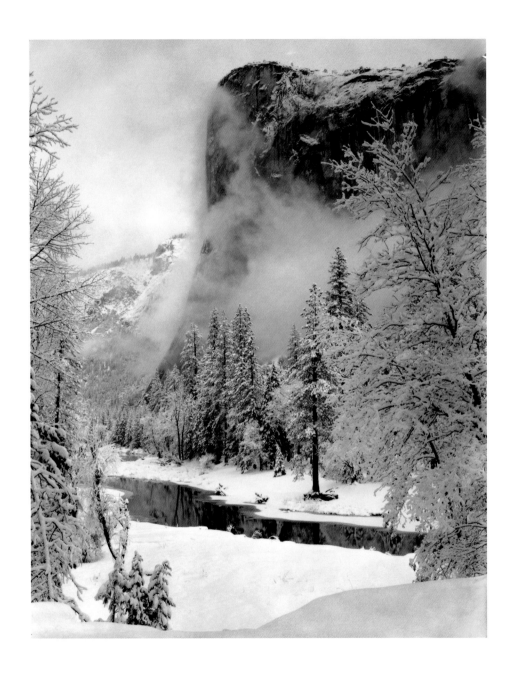

EL CAPITAN, WINTER, YOSEMITE NATIONAL PARK, CALIFORNIA, 1948

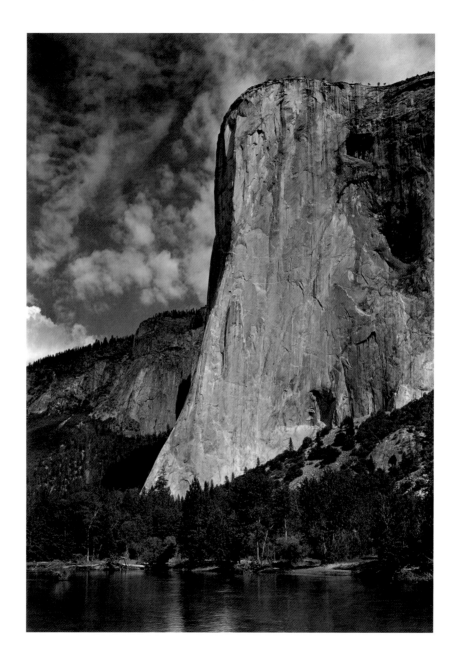

EL CAPITAN, MERCED RIVER, CLOUDS, YOSEMITE NATIONAL PARK, CALIFORNIA, 1948

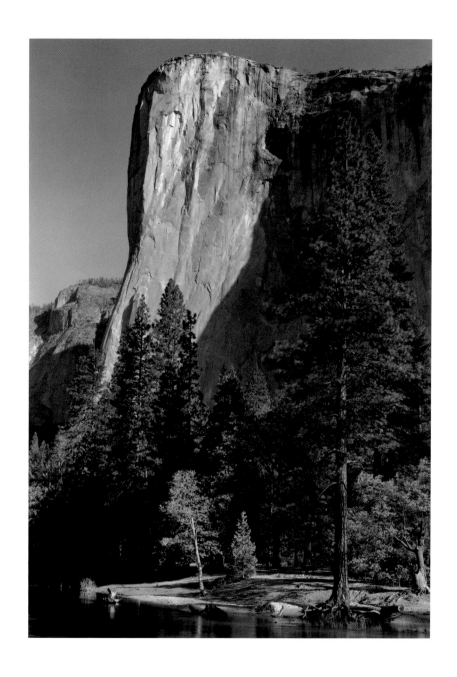

EL CAPITAN, MERCED RIVER, YOSEMITE NATIONAL PARK, CALIFORNIA, 1948

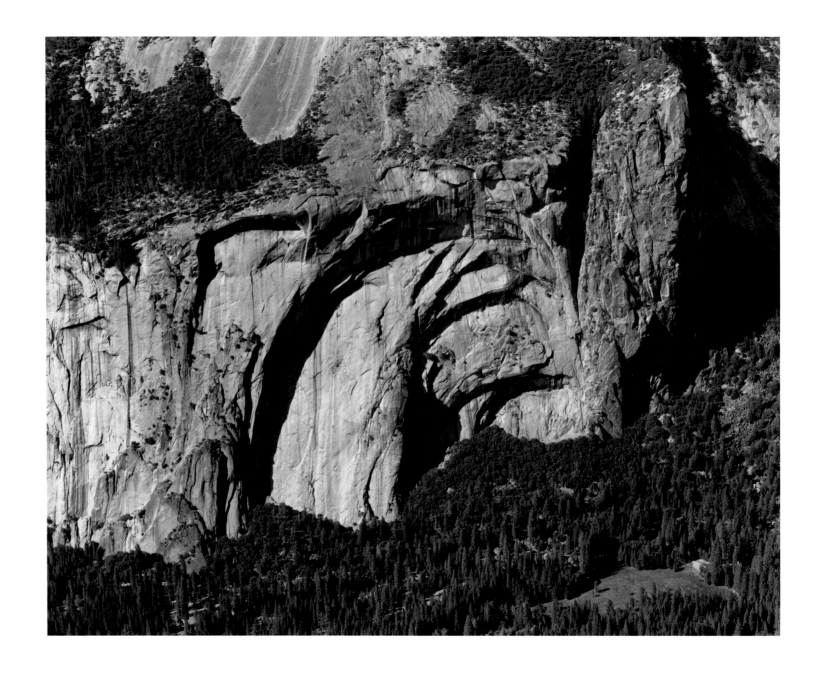

ROYAL ARCHES, WASHINGTON COLUMN AND THE BASE OF NORTH DOME, YOSEMITE NATIONAL PARK, CALIFORNIA, C. 1940

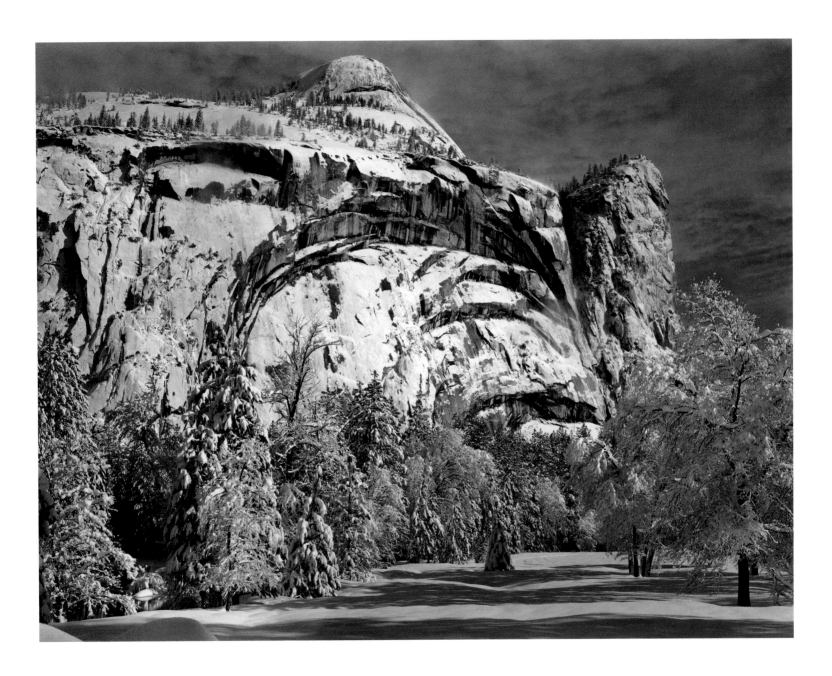

NORTH DOME, ROYAL ARCHES, WASHINGTON COLUMN, WINTER, YOSEMITE NATIONAL PARK, CALIFORNIA, C. 1940

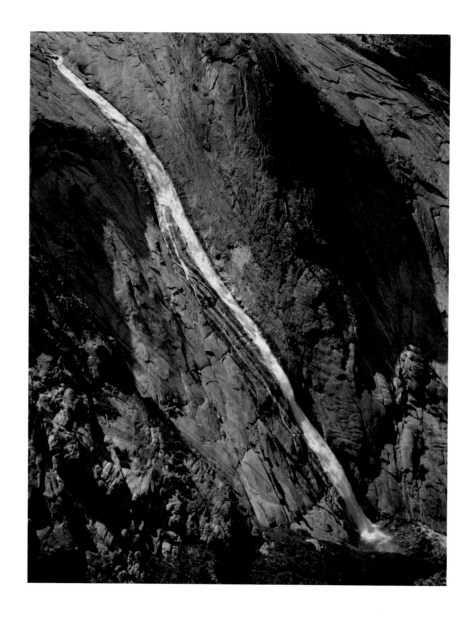

PYWIACK CASCADE, TENAYA CANYON, YOSEMITE NATIONAL PARK, CALIFORNIA, C. 1940

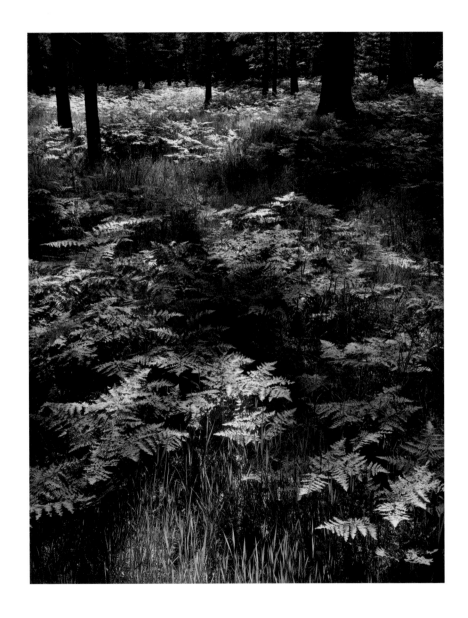

FERNS ON THE FLOOR OF YOSEMITE VALLEY, CALIFORNIA, 1948

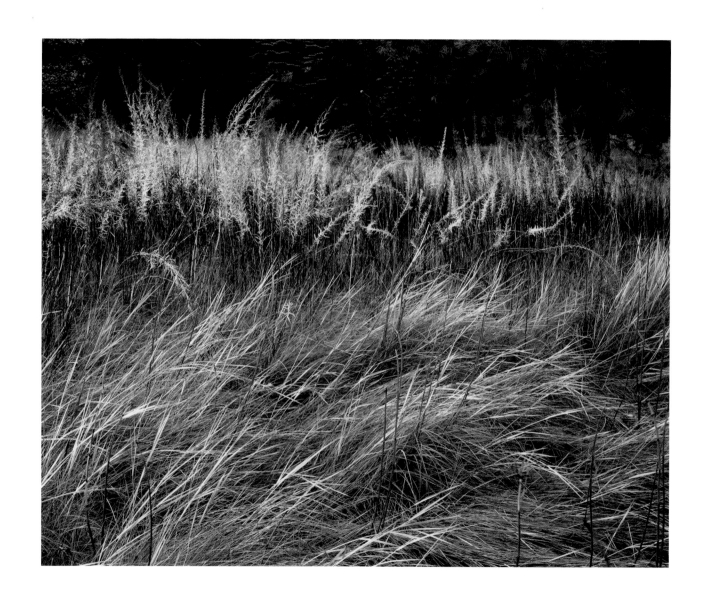

GRASS, YOSEMITE NATIONAL PARK, CALIFORNIA, 1944

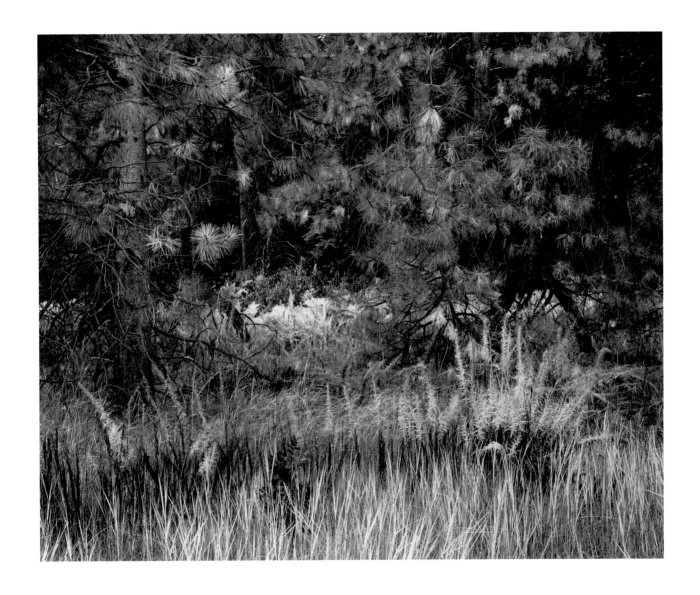

GRASS, YOSEMITE NATIONAL PARK, CALIFORNIA, 1944

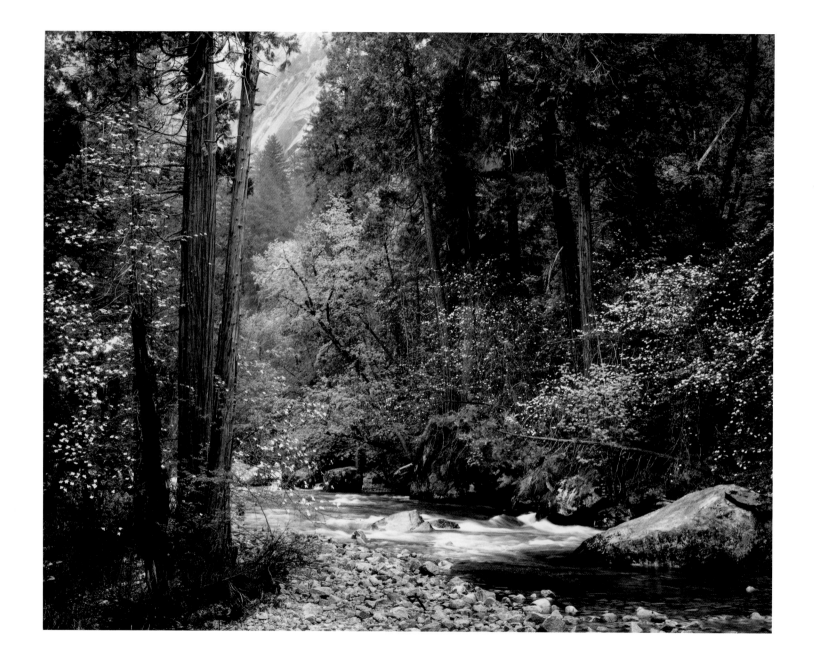

TENAYA CREEK, DOGWOOD, RAIN, YOSEMITE NATIONAL PARK, CALIFORNIA, C. 1948

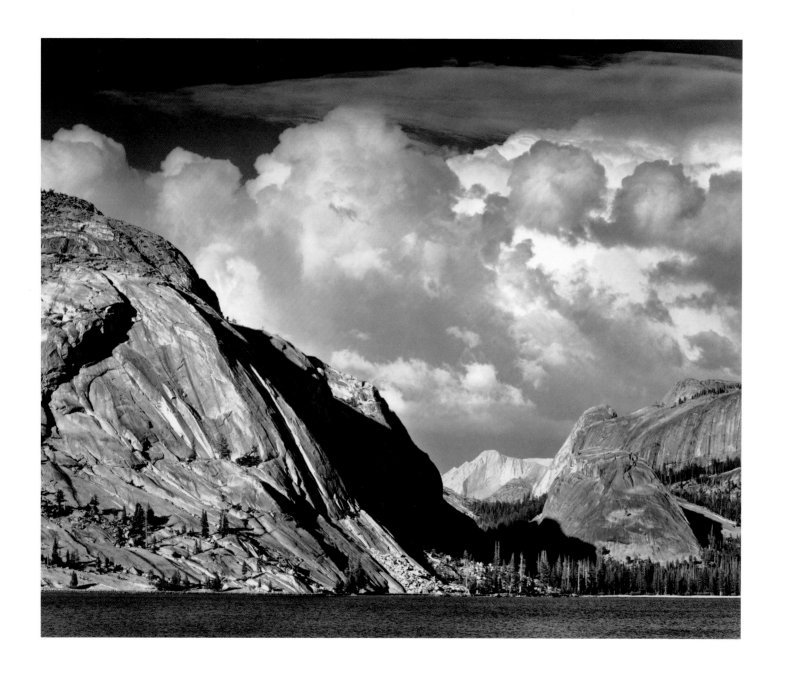

TENAYA LAKE, MOUNT CONNESS, YOSEMITE NATIONAL PARK, CALIFORNIA, C. 1946

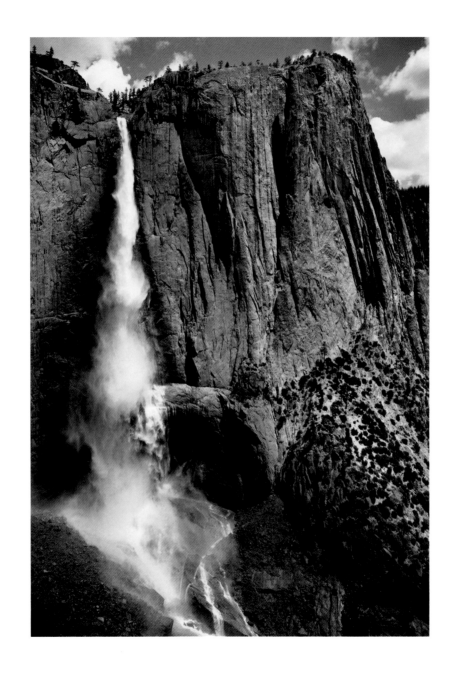

UPPER YOSEMITE FALL AND YOSEMITE POINT, YOSEMITE NATIONAL PARK, CALIFORNIA, 1945

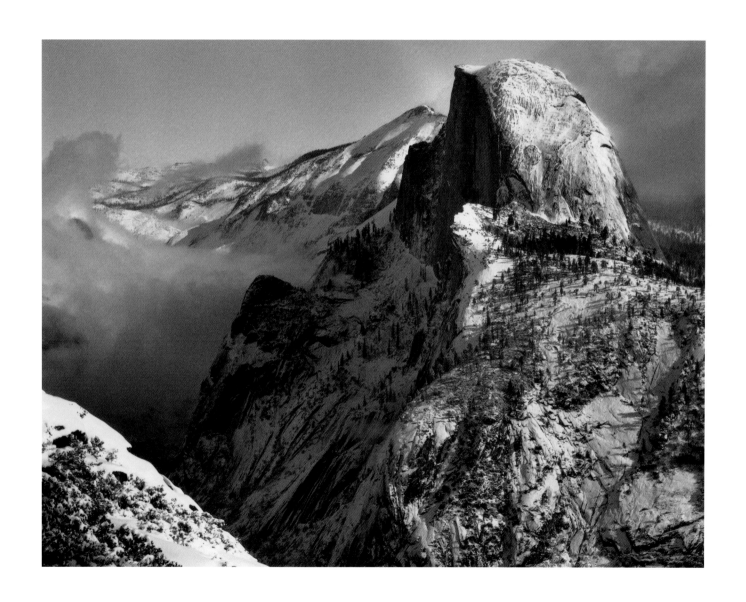

HALF DOME, WINTER, FROM GLACIER POINT, YOSEMITE NATIONAL PARK, CALIFORNIA, C. 1940

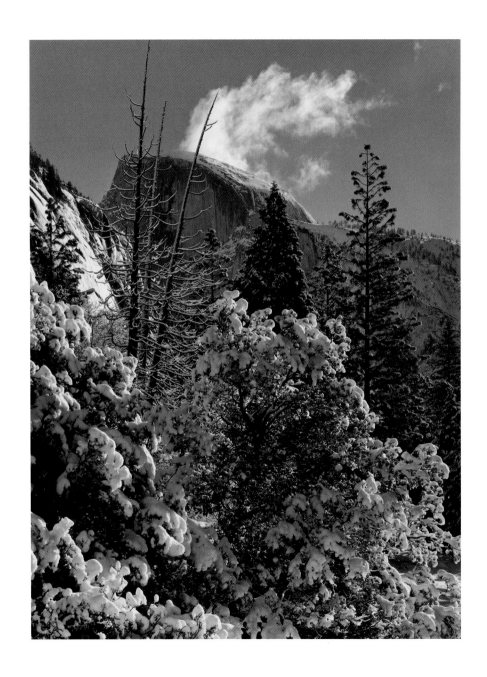

HALF DOME, WINTER, YOSEMITE NATIONAL PARK, CALIFORNIA, 1940

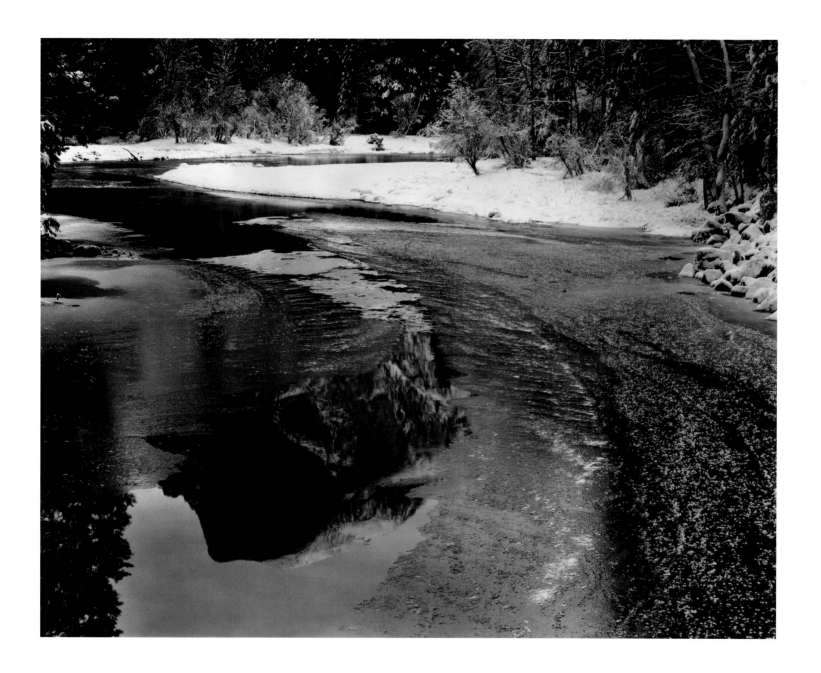

HALF DOME, REFLECTIONS, MERCED RIVER, WINTER, YOSEMITE NATIONAL PARK, CALIFORNIA, C. 1945

GIANT SEQUOIAS, YOSEMITE NATIONAL PARK, CALIFORNIA, C. 1944

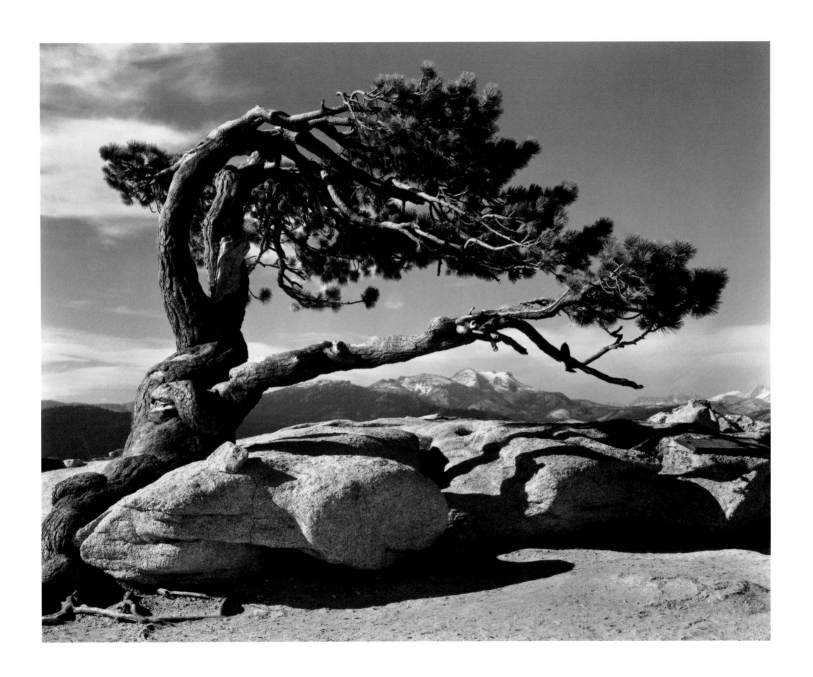

JEFFREY PINE, SENTINEL DOME, YOSEMITE NATIONAL PARK, CALIFORNIA, 1940

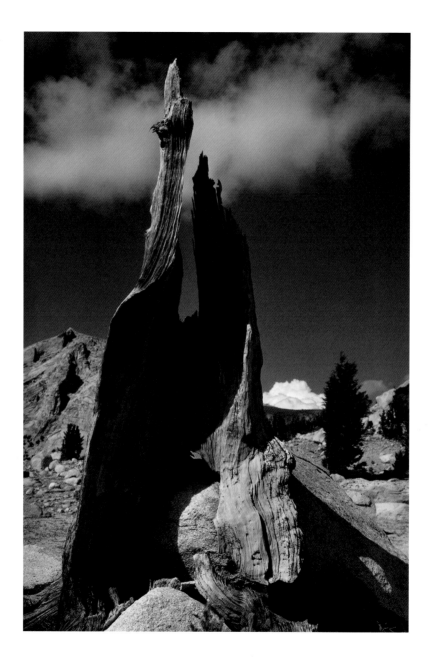

STUMP AND CLOUDS, NEAR YOUNG LAKES, YOSEMITE NATIONAL PARK, CALIFORNIA, C. 1945

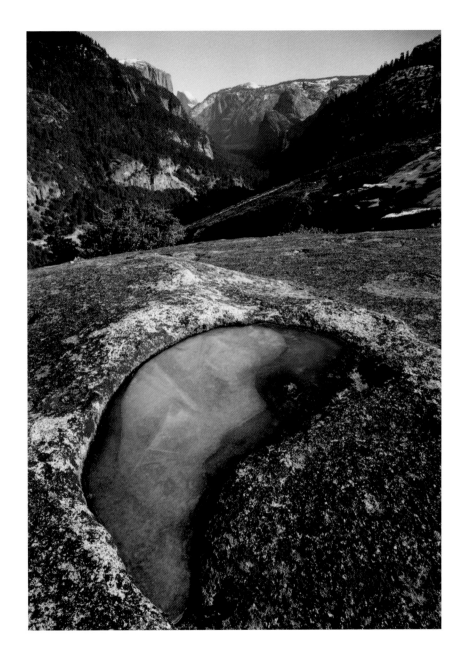

ICY POOL ON BALD MOUNTAIN, YOSEMITE NATIONAL PARK, CALIFORNIA, C. 1947

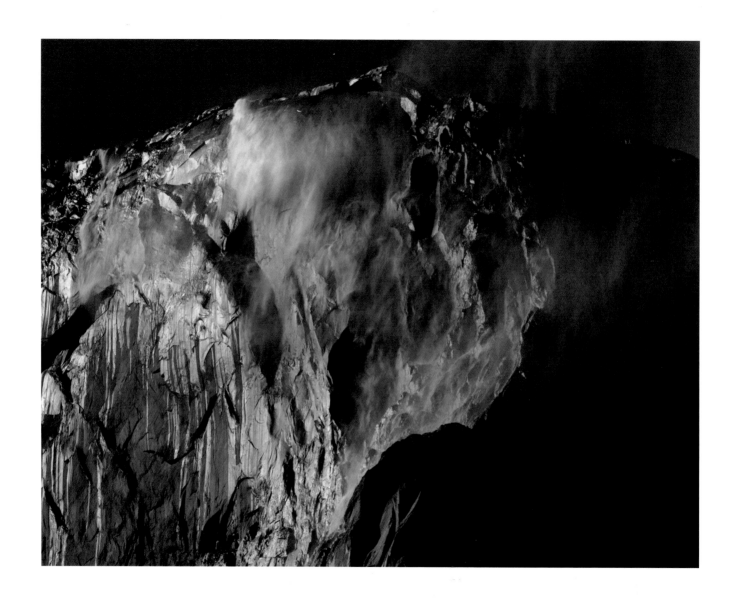

EL CAPITAN FALL, YOSEMITE NATIONAL PARK, CALIFORNIA, C. 1940

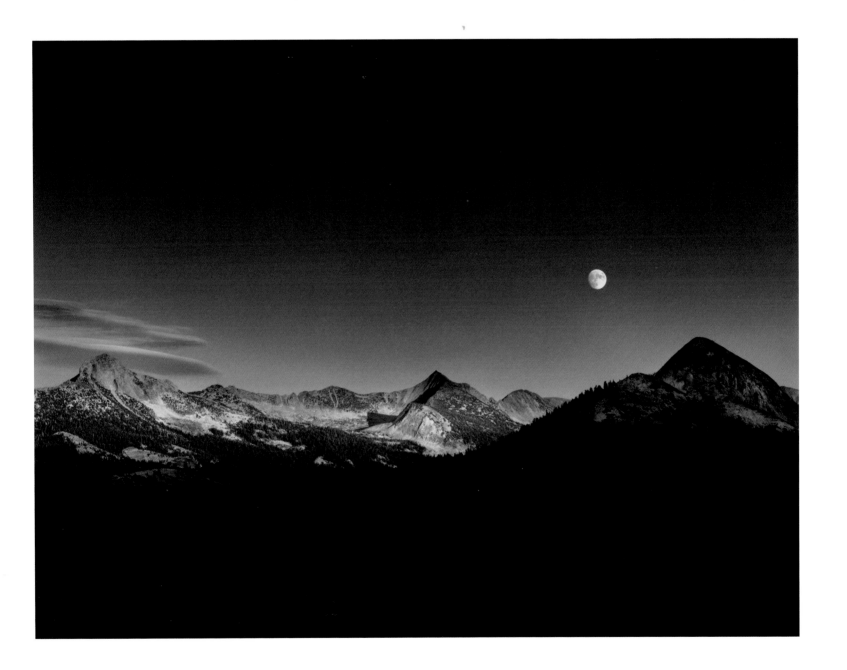

AUTUMN MOON, HIGH SIERRA FROM GLACIER POINT, YOSEMITE NATIONAL PARK, CALIFORNIA, 1948

1950–1959 CONSERVATION, PUBLICATIONS, AND COMMISSIONS

As the decade of the 1950s progressed, Adams concentrated mostly on photographic commissions, writing technical books and articles, publishing books of his photographs, organizing and printing for exhibitions, and working on conservation issues with the Sierra Club.

In 1956, Adams and Nancy Newhall mounted an exhibition for the Sierra Club titled "This Is the American Earth," which was later turned into a book. Composed of Newhall's poetic text and many of Adams' photographs, its environmental message has been characterized as "a wake-up call for the nation." Adams' photograph of aspens (page 375), made in 1958 and used on the cover of the book, became synonymous with both the Sierra Club and the environmental movement. William Turnage, then the president of The Wilderness Society, wrote, "Adams, perhaps more than any artist before, was able to send his art into battle."

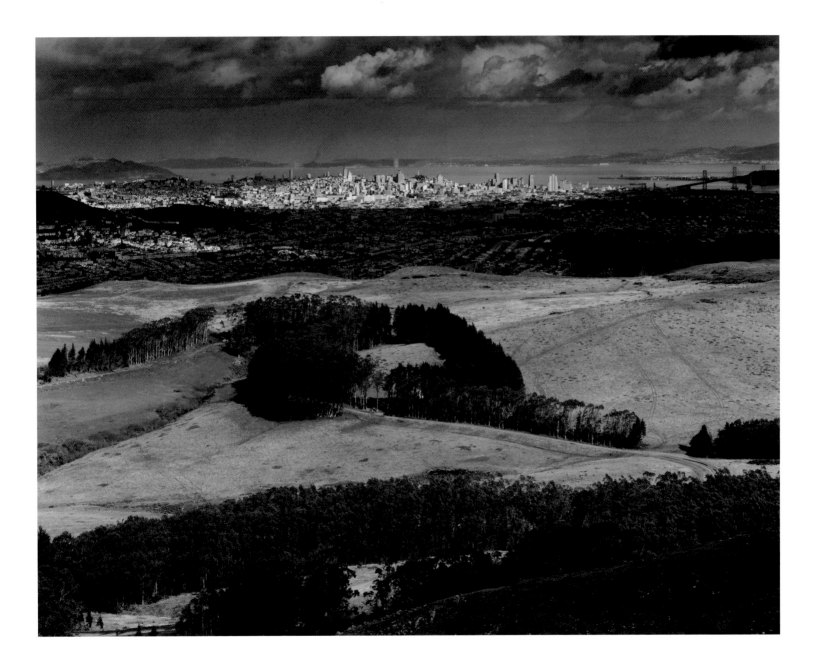

SAN FRANCISCO FROM SAN BRUNO MOUNTAIN, CALIFORNIA, 1952

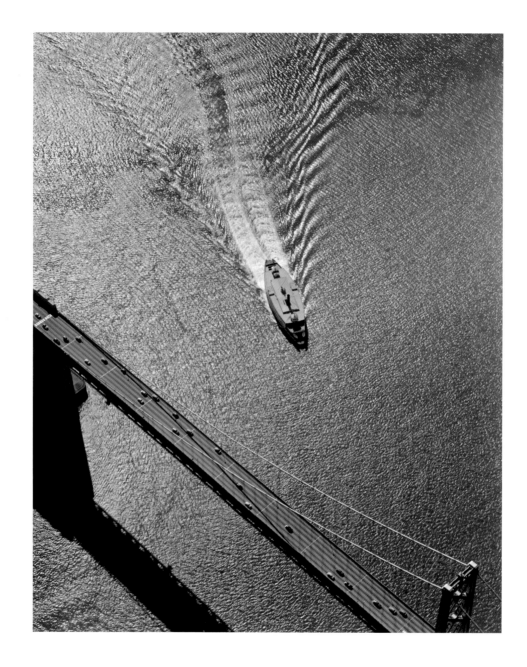

324 FERRY AND BAY BRIDGE FROM THE AIR, SAN FRANCISCO, CALIFORNIA, 1954

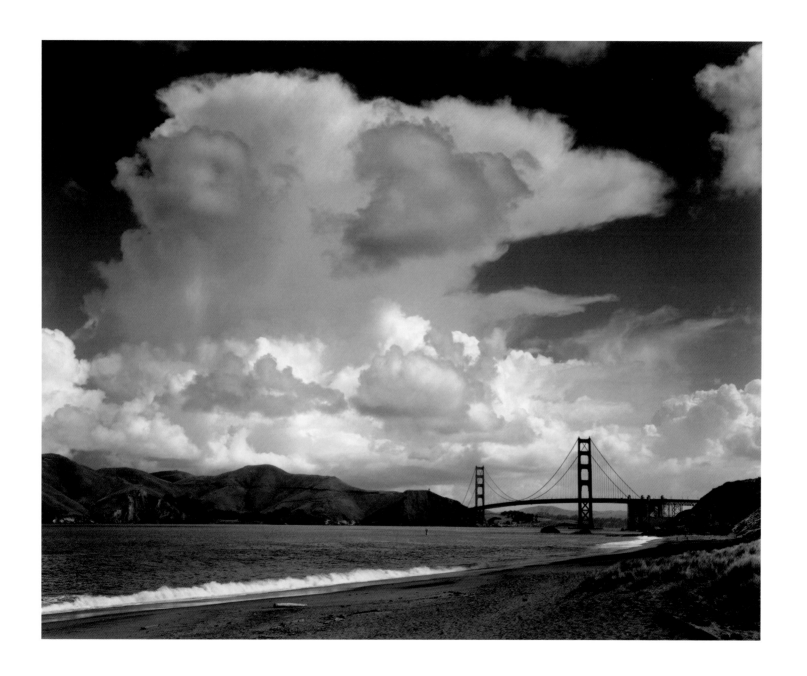

THE GOLDEN GATE AND BRIDGE FROM BAKER BEACH, SAN FRANCISCO, CALIFORNIA, C. 1953

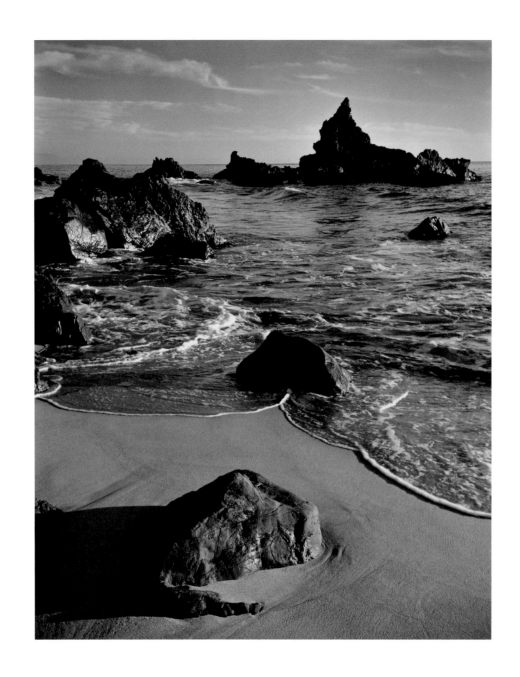

SURF AND ROCK, MONTEREY COUNTY COAST, CALIFORNIA, 1951

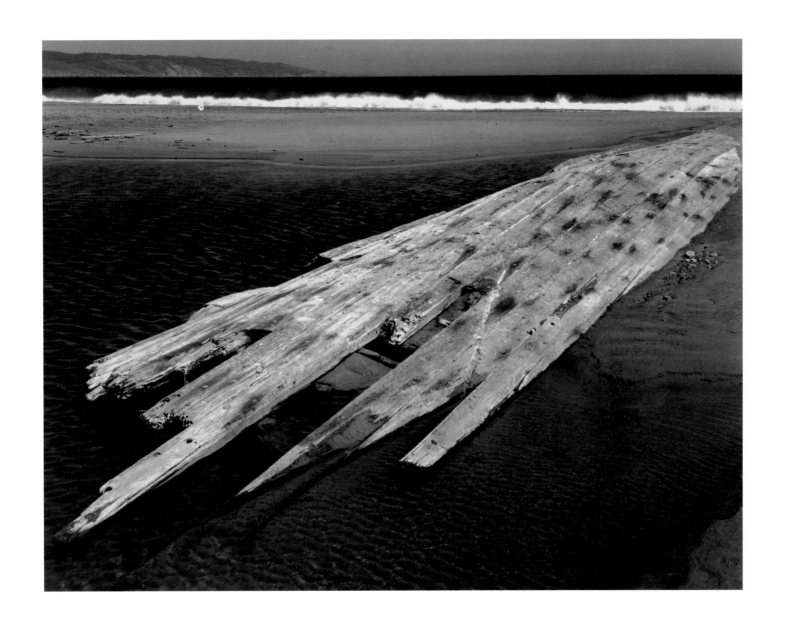

HULL OF WRECKED SHIP, DRAKE'S BAY, POINT REYES NATIONAL SEASHORE, CALIFORNIA, 1953

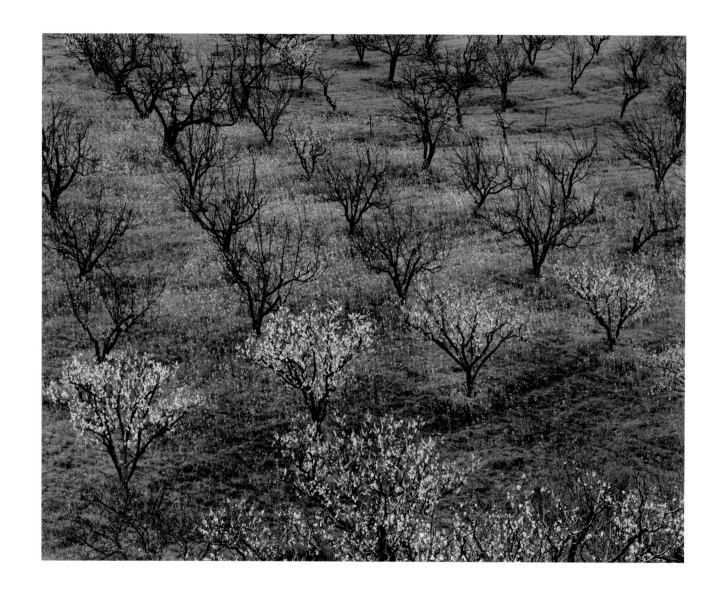

ORCHARD, EARLY SPRING, PORTOLA VALLEY, CALIFORNIA, C. 1953

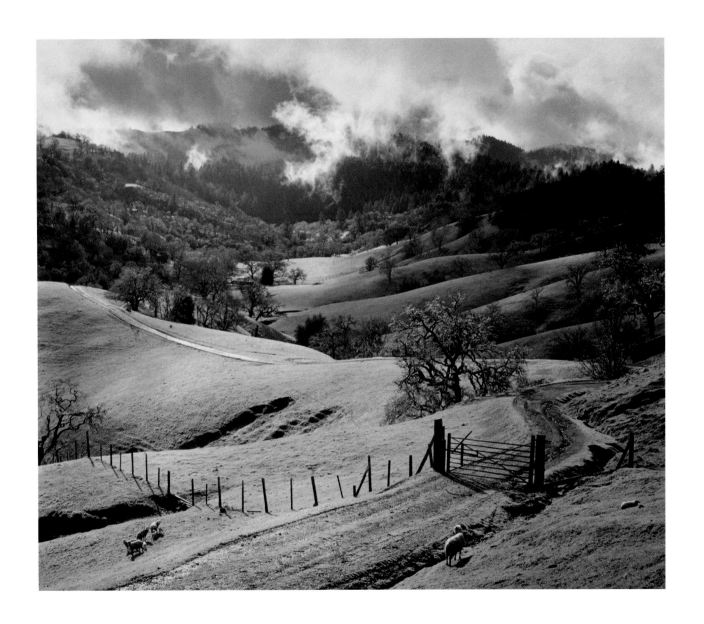

PASTURE, SONOMA COUNTY, NORTHERN CALIFORNIA, 1951

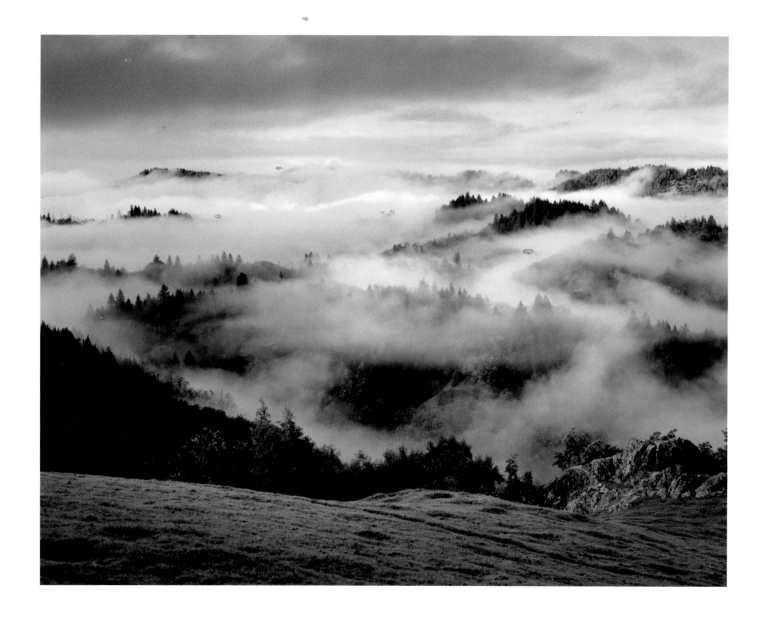

CLEARING STORM, SONOMA COUNTY, CALIFORNIA, 1951

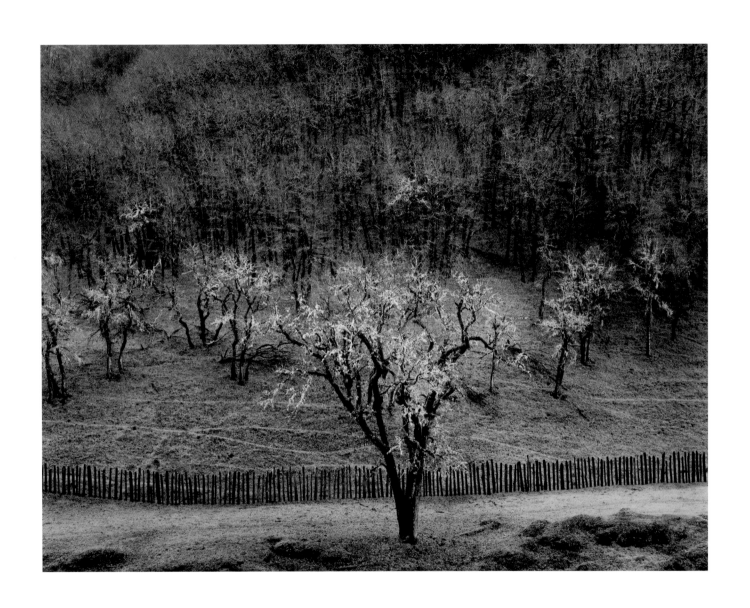

OAK TREE, RAIN, SONOMA COUNTY, CALIFORNIA, 1951

ORCHARD, SANTA CLARA, CALIFORNIA, C. 1954

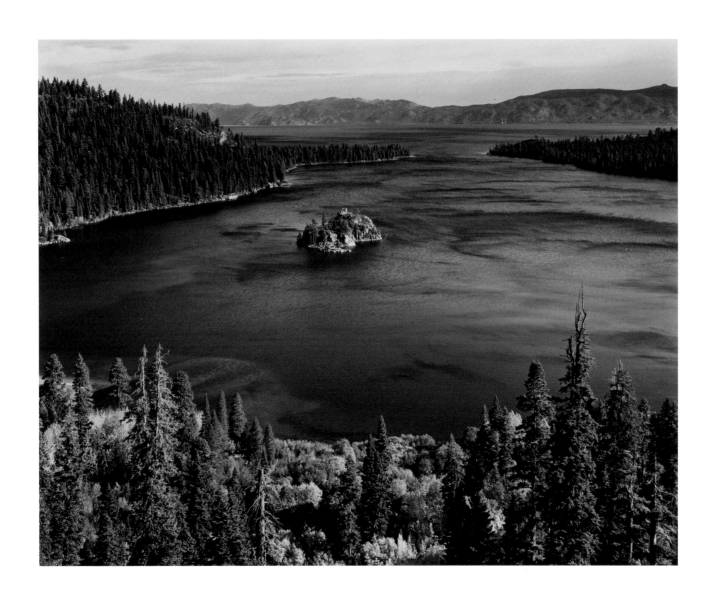

EMERALD BAY, LAKE TAHOE, NORTHERN CALIFORNIA, C. 1955

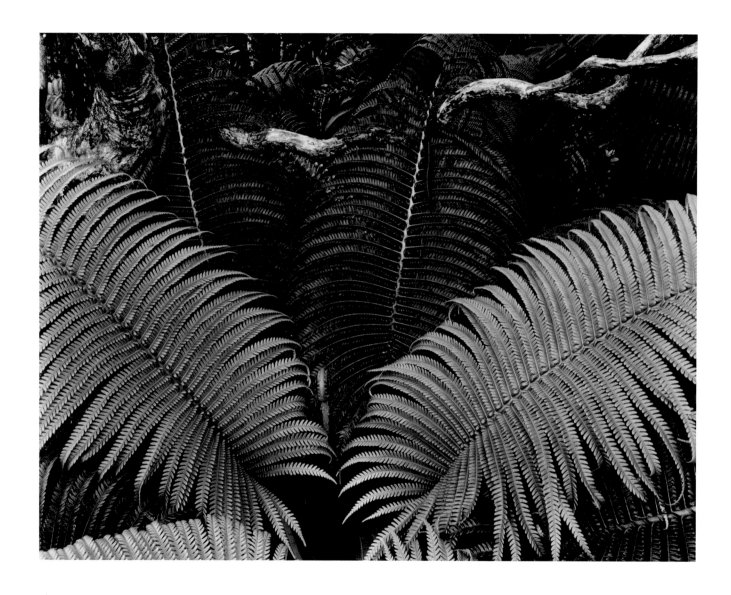

FERNS, NEAR KILAUEA CRATER, HAWAII VOLCANOES NATIONAL PARK, HAWAII, C. 1956

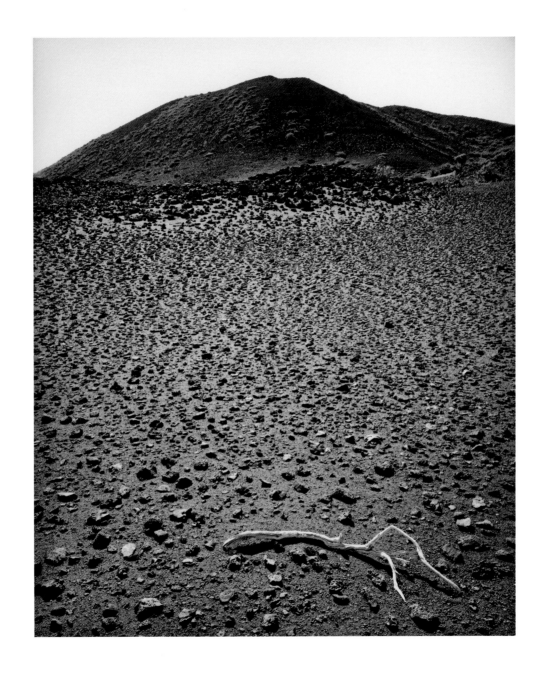

CINDER CONE IN THE CRATER OF HALEAKALA, HALEAKALA NATIONAL PARK, HAWAII, C. 1956

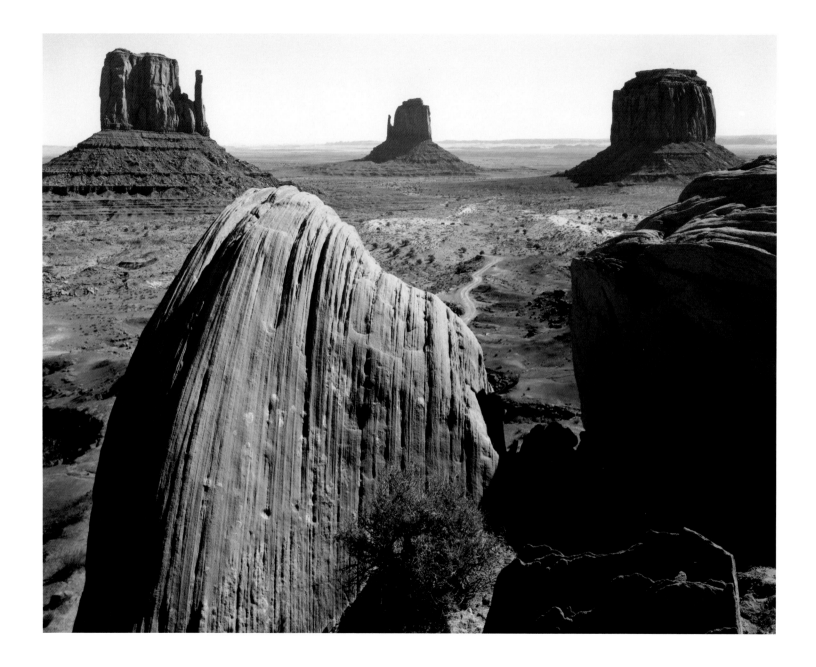

MONUMENT VALLEY, ARIZONA, 1958

PAPAGO BOY, MISSION SAN XAVIER DEL BAC, TUCSON, ARIZONA, C. 1950

PAPAGO GIRL, MISSION SAN XAVIER DEL BAC, TUCSON, ARIZONA, C. 1950

INTERIOR, TUMACACORI NATIONAL HISTORIC PLACE, ARIZONA, 1952

SAINT FRANCIS CHURCH, RANCHOS DE TAOS, NEW MEXICO, C. 1950

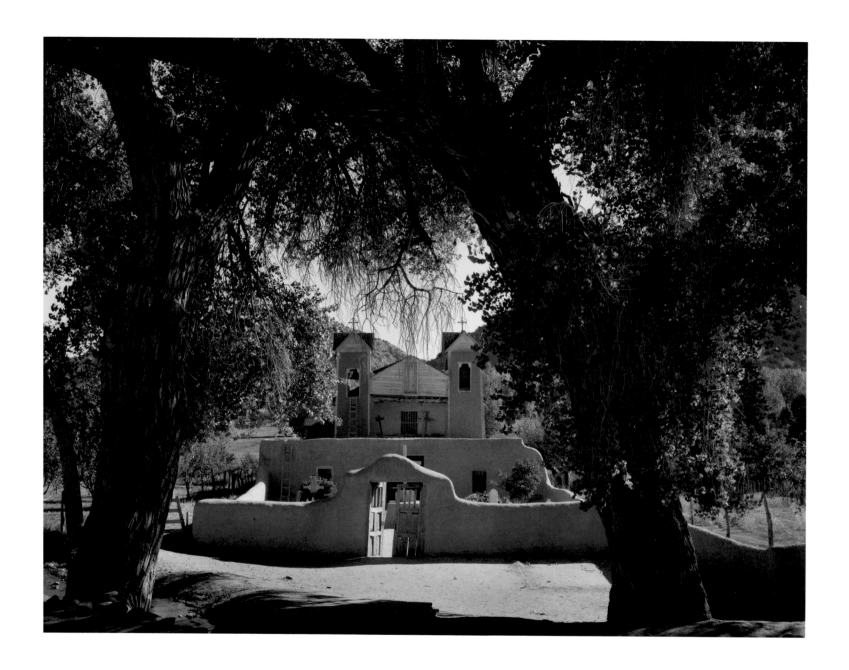

SANTUARIO DE CHIMAYO, NEW MEXICO, C. 1950

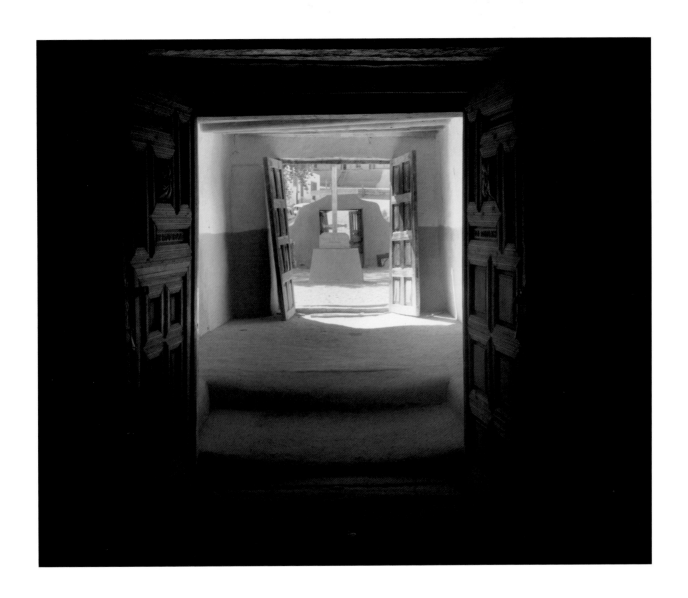

INTERIOR, SANTUARIO DE CHIMAYO, NEW MEXICO, C. 1956

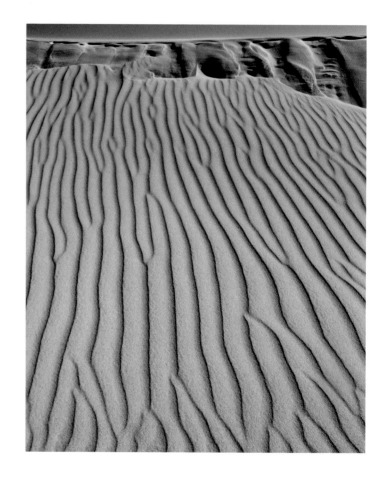

ORGAN PIPE CACTUS NATIONAL MONUMENT, ARIZONA, C. 1952

SAND DUNES, OCEANO, CALIFORNIA, C. 1950

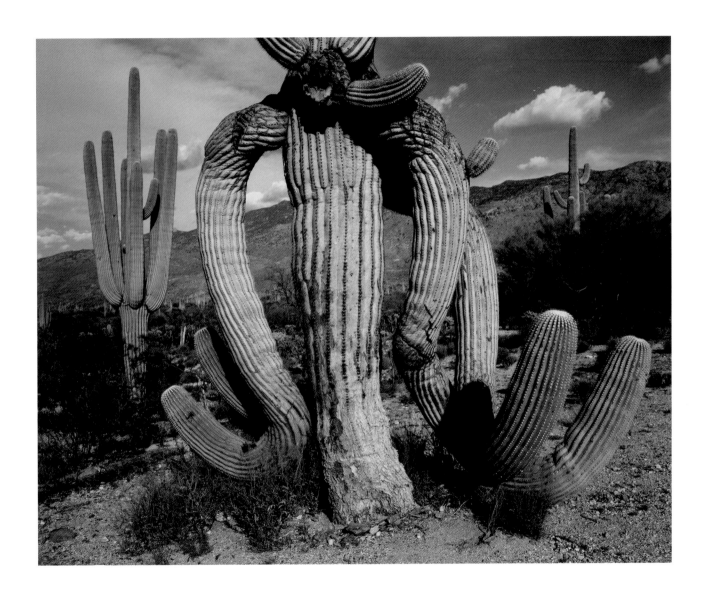

INVOLUTE CACTUS, SAGUARO NATIONAL MONUMENT, ARIZONA, C. 1952

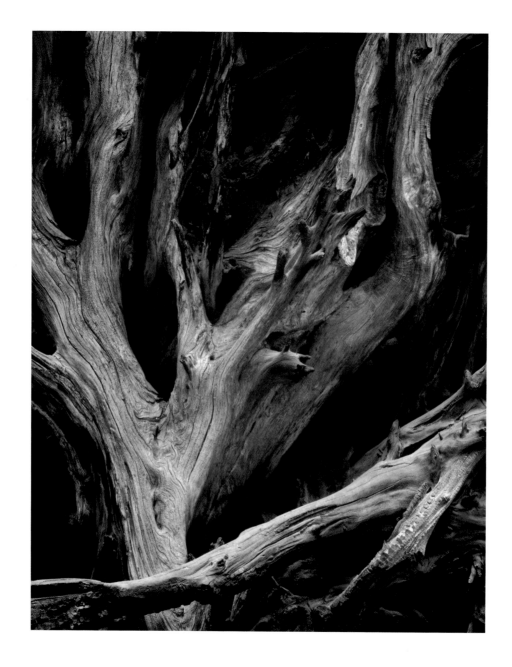

SEQUOIA ROOTS, MARIPOSA GROVE, YOSEMITE NATIONAL PARK, CALIFORNIA, C. 1950

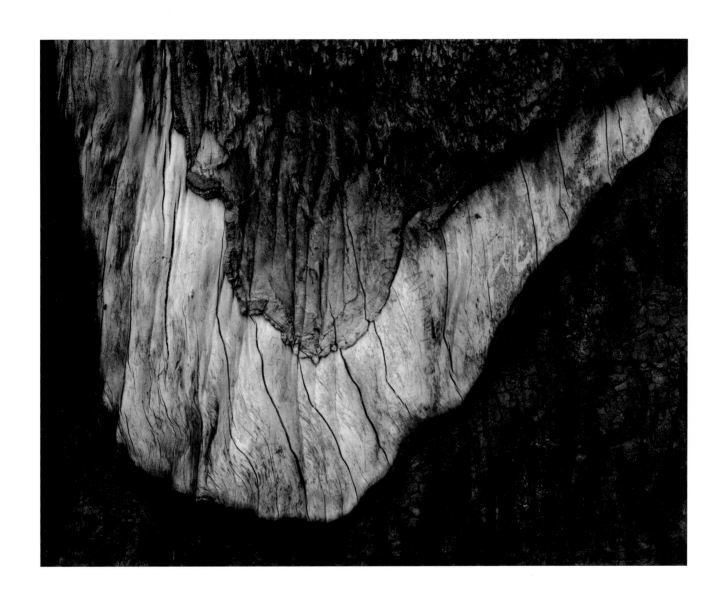

SEQUOIA BARK DETAIL, YOSEMITE NATIONAL PARK, CALIFORNIA, C. 1956

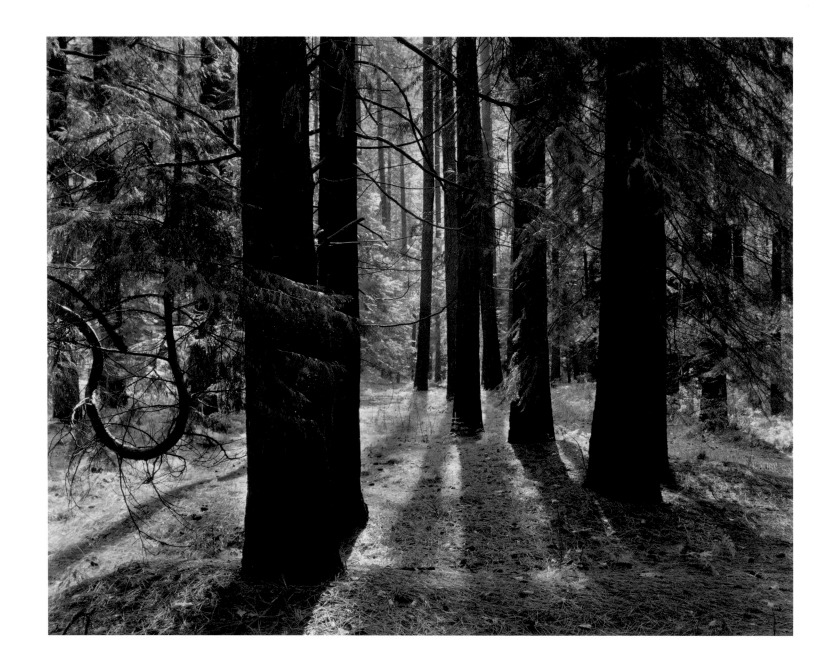

FOREST FLOOR, YOSEMITE NATIONAL PARK, CALIFORNIA, C. 1950

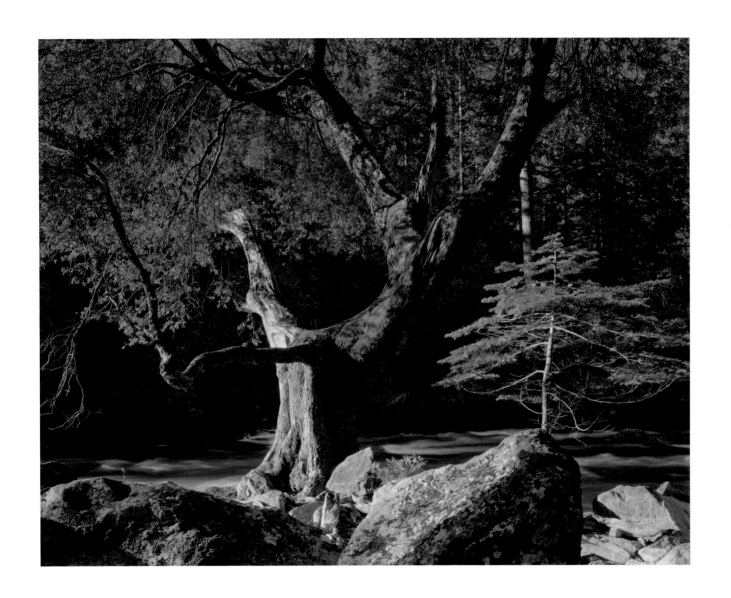

EARLY MORNING, MERCED RIVER, YOSEMITE NATIONAL PARK, CALIFORNIA, C. 1950

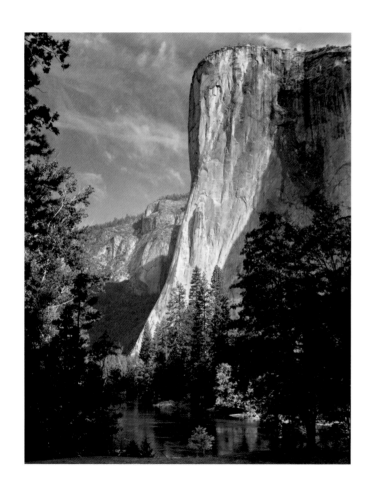 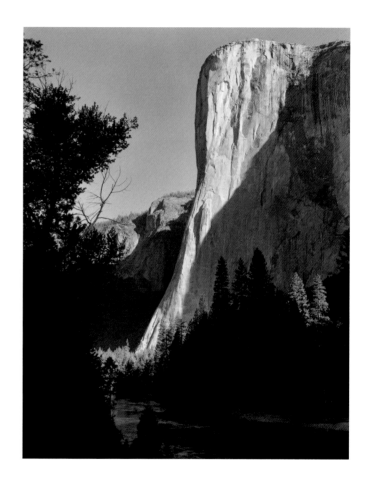

EL CAPITAN, MERCED RIVER, YOSEMITE NATIONAL PARK, CALIFORNIA, 1952
EL CAPITAN, MERCED RIVER, SUNRISE, YOSEMITE NATIONAL PARK, CALIFORNIA, 1956

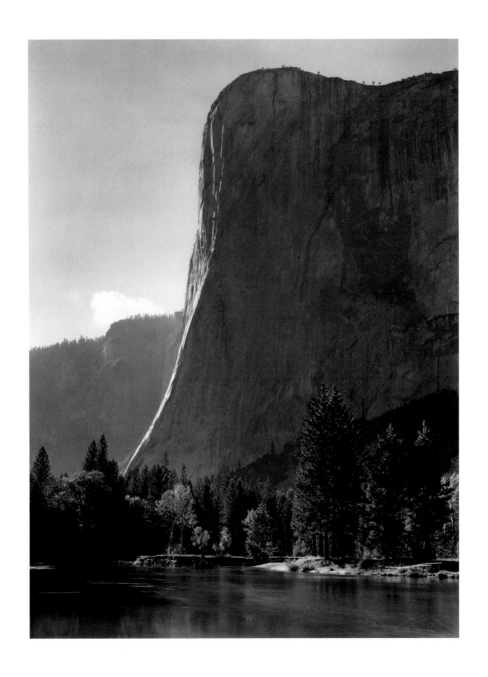

EL CAPITAN, MERCED RIVER, AGAINST SUN, YOSEMITE NATIONAL PARK, CALIFORNIA, C. 1950

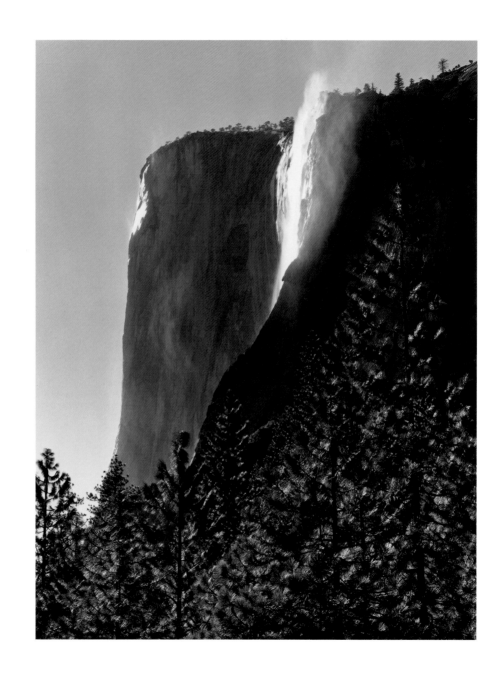

EL CAPITAN FALL, YOSEMITE NATIONAL PARK, CALIFORNIA, 1952

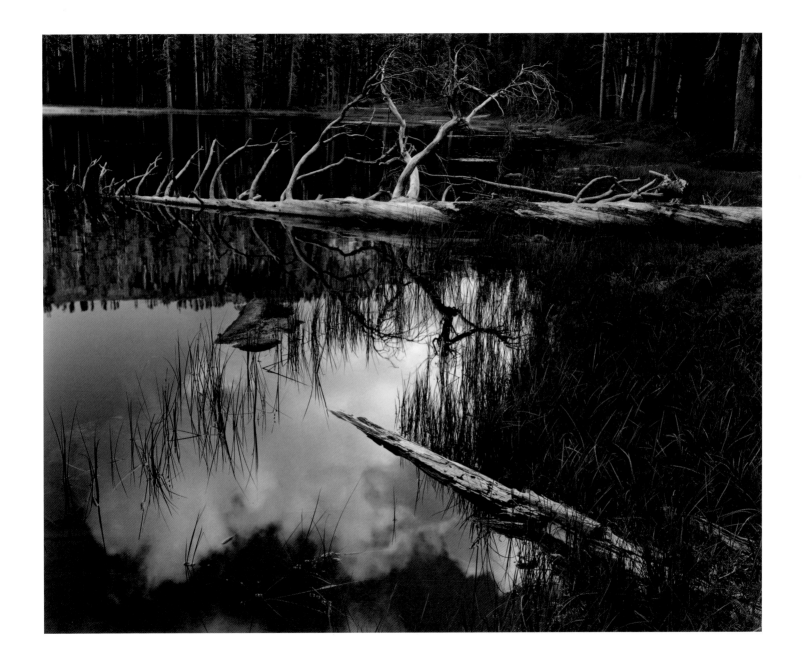

SIESTA LAKE, YOSEMITE NATIONAL PARK, CALIFORNIA, C. 1958

MERCED RIVER POOL, YOSEMITE NATIONAL PARK, CALIFORNIA, C. 1950

WATER AND FOAM, YOSEMITE NATIONAL PARK, CALIFORNIA, C. 1959

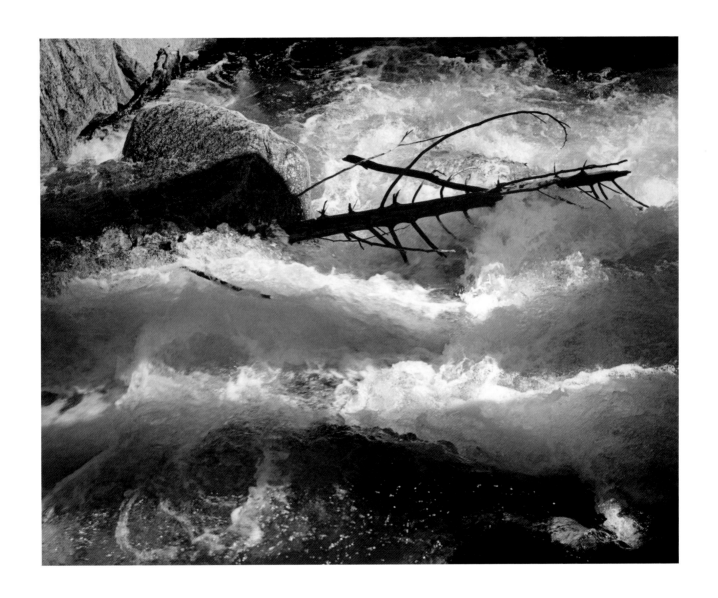

RUSHING WATER, MERCED RIVER, YOSEMITE NATIONAL PARK, CALIFORNIA, C. 1955

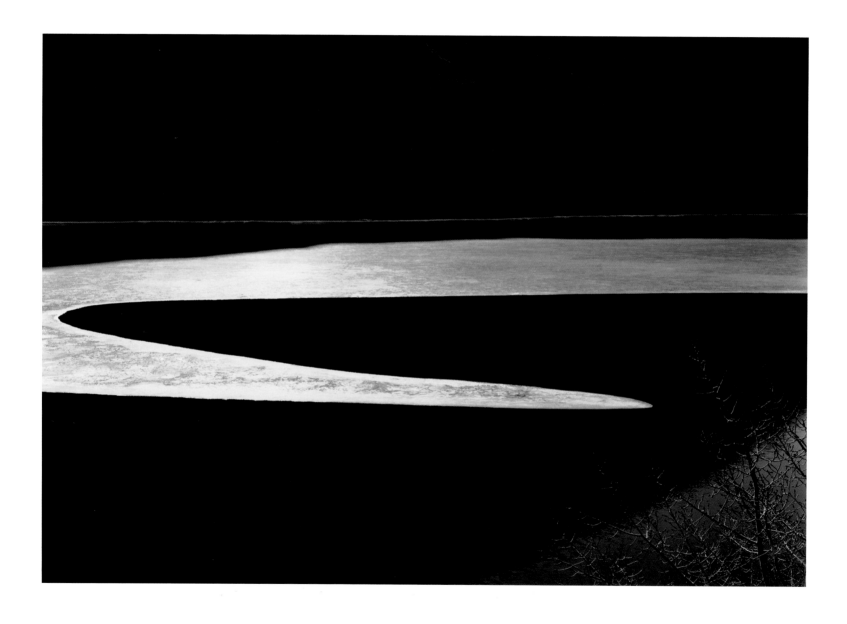

ICE ON ELLERY LAKE, SIERRA NEVADA, CALIFORNIA, 1959

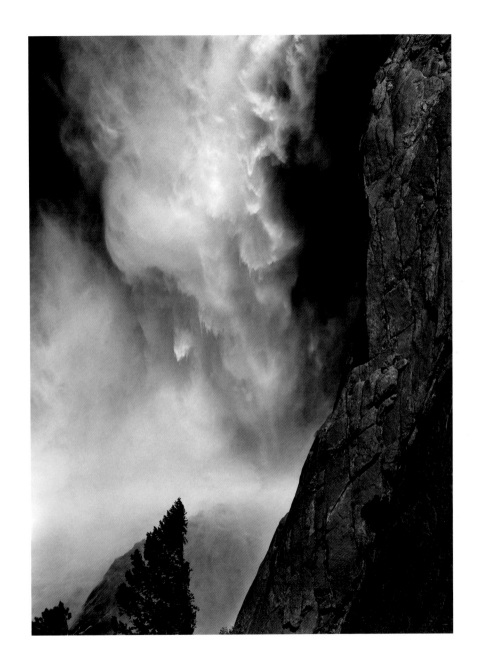

BASE OF UPPER YOSEMITE FALL, YOSEMITE NATIONAL PARK, CALIFORNIA, C. 1950

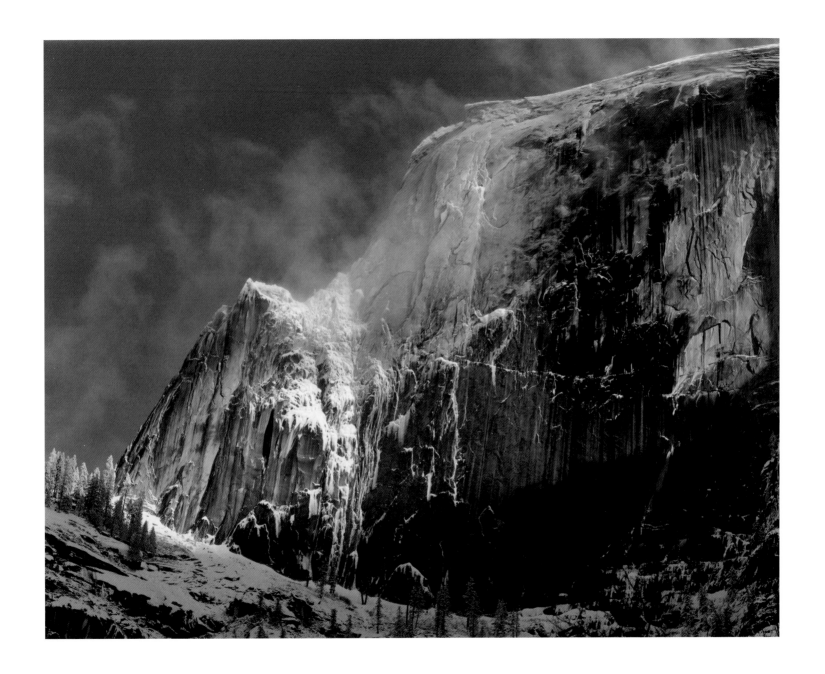

HALF DOME, BLOWING SNOW, YOSEMITE NATIONAL PARK, CALIFORNIA, C. 1955

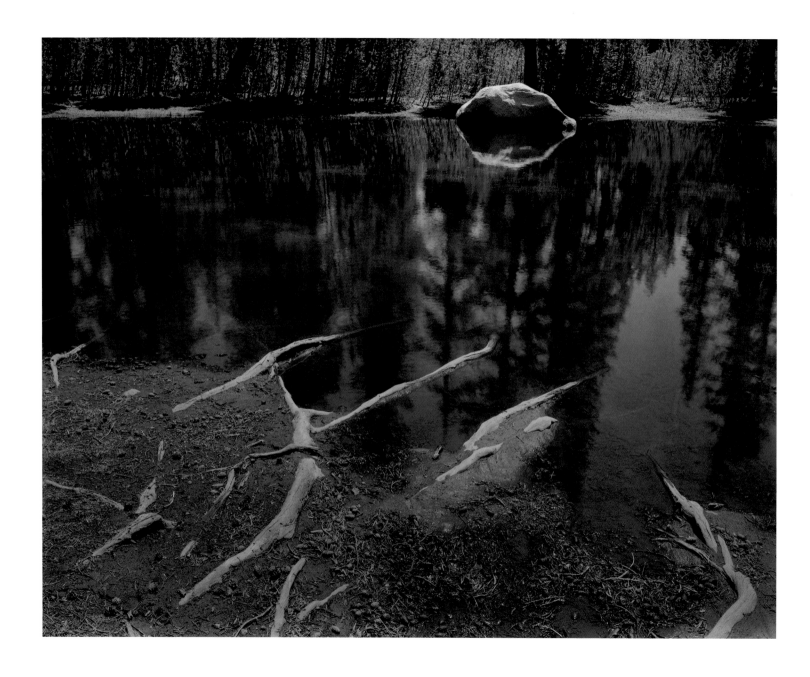

ROOTS AND POOL NEAR TENAYA LAKE, YOSEMITE NATIONAL PARK, CALIFORNIA, 1955

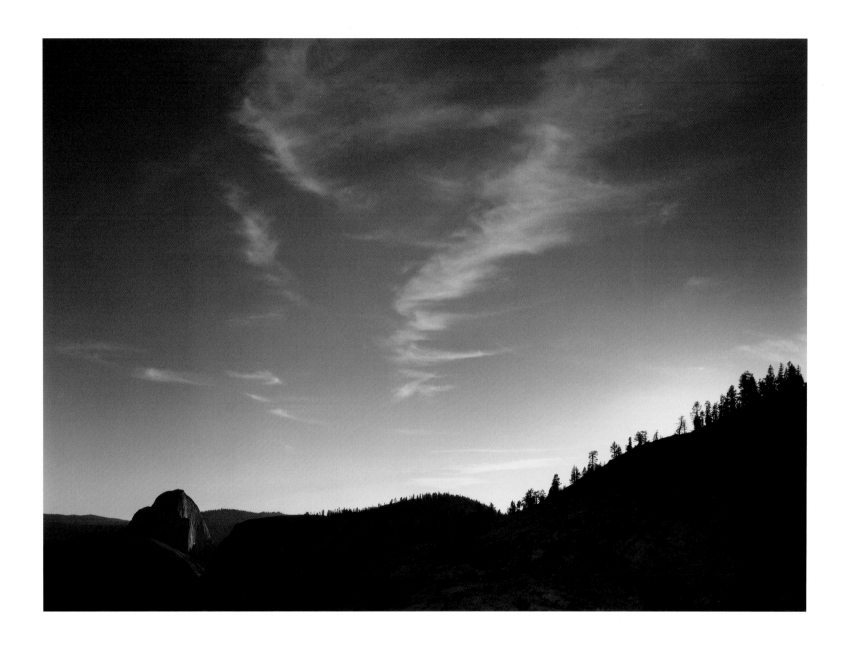

HALF DOME, EVENING, FROM OLMSTED POINT, YOSEMITE NATIONAL PARK, CALIFORNIA, C. 1959

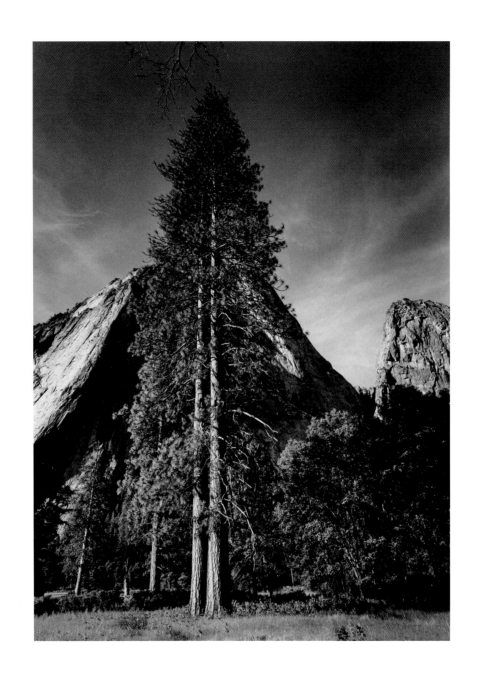

TREES AND CLIFFS, YOSEMITE NATIONAL PARK, CALIFORNIA, 1954

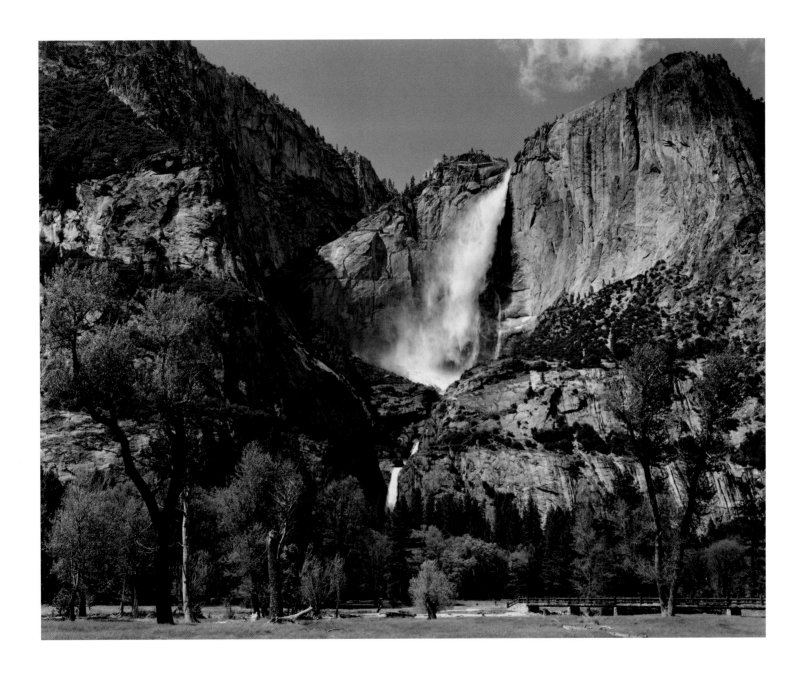

YOSEMITE FALLS AND MEADOW, YOSEMITE NATIONAL PARK, CALIFORNIA, 1953

MOON AND CLOUDS, NORTHERN CALIFORNIA, 1959

MOUNTAINS FROM CONWAY SUMMIT, EARLY SPRING, SIERRA NEVADA, CALIFORNIA, 1952

TREE, STUMP, AND MIST, NORTH CASCADES NATIONAL PARK, WASHINGTON, 1958

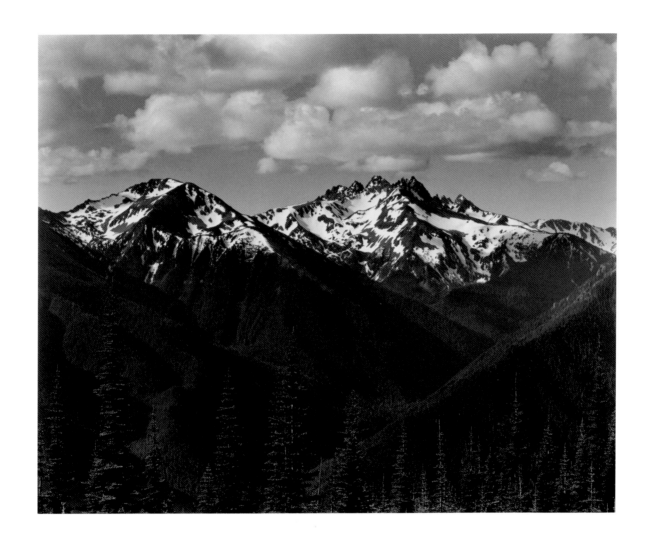

FROM HURRICANE HILL, OLYMPIC NATIONAL PARK, WASHINGTON, C. 1950

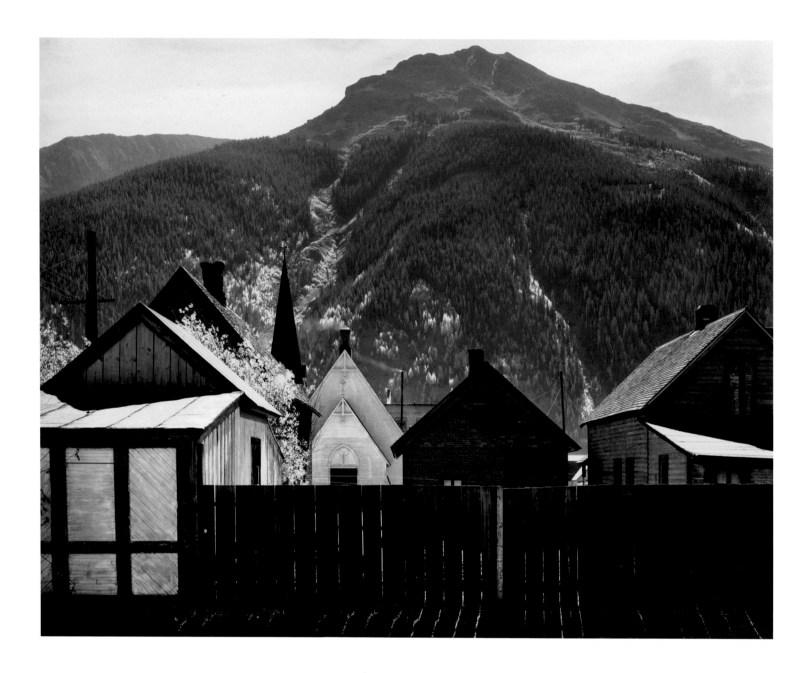

SILVERTON, COLORADO, 1951

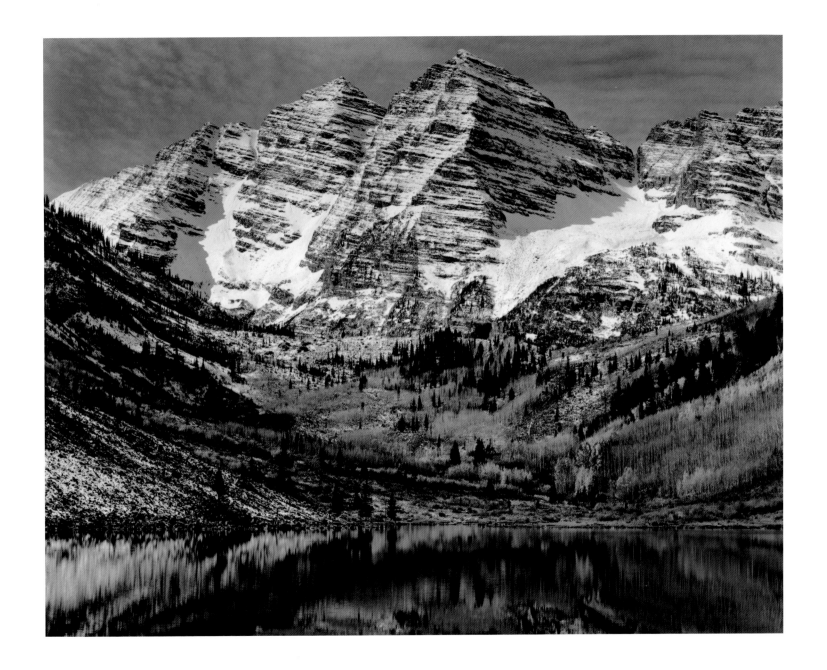

MAROON BELLS, NEAR ASPEN, COLORADO, 1951

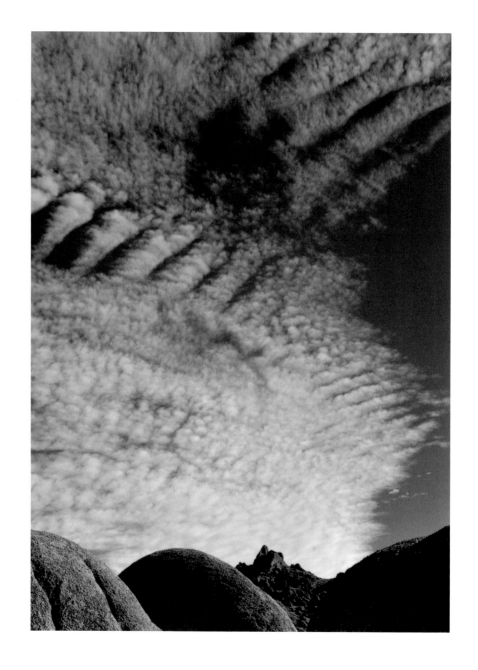

ALABAMA HILLS, CLOUDS, OWENS VALLEY, CALIFORNIA, 1950

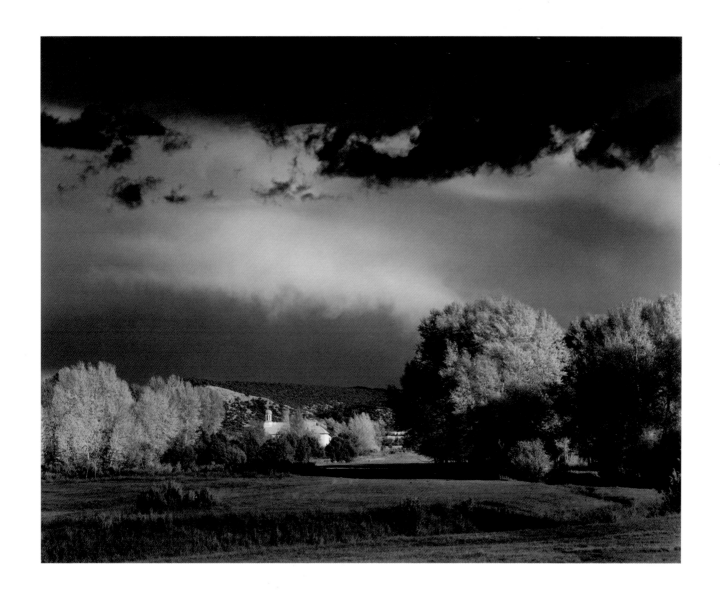

AUTUMN STORM, LAS TRAMPAS, NEAR PEÑASCO, NEW MEXICO, C. 1958

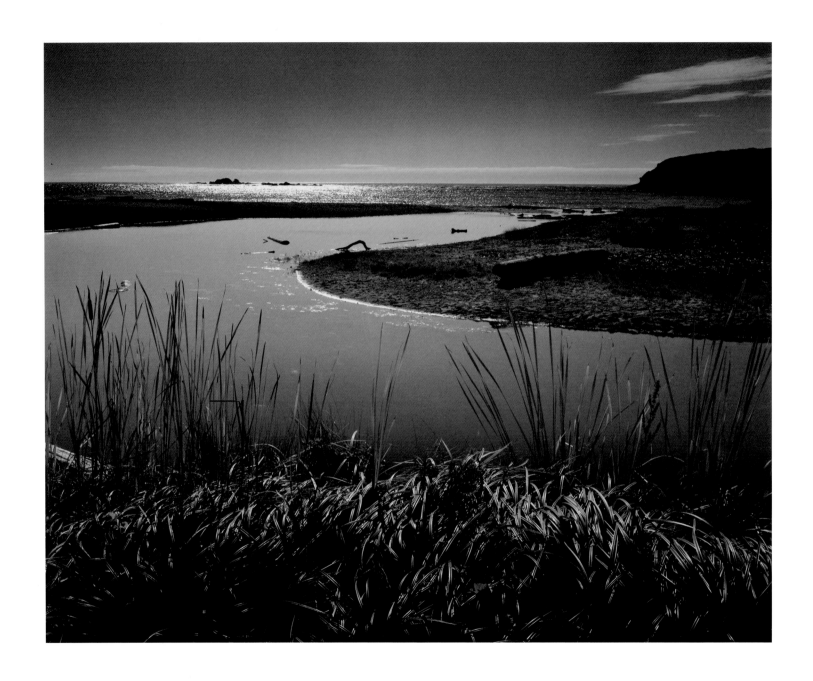

GRASS, REEDS, WATER, NEAR LITTLE RIVER, NORTHERN CALIFORNIA, 1959

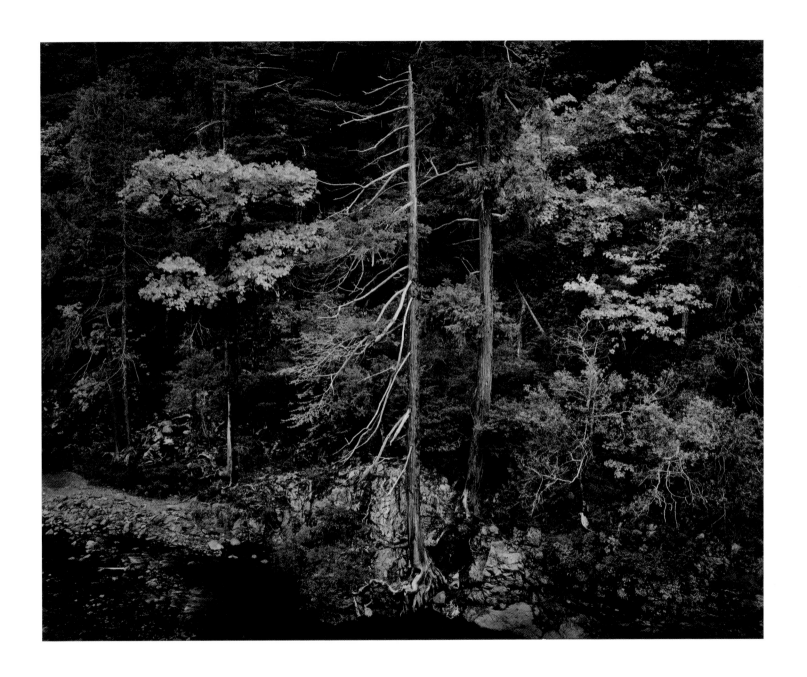

FOREST AND STREAM, NORTHERN CALIFORNIA, 1959

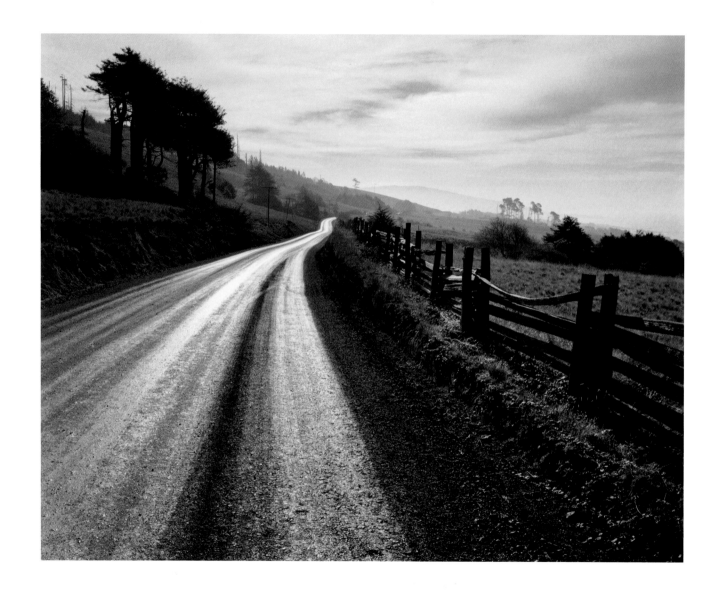

ROAD AFTER RAIN, NORTHERN CALIFORNIA, 1959

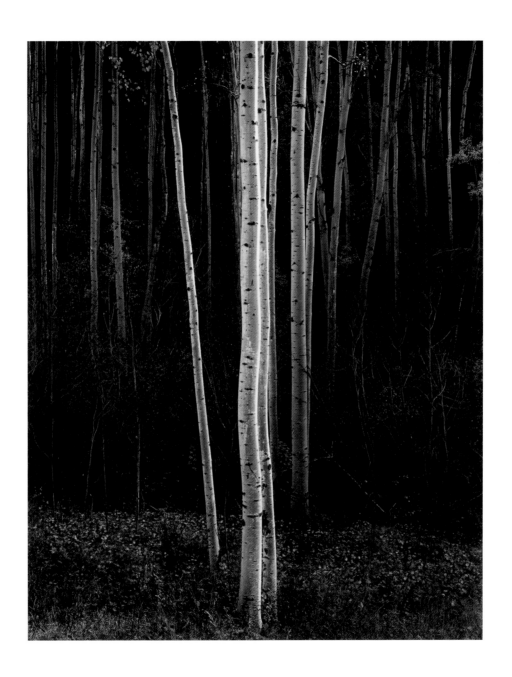

ASPENS, NORTHERN NEW MEXICO, 1958

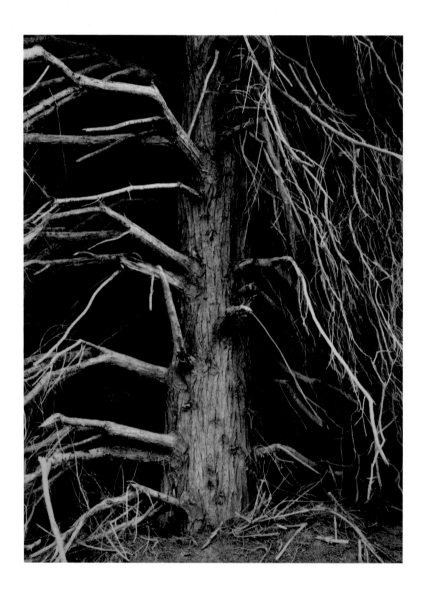

CYPRESS TREE, POINT ARENA, CALIFORNIA, 1959

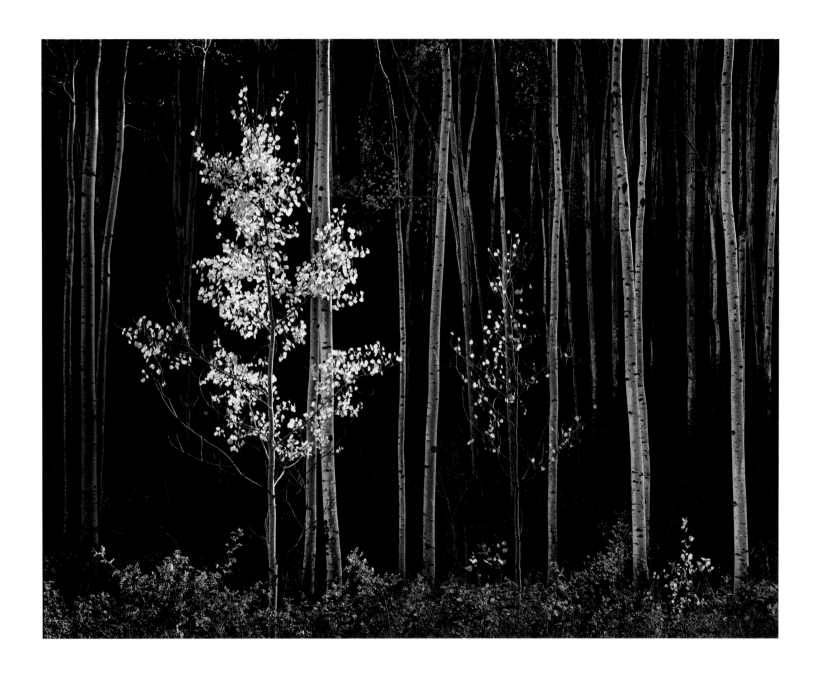

ASPENS, NORTHERN NEW MEXICO, 1958

1960–1968 CARMEL

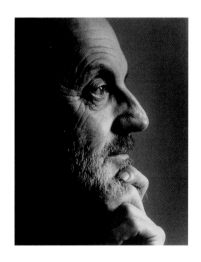

Adams photographed less and less in this period, but he printed more and more. Unlike photographers who work with professional labs, Adams made every print himself, and in the last decade of his life, from 1974 to 1984, he could be found almost every morning in his state-of-the-art darkroom making prints to fill the hundreds of orders from individuals and galleries. When he was not in the darkroom, he devoted his time to working on books and exhibitions of his photographs, revising his technical books, teaching, and tackling conservation issues. He was happiest when his days brimmed over with people and projects.

Yet, when the opportunity arose, Adams could still make impressive photographs. One early morning in 1968, when he and his family were in Yosemite for Christmas, he awoke to find the valley covered with newly fallen snow. He drove to the classic El Capitan viewpoint, set up his Hasselblad camera and tripod in deep snow, and made *El Capitan, Winter, Sunrise* (page 411), perhaps his last important photograph.

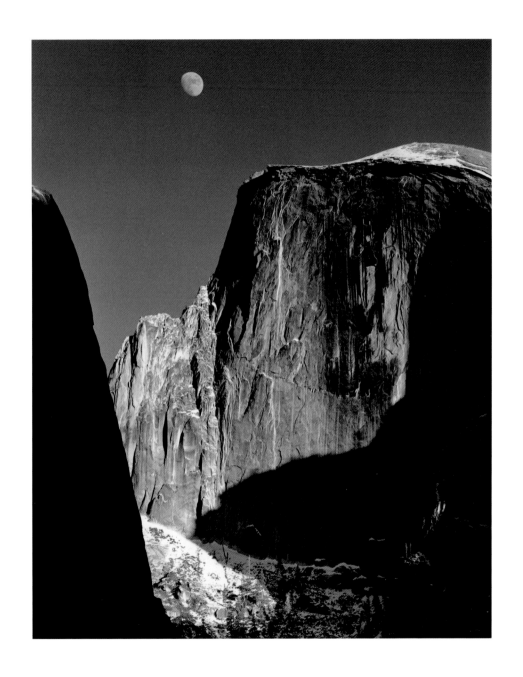

MOON AND HALF DOME, YOSEMITE NATIONAL PARK, CALIFORNIA, 1960

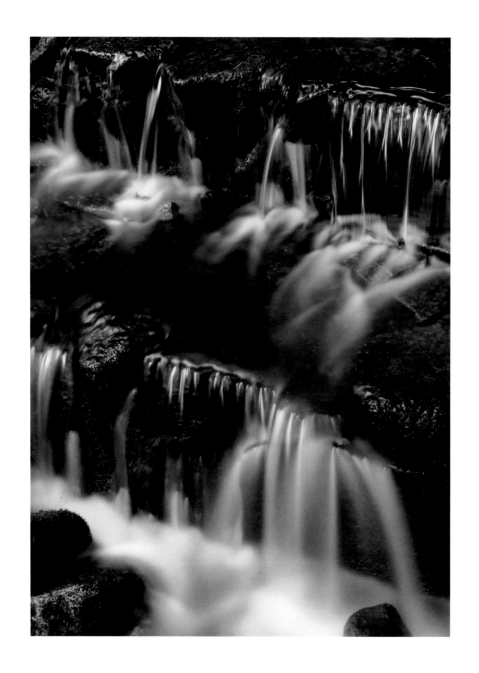

FERN SPRING, DUSK, YOSEMITE NATIONAL PARK, CALIFORNIA, C. 1961

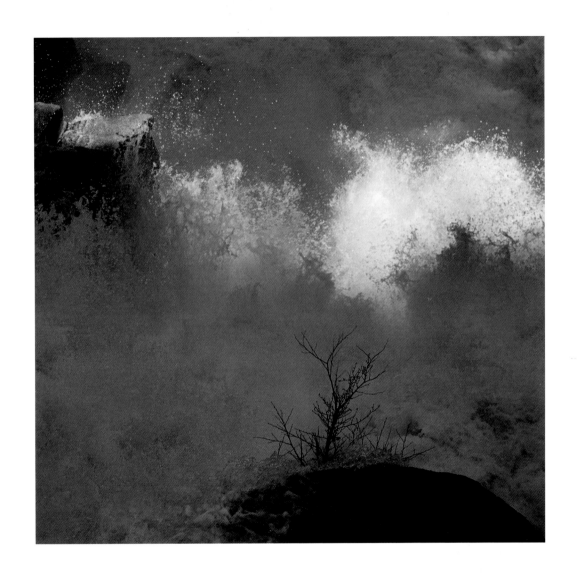

SHRUB AND RAPIDS, MERCED RIVER, YOSEMITE NATIONAL PARK, CALIFORNIA, C. 1960

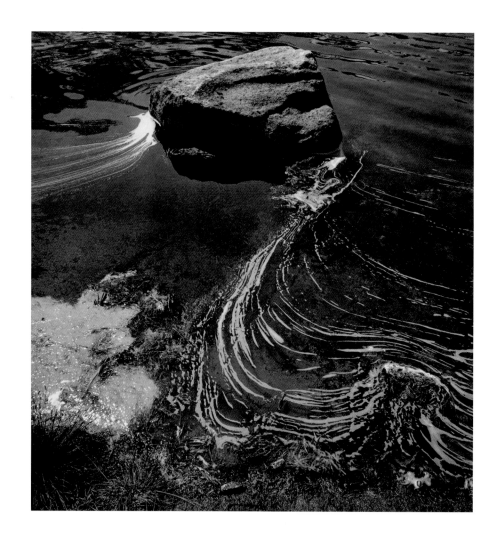

ROCK AND FOAM, TENAYA LAKE, YOSEMITE NATIONAL PARK, CALIFORNIA, C. 1960

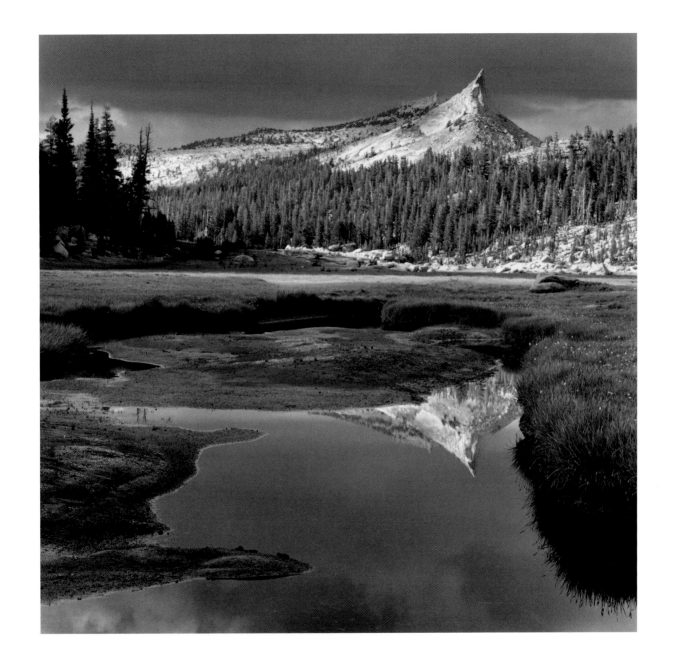

COLUMBIA FINGER, POOL, YOSEMITE NATIONAL PARK, CALIFORNIA, C. 1960

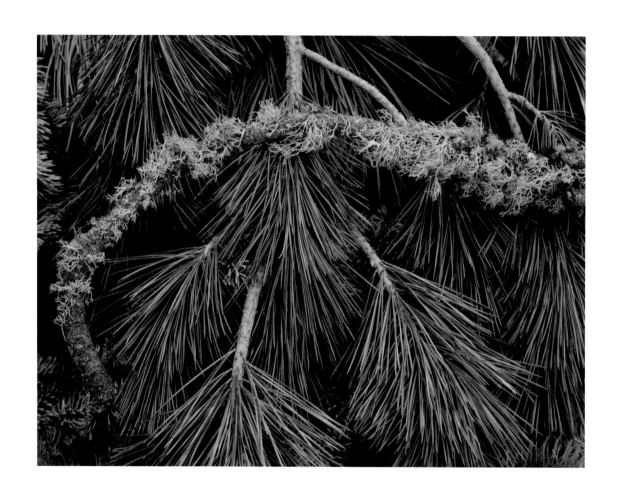

SUGARPINE BOUGHS AND LICHEN, YOSEMITE NATIONAL PARK, CALIFORNIA, 1962

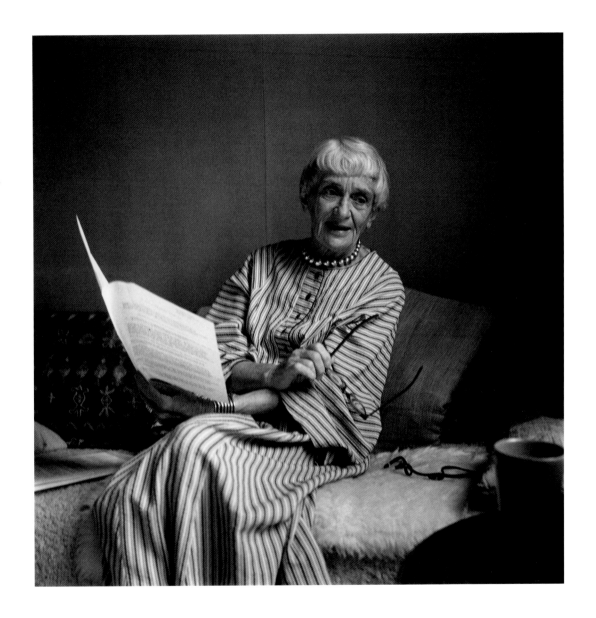

DOROTHEA LANGE, BERKELEY, CALIFORNIA, 1965

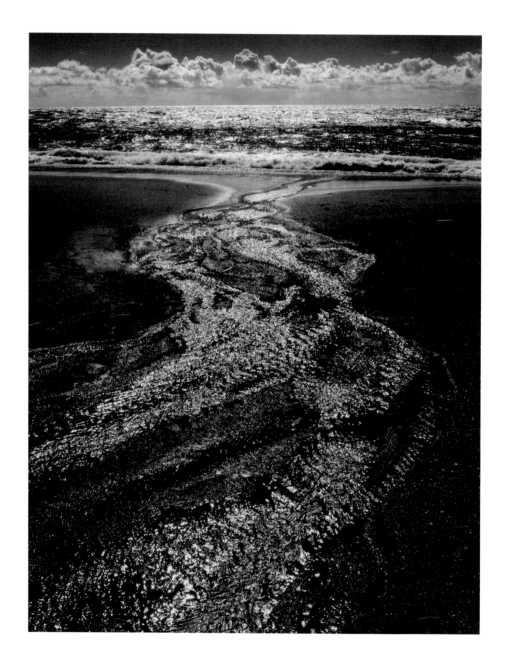

STREAM, SEA, CLOUDS, RODEO LAGOON, GOLDEN GATE NATIONAL RECREATION AREA, CALIFORNIA, 1962

BLAIR STAPP, MOSS LANDING, CALIFORNIA, 1965

ROBERT BOARDMAN HOWARD, SAN FRANCISCO, CALIFORNIA, 1961

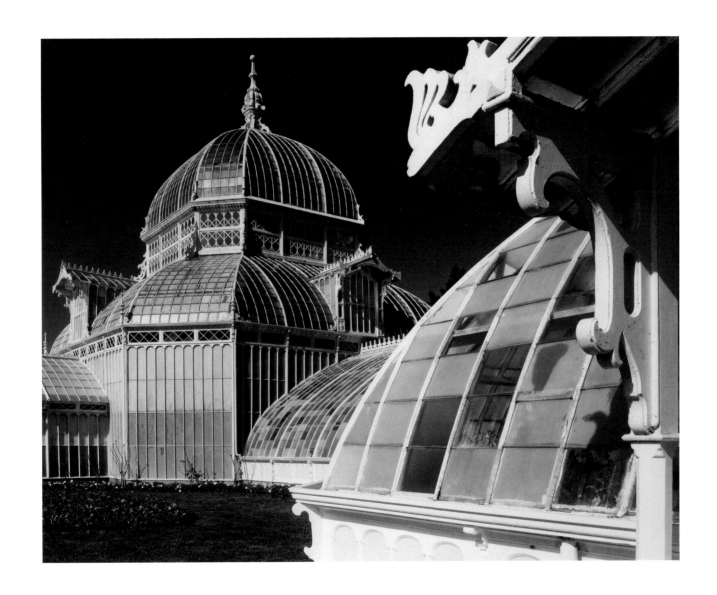

CONSERVATORY, GOLDEN GATE PARK, SAN FRANCISCO, CALIFORNIA, 1962

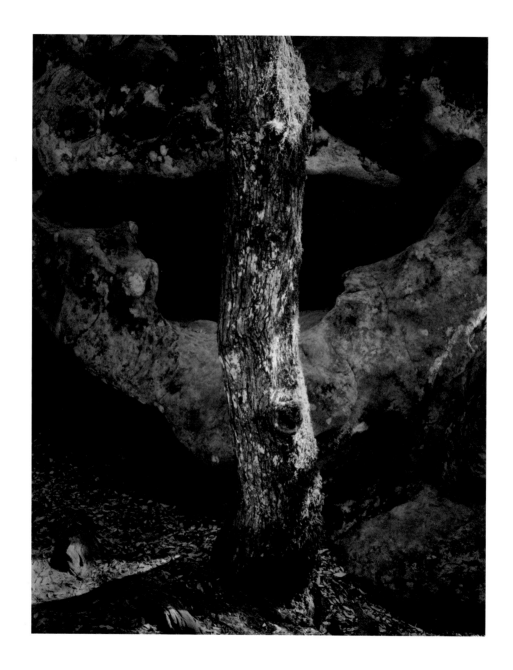

CASTLE ROCK, SUMMIT ROAD ABOVE SARATOGA, CALIFORNIA, 1963

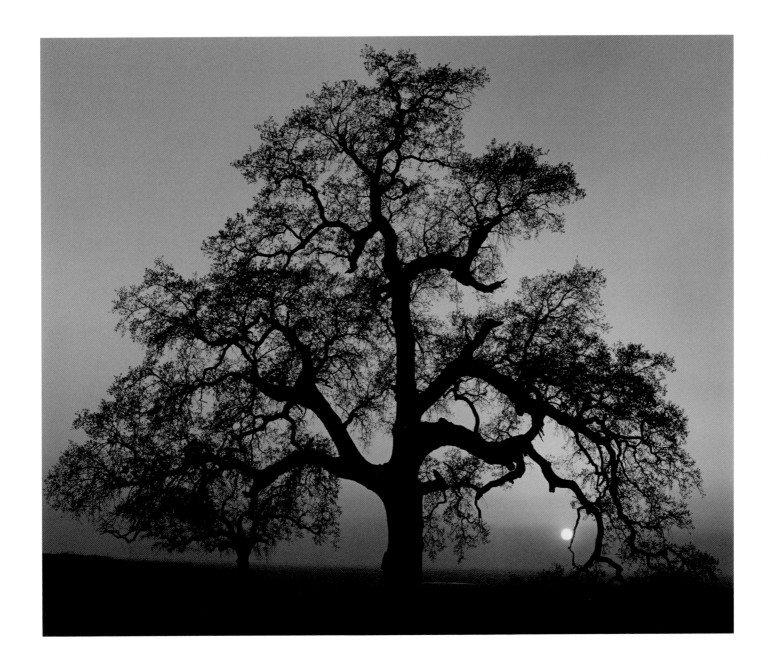

OAK TREE, SUNSET CITY, CALIFORNIA, 1962

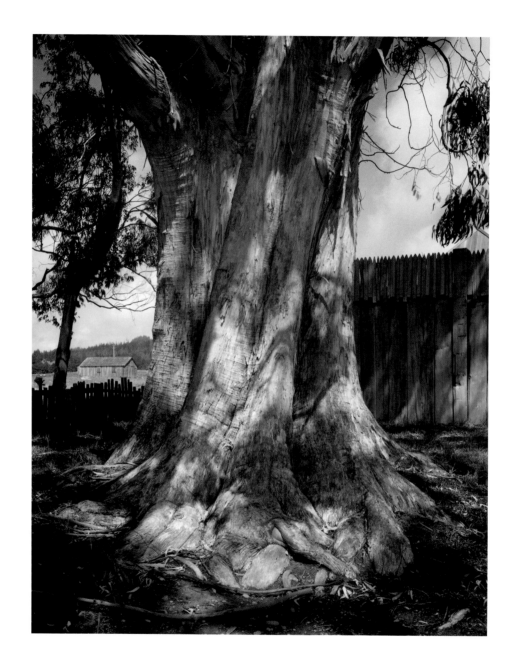

EUCALYPTUS TREE, FORT ROSS, CALIFORNIA, 1969

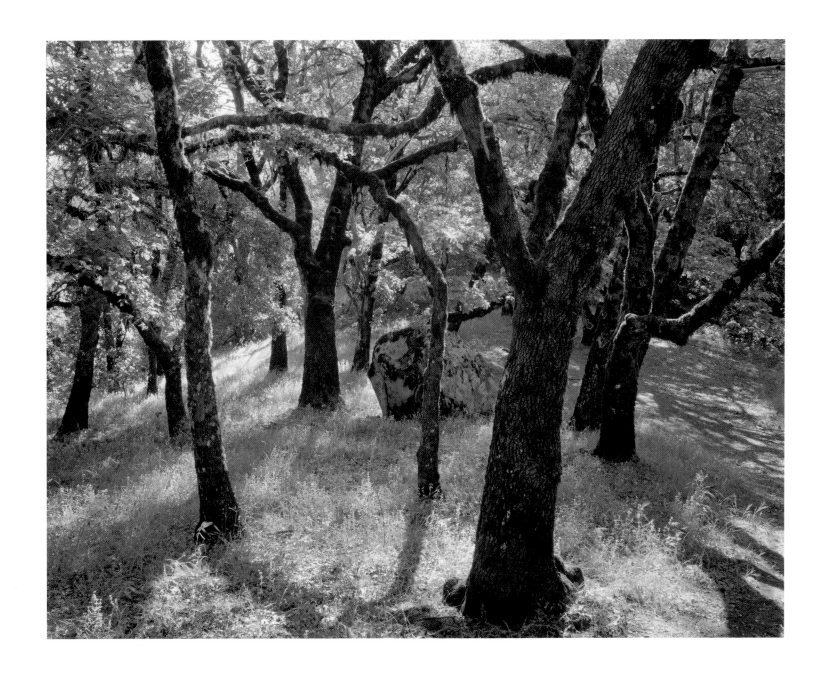

FOREST, CASTLE ROCK STATE PARK, CALIFORNIA, 1962

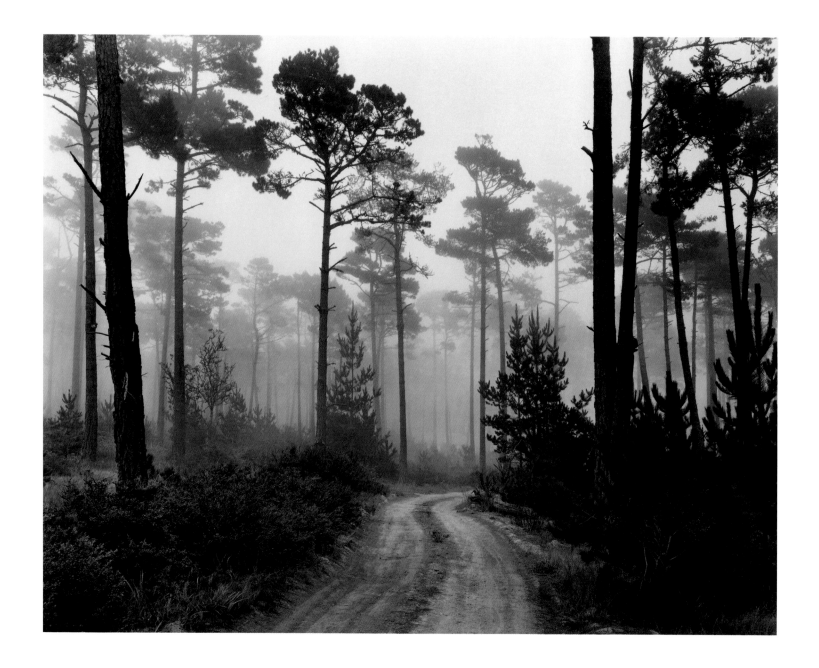

394 ROAD AND FOG, DEL MONTE FOREST, PEBBLE BEACH, CALIFORNIA, 1964

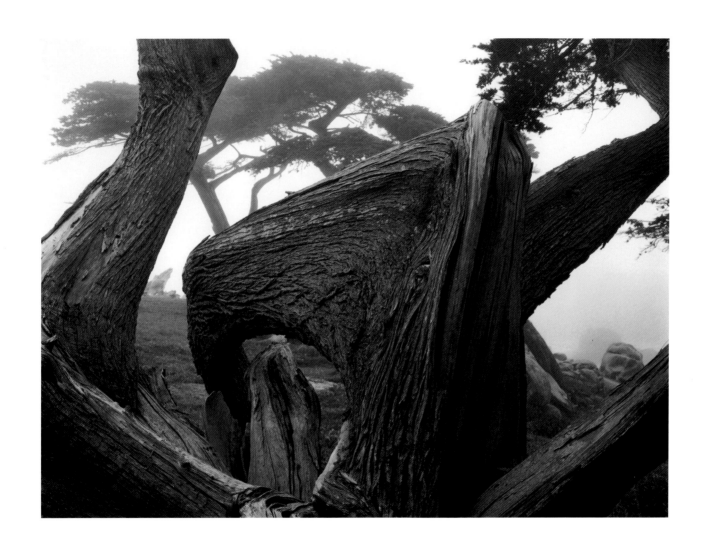

CYPRESS AND FOG, PEBBLE BEACH, CALIFORNIA, 1967

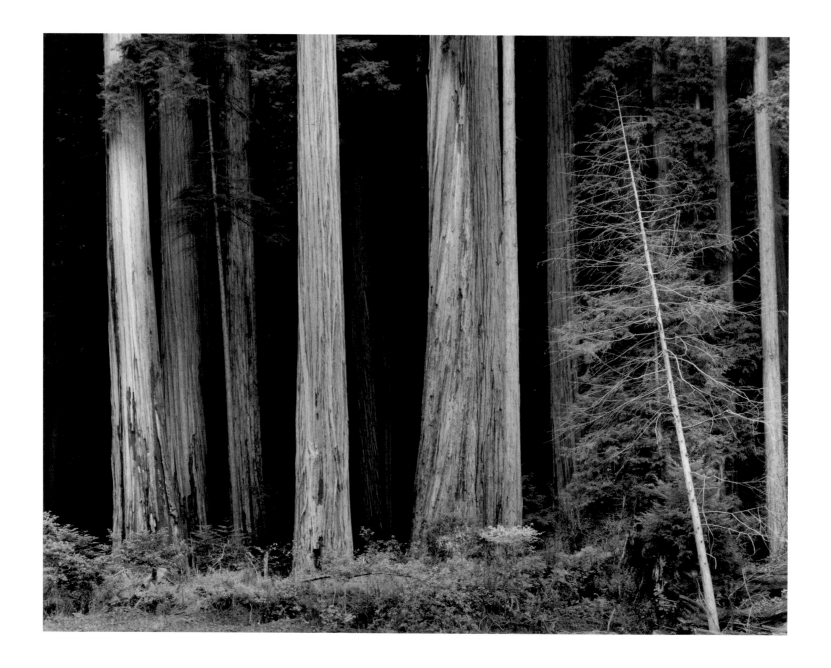

REDWOODS, BULL CREEK FLAT, NORTHERN CALIFORNIA, 1960

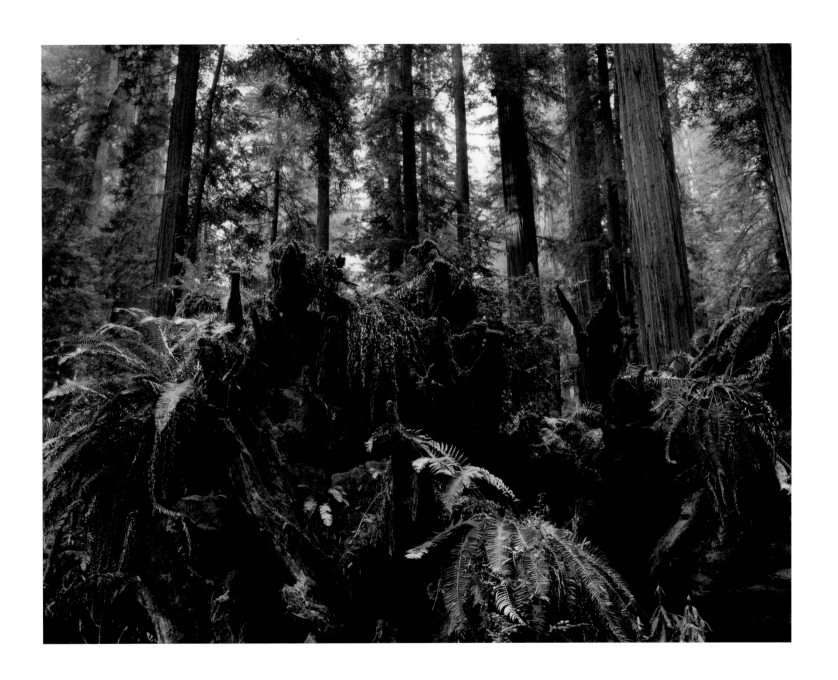

REDWOOD STUMP AND FERNS, ROCKEFELLER GROVE, CALIFORNIA, 1964

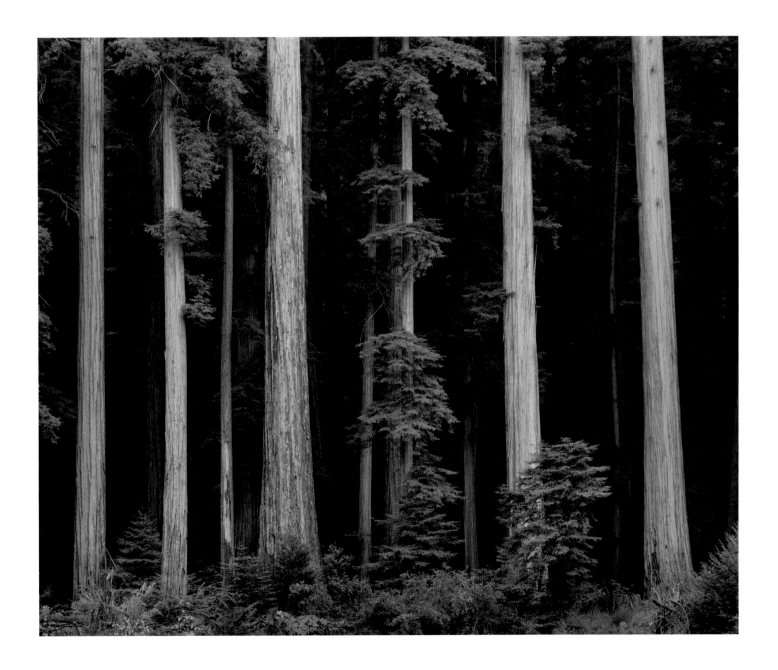

REDWOODS, BULL CREEK FLAT, NORTHERN CALIFORNIA, 1960

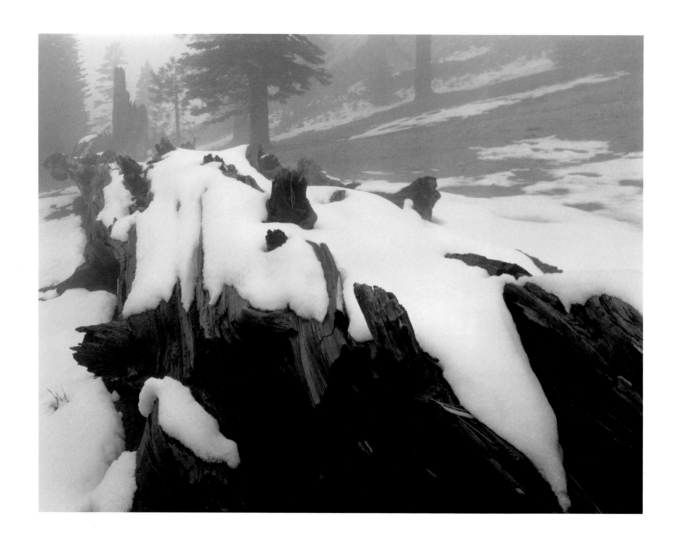

MORNING MIST, NEAR GLACIER POINT, YOSEMITE NATIONAL PARK, CALIFORNIA, C. 1962

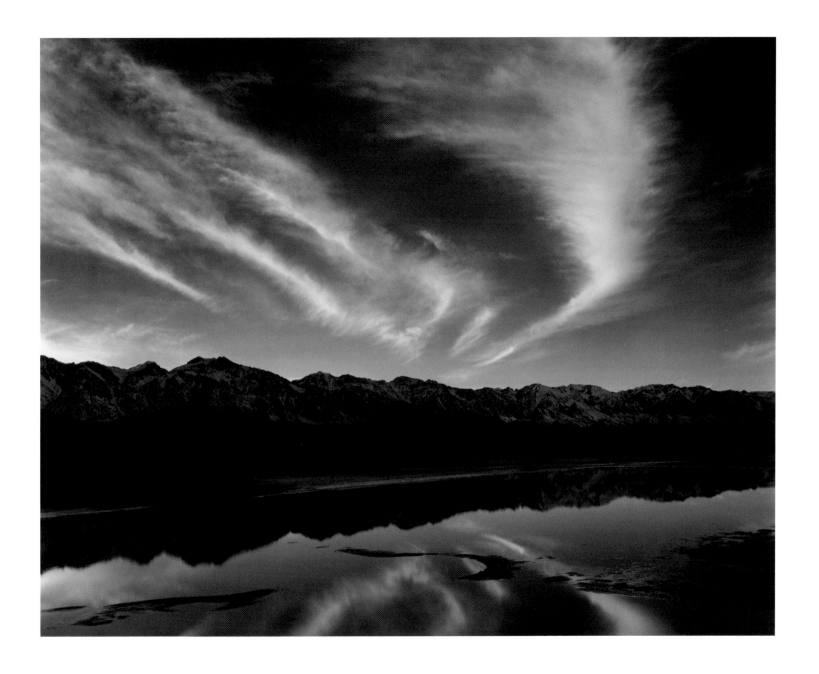

EVENING CLOUDS AND POOL, EAST SIDE OF THE SIERRA NEVADA, FROM THE OWENS VALLEY, CALIFORNIA, C. 1962

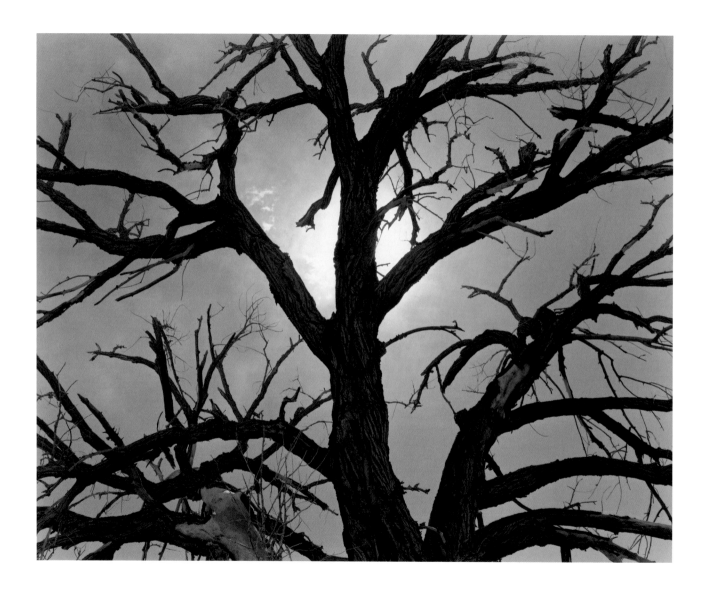

DEAD COTTONWOOD TREE, NEAR SANTA FE, NEW MEXICO, 1961

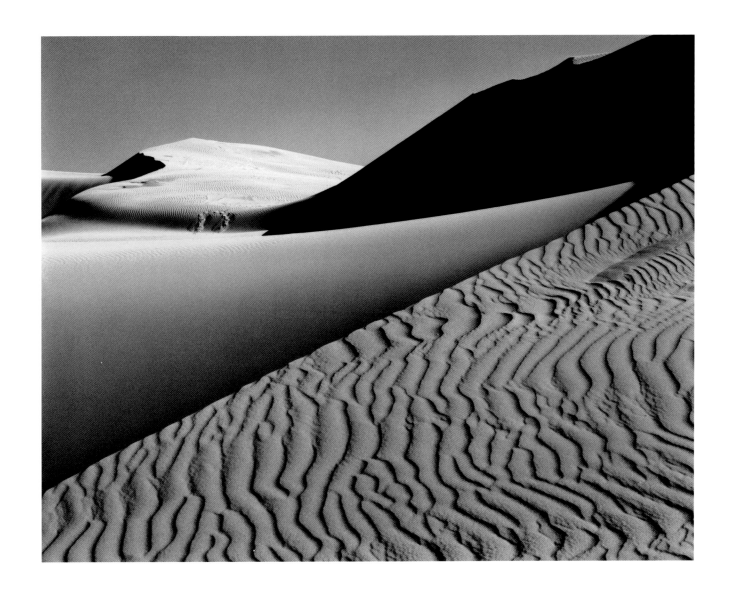

DUNES, OCEANO, CALIFORNIA, 1963

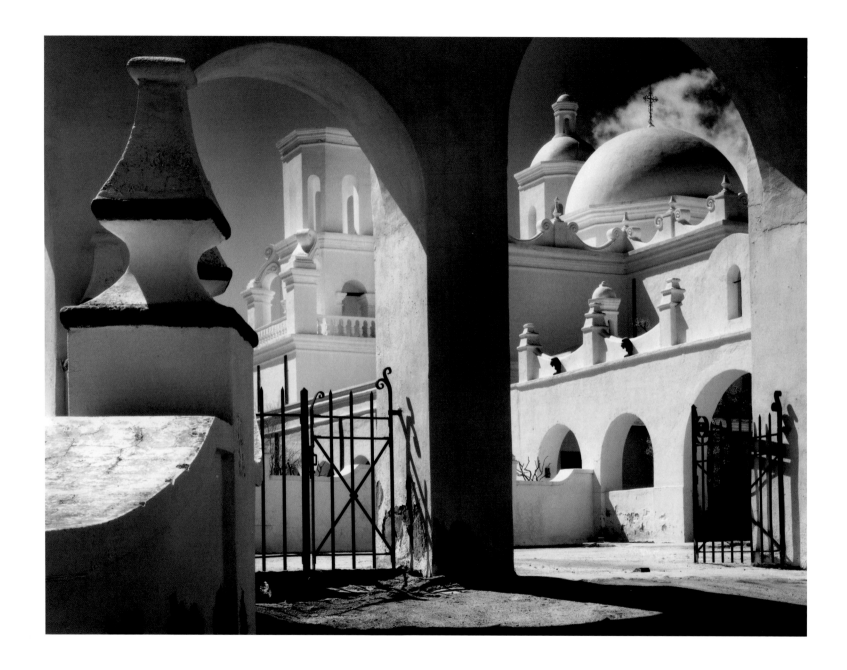

ARCHES, NORTH COURT, MISSION SAN XAVIER DEL BAC, TUCSON, ARIZONA, 1968

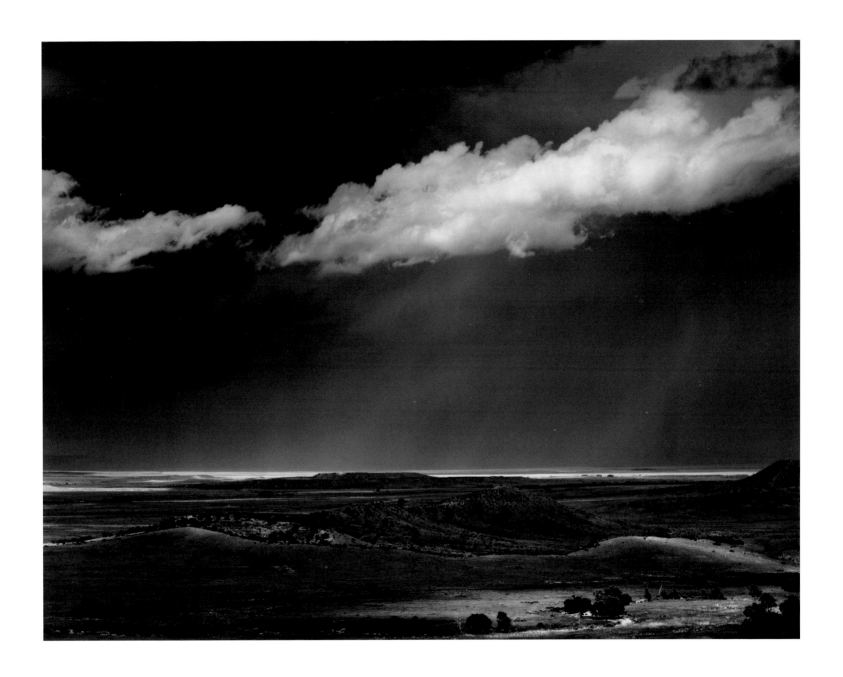

THUNDERSTORM OVER THE GREAT PLAINS, NEAR CIMARRON, NEW MEXICO, 1961

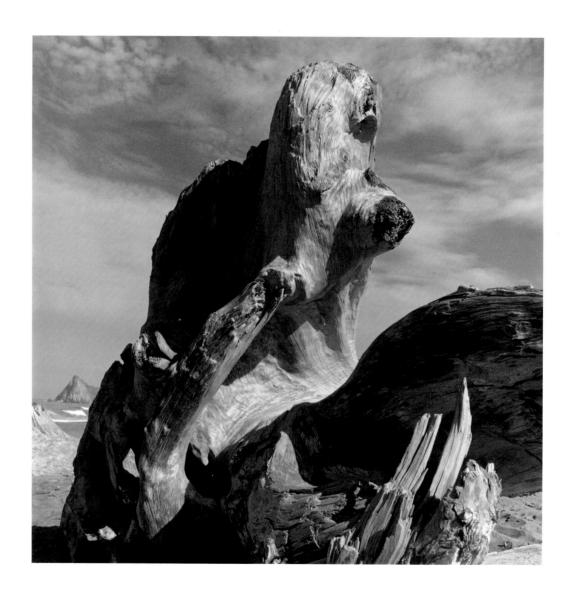

STUMP, TRINIDAD HEAD, NORTHERN CALIFORNIA, 1966

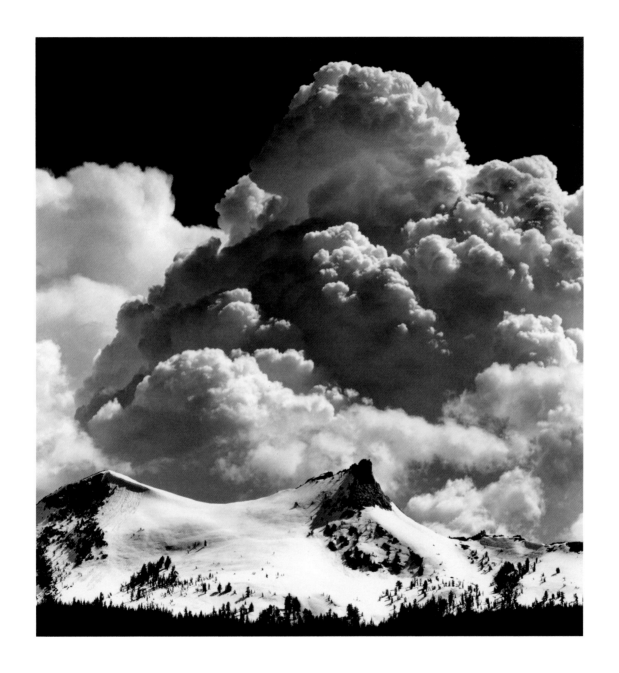

THUNDERCLOUD, UNICORN PEAK, YOSEMITE NATIONAL PARK, CALIFORNIA, 1967

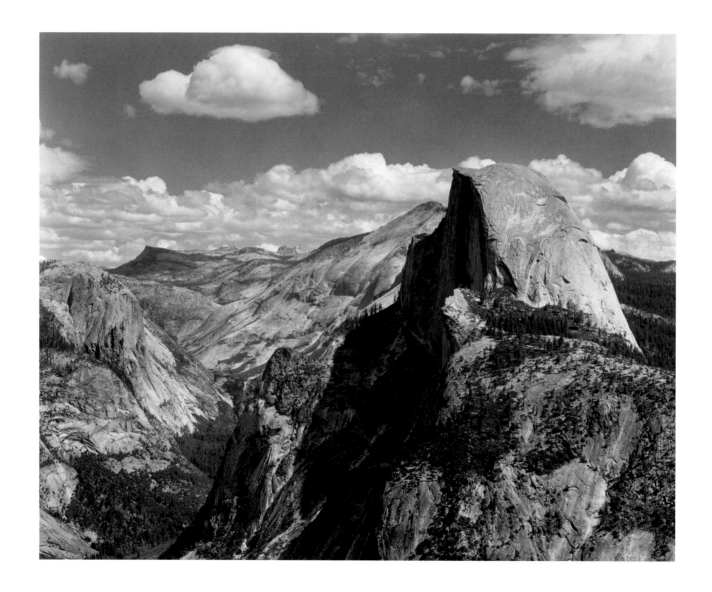

HALF DOME AND CLOUDS, YOSEMITE NATIONAL PARK, CALIFORNIA, C. 1968

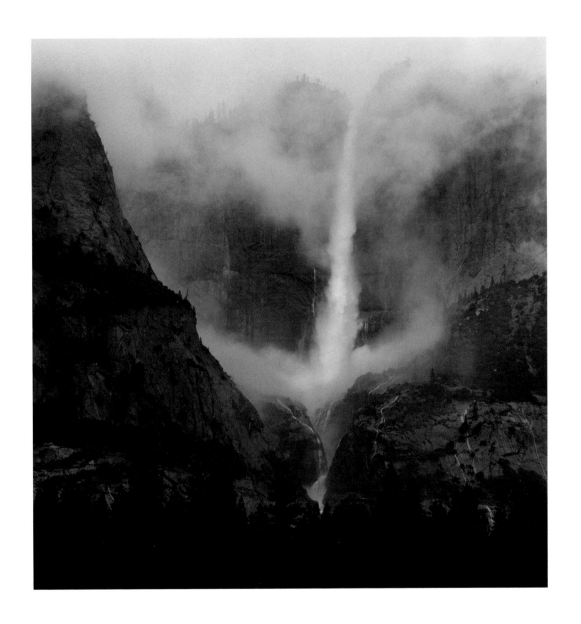

YOSEMITE FALLS, CLOUDS AND MIST, YOSEMITE NATIONAL PARK, CALIFORNIA, 1964

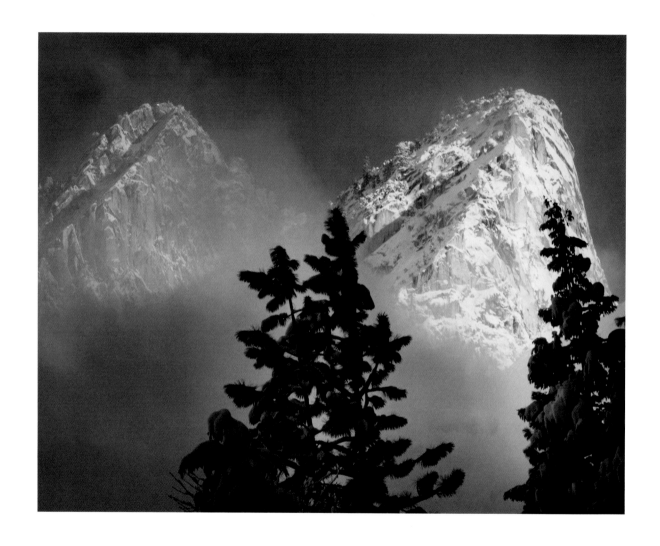

EAGLE PEAK AND MIDDLE BROTHER, WINTER, YOSEMITE NATIONAL PARK, CALIFORNIA, C. 1968

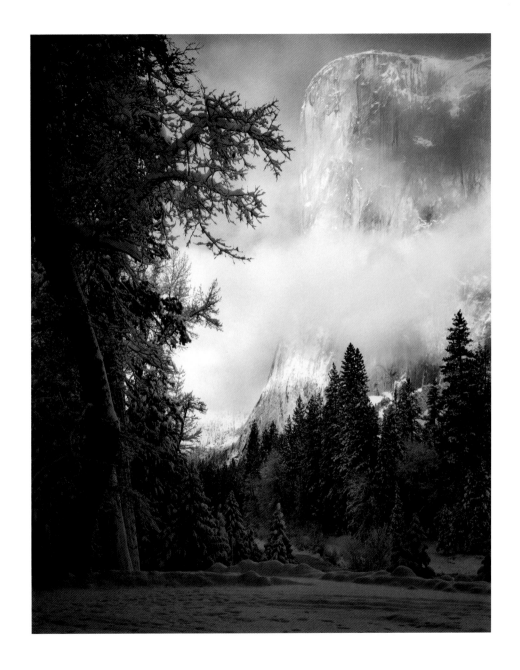

EL CAPITAN, WINTER, SUNRISE, YOSEMITE NATIONAL PARK, CALIFORNIA, 1968

NOTES ON SELECTED PHOTOGRAPHS

1916–1930

Pages 13–15. *Album of photographs Adams made after his first trip to Yosemite National Park in June 1916.*

With his new Kodak Box Brownie camera, the fourteen-year-old Adams made a "visual diary" of the trip. His father helped him glue the photographs into an album and painstakingly wrote captions in white ink on the black pages. Adams continued to photograph Half Dome and El Capitan over the next sixty years. "I knew my destiny when I first experienced Yosemite!" Adams later wrote.

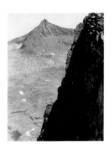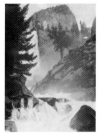

Page 22. *Fall in Upper Tenaya Canyon, Yosemite National Park, California, c. 1920; Simmons Peak, in the Maclure Fork Canyon, Yosemite National Park, California, c. 1924.*
Page 23. *Vernal Fall through Tree, Yosemite National Park, California, 1920; Back of Half Dome, Yosemite National Park, California, c. 1920.*

Although these four images were made when Adams was in his late teens, they show a remarkably sophisticated sense of composition. They exist only as small contact prints made around the same time as the negatives. Because Adams neither published them in articles or books nor included them in exhibitions, they are largely unknown.

Page 25. *Lodgepole Pines, Lyell Fork of the Merced River, Yosemite National Park, California, 1921.*

By the time Adams was nineteen years old, he had taught himself the fundamentals of photography and enjoyed experimenting with different equipment. For this photograph, he used a soft-focus lens, producing what he described as a "flare of shimmering light."

In 1927 Adams published a portfolio of eighteen original photographs, *Parmelian Prints of the High Sierras*. He included this image in the portfolio. The edition of fifty copies sold out at $50 each, a high price for the period. He began to see for the first time that he might be able to make a living in photography.

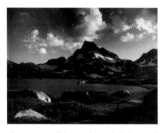

Page 40. *Banner Peak and Thousand Island Lake, Sierra Nevada, California, 1923.*

Adams took this picture on an extended pack trip in the Yosemite High Sierra with his friend Harold Saville. He was drawn to the "glowing evening cloud" that appeared after a drenching thunderstorm. "I can recall the excitement of the scene," he related, "though I had no precise idea of the image I was to make." (Compare this statement with what he wrote only four years later about *Monolith*, page 35.) While Adams worked, Saville assisted by holding the lead for the pack burro, or, as he laughingly described it, "holding Ansel's ass."

Although Adams could easily recall such details as camera, lens, film, or the feeling of wind on his cheek, he never remembered dates. We have the date for this image, however, because it appears on the application for copyright: August 24, 1923.

Page 27. *Kearsarge Pinnacles, Kings Canyon National Park, California, c. 1925.*
In the 1920s Adams printed this negative on cream-colored photographic paper with a slightly textured matte surface. Less than ten years later, he photographed the same view, without the intrusive foreground trees,

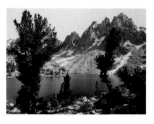

and printed the negative on glossy white paper (page 108). The subject remains the same, but the photographs are quite different, in terms of both composition and presentation.

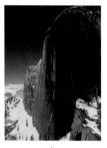

Page 35. *Monolith, the Face of Half Dome, Yosemite National Park, California, 1927.*
At the age of fourteen, Adams first recorded the Yosemite monolith known as Half Dome with his Kodak Box Brownie (page 13). Eleven years later he made this image with a view camera and a glass plate negative.

On an April morning in 1927, Adams undertook a difficult four-thousand-foot climb through heavy snow to the granite outcropping known as the Diving Board, where he set up his 6½ x 8½-inch view camera, inserted a glass plate, and waited for the light to fall directly on the sheer granite cliff. He made one exposure with a yellow filter. Then it occurred to him that if he used a dark red filter, both sky and cliff would register darker in the finished print than in the actual scene. He changed to the red filter, with this dramatic result. He described this episode as his first "visualization" — his attempt to express the emotional and aesthetic feelings he felt at the time he made the photograph. Adams considered it a seminal moment in his development as a photographer.

Page 37. *On the Heights, Yosemite National Park, California, 1927.*
Barely visible on the distant rocky outcrop called the Diving Board is Virginia Best, Adams' future wife. She accompanied Adams on the trek to make the picture known as *Monolith* (page 35). As they ascended from the floor of Yosemite Valley, Adams made a number of photographs, including this image and the one on page 33. What is the subject of this photograph? Is

it Virginia Best? Is it the tree in the foreground? Is it the distant cliffs of Yosemite? In the 1970s, Adams would describe this as "confused seeing," but at the time he was quite proud of this photograph and included it in his portfolio, *Parmelian Prints of the High Sierras.*

Page 53. *Robinson Jeffers, Carmel, California, 1927.*
The celebrated poet Robinson Jeffers was described by Adams as "a tall man with a hard face and a bold shock of hair." For this portrait of the poet, Adams tried out a new 4 x 5 camera. "I knew very little about technique," he remembered. "It was done quite 'naturally,' by the window." Adams loved Jeffers' poetry and frequently quoted from the first lines of the poem "Return": "A little too abstract, a little too wise, it is time for us to kiss the earth again."

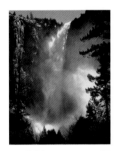

Page 41. *Bridalveil Fall, Yosemite National Park, California, 1927.*
Bridalveil Fall is one of the most beautiful waterfalls in North America. In late summer, the rush of water assumes the veil-like quality indicated by its name. The base of the fall was a popular spot for weddings, and Virginia Adams' parents were married there in 1901. In a feature about the ceremony, a San Francisco newspaper reported, "Nobody could hear a word" of the service because of the terrific noise created by thousands of gallons of water per second pounding the rocks on the valley floor.

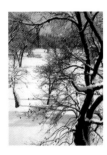

Page 46. *From the Ahwahnee Hotel, Winter, Yosemite National Park, California, 1927.*
The composition of this photograph demonstrates the artistic device that Adams referred to as "near-far." The tree on the right-hand side (near) served to focus attention on the snow-covered meadow (far). Forty years later, Adams used the same device in *El Capitan, Winter, Sunrise* (page 411).

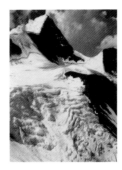

Page 52. *Mount Robson, Jasper National Park, Canada, 1928.*
On his first trip outside the United States, in July 1928, Adams camped in the Canadian Rockies with a group of Sierra Club members. To his wife, Virginia, he wrote, "The panorama is enormous — imagine about four Sierra crests spread out before you plus a myriad glaciers — and the great rock and ice-cone of Robson looming 2,000 feet above you. It's all very breathtaking."

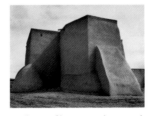

Page 59. *Saint Francis Church, Ranchos de Taos, New Mexico, c. 1929.*
"Many of my early photographs were made on orthochromatic glass plates or film," wrote Adams, "which gave a lighter value for blue sky than does panchromatic film." The photograph was made in the afternoon with no filter, rendering the blue sky quite pale and the shadows soft. "This image is an experience in light," wrote Adams. Compare this photograph with the one on page 339 made around twenty years later: the building, photographed squarely from the back, crowds the edges of the image, and the dark, lowering sky creates an ominous effect.

Some of the twentieth century's greatest artists (Paul Strand and Georgia O'Keeffe, among others) have also interpreted the church, although Adams had not seen their works when he made this photograph. The rear elevation, he wrote, "defines this building as one of the great architectural monuments of America."

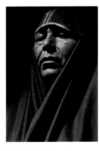

Page 53. *Tony Lujan of Taos Pueblo, New Mexico, 1930.*
In 1930, the Taos Pueblo tribal elder Tony Lujan and his wife, Mabel Dodge, visited Adams in San Francisco. "Wrapped in his blanket," Adams remembered, "Lujan seated himself on the curb in front of our house and began singing and loudly beating his resonant drum. In no time at all neighbors and children living blocks away were drawn by the insistent throb and the guttural chants he rumbled forth."

It was Lujan who negotiated permission for Adams to photograph at Taos Pueblo in New Mexico, which led to Adams' first book, *Taos Pueblo,* in 1930. The limited edition featured twelve original photographs by Adams. The 108 copies sold quickly, even at the then exceptionally high price of $75. The book is considered a masterpiece of twentieth-century book making.

the most exasperating problems to be found in all Landscape photography. The photographer is confronted with extremes of tonal value and a minimum of texture (in the snow itself). . . . The main difficulty is in the suggestion of *white substance.* The blank white of the paper is very inadequate, and, no matter how intense the blacks of the image are, unless there is some tone in the whitest part of the snow image there is no life whatever in the picture."

1931–1939

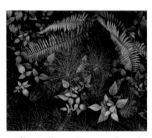

Page 64. *Leaves, Mills College, California, c. 1931.*

In 1933 Adams showed a selection of his photographs to the dean of the Art Department at Yale University. Adams wrote, "The dean was a most gracious and kindly person but had never seen my type of photographs. He was taken with 'Leaves, Mills College Campus' and asked, 'Just what is this?' I said, 'It is a picture of foliage.' 'Yes, I understand that, but what is the subject?' I said, 'What do you mean?' He replied (just a bit testily), 'What is the medium — is it an etching, a lithograph, or a detailed painting?' I said, 'It's a photograph!' I was finally able to convince him that it was a direct photograph from nature. He became quite excited and arranged an exhibit of my work at Yale in 1934."

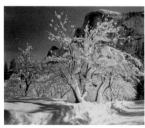

Page 117. *Half Dome, Apple Orchard, Winter, Yosemite National Park, California, c. 1932.*
After several summer visits to Yosemite, Adams made his first winter trip in 1920. "I wouldn't have missed this for the world," he wrote his father, "and consider it the finest season I have seen at Yosemite."

Of the difficulties the photographer faces in winter photography, Adams wrote, "Perhaps snow subjects offer

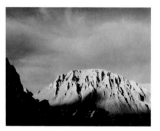

Page 95. *Mount Whitney from the West, Sierra Nevada, California, 1932.*
This photograph was made on one of the annual summer camping trips organized by the Sierra Club. The High Trips, as they were known, gathered up to two hundred hardy members for several weeks of camping, strenuous hiking, and climbing in the Sierra Nevada. Adams accompanied the trips, sometimes as official photographer, sometimes as assistant manager, from 1927 to 1935. After every outing, he put together an album of several hundred photographs taken on the trip from which Sierra Club members could order prints for $1 each.

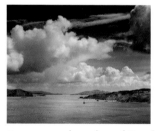

Page 75. *The Golden Gate before the Bridge, San Francisco, California, 1932.*
"One beautiful storm-clearing morning," Adams wrote, "I looked out the window of our San Francisco home and saw magnificent clouds rolling from the north over the Golden Gate. I grabbed the 8 x 10 equipment and drove to the end of 32nd Avenue, at the edge of Seacliff. I dashed along the old Cliff House railroad bed for a short distance, then down to the crest of a promontory. From there a grand view of the Golden Gate commanded me to set up the heavy tripod, attach the camera and lens, and focus on the wonderful evolving landscape of clouds."

To the author Mary Austin, he wrote, "I am going to send you the latest picture I have made — a view of the Golden Gate. I have been after that for ten years, and at last got a really satisfactory plate."

Page 85. *Carolyn Anspacher, San Francisco, California, 1932.*

This portrait of a San Francisco actress pleased Adams, but, he wrote, "to many, it was called 'The Great Stone Face' and was thought by some to be a picture of a sculptured head. This actually pleased me. . . . A painter can synthesize many impressions, observations, and reactions — creating a single expressive complex. The portrait photographer has only one passage of time." Compare this portrait with the image on page 157, made a few years later.

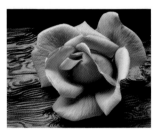

Page 87. *Rose and Driftwood, San Francisco, California, c. 1932.*

"My mother proudly brought me a large pale pink rose from our garden," wrote Adams, "and I immediately wanted to photograph it . . . but I could not find an appropriate background. . . . I finally remembered a piece of weathered plywood, picked up at nearby Baker Beach." He balanced the board on two pillows on a table under a large north-facing window and made the exposure using natural light.

Page 71. *Gottardo Piazzoni in His Studio, San Francisco, California, 1932.*

"Piazzoni was working on his murals for the San Francisco Public Library," Adams said. "Albert Bender asked me to do a picture of him. I went down to his studio with the 8 x 10 expecting to take a portrait by the window. When I came in he was standing on the scaffold mixing paint. I asked him to just keep mixing, set up very quickly and made the portrait." Piazzoni's murals have been restored and are now installed in San Francisco's de Young Museum.

Adams reproduced this photograph in his first book on photographic technique, *Making a Photograph.* He went on to publish more than a dozen instruction books, of which hundreds of thousands of copies have been sold. He also wrote countless articles on technique and taught thousands of students in workshops over a period of forty years.

Page 93. *Frozen Lake and Cliffs, Kaweah Gap, Sierra Nevada, California, 1932.*

Adams wrote, "I made this photograph while on the annual [Sierra] Club outing in the Kaweah and Kern River watersheds, in many ways the most spectacular region of the Sierra. On the long trek from Giant Forest over Kaweah Gap the trail passes Precipice Lake. . . . The lake was partially frozen and snowbanks rested in the recesses of the cliffs. I was impressed with the solemn beauty of the scene and saw the image quite clearly in my mind. . . .

"Many speak of this image as abstract, but I was not conscious of any such definition at the time. . . . For photographic compositions I think in terms of creating configurations out of chaos, rather than following any conventional rules of composition. Edward Weston said simply that 'composition is the strongest way of seeing.' "

According to Adams, a friend made a photograph from exactly the same location at the same time. Later, on seeing Adams' finished photograph, he exclaimed, "Jeez! Why didn't I see *that!*"

Page 63. *Boards and Thistles, San Francisco, California, 1932.*

Adams was a founding member of the loose photographic "association" known as Group f/64, which included Edward Weston and Imogen Cunningham. "We wanted to make sharp, clean photographs" of ordinary daily surroundings, Adams wrote. He considered this photograph emblematic of the group's tenets.

Making this photograph "was an experience I can recall vividly," Adams wrote. "It occurred about 11 A.M. on a clear crisp San Francisco day. I was walking along a street in the southern section of the city, carrying my 8 x 10 camera-on-tripod over my left shoulder and a case with the film holders in my right hand, looking for that moment of true excitement experienced not too often by serious photographers. I

came across this striking arrangement of weathered boards, the side of an old barn. Bright thistles glistened, and the gray boards were sunlit at an angle that enhanced their texture."

Page 92. *Courthouse, Mariposa, California, c. 1933.*
Adams photographed the entire face of the courthouse in the town of Mariposa, but he preferred this tightly cropped image. Notice how he carefully included the extreme left and right angles of the triangular pediment and only the tops of the shuttered windows.

Adams occasionally visited this courthouse on family business, and in December 1927 he obtained his marriage license here. Today the beautifully maintained building still stands on a side street.

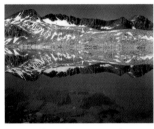

Page 114. *Lake near Muir Pass, Kings Canyon National Park, California, c. 1934.*
The surreal *Lake near Muir Pass* is one of fifty photographs reproduced in the signed limited edition of *Sierra Nevada: The John Muir Trail.* Published in 1938, it was the second deluxe volume of Adams' photographs, following *Taos Pueblo* in 1930. *The John Muir Trail* was republished in both trade and deluxe limited editions in 2006.

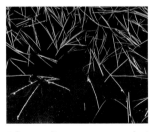

Page 112. *Grass and Pool, Tuolumne Meadows, Yosemite National Park, California, c. 1935.*
This photograph and its companion on page 112 were made at virtually the same time. By reorienting his camera slightly, Adams created two different images.

Adams sent a print of this image to his friends Beaumont and Nancy Newhall. After a dinner party at their home, Nancy wrote that the guests were "wowed" by the new photograph: "Them as thought they knew some-thing of modern art were sure it was an Albers or a Klee or name your favorite abstract painter and *what* was the medium?"

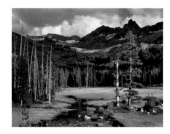

Page 124. *Mount Ansel Adams, Lyell Fork of the Merced River, Yosemite National Park, California, c. 1935.*
The high peak in this photograph was formally named Mount Ansel Adams on April 22, 1985. It is located in the southeast section of Yosemite National Park, adjoining the Ansel Adams Wilderness. Adams' ashes were scattered near the summit by his son, Michael.

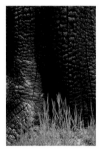

Page 83. *Burnt Stump and New Grass, Sierra Nevada, California, 1935.*
This composition is a study in contrast of dark and light, new and old, dead and alive. It was made in an area just south of Yosemite National Park that had recently burned. Adams remembered being drawn to the juxtaposition of the bright new grass and the charred black wood.

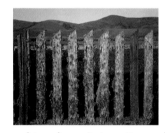

Page 144. *Fence near Tomales Bay, California, 1936.*
In January 1936 Adams traveled to New York and visited several times with Stieglitz at his gallery, An American Place. Stieglitz offered to give Adams an exhibition. Elated, Adams wrote to Virginia. "My dearest, everything seems to come to him who waits! . . . I am to have a show at Stieglitz in the fall. Jezuz!!!" Back home in California, Adams wrote to Stieglitz in March, "I have done one good photograph since my return which I think you will like. It is a rather static picture of a fence — the pickets covered with moss and dark rolling hills moving beyond it." The photograph was shown in the November exhibit. After Stieglitz's death, Adams gave it to the Museum of Modern Art in New York City.

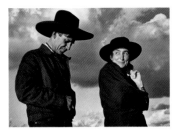

Page 157. *Georgia O'Keeffe and Orville Cox, Canyon de Chelly National Monument, Arizona, 1937.*
To make this photograph Adams used his first 35mm camera, a Zeiss Contax, which he praised in an article in *Camera Craft* in 1936: "The camera is for life and for people, the swift and intense moments of existence." Compare this lighthearted, spontaneous portrait with that on page 85.

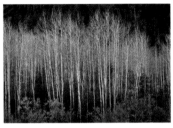

Page 151. *Aspens, Dawn, Autumn, Dolores River Canyon, Colorado, 1937.*
In November 1936, Adams' exhibition at Alfred Stieglitz's gallery, An American Place, opened in New York City. Adams was deeply moved by the fact that his photographs were exhibited in the same gallery known for showing paintings by Georgia O'Keeffe, John Marin, and Arthur Dove. An essentially modest man, Adams spent his life trying to live up to Stieglitz's recognition.

From the Southwest in September 1937, he wrote Stieglitz, "I think I am getting some very good things — quite different, I believe. I like to think of my present stuff as more subtle, more lifting-up-the-lid, if you know what I mean. . . . Perhaps I am on the edge of making a really good photograph."

Only one month later, in October 1937, Adams made this photograph of bare aspen trees. It is at once simple and complex. To his patron and friend David Hunter McAlpin, he sent one of the first prints. McAlpin subsequently gave it to New York's Museum of Modern Art, whose Photography Department he founded in 1941 with Adams and Beaumont Newhall. John Szarkowski, curator emeritus of photography at the museum, has described this photograph as "a fugue of aspens."

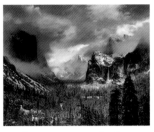

Page 123. *Clearing Winter Storm, Yosemite National Park, California, c. 1937.*
This is one of Adams' best-known photographs. "It came about on a December day," Adams remembered, when he had driven to the scenic overlook at the western entrance to Yosemite Valley. Typically, he was not sure of the date, but evidence suggests the late 1930s.

"I had been at this location countless times over many years," Adams continued, "but only once did I encounter just such a combination of visual elements. . . . The storm was first of heavy rain, which turned to snow and began to clear about noon. I drove to the place known as New Inspiration Point. . . and waited for the clouds to form. . . .Rapidly changing situations such as this one can create decision problems for the photographer. A moment of beauty is revealed and photographed; clouds, snow or rain then obscure the scene, only to clear in a different way with another inviting prospect. There is no way to anticipate these occurrences."

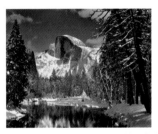

Page 115. *Half Dome, Merced River, Winter, Yosemite National Park, California, 1938.*
Adams was long concerned about the cheap, tacky, and inappropriate souvenirs that were sold in the national parks. In order to offer a more suitable memento to visitors to Yosemite, he decided to produce from his negatives "special edition" prints to be offered at affordable prices at several shops in the park. They were instantly popular and are still sold today at the Ansel Adams Gallery in Yosemite Valley. This image of Half Dome is one of the most popular of these prints.

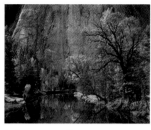

Page 135. *Merced River, Cliffs of Cathedral Rocks, Autumn, Yosemite National Park, California 1939.*

"This photograph was made in late autumn," remembered Adams, "on a chilly morning when the air was crystal clear and still and the silence impressive." He found that this image was "more effective in large size, because, at normal viewing distance . . . the details are visually better separated and appreciated." In the 1930s he printed this image on 8 x 10-inch paper, but he thereafter usually printed it on 16 x 20-inch paper to better show the glorious details of the fall foliage against the granite cliff.

1940–1949

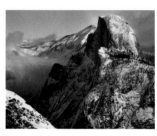

Page 311. *Half Dome, Winter, from Glacier Point, Yosemite National Park, California, c. 1940.*

By 1940, Adams had photographed this view of Half Dome from Glacier Point in every season, in every conceivable weather condition, and at numerous times of day. (From the same vantage point, in 1916, Adams took the photograph in the upper left corner of page 14.) Returning from a trip up Half Dome via the steep gully at its base, Adams wrote to David McAlpin: "You can rest your hand on hard smooth granite which goes up two thousand feet above you in one straight line. And there is nearly three thousand feet below you to the floor of the Valley. This is quite a place, Dave — it is really quite something to live here!"

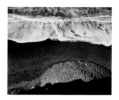 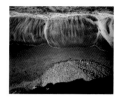

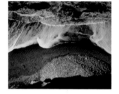 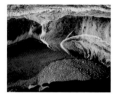 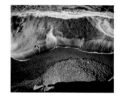

Pages 252–253. *Surf Sequence, San Mateo County Coast, California, 1940.*
Adams created only one true sequence, these five photographs made from a cliff overlooking a beach south of San Francisco. "I set up the 4 x 5 view camera," wrote Adams, "and awaited appealing arrangements of flowing water and foam." The images are usually arranged in the order in which they were made, with the foreground shadow moving little by little to the right.

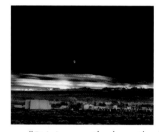

Page 175. *Moonrise, Hernandez, New Mexico, 1941.*
Adams sold almost one thousand prints of this photograph during his lifetime. He sold one of the first in 1948 for $50. A second print made at the same time brought $609,600 at auction at Sotheby's in New York City in 2006.

"Driving south along the highway," wrote Adams, "I observed a fantastic scene as we approached the village of Hernandez. In the east, the moon was rising over distant clouds and snowpeaks, and in the west, the late afternoon sun glanced over a south-flowing cloud bank and blazed a brilliant white upon the crosses in the church cemetery. I steered the station wagon into the deep shoulder along the road and jumped out, scrambling to get my equipment together. . . . With the camera assembled and the image composed and focused, I could not find my Weston

exposure meter! Behind me the sun was about to disappear behind the clouds, and I was desperate. I suddenly recalled that the luminance of the moon was 250 candles per square foot. I placed this value on Zone VII of the exposure scale; with the Wratten G (No. 5) deep yellow filter, the exposure was one second at f/32. I had no accurate reading of the shadow foreground values. After the first exposure I quickly reversed the 8 x 10 film holder to make a duplicate negative . . . but as I pulled out the slide the sunlight left the crosses and the magical moment was gone forever."

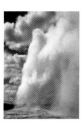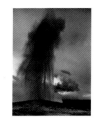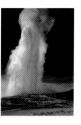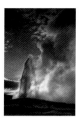

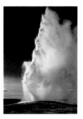

Pages 213–215. *Old Faithful Geyser, Yellowstone National Park, Wyoming, 1941–1942.*
Adams created a series of photographs of Old Faithful Geyser on two trips for the mural project. "It is difficult to conceive of a substance more impressively brilliant than the spurting plumes of white waters in sunlight against a deep blue sky," he wrote.

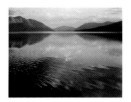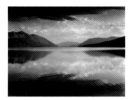

Pages 220–221. *Lake McDonald, Evening, Glacier National Park, Montana, 1942.*
These two images were made at virtually the same time on Adams' second mural project trip in the summer of 1942. In the image on page 221, Adams slightly lowered the horizon to include dark clouds, thereby changing the tenor of the photograph.

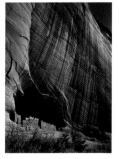

Page 165. *White House Ruin, Canyon de Chelly National Monument, Arizona, 1942.*
"Only when I had completed the prints [of this image] months later did I realize why the subject had a familiar aspect: I had seen the remarkable photograph made by Timothy O'Sullivan in 1873, in an album of his original prints that I once possessed. I had stood unaware in almost the same spot on the canyon floor, about the same month and day, and at nearly the same time of day that O'Sullivan must have made his exposure, almost exactly sixty-nine years earlier." Adams' photograph differs from O'Sullivan's: he included a triangle of sky in the upper right corner and used a filter to darken the sky and cliffs.

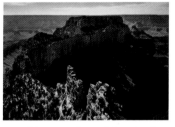

Page 202. *Grand Canyon from Cape Royal, Arizona, 1942.*
On his mural project trips, Adams made what he called an "extended series" of photographs of the Grand Canyon. He stayed on the rim, moving about to vary perspective and light. He worked at dawn or sunset, searching out the striking shadow effects cast by the low sun.

When talk arose about damming the Colorado River, Adams spoke out against it with asperity: "Friends say to me, 'I don't see how the Lower Colorado dam can do any harm — only a handful of people see that part of the Grand Canyon anyway and with a lake there people can easily see things that they have never been able to see before.' I suggest we fill the Sistine Chapel about two-third's full of water so the visitors can float around and see the ceiling paintings to better advantage!"

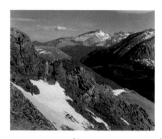

Page 206. *Long's Peak, Rocky Mountain National Park, Colorado, 1942.*

On his second trip for the mural project, in June 1942, Adams saw the Rockies with new enthusiasm. He wrote to his friend Cedric Wright from Estes Park in a jubilant attitude: "This is a superb place. It's like the Sierra East Side, only bigger, higher, more something I never saw before. Space, enormous mountain slopes just smoothed out with solid forest. Aspens, lodgepole, spruce. Wonderful creeks. Snow fields. Sort of cosmic endless sculpture of granite mountains. Too big to spoil; not too big to experience."

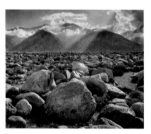

Page 261. *Mount Williamson, Sierra Nevada, from Manzanar, California, c. 1944.*

Adams did not enlist during World War II, but he very much wanted to make some patriotic contribution. Ralph Merritt, a Sierra Club friend and the director of the Manzanar Relocation Center, urged Adams to document the Japanese Americans interned at the center in Manzanar, California. Adams made hundreds of photographs there during 1943 and 1944. On one of his visits, he drove to a spot overlooking a field of boulders and took this picture. "There was a glorious storm going on in the mountains," he wrote. "I set up my camera on the rooftop platform of my car," which "enabled me to get a good view *over* the boulders to the base of the range."

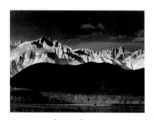

Page 245. *Winter Sunrise, Sierra Nevada, from Lone Pine, California, 1944.*

On four successive mornings Adams tried to take this photograph of the east side of the Sierra. On the fifth day it was still dark and bitterly cold when he set up his camera on the new platform on top of his car and retreated to the warm interior. As dawn drew near, he returned to the camera to await the sun's first rays on the meadow. "I finally encountered a bright, glistening sunrise with light clouds streaming from the southeast and casting swift moving shadows on the meadow and dark rolling hills." At the last possible moment, the horse turned to offer a profile view. Many years later he wrote, "Sometimes I think I do get to places just when God's ready to have somebody click the shutter!"

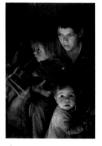

Page 248. *Trailer Camp Children, Richmond, California, 1944.*

Toward the end of World War II, *Fortune* magazine commissioned Adams and Dorothea Lange to document the military shipyards at Richmond, California. On a dare from Lange, Adams borrowed her twin-lens Rolleiflex and took this touching photograph of children in the doorway of their cardboard and canvas shack. Critics consider *Trailer Camp Children* the strongest image from the entire Adams-Lange collaboration. *Fortune's* editors, however, did not print it; they chose to illustrate the positive aspects of the wartime city.

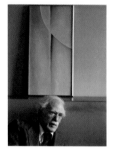

Page 249. *Alfred Stieglitz and Painting by Georgia O'Keeffe, An American Place, New York City, 1944.*

Adams held Stieglitz and O'Keeffe in the very highest esteem. In 1944, Adams made a series of portraits of Stieglitz and his gallery, An American Place. This image was made in the back room that served as an office. Stieglitz reclined on a daybed. A painting by O'Keeffe leaned against the wall above him.

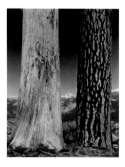

Page 276. *Trees, Illilouette Ridge, Yosemite National Park, California, 1945.*

The exquisite detail in the bark of the trees and the rubble on the forest floor reveals Adams' solid grasp of photographic technique. "We all have our stresses," wrote Adams, and "with me it happens to be technique. It's a sort of stock in trade; it really does not relate to what happens inside of me—except to help me to say things a little clearer."

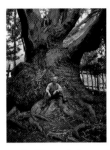

Page 247. *Edward Weston, Carmel Highlands, California, 1945.*

Adams was a devoted friend of the great photographer Edward Weston. On a September day in 1945, when Adams was visiting Weston at his Carmel Highlands home, he took this picture of his friend sitting on the roots of a giant eucalyptus tree.

Adams' description of what was involved in making this portrait illustrates his mastery of his craft: "I used the 10-inch Kodak Wide-Field Ektar, with a meter found the range, placed the important low values on Zone III and the high value of the head between Zones VII and VIII; obviously a normal negative scale. I recall the exposure as ½ second at f/32 with Isopan Film (ASA 64), developed normally."

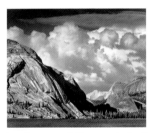

Page 309. *Tenaya Lake, Mount Conness, Yosemite National Park, California, c. 1946.*

The photographer Edward Weston visited Adams in Yosemite in the summer of 1940, and they photographed on the glacially polished slopes shown on the left in this image. "Edward was especially excited when he was surrounded by the granite landscape of Tenaya Lake," wrote Adams, "glaciated rock, erratic boulders brought thousands of years ago by the glaciers from the distant summit peaks, and the beautiful Sierra junipers growing in the bare native rock."

In 1958 the National Park Service authorized the construction of a road along the edge of the lake on the left side in this photograph. Adams protested vigorously in a telegram to the secretaries of the interior and commerce: "I wish to lodge a most sincere and severe protest against the desecration of Tenaya Lake and the adjoining canyon in Yosemite National Park which is being perpetrated by the ruthless construction of the new Tioga Road. . . . In 40 years' experience in national park and wilderness areas I have never witnessed such an insensitive disregard of prime national park values." In spite of Adams' protest, highway construction proceeded. His photograph is a record of what was lost.

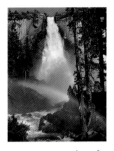

Page 284. *Nevada Fall, Rainbow, Yosemite National Park, California, c. 1947.*

The Eastman Kodak Company paid Adams to make hundreds of color transparencies in the 1940s and 1950s. In April 1946 Kodak commissioned him to make color photographs with rainbows. In one of his almost daily letters to Beaumont and Nancy Newhall, he wrote: "High Ho!! Believe it or not the Eastman Kulak (I mean Kodak) Co. are paying me $250.00 per shot for at least three 8 x 10 Kodachromes of Waterfalls mit Rainbows! No discount if there ain't no rainbow! Some new experimental film. HUshhhhhhhhhh. So, next week I go off to that hole in the ground Yosemite and click some shutters." He photographed this scene in both black and white and color.

Adams relied on commercial work to "keep the wolf from the door," as he said. It was not until the early 1970s that he could afford to decline such assignments.

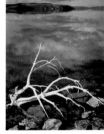

Page 254. *White Branches, Mono Lake, California, 1947.*

In the company of his friends Beaumont and Nancy Newhall, Adams made this photograph on the shores of Mono Lake. He wrote, "This is one of the few images I have where high values, in this case the white branches, are printed pure white. They are alkali encrusted and show little or no texture to the eye, and none in the negative. . . . The intention is that they stand in glaring contrast with the relatively dark background of the thundercloud reflections. The print is not realistic but a faithful equivalent of the visualization." At the same time, Adams also made a horizontal image of the scene (page 257).

Beaumont Newhall selected this image to include in his pioneering *History of Photography*, published by the Museum of Modern Art in 1948.

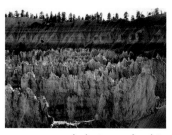

Page 170. *Formations, Bryce Canyon National Park, Utah, 1947.*
On a trip with Adams to the Southwest in June 1947, Beaumont Newhall wrote that it was difficult to find a good vantage point from which to photograph the thirty-mile-long amphitheater-shaped canyon at Bryce. "The scenery was so overwhelming and so big that it did not seem possible to isolate it. Ansel did so, and again we marveled at the way that he is able to pick out of a landscape a significant detail and make it seem more natural than what we saw with our own eyes."

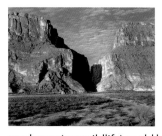

Page 181. *Santa Elena Canyon, Big Bend National Park, Texas, 1947.*
"Whatever you hear about Big Bend not being of National Park status, please discount it. It is one of the grandest places I have seen.... You would be nuts about it because it is undeveloped and clearly shows what a park could be if the damned predators (not wildlife) could be kept at bay." Adams thus waxed enthusiastic about Big Bend in a letter to Francis Farquhar, a Sierra Club elder statesman. At the same time he also alludes to his long-standing disapproval of the National Park Service's policies; in his opinion, they promoted excessive commercial development in the parks. Adams made two other important photographs on the same trip (pages 180 and 185).

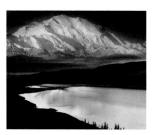

Page 233. *Mount McKinley and Wonder Lake, Denali National Park, Alaska, 1947.*
One early evening in Alaska in July 1947 Adams set up his 8 x 10-inch view camera to frame this image of Mount McKinley, thirty miles distant, then left for his cabin and went to bed. He rose at midnight, returned to his camera, and waited for dawn. "About 1:30 A.M. the top of the mountain turned pink," he wrote. "Then gradually the entire sky became golden and the mountain received more sunlight." After he clicked the shutter, he tried two more photographs, "but within thirty minutes clouds had gathered and obscured the summit, and they soon enveloped the entire mountain."

Adams had photographed extensively in the Sierra Nevada, the Rockies, and the Southwest, but he had not encountered anything like the majestic scale of Alaska. The experience moved him profoundly and inspired him to strengthen his commitment to the conservation of wilderness.

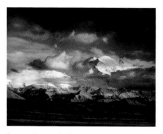

Page 235. *Moon and Mount McKinley, Denali National Park, Alaska, 1947.*
"On the afternoon of my arrival . . . I had been able to get a photograph of the mountain wreathed in cloud with the moon hovering beside it," wrote Adams. At the end of the trip, "I was unloading my gear from a float plane to a small launch and the case containing all the exposed film of the trip fell into the shallow water. I jumped in up to my waist and quickly retrieved the case, but some water had penetrated it and damaged some of my 8 x 10 Mt. McKinley negatives." The negative for this image suffered water damage, and even with extensive retouching Adams was able to make prints suitable only for reproduction in books.

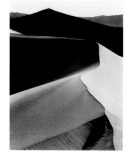

Page 184. *Sand Dunes, Sunrise, Death Valley National Park, California, c. 1948.*
Adams applied to the Guggenheim Foundation for a fellowship to complete his documentation, begun in 1941 with the mural project, of America's national parks and monuments. In April 1947, he wrote to Edward Weston: "I got the Guggenheim Fellowship! Yep! At last! Generous project — interpretation of the Natural Scene — National Parks and Monuments! Two years — perhaps three. It's the turning point in Adams Creative Work, I am sure."

The first stop on his initial Guggenheim trip was Death Valley. In a

letter to the photographer Minor White, he exulted that he had already made more than eight dozen exposures. "It's marvelous! . . . Just a tremendous nest of photographic opportunity."

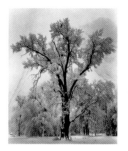

Page 275. *Oak Tree, Snowstorm, Yosemite National Park, California, 1948.*
This oak tree stood just off the park road near El Capitan Meadow in Yosemite Valley. Adams drove by the scene countless times, and he photographed it in all seasons (pages 116 and 274).

In 1984 Little, Brown and Company published a poster of this photograph. It has since sold well over 200,000 copies.

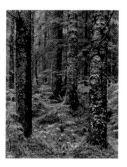 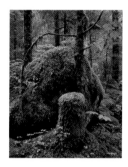

Page 246. *Forest, Beartrack Cove, Glacier Bay National Park, Alaska, 1948.*
On a trip to Glacier Bay in 1948, Adams experienced disappointing weather — only four clear days in the month of July. These two photographs were made in a light rain in what he remembered as a "moss draped primeval forest."

Adams included the image on the left in *My Camera in the National Parks*, a book that was made possible by his second Guggenheim fellowship and is now a collector's item.

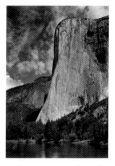

Page 300. *El Capitan, Merced River, Clouds, Yosemite National Park, California, 1948.*
Over two-thirds of a mile high, with a sheer vertical drop, El Capitan dominates the west end of Yosemite Valley. By varying the camera, lens, filter, film, viewpoint, lighting conditions, and season, Adams made many different photographs of this classic view (pages 299, 301, 348, and 349). He included this image in *My Camera in Yosemite Valley*, a large-format book. In the foreword, he wrote, "The great rocks of Yosemite, expressing timeless, yet intimate grandeur, are the most compelling formations of their kind. We should not casually pass them by for they are the very heart of the earth speaking to us."

1950–1959

Page 347. *Early Morning, Merced River, Yosemite National Park, California, c. 1950.*
"This serene subject is only about one hundred feet from the highway," wrote Adams. Many of his photographs of wild places were made near a major road, in a parking lot, or from a scenic overlook. But, particularly in the 1920s and 1930s, many were made on long pack trips into the wilderness accompanied only by a burro to carry heavy photographic equipment and camping supplies.

Adams photographed this tree on two different occasions. This version was taken just after sunrise; the other, earlier image was taken on a late autumn evening (page 277) in both black and white and color.

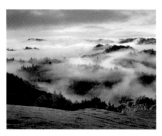

Page 330. *Clearing Storm, Sonoma County, California, 1951.*

In 1951 Adams accepted a commission to produce a five-panel screen for the dining room in a ranch house north of San Francisco. "I have spent several days at the ranch, mostly in the rain, but I think I got a beautiful negative — hills and forested summits rising above the fog and clouds — very much Chinese in mood," he wrote. At the ranch, Adams made two other significant images (pages 329 and 331).

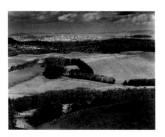

Page 323. *San Francisco from San Bruno Mountain, California, 1952.*

Adams was proud to be a native San Franciscan. He was born in the city in 1902, grew up in a house on the dunes west of the Golden Gate, and experienced the famous earthquake and fire of 1906.

This photograph was commissioned by the American Trust Company of San Francisco for *The Pageant of History in Northern California*, a book published under the bank's auspices. The assignment afforded Adams the satisfying opportunity to roam northern California and photograph at will. The undeveloped area in the foreground of the photograph is now completely suburbanized.

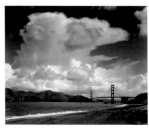

Page 325. *The Golden Gate and Bridge from Baker Beach, San Francisco, California, 1953.*

Long before the bridge was built, the teenage Adams often took the streetcar from his home near Baker Beach to the waterfront downtown, caught the ferry across the Golden Gate, and spent the day roaming the Marin hills seen to the left in this photograph. Compare this image with Adams' earlier view without the bridge (page 75) made in 1932.

In the 1960s, the Sierra Club, with Adams' help, fought the proposal to allow construction of high-rise apartment buildings on these hills. As a protest, he pasted tiny pictures of apartment buildings on top of the hills in this photograph and exhibited it in a San Francisco storefront. The Golden Gate National Recreation Area was established in 1972 and now protects these headlands.

Page 324. *Ferry and Bay Bridge from the Air, San Francisco, California, 1954.*

Adams made this photograph with a Hasselblad camera given to him by Victor Hasselblad after they met in New York in 1950. Shortly after he received it, Adams wrote to Nancy and Beaumont Newhall, "New seeing with Hasselblad!" The camera met Adams' rigorous standards, and for many years he acted as a key consultant — unpaid — in its continuing development. One of his most acclaimed late photographs was made with the camera (page 379), and in the last decades of his life he primarily used a Hasselblad.

Page 364. *Tree, Stump, and Mist, North Cascades National Park, Washington, 1958.*

In August 1958 Adams traveled to Washington on a commission from Kodak. Afterward he wrote, "Never have I packed so many pounds of equipment so far for so little! . . . It is perfectly marvelous country — but is undergoing the worst drought in history. Forest fires and smog over everything. . . . Yesterday morning we awoke on Cascade Pass in a thick fog — which lasted until 10:30 — at which time we gave up and descended to the lowlands. . . . I have not a single picture of the type I came for!"

Pages 373 and 375. *Aspens, Northern New Mexico, 1958.*

While returning from an unsuccessful trip to Canyon de Chelly in search of a color photograph for Kodak, Adams happened upon this grove of aspens. "We were in the shadow of the mountains," Adams wrote, "the light was cool and quiet and no wind was stirring. The aspen trunks were slightly greenish and the leaves were a vibrant yellow. . . . I made the horizontal picture first, then moved to the left and made the vertical image at

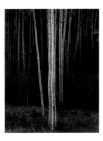 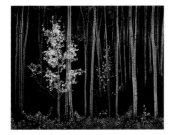

about the same subject distance. The few yellow leaves seen in the vertical image were not as bright as those in the horizontal version. . . . The majority of viewers of the horizontal image think it was a sunlit scene. When I explain that it represented diffused lighting from the sky and also reflected light from distant clouds, some rejoin, 'Then why does it *look* the way it does?' Such questions remind me that many viewers expect a photograph to be the literal simulation of reality."

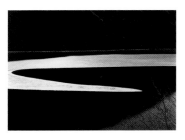

Page 354. *Ice on Ellery Lake, Sierra Nevada, California, 1959.*
If it were not for the branches in the lower right corner it would be difficult, even for a trained eye, to recognize this image as a landscape. Adams had explored abstractions previously (page 112) but had seldom pushed them to this extent.

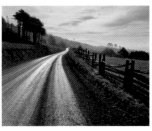

Page 372. *Road after Rain, Northern California, 1959.*
Adams met the inventor Edwin Land in 1948 and soon thereafter began a long association with the Polaroid Land Corporation, advising on technical matters and photographing with Polaroid materials. For this picture he used a conventional 4 x 5-inch view camera fitted with the new Polaroid negative film pack that he helped test before it was first offered for sale in 1958.

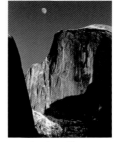

Page 379. *Moon and Half Dome, Yosemite National Park, California, 1960.*
"I have photographed Half Dome innumerable times, but it is never the *same* Half Dome, never the same light or the same mood," wrote Adams. "The many images I have made reflect my varied creative responses to this remarkable granite monolith."

Forty-four years after Adams first photographed Half Dome (page 13), the fascination endured. "As soon as I saw the moon coming up by Half Dome I had visualized the image," Adams wrote. Only the essentials remain: no clouds or foliage, no foreground elements — just Adams, the moon, and Half Dome.

Half Dome appears in twenty-two of the four hundred photographs in this book.

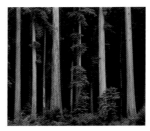

Page 399. *Redwoods, Bull Creek Flat, Northern California, 1960.*
This view of a stand of redwoods was accessible to Adams because it adjoined a lumber company's clear-cut. The juxtaposition is a reminder that saving the redwoods was one of the most important environmental issues of the 1960s, which Adams and the Sierra Club energetically supported. His thirty-eight years as a member of the Sierra Club's board, plus the high public profile he developed as a photographer, turned Adams into a powerfully effective voice for the modern conservation movement.

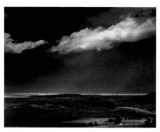

Page 405. *Thunderstorm over the Great Plains, near Cimarron, New Mexico, 1961.*
The Boy Scouts of America commissioned Adams to photograph their ranch in Philmont, New Mexico, in 1961. While there, he made this dramatic photograph.

On an earlier trip to the Southwest with Georgia O'Keeffe, in 1937, he wrote to her husband, Alfred Stieglitz: "It is all very beautiful and magical here — a quality which cannot be described. You have to live it and breathe it, let the sun bake it into you. The skies and land are so enormous, and the detail so precise and exquisite that wherever you are you are isolated in a glowing world between the macro and the micro, where everything is sidewise under you and over you, and the clocks stopped long ago."

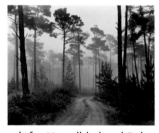

Page 394. *Road and Fog, Del Monte Forest, Pebble Beach, California, 1964.*
In 1962 Adams and his wife moved from San Francisco to a home they built on a hillside overlooking the Pacific just south of Carmel. It included a state-of-the-art darkroom and a large workroom. Adams continued to write, edit books, and consult for Hasselblad and Polaroid. A major focus of his work was printing hundreds of the negatives stored in the vault behind the house, and he spent almost every morning, sometimes seven days a week, in the darkroom.

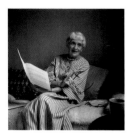

Page 385. *Dorothea Lange, Berkeley, California, 1965.*
Dorothea Lange and Adams photographed together on several occasions, and he held her in the highest regard. When he learned that she was suffering from inoperable cancer, he made this portrait. "To my mind," wrote Adams, "she presents the almost perfect balance between artist and human being."

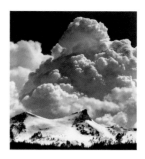

Page 407. *Thundercloud, Unicorn Peak, Yosemite National Park, California, 1967.*
Adams was sixty-five when he hiked across Tuolumne Meadows with his Hasselblad to make this photograph. He referred to peaks in the Sierra Nevada as "sculptures in stone."

Page 404. *Arches, North Court, Mission San Xavier del Bac, Tucson, Arizona, 1968.*
Adams used this image to illustrate the photographic tenet he called "careful seeing." "Had the camera been moved in closer," he pointed out, "it would have enlarged the arches or at least crowded them severely. And moving the camera to the left even a few inches would have merged the west tower's cornice with the central arch and confused the gate at left with the edge of the finial base."

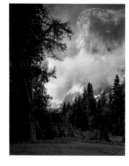

Page 411. *El Capitan, Winter, Sunrise, Yosemite National Park, California, 1968.*
"I visualized the opalescent glow of the sun on the icy cliff," wrote Adams. "In an overpowering area such as Yosemite Valley it is difficult for anyone to make photographs that do not appear derivative of past work. The subjects are definite and recognizable, and the viewpoints are limited. It is therefore all important to strive for an individual and strong visualization."

AFTERWORD

THE FIRST TIME I saw original Ansel Adams photographs was in 1974, as I unpacked the shipment of his work for a retrospective at the Metropolitan Museum of Art, in New York City, where I worked in the Department of Prints and Photographs. I was astounded. I recall standing in the gallery, mesmerized by *Clearing Winter Storm*. It was the first time I had ever had a powerful emotional response to a photograph.

When the show closed, Ansel asked me to move to California and become his assistant. Working for Ansel meant doing whatever was called for at the moment: typing his letters, handling sales of hundreds of photographs, editing his writings, helping to select photographs for his books, and then spending hours with him at the printer to make sure that the reproductions were as close to the originals as possible. We traveled together to book signings and museum openings, from Quebec to Milwaukee to Oklahoma City to London. Ansel's work was his life, and he spent seven days a week focused on his photography. He had a hard time understanding that I needed a day off. On Friday

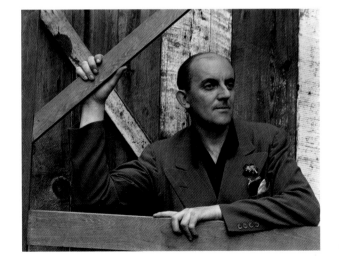

afternoon I would invariably leave his studio as he asked this hopeful question: "Will I see you tomorrow?" The next morning, as I worked in my garden, his bearded face would pop up over the fence, and he would say, "I was just passing by..."

In the last years of Ansel's life, I worked on three major projects that drew on all aspects of my knowledge and expertise: a one-hour biographical documentary film for public television; a re-creation of Ansel's exhibition at Alfred Stieglitz's gallery, using the original photographs shown in 1936; and a book of Ansel's letters.

Since Ansel's death in 1984, The Ansel Adams Trust has commissioned me to edit seven books of his photographs and to select images for posters, postcard books, and even a screen saver. When The Trust asked me to select the photographs that constitute Ansel's most significant work for this book, I was thrilled. Ansel has been part of my life for more than thirty years. Working on this book has deepened and enriched my connection with his joyous spirit.

Andrea G. Stillman

ANSEL ADAMS AT WILDCAT HILL, CARMEL, 1943, BY EDWARD WESTON

Adams, Ansel, and Mary Austin. *Taos Pueblo*. San Francisco: Ansel Adams, 1930.

Adams, Ansel. *Making a Photograph*. London and New York: Studio Publications, 1935.

———. *Sierra Nevada: The John Muir Trail*. Berkeley, CA: Archetype Press, 1938.

Adams, Ansel, and Virginia Adams. *Illustrated Guide to Yosemite Valley*. San Francisco: H. S. Crocker, 1940.

———. *Michael and Anne in Yosemite Valley*. London and New York: Studio Publications, 1941.

Adams, Ansel. *Born Free and Equal: Photographs of the Loyal Japanese-Americans at Manzanar Relocation Center, Inyo County, California*. New York: U.S. Camera, 1944.

———. *Camera and Lens*. New York: Morgan and Lester, 1948.

———. *The Negative*. New York: Morgan and Lester, 1948.

———. *Yosemite and the Sierra Nevada*. Edited by Charlotte E. Mauk. Boston: Houghton Mifflin, 1948.

———. *My Camera in Yosemite Valley*. Yosemite and Boston: Virginia Adams and Houghton Mifflin, 1949.

———. *My Camera in the National Parks*. Yosemite and Boston: Virginia Adams and Houghton Mifflin, 1950.

———. *The Print*. New York: Morgan and Lester, 1950.

Adams, Ansel, and Mary Austin. *The Land of Little Rain*. Boston: Houghton Mifflin, 1950.

Adams, Ansel. *Natural-Light Photography*. New York: Morgan and Lester, 1952.

Adams, Ansel, and Nancy Newhall. *Death Valley*. San Francisco: 5 Associates, 1954.

———. *Mission San Xavier del Bac*. San Francisco: 5 Associates, 1954.

———. *The Pageant of History in Northern California*. San Francisco: American Trust Company, 1954.

Adams, Ansel. *Artificial-Light Photography*. New York: Morgan and Morgan, 1956.

Adams, Ansel, and Edward Joesting. *The Islands of Hawaii*. Honolulu: Bishop National Bank of Hawaii, 1958.

Adams, Ansel, and Nancy Newhall. *Yosemite*. San Francisco: 5 Associates, 1959.

———. *This Is the American Earth*. San Francisco: Sierra Club, 1960.

Adams, Ansel. *These We Inherit: The Parklands of America*. San Francisco: Sierra Club, 1962.

———. *Illustrated Guide to Yosemite*. San Francisco: Sierra Club, 1963.

———. *Polaroid Land Photography Manual*. New York: Morgan and Morgan, 1963.

Adams, Ansel, and Nancy Newhall. *The Eloquent Light*. San Francisco: Sierra Club, 1963.

Adams, Ansel, and Edward Joesting. *An Introduction to Hawaii*. San Francisco: 5 Associates, 1964.

Adams, Ansel, and Nancy Newhall. *Fiat Lux: The University of California*. New York: McGraw Hill, 1967.

———. *The Tetons and the Yellowstone*. Redwood City, CA: 5 Associates, 1970.

Adams, Ansel. *Ansel Adams* (monograph). Edited by Liliane DeCock. Hastings-on-Hudson, NY: Morgan and Morgan, 1972.

———. *Ansel Adams: Singular Images*. Hastings-on-Hudson, NY: Morgan and Morgan, 1974.

———. *Images 1923–1974*. Boston: New York Graphic Society, 1974. (First Little, Brown and Company book.)

———. *Photographs of the Southwest*. Boston: New York Graphic Society, 1976.

———. *The Portfolios of Ansel Adams*. Boston: New York Graphic Society, 1977.

Adams, Ansel, and Mary Austin. *Taos Pueblo* (facsimile edition). Boston: New York Graphic Society, 1977.

Adams, Ansel. *Yosemite and the Range of Light*. Boston: New York Graphic Society, 1979.

———. *The New Ansel Adams Photography Series/Book 1: The Camera*. Boston: New York Graphic Society, 1980.

———. *The New Ansel Adams Photography Series/Book 2: The Negative*. Boston: New York Graphic Society, 1981.

———. *The New Ansel Adams Photography Series/Book 3: The Print*. Boston: New York Graphic Society, 1983.

———. *Ansel Adams: An Autobiography*. Boston: Little, Brown and Company, 1985.

———. *Ansel Adams: Classic Images*. Boston: Little, Brown and Company, 1986.

———. *Letters and Images*. Boston: Little, Brown and Company, 1988.

———. *Examples*. New York: Little, Brown and Company, 1989.

———. *The American Wilderness*. Edited by Andrea G. Stillman. New York: Little, Brown and Company, 1990.

———. *Ansel Adams: Our National Parks*. Edited by Andrea G. Stillman and William A. Turnage. New York: Little, Brown and Company, 1992.

———. *Ansel Adams in Color*. Edited by Harry Callahan. New York: Little, Brown and Company, 1993.

———. *Yosemite and the High Sierra*. Edited by Andrea G. Stillman. New York: Little, Brown and Company, 1994.

———. *Yosemite*. Edited by Andrea G. Stillman. New York: Little, Brown and Company, 1995.

———. *California*. Edited by Andrea G. Stillman. New York: Little, Brown and Company, 1997.

———. *The Grand Canyon and the Southwest*. Edited by Andrea G. Stillman. New York: Little, Brown and Company, 2000.

Szarkowski, John. *Ansel Adams at 100*. New York: Little, Brown and Company, 2001.

Gherman, Beverly. *Ansel Adams: America's Photographer*. New York: Little, Brown and Company, 2002. (Biography for young people.)

Adams, Ansel. *Trees*. Edited by Janet Swan Bush. New York: Little, Brown and Company, 2004.

———. *Sierra Nevada: The John Muir Trail*. New York: Little, Brown and Company, 2006. (Limited edition of 500 copies and trade edition.)

Prepared by Claudia Rice and William Turnage

ACKNOWLEDGMENTS

Thanks first of all to David Young, chairman and chief executive of Hachette Book Group USA, who proposed this book, and to Jean Griffin, Ansel Adams' publisher, for their energetic backing.

Much depends, in a book of photographs, on the fidelity of the reproductions to the originals; the beauty of the plates herein is in large part due to Thomas Palmer's artistry with the scanner. The Center for Creative Photography loaned almost four hundred photographs from which Palmer worked; my thanks to Leslie Calmes, Denise Gose, Marcia Tiede, and Carol Elliott, who allowed me to choose from thousands of photographs the ones that appear in these pages. In addition, the collectors Hans P. Kraus, Jr., Ezra Mack, and R. Thayer Tutt, Jr., graciously loaned rare vintage photographs to be scanned. This is the second book of Ansel's photographs that Mondadori has printed to the highest standards. In 1979 Lance Hidy designed one of Ansel's greatest books, *Yosemite*

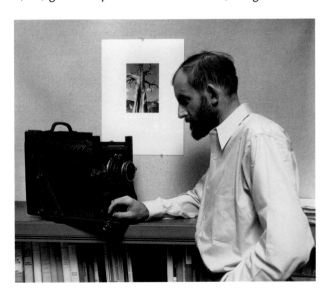

and the Range of Light; it was a pleasure to work with him again on the design of this complex book. I am fortunate that Little, Brown's Jayne Yaffe Kemp contributed her deft but sure touch as copyeditor. Editorial assistant Julia Novitch provided invaluable behind-the-scenes support. To my joy and comfort, Sandra Klimt oversaw the production from the initial idea to the books on the shelf.

In addition, I am indebted to Steven Hennenfent, whose friendship and inspiration gave me the confidence to undertake this book; to my mother, Ann Gray, who pored endlessly over manuscripts; and to four friends with editorial expertise, Anne Horton, Angeline McGruder, Chris Mahoney, and Marianne Macy, whose advice was invaluable.

Finally, Bill Turnage and Michael Sand assisted every step of the way, from the concept of the book to the selection of photographs to detailed commentary on the manuscript.

A.S.

ANSEL ADAMS SELF-PORTRAIT, C. 1936

CREDITS

PHOTOGRAPHY CREDITS

Pages **2, 8, 11, 61**: copyright © Cedric Wright Estate

Page **6**: copyright © 1947, Beaumont Newhall, copyright © 2007, the Estate of Beaumont and Nancy Newhall. Permission to reproduce courtesy of Scheinbaum & Russek Ltd., Santa Fe, New Mexico

Pages **9** (left) and **163**: copyright © 1944, Nancy Newhall, copyright © 2007, the Estate of Beaumont and Nancy Newhall. Permission to reproduce courtesy of Scheinbaum & Russek Ltd., Santa Fe, New Mexico

Pages **9** (center) and **321**: copyright © The Imogen Cunningham Trust

Page **9** (right): Ansel Adams Archive, Center for Creative Photography, University of Arizona

Pages **429** and **440**: Collection of the Center for Creative Photography copyright © 1981 Arizona Board of Regents.

LITTLE, BROWN AND COMPANY
HACHETTE BOOK GROUP USA
237 Park Avenue
New York, NY 10017

Visit our Web site at
www.HachetteBookGroupUSA.com
First Edition: October 2007

10 9 8 7 6 5 4 3 2 1

LIBRARY OF CONGRESS
CATALOGING-IN-PUBLICATION DATA
Adams, Ansel, 1902–1984.
 Ansel Adams : 400 photographs /
 edited by Andrea G. Stillman.
 p. cm.
 Includes bibliographical references.
 ISBN-13: 978-0-316-11772-2
 ISBN-10: 0-316-11772-2
 1. Adams, Ansel. 2. Photography, Artistic.
 I. Stillman, Andrea Gray. II. Title.
 III. Title: Ansel Adams, four hundred
 photographs.
 TR647.A43A24 2007
 779.092—dc22 2006102888

COLOPHON

Design by Lance Hidy
Duotone separations by Thomas Palmer
Production supervision by Sandra Klimt
The text typeface is Magma, designed by Sumner Stone for the Stone Type Foundry. The titles are composed in Penumbra Flare Serif, designed by Lance Hidy for Adobe Systems. The paper stock is 150 gsm Galaxi Keramik demi-matte.
Ansel Adams: 400 Photographs was printed and bound by Mondadori in Verona, Italy.

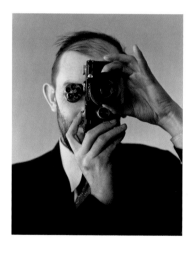

ANSEL ADAMS AFTER HE GOT
A CONTAX CAMERA, 1936,
BY EDWARD WESTON